-The- Extraordinary -Works of- ALAN MOORE

-by-

George Khoury
and friends

The Extraordinary Works of
ALAN MOORE

written and edited by George Khoury
front cover art by Dave McKean
logo design by Todd Klein
back photograph and chapter spread photography by Jose Villarrubia
book design by John Morrow
interviews were transcribed by George Khoury, Marc McKenzie and Steven Tice
proofreading and production assist by Eric Nolen-Weathington

TwoMorrows Publishing
1812 Park Drive
Raleigh, North Carolina 27605
www.twomorrows.com • e-mail: twomorrow@aol.com

First Printing • July 2003 • Printed in Canada

Softcover ISBN: 1-893905-24-1

TRADEMARKS & COPYRIGHTS

DEDICATION
To the memory of Sylvia and Ernest

ACKNOWLEDGEMENT
ALAN MOORE, thank you for over twenty years of storytelling and for making this book possible.

CONTRIBUTORS
Hilary Barta, Brian Bolland, Mark Buckingham, Scott Dunbier, Neil Gaiman, Melinda Gebbie, Ian Gibson, Dave Gibbons, David Hume, Sam Kieth, Todd Klein, Garry Leach, David Lloyd, Marc McKenzie, Mike Matthews, Dave McKean, Amber Moore, Leah Moore, Kevin O'Neill, Harvey Pekar, Alex Ross, Don Simpson, Chris Sprouse, Greg Strokecker, Lloyd Thatcher, Steven Tice, John Totleben, Rick Veitch, Jose Villarrubia, and J.H. Williams III

SPECIAL THANKS
Richard Ashford, Peter Bagge, Bart Beatty, Tony Bennett, Eddie Campbell, Stephen Camper, Mike Collins, Jon B. Cooke, Steve Darnall, Pat Fish, Dick Foreman, Michael T. Gilbert, Trevor Goring, Paul Gravett, Alex Green, Ed Hillya, Jason Hofius, Omar Khoury, Joseph Koch, Jean Matthews, Mike Moore, Steve Moore, Mark Nevins, Stan Nicholls, Walt Parrish, David Roach, Dave Sim, Matt Smith, David Sutton and to all the contributors as well because we couldn't have done it without you.

£#@%ING DEADLINES! WHILE MY FRIENDS ARE BOOGIEING AWAY A FRIDAY NIGHT, I'M STUCK WORKING AGAINST THE CLOCK-- TRYING TO FINISH THIS LOUSY, STINKING--

OH, HELLO THERE! MY NAME IS GEORGE KHOURY. YOU MIGHT KNOW ME FROM SUCH BESTSELLERS AS KIMOTA! AND G-FORCE: ANIMATED*. OR MAYBE NOT.

EDITOR'S NOTE: HEY, I HAD TO READ 'EM!

WELCOME TO THIS SPECIAL TOME DEDICATED TO THE BEST* COMICS WRITER EVER-- THE AFFABLE ALAN MOORE!

ED'S NOTE: HE IS IF I SAY HE IS!

WHEN I CALLED MR. MOORE ABOUT DOING THIS PROJECT, HE HAD ONLY ONE REQUEST:

JUST DON'T LET IT BE A WAKE, GEORGE.

FOR YEARS THIS PHOTO OF MOORE INTIMIDATED MANY FOLKS. IT MADE HIM APPEAR MENACING AND UNAPPROACHABLE. THIS COULDN'T BE FURTHER FROM THE TRUTH.

HE'S NEITHER IMMORTAL, IMMORAL, NOR PARANORMAL. I'VE MET HIM. HE'S FLESH AND BLOOD!

AND ALL THOSE THINGS YOU'VE HEARD ABOUT HIM... LIES!

WHAT IS TRUE, IS THAT YOU WILL NEVER FIND A BETTER MAN THAN ALAN MOORE.

LOOK! I HOPE FROM READING THIS BOOK YOU'LL GET A REAL SENSE OF WHO ALAN MOORE IS. OF WHAT IT TAKES TO DO WHAT HE HAS DONE SO WELL FOR DECADES.

THERE'S A LOT MORE TO THIS MAN THAN MEETS THE EYE.

I'VE HAD THE TIME OF MY LIFE WORKING WITH ALAN AND ALL THE OTHERS THAT CONTRIBUTED TO THIS BOOK.

I HOPE THAT YOU FIND IT AS ENLIGHTENING AS I HAVE FOUND THE EXPERIENCE.

WOW! LOOK AT THE TIME! I THINK WE'D BETTER START THIS LITTLE SHINDIG. SO SIT BACK, TURN THE PAGE, AND ENJOY!

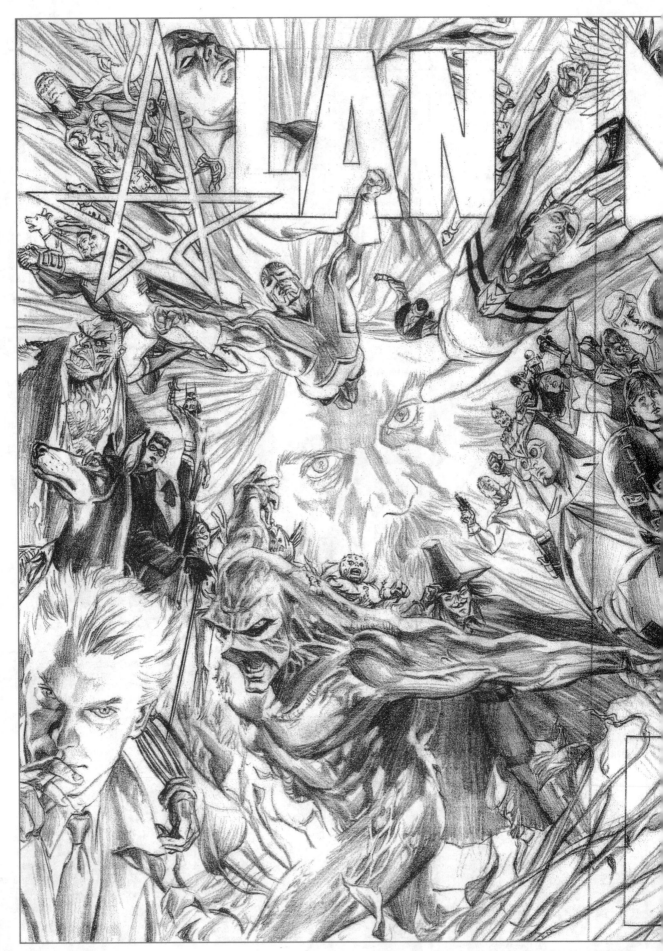

CONTENTS

INTRODUCTION6
by Leah Moore

CHAPTER I10
Once Upon A Time

CHAPTER II30
A Funny Wonder

CHAPTER III54
The Rising

CHAPTER IV82
Swamp Daze

CHAPTER V108
Watchmania

MIRACLEMAN
INTERLUDE146

CHAPTER VI148
The Auteur

CHAPTER VII172
Back to the Frontline

CHAPTER VIII194
New Beginnings

AFTERWORD200
by Amber Moore

BIBLIOGRAPHY202

STORIES & SCRIPTS

SHRINE OF
THE LIZARD22

OLD GANGSTERS
NEVER DIE49

JUDGE DREDD50

LUST98

IN PICTOPIA128

BELLY OF CLOUD . . .162

I CAN HEAR THE
GRASS GROW202

TRIBUTES

NEIL GAIMAN &
MARK BUCKINGHAM8

RICK VEITCH28

DAVID LLOYD53

JOHN TOTLEBEN80

DAVE GIBBONS106

BRIAN BOLLAND107

J.H. WILLIAMS III142

IAN GIBSON144

GARRY LEACH145

HILARY BARTA168

CHRIS SPROUSE170

SCOTT DUNBIER &
SAM KIETH171

TODD KLEIN190

KEVIN O'NEILL192

LEFT

Alex Ross' homage to Alan Moore's prolific career. The painted version of this drawing was featured in *Wizard* magazine.
Character TM & ©2003 their respective holders. Art ©2003 Alex Ross.

ABOUT THE COVER

This illustration was done by artist Dave McKean back in the late '80s for a Moore book which Neil Gaiman never completed. Years later, Gaiman suggested the painting for the cover of this book, which McKean retouched with new momentos.

PAGE THREE

This hilarious prelude strip was written by George Khoury and illustrated by Hilary Barta.

This year Alan Moore is fifty. For most men, this would signal a sudden influx of golf sweaters, an overwhelming urge to drive a very small fast car, and possibly a fling with a secretary. These things are unlikely to occur in my father's case. He is, thankfully, one of life's passengers. When I say thankfully I mean it, having twenty/zero vision, and thus seeing in only two of our earth dimensions, he would be a terrifying prospect behind the wheel of any vehicle. This fact alone means that ninety percent of Northampton taxi drivers can now retire early, and afford to put their children through college.

Having a fling with his secretary is impossible, not least because he is still blissfully attached to smut peddler Melinda Gebbie, but also because he has no secretary. This means that he does all his own 'filing' in towering heaps around the house, takes all his own phone calls despite his deep and earnest desire not to speak to *anyone*, and types every word of his staggering body of work himself. His typing is thunderous and rhythmic, sounding from a distance like demons tap-dancing.

So what does this birthday mean to him? As far as I can make out, he plans to retire. Not in the putting your feet up and doing more in the garden sort of way, but in the continuing to put out great swathes of work but for laughs not money sort of way. I feel he has not realized what a powerful narcotic creativity can be, and hope to get him into some sort of literary rehab, where he will slowly be weaned off great historical works of genius, onto less addictive texts, maybe formulaic thrillers, or romantic short stories.

Although this book commemorates his fiftieth birthday, it's worth noting that half my father's life was spent outside the glare of the public eye. Whilst productive throughout his teens and early twenties, he was not really launched into his chosen career until he was about twenty-five. This, by coincidence was also the year I was born. Many people, on hearing of their impending fatherhood would attempt to secure a steady job, with a regular wage to insure fiscal security for their growing family. They would not embark on such a perilous journey as becoming a professional writer, let alone a writer of comics. I think it shows great determination in my father, and no small measure of courage in my mother, who would have the task of raising me, and later my sister, on his wages from the local newspaper strip "Maxwell the Magic Cat" and the occasional half-page strip in *Sounds* magazine.

It does not take a great mind to work out that as my father is turning fifty, I am twenty-five. The thing is that by a quirk of fate, I am also embarking upon a career in the funny papers. It is only since I have experienced some of the difficulties of the industry into which I have ventured that I've begun to understand what a mammoth undertaking it must have been for my parents. It is also worth noting that my birth, and the drive for financial security that I brought, probably forced my father to work harder, take on more projects and stretch himself more creatively than he would have needed to had I not arrived. This may sound like I'm taking the credit for making Alan Moore get off his arse and write great comics. I am.

My formative years were spent for the most part in the company of my mother, with my father present only as the rumble of typewriter keystrokes from upstairs. This cacophony is still a comforting sound to which I can doze off if not careful. My sister will corroborate that this noise, a cloud of smoke and a vague smell of Tippex were the things that represented our father for us. He did emerge from his workroom occasionally, usually at our bedtime, when our mother could hand us over for a bedtime story, and we would enjoy a writer doing what he loved best, telling stories. Before this gets too sickly sweet, I'd like to point out that not all these stories were really children's books, and indeed several of them might be considered a little old for us. I have been told since that it was 'character building'. While this may be so, I distinctly remember Ray Bradbury's *Something Wicked This Way Comes* scaring the sh*t out of us both.

This period, when Amber and I were small, was when he had to work the hardest. You can always tell when he's got bills to pay, because the amount of stories he's got out doubles overnight. By my reckoning this occurred roughly every six months between my birth and the present day. The hard work paid off in the Eighties, when the success of *V for Vendetta*, *Watchmen*, *Miracleman* and the rest meant we had money for the first time. We had a nice house, and all the trappings that money brought with it at that time. There is footage somewhere of me demonstrating our brand new CD player, something we felt very 'cutting-edge' to own at the time. It was filmed by a crew who came to make a documentary on 'Alan Moore—Eighties Icon'. Thankfully, the footage didn't make the final cut, but there is a scene where he is striding down a path in an ornate Victorian garden just outside Northampton. My sister and I run in from out of shot, and he scoops us up in his arms and continues striding. The very image of fatherly strength. What somewhat spoils this image, is that when he is almost out of shot, and puts us down grate-

fully to the side of the path (neither of us were ever sylph-like, even as children), he myopically doesn't realize that the lawns to either side of the path were sunken, by about two feet, and that he was actually dropping us on quite a steep grassy slope. The televised documentary ends with us flailing comically as we pinwheel down to the lawn below.

As you can see, being his daughters meant we reaped all the rewards of the comic industry. Karen Berger sent us boxes of DC action figures; and we were once given two huge stuffed Marsupilami toys, which were bigger than we were, and were nearly ripped open by jumpy customs officials. Other treats included being taken to the Angouleme convention, where we met the legends Will Eisner and Harvey Kurtzman. It was Kurtzman's daughter Liz, and her boyfriend, who took us up in a little biplane when our minder for the day wandered off. It

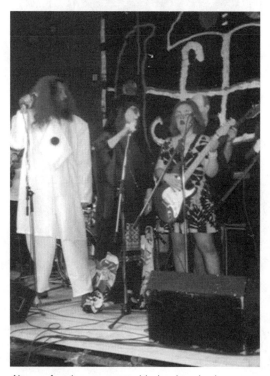

Alan performing on-stage with daughter Leah (she's the one with the guitar).

was David Lloyd who bought us orange juice when we got back to terra firma, and could see no sign of our errant Gallic babysitter. It was on the bus back from this alpine merriment that I found myself sitting across from Sergio Aragonés, who incidentally had no idea he would be drawing my very first published comic strip nearly fifteen years later.

The Nineties were strange times for everyone; the bubble of Eighties wealth had burst, taking with it several comics companies. This meant that two of my father's biggest projects, *From Hell* and *Lost Girls* nearly never saw the light of day. As we all know, *From Hell* was eventually finished and was even turned into a movie. This filled my father with joy and merriment. Oh... no, it didn't, did it? At the time, me and Amber were all for it, especially when we heard Johnny Depp would star. We twisted his arm and pleaded and cajoled, but he remained firm... we were on no account to go to Prague and kidnap the chiseled hunk. We were also denied a 'Premiere' with spangled frocks and big hair. We did however

get copies of photos from the set, some of which showed the lovely Mr. Depp in a rather fetching kilt. Did I mention that being Alan Moore's kid has its perks? As for *Lost Girls*, it is a flesh fest *par excellance*, to which my dad and his bird have devoted most of their fourteen-year relationship. With regard to this publication I have held the glamorous title of pubic hair continuity advisor for many years, and never cease to be amazed at the depths to which they sink in the name of 'art'.

Anyway, in between all the stopping and starting of projects and the work for Image comics (I actually quite liked the *Violator* mini-series!) he found the time to go mad. At his fortieth birthday party he declared himself a magician. He wasn't of course. He couldn't even do balloon animals. Not long after that, he started worshipping a snake. You can see how we might have worried about him. The thing is, that to a pair of teenagers his antics, no-matter how odd, were more amusing than anything else. It was only when I recovered from that really long fit of the giggles that I realized he was serious. He was getting into ritual magic, learning about the Kabbalah and filling his house with occult paraphernalia. Although the thought of candles balanced about the place in a house filled entirely with books and papers gave me cause for concern, I decided that his beliefs were no more crazy and spurious than most people's.

Now it's nearly ten years since he made that surprise announcement, and he's a lot less mad. He's stopped thrashing about in the water of the occult. He has ditched the water wings. He's doggy paddling nicely thank you. This makes life a lot easier for him. When the doorbell goes at eight in the morning, the postman may still be greeted by a grizzly bear in a dressing gown, but at least it isn't covered in blood and feathers.

His productivity has continued to increase, with his own line of comics allowing him to explore all the different types of comics he loves so much. The two which please him most, *Promethea* and *League Of Extraordinary Gentlemen*, have proven to be the most successful, with *Promethea* giving its readers an easy to understand guide to magic and the Kabbalah, and *League* bringing all the best characters from classic fiction together in a powerful and educational romp. *League* is being made into a film, also shot in Prague. It looks likely that it will make him just as gloomy as *From Hell* did, and this time I don't intend to kidnap any of the cast.

As the big day looms ever closer, I wonder what it will be like for him at 'Nifty Fifty', whether he will slow down and take it easy, or whether there is another surprise announcement on the way. Maybe he'll elope with his blonde-haired hussy of a snake-god, or perhaps he'll decide to take up Kabbalistic golf where there are only ten holes, but the sweaters are groovier.

Whatever happens, I can't wait for his introduction to my fiftieth birthday book.

True Things

Neil Gaiman: *writer* Mark Buckingham: *artist* Todd Klein: *letters*

Alan Moore wanders the streets of Northampton with a cane. His eyes glitter and gleam even in the half-dark.

The small children of the town think it funny to dare each other until the bravest of them finally runs up to him and asks...

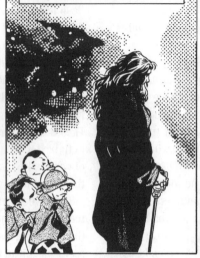

Mr. Moore? Mr. Moore? Will you tell me my fortune?

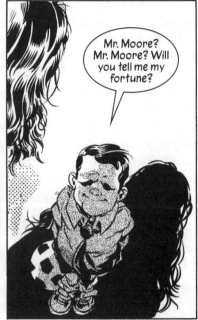

You will get a job in an abattoir, when you leave school. On your thirtieth birthday you'll learn that your wife is having an affair with your boss, and you'll go out to your car, connect a hose to the exhaust, and attempt to kill yourself.

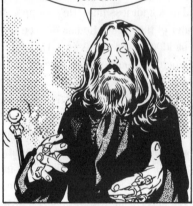

But they'll find you before you're dead, and you'll spend the next four years unable to talk or feed yourself. Your wife will bring men home. Eventually one of them will drop a cigarette that'll set fire to the house. You'll die in the blaze.

Your wife will remarry and move to Droitwich.

Oh.

He is never wrong.

In his study is a small shrine, and in the shrine is the skull of a Buddhist monk.

They argue late into the night, Alan and the monk, while the smoke-ghosts wreathe all serpentine about them claiming to be demons.

Imagine the state of your lungs!

At least I've got lungs. You've got no body at all.

Nobody? I've got you, Alan. I'll always have you. How about a cup of tea? Pop an extra lump of yak-butter into mine.

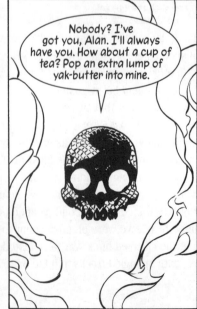

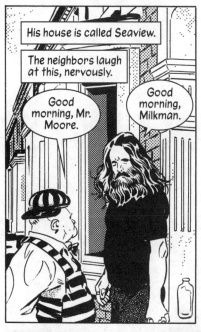

His house is called Seaview.

The neighbors laugh at this, nervously.

Good morning, Mr. Moore.

Good morning, Milkman.

I couldn't help noticing that your house was called Seaview. Did you know that Northampton was the city in England furthest away from the sea? They teach us things like that in Milkman school.

Actually, I did know that already, Milkman.

Ah well. Top of the morning to you anyway, sir.

Alan is an explorer. He knows all about idea space.

For a while he dug down under his house, believing that the dark truth of ideas was under there, but he found only twelve dancing princesses and the gates to Hades.

These days he goes out into his back garden.

There is a pond in his back garden as big as the world, and waves lick the sides of the pond like the tongues of too-friendly sea monsters.

Sometimes he carries a beach ball, sometimes he ties all his worldly possessions and the skull of the Tibetan monk up in a spotted hankie on a stick, and sometimes he just packs sandwiches.

The ship is always waiting.

There are lands that wait to be charted. Imaginary lands, which are the only ones that matter. Sometimes the seas are choppy, and sometimes they are smooth.

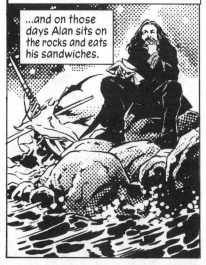

Sometimes the winds are good. Every now and again, the ship is wrecked on the rocks, as it's rounding the Cape or squaring the circle...

...and on those days Alan sits on the rocks and eats his sandwiches.

Then he goes back up the garden path to the kitchen, and goes inside, and makes himself a cup of tea.

END

9

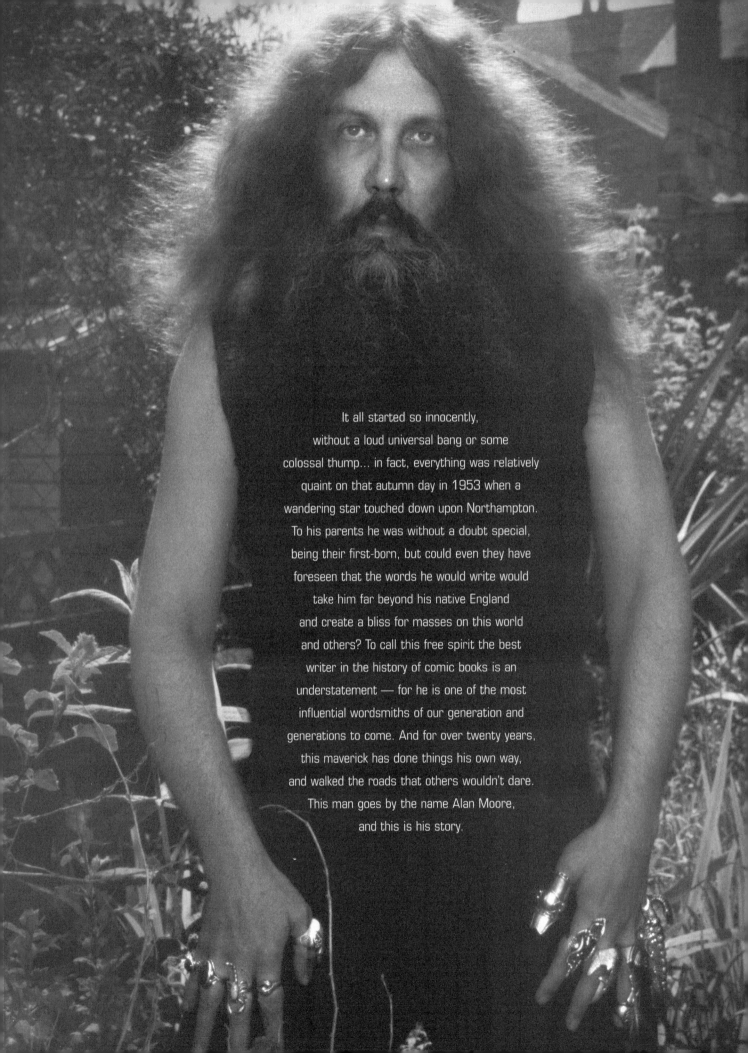

It all started so innocently,
without a loud universal bang or some
colossal thump... in fact, everything was relatively
quaint on that autumn day in 1953 when a
wandering star touched down upon Northampton.
To his parents he was without a doubt special,
being their first-born, but could even they have
foreseen that the words he would write would
take him far beyond his native England
and create a bliss for masses on this world
and others? To call this free spirit the best
writer in the history of comic books is an
understatement — for he is one of the most
influential wordsmiths of our generation and
generations to come. And for over twenty years,
this maverick has done things his own way,
and walked the roads that others wouldn't dare.
This man goes by the name Alan Moore,
and this is his story.

So, we'll start at the beginning, like when and where were you born.

Right. I was born on November 18, 1953, in the St. Edmond's Hospital in Northampton, which was a converted workhouse from the Victorian period. This was in Northampton. As far as I know my family has lived in Northampton for generations, as far back as anybody can remember. At some point, somebody in the family married a Belgian woman who I believe was one of the Huguenots, a culture that had settled in England; they were mostly known for their ribbon and lace making.

They were also very self-sufficient; they had a community in Spitalfields, in Jack the Ripper territory, where they educated their own children, looked after their own sick and elderly, and were a completely self-sufficient community, which of course didn't go down well with the government of the day, who thought it was too much like anarchy. People who thought of actually running their own lives without leaders and are actually making a good job of it—that's not a good thing to have happening, because if other people saw that, they might think they could do that as well. So, what the government did was to bring in taxes upon lace and ribbons, which were purely designed to cripple the Huguenots.

Is this on your father's side or your mother's side?

This is on my father's side, the Moore side of the family. So, they brought in these crippling taxes to damage the Huguenots. The Huguenots, being proud people, protested publicly in the streets. The authorities sent in troops, which were actually barracked in Hawksmoor's church, and they shot the rioters. I think the Huguenots were dispersed, probably widely across the country; one of them evidently got as far as Northampton and married into the family. At which point the family added lace and ribbon work to their skills. That said, this is a very working class family, this is before the term "working-class" was invented—it would have been called peasant stock. Northampton is the dead center of the country geographically. It's probably the area of the country where if there is any ancient British—ancient Briton blood left anywhere in Britain, it would probably be around the Midlands, around the "Black Country" around Northampton.

But it's a working-class town? Nowadays it's different, I suppose.

Well, it's difficult to say. Originally Northampton was, oh—when I say originally, I'm talking about the Neolithic period; there was a settlement here in Neolithic times. That would

have been a number of wigwams and a bridge. The reason the town is here is because there is a track, an ancient kind of natural path that runs all the way from Glastonbury up to Lincolnshire. Now this track would have been the path that more or less turned England into a country. What had previously been a bunch of scattered tribes would have used this path to instigate trade and communication, and this path happens to cross the River Nene at Northampton. Therefore, anybody traveling that path would have to cross the river. So if we put a town by the bridge, then it was likely to be quite a prosperous town, in that there would be lots of trade moving through.

So I presume that's why Northampton's here, but it grew up slowly from that point; I mean, there were some Roman settlements here. There was a big Iron Age camp just before the Romans got here, where there's a kind of local mystery—the entire population vanished overnight; no one knows what happened to them. There have been lots of theories put forward but none of them really work. The fact that they left overnight was evident by the fact that they had left all corn querns behind. A quern—it's a sort of a hand-held corn mill. Now this would have been as valuable—I mean, these were relatively new corn querns so this would have been like, people leaving their mobile phones behind. [laughs] These would have been relatively expensive; they wouldn't be things you threw away. So if they were all left there that means that the people had to leave so quickly that they couldn't even wait to take them. It's kind of like the Mary Celeste, but on dry land. It wasn't an attack by enemies; I mean, the camp was on top of a hill—if you're being attacked by enemies you don't give up the high ground. And also, there would have been bodies left

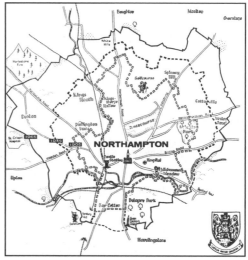

No place like home. Northampton has been a borough in England for over 800 years, and Moore has never lived anywhere else. This vintage map from 1965 shows the borough.
©2003 Respective holder.

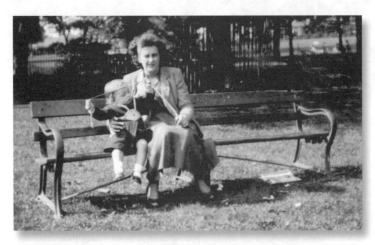

"With Mum in Victoria Park, maybe 1955. I was kept tethered like a wild, feral beast, and this is probably why I turned out the way I did."

from the massacre. The same thing if there had been a fire, there would have been evidence of it or a plague. But, no—the entire community just vanished, and later, the Romans turned up. There were some Roman villas here; we keep finding odd little sorts of archaeological remains.

During the Roman period, Bodacia who was—she was an ancient British queen, a queen of the ancient Britons more accurately—the tribe that she ruled was called the Iceni and Bodacia was kind of famous because during the Roman occupation of Britain, apparently the Iceni were a matrilineal tribe in that rulership of the tribe was passed down from mother to daughter. But this didn't sit well with the Romans who had a patriarchal tradition. When Bodacia wanted to pass down her queenship of the Iceni to her daughter, they forbade her to, and apparently just to get the point home they raped her and her daughters then, I think, had them flogged. This was kind of a miscalculation on the Roman's part, because Bodacia wasn't just the queen of the Iceni, she was their goddess. It was their goddess that the Romans had raped. Bodacia wasn't pleased with it either, and she raised an army of the Iceni. They descended first upon the Roman settlement at Colchester and killed everyone and destroyed the place. And then they carried on, they got to St. Albans next, then they destroyed the place. And then they carried on to London; the Roman garrison in London saw them coming and fled, because this was a bunch of absolutely crazed ancient Britons—and they destroyed London.

I mean, if you actually look at the geologic cross-section of rock that London's built on—which they have on display in the London Museum—there's this little half-inch black stripe that runs all the way through it. That's Bodacia; she burned the place to the ground, and there's this little half-inch of black running all the way through the rock under London; that's what Bodacia did.

Now if she'd carried on after the Romans, she could have probably driven the Romans out of England. But she went on an orgy of destruction in London; I mean the gutters were piled high with human heads. She was just having everybody killed. Meanwhile, the Romans—the legion that had been in London—carried on into Wales and met up with another Roman legion that were in Wales trying to suppress the Welsh revolutionaries—people like Caradoc. And the two Roman legions, together, returned to London, by which time Bodacia and her men were kind of exhausted or killed off. It's reckoned—I mean, the official story is that Bodacia was killed and buried under what is now Platform 10 at King's Cross Station, but frankly, that's not likely. I mean if the Romans had killed Bodacia she wouldn't have been buried anywhere. Bits of her would have been paraded around the Roman Empire for years to come. What's most likely is that she took poison, and probably while her forces remained at Battle Bridge to die uselessly at the hands of the Romans, there would have been a small group of cavalry who would probably have taken the queen's body back to Northampton, where it was believed to have been buried at a place near the Silverstone racetrack in Northamptonshire—a place that in the Doomsday Book was called "Dedequenesmore," or "Dead Queen's moore." So a few years ago, they actually dug up a huge barrow with—it was obviously the remains of some kind of queen from around the 2nd century. It was almost certainly Bodacia. But we can't prove that—they're still working on deciphering the remains. But, yeah, in all likelihood that's where Bodacia ended up.

It's a funny little town [Northampton]; most of the wars in England have ended up in Northampton—the British Civil War was decided at Naseby; the War of the Roses was decided, I think, near Delapre Abbey in Northampton. It's just because it's right in the middle of the country; it's like everything seemed to happen there or everybody seemed to pass through there on their way to whatever destiny awaited them. It has a certain character of its own as a result. My family, Lord knows where they originated from, but it wouldn't have been very far from Northampton; people didn't travel very far in those days. I mean, I doubt that

"Northampton, 1956 or thereabouts. Me at a local nightspot with my bitches."

my grandmother ever traveled much more than five or ten miles from the place where she was born during her entire life, you know? Certainly not her mother, or her mother's mother. Mobility is a fairly modern invention. So yeah, I think that my family more or less crawled out of the fen lands, and pretty much stayed here. We can trace the family tree back to the 17th century, early 1600s, something like that.

The people in my family who are still in living memory, these are sort of working-class stock from what was called "the Burroughs" in Northampton. Basically you had the Romans, right—the Romans had been here, then the Roman Empire fell, and then the Romans with-

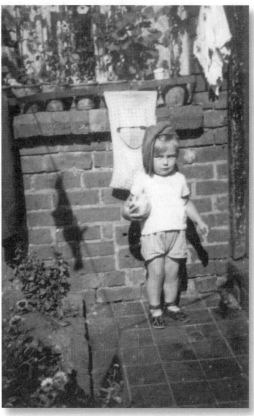

"Backyard at St. Andrews Rd., 1956/1957. Me, with cloth cap and football, self-consciously trying to look working-class because I knew it would look cool in future biographies. Actually, there's a heli-pad and a swimming pool just out of shot."

drew. The Saxons next came over and invaded. During the Saxon period Northampton was right at the center of Mercia, which was the most important of the Saxon kingdoms. So, during the Saxon period, Northampton was probably pretty much the capital of the country. Then in 1066, the Normans come over. The Saxons are driven out or subjugated, so the Normans appoint Saxon traitors as barons and earls—and give them all castles. We actually had—I think it was some relative, almost certainly a relative of William the Conqueror called Simon de Senlis who had the castle in Northampton. And he also built the round Templar Church that we've got here and various other things. Not a very pleasant character; he was a crusader, and none of the crusaders were that pleasant, you know. Sort of an 11th century "Stormin' Norman" Schwarzkopf or whatever. The area around the castle—when that was built in the 11th century—was where the serfs lived, and that became the town, in effect, just the small area around the castle.

Now later, as the town expanded, the castle was eventually pulled down. The area where the castle had been—all these little streets with names like Moat Street, Fort Street—which were actually where the castle limits had extended to—that became an area known as the Burroughs. No one was exactly sure why it was called that. Some people said it was

because it sort of had originally been spelt "b-u-r-r-o-w-s" because the people down there were poor and that they bred like rabbits. That's possible. Other people had different theories as to why it was called that, but the Burroughs was—I loved it, loved it. But looking back it was what we had in this country before we had sink states. I suppose the equivalent would be housing projects over there. This was the place where you put the poor. In my family's case, this was people who had lived in the villages in Northamptonshire, outside of Northampton town itself.

When the Industrial Revolution needed people to run the machines, then it moved people in from the villages into the towns, and it put them in low-grade accommodations—you know, these ancient Victorian terraced houses rented from the council—and that was where I grew up. That was where I spent the first 17 years of my life, in the most ancient district of this very ancient town. Where, to a certain degree, the lifestyles of the people around me, people like my gran, who lived with me and my parents and my brother—my gran's life had not changed significantly for—it wasn't that much different to her mother's life or the life of her mother before her. I mean, the house that we lived in, which was in fact me, my dad, my mum, my brother, and my maternal grandmother—down on Andrews Road in Northampton, opposite the train station, which is what the castle had been replaced by. They replaced it with a train station called Castle Station. But living down there, we did have electricity, which was good.... My paternal grandmother, my nan, who lived not far away, she still had gaslights. She didn't have electricity.

On the other hand, my nan did have a flush toilet, which I remember spending a lot of time as a child wondering which of us lived in the best accommodation. We got electric light but didn't have an indoor flush toilet; we had an outhouse without a cistern at the bot-

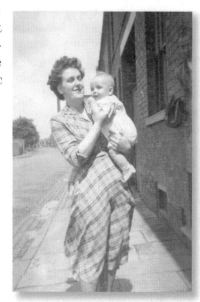

"Me and Mum, St. Andrews Rd., 1954. (The neighbour accidentally leaning into the right near background is, it will be noted, carrying a brick-patterned urban camouflage coat, very popular in Northampton of the early 1950s.)"

13

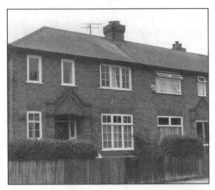

The Moore home might have been similar to the one pictured. After World War II, the Municipal Housing Program expanded into Northampton. ©2003 Respective holder.

tom of the yard, and there was no light in there. But at the same time, like I said, I was completely happy. I mean, because for the first—I guess for the first ten or eleven years of my life I've got no idea that there was any other sort of way that people lived.

You never had an urge to move out of there?

No, I loved it. I loved the people, I loved the community, and like I said, I didn't know that there was anything else. I didn't understand that there was a class of people called middle-class people and that they were better off and generally better placed socially than my family or our neighbors. I just assumed that everybody lived like us, apart from the Queen.

So what happened after you were 17, you moved out of the house?

Well, when I was about 17, what the Northampton council decided was—this was ostensibly for the good of the poor, uneducated inbred people—for our own good they would put us in better houses in nicer parts of town. This was largely because the ground we were living on, wretched though it was, could actually be put to more profitable use if you could get rid of the people. [laughs] So, what we had previously referred to as our neighborhood or community suddenly got a new name; it was called a "clearance area." And they just bulldozed everything [laughs] and they moved all these people who had lived there all of their lives to wretched blocks of flats in other parts of town, neighborhoods that weren't actually that much better than the ones they'd moved out of, and were certainly no friendlier.

My paternal grandmother was moved out of her flat on Green Street and was relocated into some—well, she was moved out of her house on Green Street where she's lived and brought up all of her children—she was moved to an old person's flat in the King's Heath area of Northampton. She was dead within three months. Then they moved my family—my mum, my dad, me, my maternal grandmother, my brother— we were all moved up to—yeah, another similar area, and my maternal grandmother—she was dead within about six months. Just because, being moved from the place where you got your roots was enough to kill most of those people. Yeah, I mean, the place where I'd grown up was more or less completely destroyed. It wasn't that they put anything better there; it was just that they were able to make more money out of it without all these bothersome people. At that point, like I said, we were all living in this reduced family after my gran had

died; we were all sort of living up at—it's called Abington; it's quite a nice area, you know, or at least it was. But, the very fact that they were moving my family there was probably a sign that it wouldn't remain a nice area for long. It was one of the places where they were putting poor people. Those areas—it was very much a kind of a thing where you put them where they were out of the way; where they didn't bring down the property values for better-off people. Where they didn't cause an embarrassment. So you tend to find these kind of areas where poor families, or in some cases actual problem families were dumped in these areas, and the areas were more or less allowed to fall to pieces.

So yeah, that was—we lived at the new house for a little while; that was around the time that I was thrown out of school. I still continued living with my mum and dad for a good couple of years after I got thrown out of school. Then I moved out and got a flat with my former wife and that was the start of my adult life.

At what age would you consider yourself an adult?

Uhm... about eleven?

Eleven? [laughs]

Well, at the time, I mean, I'm sure I wasn't an adult but at the time when I was eleven I realized that I was at least as intelligent as a lot of the adults around me. More or less as sensible. So I was indignant that I wasn't treated as an adult from the age of eleven; basically, I think I'm still growing up, to be honest. But I'd say—when I got kind of thrown out of the nest or when I jumped out of the nest, if you like, that was when I was around about, what, 19 just turned 20, something like that.

Was the schooling system any good in Northampton, or—

Well, I mean, you're asking probably the wrong person. I'm very embittered by the entire education system over here; I think that there's nothing more important in the world than

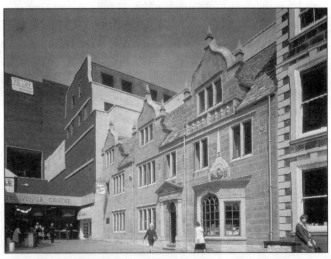

A view of Market Square in Northampton. The town is growing fast from a blue collar community to big commerce.
©2003 Respective holder.

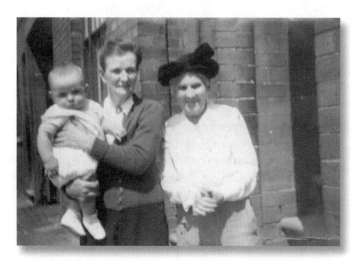

"'I was bored before I even began.' Me, my grandmother, Clara Elizabeth, and neighbour, Mrs. Ward, outside 17 St. Andrews Rd., circa 1954."

education. I also think that the education system over here is—perhaps this is true in America as well—it is not actually geared towards educating people or making them happy or making them more functional in the way that they live their lives. As I understand it, I mean, over here in this country, us people in the serf classes—we didn't get educated at all until comparatively recently. It was more or less with the Industrial Revolution that you had to educate the peasants. Because prior to that, living in rural communities, they didn't really need to be able to write, or read. They didn't really need to be able to count in any more complicated way than just marking a few marks in the dust. That was sufficient.

But once you move them into the towns to work at the factories, they need to at least be able to read instructions, to know what time to turn up for work. To be able to do basic things. So you need to educate the working classes. Now I believe that the theory upon which British education was originally founded was that—well, upon which the British class system was founded—was that it was genetic. The ruling classes ruled because they were genetically more suitable to rule. The working classes were sickly, poorly, ugly, largely unintelligent creatures, a little bit above the apes, who were destined to be ruled. Now, because they were so convinced that this was a genetic divide between the classes, it didn't matter if you educated the working classes a little bit. There's been no danger to it; because it's not like they'd ever be like proper human beings. They started educating the working classes, and that's why in the school system we even used to get free half-pints of milk at break. Now, actually when you start giving the working classes calcium—actual nourishment and a proper diet—all of sudden there would be members of the working class born who weren't bent over with rickets, who weren't small, emaciated, sickly little things. You got these quite large, strapping members of the

working class breed who in fact looked a lot more sturdy than some of the rather weak-chinned and inbred members of the upper classes who actually of course have a policy of interbreeding. And also they then responded to the education—they became smart, and this was a little problem, because this was kind of, what, in the '60s, that you've suddenly got this huge generation of sturdy, intelligent, working-class people who had had their expectations raised.

I can remember—I mean, working-class expectations—I remember my father, who at the time was earning, I think, 15 pounds a week in his laborer's job, telling me about the future. He said that when I grew up, I didn't want to be earning 15 pounds a week like he was; I wanted to be earning, oh, 18 pounds a week. That was as much as he could imagine me ever achieving. [laughs] To think of 19 pounds a week would have been a madman's dream.

So, working-class expectations were not traditionally high, because the working classes, having not been educated frankly, were not bright. Once they'd been educated however, their expectations soared. They suddenly thought, hey, yeah, we're working-class, but we're intelligent and look at the Beatles—most of them were working-class, but they're all of a sudden being acclaimed by academics, and viewed as the greatest artists of the century, you know... there are possibilities. Even if you're born working class, that doesn't mean that you have to be crushed by this class system. Now, of course, this was just at the time when the postwar employment boom was starting to peter out. We were starting to feel the growing effects of automation in industry, and this was obviously something that was going to get more pronounced in the future. I mean, I think that probably by the late '60s, the people who were running our laws must have been very well aware that there was gonna be a massive crash in employment in the '70s. Indeed that proved to be true.

Did you have a pivotal moment where you started wanting to read, and was it a teacher—what was it that got you into reading?

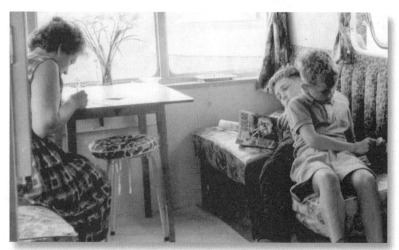

"Mum, me and Mike, and Dr. Solar, Man of the Atom. North Denes Caravan Camp, Great Yarmouth, early Sixties."

"The Wild Ones. Cousin Jim and me, North Denes, maybe '65, '66. My motorcycle rebel period. Note side parting and, from the design of my hand-knitted jumper, that my mum's medication probably needed adjusting around this time."

The thing is, like I was saying, my parent's generation, living around the Burroughs, there were a lot of them that couldn't read. They were people that had come in from rural areas and for some reason or another had never bothered to learn how to read or write.

But your parents never learned to read or write, right?

My parents had learned to read and write. I mean, my Dad had—he actually won a scholarship for his ability with mathematics. He could've gone to one of the well-to-do and special schools in the area, but the thing is, his family would have had to pay for school uniforms, books, and they would have to have forgone the wages he'd be bringing. So, he went on to a life as a laborer, because he couldn't afford to follow any academic challenges. But, they still valued intelligence.

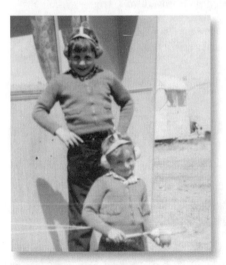

"North Denes Caravan Camp, Great Yarmouth. Me and Mike, around 1962, when we were in the Space Patrol, before they found out our ages and we had to give the sub-space communicators back."

They valued it fiercely. My dad read omnivorously for most of his life, and they considered literacy vital. There were people in my neighborhood who had to go through a constant, sad charade. You'd be around their houses because one of their kids was a friend of yours, and the dad would come in, and he'd say to the wife, "Oh the eyes are a bit tired tonight, read the papers for us would you?" And that was because you were there. That was because they've got guests and it was shameful for him; he had to pretend that he just wanted his wife to read the paper because his eyes were tired, because he couldn't read. There was a kind of stigma; people felt sorry for people who couldn't read. My parents, before I went to school, which was the age of five, my parents made sure that I could at least read the alphabet, could read simple sentences—"The cat sat on the mat," and that I could write the alphabet and that I could count from one to ten. They took a measure of pride in that. And it certainly paid off. I mean, I remember that I joined the library at the age of five; I remember the first book that I got out of the library—probably wasn't the first book I'd read, but it was the first book that I'd chosen for myself from the library. It was called The Magic Island. I hadn't learned about the softer "g" at that point, so I was enthralled about this book called The "Magg-ick" Island. I later realized I was pronouncing it wrong.

But, from then on, I'd go to the library and pick up two or three books every couple of days, and would just read omniv-

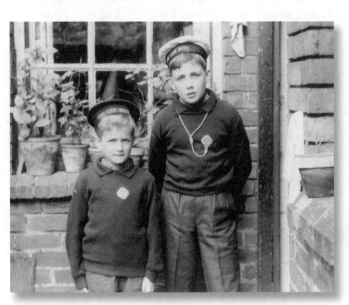

"Backyard at St. Andrews Rd., 1963 or 1964. Bonjour, matelots! After rejection by the Space Patrol, me and Mike had a brief stint in the navy, but we weren't really suited for it as Michael looked too gay."

orously. This is from the age of five. I mean, I would never claim to have read any great books, or even good books. [laughs] I just read whatever came my way. I loved it. Because my actual material life—the circumstances of it—were fairly prescribed. Limited. I didn't realize this at the time; like I said, I enjoyed playing with my friends on the wastelands that were prevalent in the area, which made exciting places to play. They were like quite natural jungle gyms, or something. But at the same time, the world that books opened up—that was a different world; that was like having this huge marvelous jeweled annex to the real world that you could wander into anytime.

There could be anything in there. You knew that in the real world governed by the laws of reality, there were certain things that you were not going to see on your way to school every morning.

When did you realize that there was this whole social class system that might have kept you down?

Up until the age of eleven, I was at Spring Lane Primary School, which was within two or three minutes walk of where I lived at the bottom of that hill. It was cozy, it was a great school; I mean, yeah, I'm sure it had the problems that a lot of schools of that period had, but everybody at school, all the children were known by their first names. Everybody knew each other. I guess it was pretty much an entirely working-class school; I didn't realize that there was a middle class. Then I passed what we used to call "Eleven Plus" exams. These were totally unfair exams in which the entire future course of a child's life was decided by how well they did in the examination when they were eleven. I did really well; I mean, I'd been— I think I was top of the class for the last two or three years at Spring Lane—I thought I was a miniature god. They made me the head prefect at Spring Lane. I was the brainiest boy in the school and the world was my oyster. And then I passed my Eleven Plus and went to the Northampton Grammar School, which was a posh school, and other than those few fluke working-class kids who'd passed the Eleven Plus, it was largely middle-class kids. Very nice middle-class kids, but all of a sudden, I realized that a lot of these kids had been to preparatory schools—the things I'd only read about in Billy Bunter books. That they actually had some grounding in Latin, in languages, in the kinds of math that we were being taught—I mean, things like Algebra, which was bewildering to me!

I realized that there were advantages that I had not had. I

"Circa 1965, backyard of 17 St. Andrews Rd. I am smiling because I had just killed a man with my bare hands."

mean, I didn't think that I'd been hard done by; I knew that there were a lot of people who were much, much worse off than I was. But at the same time I was starting to appreciate that there were a lot of people who were better off than I was as well. The first year at the grammar school I think my position in the class was 19, which was a tremendous shock to my ego. I mean, as far as I knew, I was like Jimmy Corrigan, the Smartest Boy on Earth; and then all of a sudden I'm only the 19th smartest in the class. That was such a shock to my ego that I think by the next term I was 27th in the class, and then kind of leveled out near the bottom, because I'd given up. I'd decided that if I couldn't win, I didn't really want to play. I mean, it'd been so easy for me to shine at Spring Lane. [laughs] A large number of the people in the neighborhood were mentally subnormal in some way; of course I didn't realize that at the time. I thought that I was a genuine intellectual light. I hadn't realized that actually, no, I was just about the smartest of a pretty crap bunch. [laughs] I mean, that's not to say that there weren't other kids who were every bit as smart as me; a couple of them have gone to have very interesting lives. But it was that, all of a sudden you're there at the grammar school, you suddenly realize that there is a pecking order and that you are way down in the pecking order.

And, well, I did realize that—like I said, I kind of stayed near the bottom of the class; I'd no interest in academic study. Which returns us to one of your questions about "What's the education like over here?" By this point I was starting to come to the conclusion that—or maybe this is something I'm saying with hindsight, I don't know; maybe I didn't feel this at the time,

"Brief period when I was employed by Wells Fargo in 1960-1961. The passenger is my brother, Michael, and the stain at the bottom left, as I recall, was Apache blood."

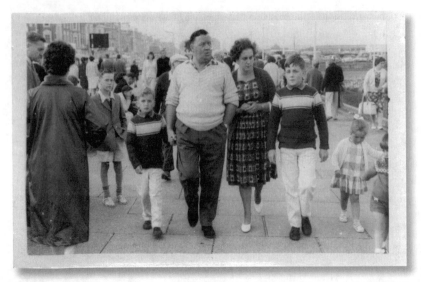

"Michael, our dad, Ern, and our mum, Sylve, and me, 1962 or 1963, on the seafront at Great Yarmouth. I can't remember all the walk-on extras we used in staging this photograph—except the "Boy" to the left of Michael, who as I recall was a 50-year-old midget called Trevor, and a tremendous theatrical character."

maybe I just felt a kind of dissatisfaction that I couldn't put my finger on at the time—but it seemed to me that, officially, the curriculum for education in this country is what we call the "Three Rs"—Reading, Writing, and 'Rithmetic. That's what they're supposed to be teaching kids. I think that's the overt curriculum, but that there is another curriculum, a covert curriculum. What we're really teaching kids over here, I believe, for the most part, is punctuality, obedience, and the acceptance of monotony—which I think are the three skills that most of them, at least speaking for the working-class part of the group, those are the three skills they'll need most in later life. They need to know when to turn up on time, to do what they're told, and even if their job is mind-destroyingly boring, to put up with it.

Accept it. [laughs]

Yeah, exactly. So it was around this time when I decided that I was never going to make it as a straight academic—and I particularly didn't want to; I didn't like the school, I didn't like the atmosphere, everybody was suddenly called by their surnames, we all wore identical uniforms—it was like being in the Hitler Youth! [laughs]

And so, around this time I'm what, 14? 15? So we're talking what, '67, '68? Something like that, '69? The hippie thing is happening, and there are a whole bunch of people who've got much better reasons for rebelling against the system than I have—I mean, my main reason is that my pride has been hurt [laughs], my vanity has been hurt by poor school results. But at the same time the fact that this was all happening, that there was a groundswell of young people who had an opinion and a more critical view of the way society was going—this time was just the right time for me. I was able to channel all my hurt and resentment—hurt at coming in 19th in the class—into some kind of social/political viewpoint. I must

admit that the class angle of it, I don't think it sunk in for a long time. During the hippie thing, I was able to delude myself, that the counterculture, the hippie revolution, was going to destroy all outmoded notions of class; that, hey, it doesn't matter whether you're a guy or a chick and the color of your skin doesn't matter either or whether you're rich or poor—we're all brothers in the Age of Aquarius. And I was able to believe that for a while.

Then I kind of noticed that actually—come the end of the hippie period, the very early '70s—that for one thing, I'd been thrown out of school for dealing acid. None of the middle-class kids who were dealing it with me [laughs] ever got their names brought up. One in particular went on to join the police force. But I'd been thrown out of school for dealing acid. Not only that, but the Headmaster had really got it in for me—he had got in touch with various other academic establishments that I'd applied to and told them not to accept me because I was a danger to the moral well-being of the rest of the students there. Which was possibly true. But at the same time, I was 17, and this headmaster not only stopped me effectively from taking any other kind of academic course out from where I was—when I applied for jobs, they would of course want references from the last place where I'd been, which was the school. So he'd be able to tell them not to employ me. I really do think, looking back, that at the age of 17, he really wanted to, effectively, end my life.

Is this the Headmaster who committed suicide?

Yeah, he hung himself. I shouldn't laugh; it was a class-related suicide. The thing was, the Headmaster had previously been the deputy Headmaster of a public school over here. Now public schools over here, that's places like Eton, Rugby, these are the schools for the aristocracy, where you have to pay immense fees, where your grandfather has to put your name down on the list for the school long before you're conceived. He'd been Deputy Headmaster at one of the public schools; so even coming to the grammar school was a step down for him.

So he was in denial?

Well, he was very much in denial. Most of the kids at the grammar school would be of an appropriate class, but you'd get some poorly behaved lower-middle-class kids and then there were the working-class kids, so he was never really happy even being at the grammar school. But then, some time in the '70s, we had a change of government over here that decided that the grammar school system and the Eleven Plus system was unfair and elitist, which was completely true, and they brought in a different sort of system called the Comprehensive System where the Eleven Plus was done away

with and kids were all just sent to the same kind of schools. So this meant that the grammar school would become a comprehensive school. This would mean that 75% of the pupils there might very well be working class. And as Headmaster of a comprehensive school, he would have to go to school with a bunch of these smelly oikes every day, and it was just too much for him. He came into school early one morning, as I heard the story, and hung himself in the central stairwell.

So after that, you never had to worry about him doing anything to you.

Well, no, but by that point I'd sorted the problem out for myself. I'd gone through a couple of really miserable jobs where they didn't care who you were. Even if you'd listed "axe murderer" as your previous means of employment, they wouldn't care. This was when I was working at the hide and skin division of the cooperative society, which was this bleak yard on the outskirts of town. I'd had to get up at about five in the morning to get down there by seven o'clock, which was when we started work hauling sheepskins out of these vats of freezing cold water that overnight had been mixed with, ah, the sort of things that you find on sheepskins when they've just been cut off the animal: sh*t, piss, blood—the usual barnyard fluids. And of course sheepskins, when you're dragging them out of vats of cold water, they're very, very heavy!

Were your parents disappointed when you got thrown out of school?

Oh, they were horrified! It must have been a real tremendous upset for them.

Did they know why you were thrown out?

Yeah, I mean, I must admit I lied through my teeth to them. I told them that I'd been framed... I dunno, they probably half-believed me, you know. I later came clean with them when I was a grown adult. Yeah, I mean, they'd hoped for more.

How did you get into that spot anyway, that you were dealing that stuff in school?

Well, like I said, this was because the hippie period had come along. I had—

Were you being an entrepreneur, or—?

No, it was purely for ideological reasons, believe it or not; I certainly wasn't making any money out of it. For one thing I was necking the profits. I wasn't very good as a drug dealer, but I'd read Timothy Leary's *Politics of Ecstasy* where he said that the heroes of the cultural revolution that was going on—that he believed was going on—were the rock musicians, the underground cartoonists, and the LSD dealers. I

thought that sounded good; sort of "I'll probably have to leave the underground cartoonist and rock musician until a little bit later, but I can probably get started on the LSD dealer." [laughs] It seemed glamorous at the time.

When you were a teenager, did you start thinking you had more freedom from your parents?

Well, yes, I suppose more freedom than, say, when I'd been a child. Yeah, I started going out and having girlfriends and staying out late at night and going to parties and things like that. And I found that I—it's difficult to overestimate the impact of psychedelic drugs upon my life and work. Starting out with just smoking cannabis—which didn't do a lot for me at first—and then I remember at one of the Hyde Park festivals—I think Canned Heat were playing or someone like that—and there was some kind of shifty-looking dope dealer straight out of a Gilbert Shelton cartoon who was coming past selling various assortments of drugs or grass or whatever. But he had these huge, unlikely-looking purple tablets that he assured us were LSD and indeed they turned out to be.

LSD was an incredible experience. Not that I'm recom-

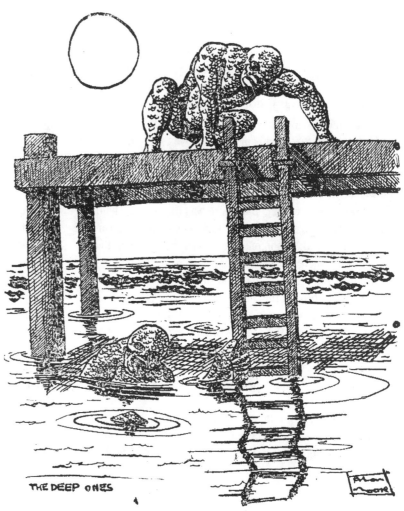

THE DEEP ONES

"The Deep Ones," by a 17-year-old Alan Moore in 1971 for the fanzine *Weird Window*. ©2003 Alan Moore.

mending it for anybody else; but for me it kind of—it hammered home to me that reality was not a fixed thing. That the reality that we saw about us every day was one reality, and a valid one—but that there were others, different perspectives where different things have meaning that were just as valid. That had a profound effect upon me, and of course there was the general rush of the '60s which people who weren't there—yeah, I know that people who were there have gone on *ad nauseum* about how great the '60s were and it's important to understand why everybody's fed up about hearing about them—but, something strange happened in the 1960s culturally. There was something phenomenal happening. You've got the biggest generation ever, thanks to our parents getting through the Second World War and being so grateful that they'd survived it—the bombing, the Blitz, everything—that they seemed to plunge themselves into a global sex orgy for the next couple of years. As a result, you had the Baby Boom. I think that everybody was just so glad to be alive that they really just wanted to have sex with their loved ones, because they could, because they weren't in bits on some foreign field or under a pile of rubble.

So you've got this huge generation, you've got the economic upturn that had been brought about by the war, you'd also got technology increasing in leaps and bounds during the war. So around about the '60s you've got this postwar generation just becoming troublesome teenagers. They've got this huge kind of pop music boom that is aided by radio and television—all of the technology that is suddenly blossoming—they've actually got a little bit of money to go out and spend on these records. But what came out of it was something that was very peculiar, and the further we get away from the '60s, and the more I look back, the stranger I think what happened then was historically. I suppose you could call it a mass psychosis, something like that. That there was this strange kind of almost undefinable set of beliefs that seemed to be, for a period there, governing the minds of nearly everybody in the Western Hemisphere who was under the age of 30. I mean, I'm sure that that's exaggerated and that there were lots of people who got through the '60s leading exactly the same lives as they would have done in the '50s or '40s—probably the majority of people. But at the same time, there were people who were caught up in this world of what the '60s were about. I think the experience altered them so radically that they themselves went on to have quite an impact in the culture that was to follow.

It changed a lot of things; I'm still not exactly sure what happened there, but there was some sort of incredible energy that rose for a number of years and changed people's lives—sometimes for the better, sometimes for the worse, sometimes not at all.

Well, after a while, reality probably sunk in and then you must have felt lost.

Hmmm.... I never felt lost.

I thought there might have been a period where your parents might have said you've got to start doing something with your life.

Well, my parents said, "You've got to get a job." But there wasn't anything I could do with my life, you know, because that had all been screwed up. However....

So you had no ambition? Yet you were reading so much.

I was reading, but sort of to no avail. I mean there was really nothing for me but laboring jobs. But you know, then again, that was what my father, my grandfather, and great-grandfather had done. That in itself wasn't the end of the world.

But you were almost ready to accept that kind of fate?

Well, no. You've got to remember that I'd been a pretty strange child to begin with. I was a bit funny from an early age. I was always very verbal, very loquacious, always jabbering about some mad stuff or other—I was odd. I was the only person that I knew who'd ever read an American comic. None of the other children at school did. I think when I got to the grammar school, there were two or three other kids there who read American comics out of about 1200 kids, you know, and science-fiction—hardly anyone read science-fiction or fantasy; it was kind of a weirdo's pursuit. I'd always been completely enthralled by this.

Now, add to this the fact that I'd always felt that I was special and important, mainly because in the area not known for its intellectual accomplishments—the Burroughs—I'd been head boy at the school. I'd always felt that I must be some special genius. It was completely ludicrous, of course, I'm just trying to explain the peculiar state of my ego. So when I was thrown out of school—and this is after, of course, the hippie thing with all of its ideological stuff had been absorbed, and after I'd taken something like, I think, 50 acid trips in a year—and this was when acid was good; none of this kind of kiddie stuff that you get these days. So I was in a peculiar state of mind. And when I realized that I'd been thrown out of school and that the headmaster had effectively stopped me from taking on any other course of further education, and felt that the only jobs I was going to be able to get would be jobs like the skinning yard or toilet cleaner at the Grand Hotel—which is where I went to work afterwards—once I realized that, I also realized that a lot of my hip counterculture friends from my school days suddenly didn't really want to have a lot to do with me anymore, once I was working down at the sheep skinning yard. Because as jobs go, that's rather smelly. It's difficult to actually get the reek of decomposing sheep out your clothing, your hair; bathing just didn't cut it. So yeah, to a large degree I was kind of abandoned by a number of my friends. They went on to college and I didn't get invited to the same parties. Now I suppose that the actual rational thing to have done then would have been to have despaired. But I was a bit manic. That was probably the saving grace, that I didn't realize what a bad situation I was in. I was just convinced that

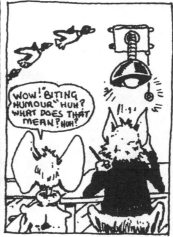
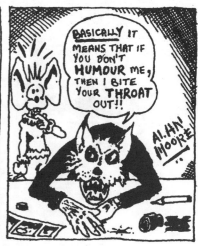

Cover to *Anon* #2, an alternative paper and home of Moore's first strip, "Anon E. Mouse" (above). Cover art by Mick Robinson. "Anon E. Mouse" strip ©2003 Alan Moore.

I must get my revenge upon society, no matter what. I'd been maltreated—as I saw it—by society, by "The Man," by straight society. Which was just another example of how The Man is always bumming out the kids. So I did decide to get revenge. I decided that there would be some way in which I could get my own back for this upon everybody that had annoyed me. I was a monster! I mean—this is after 50 tabs of acid, but try to picture, if you will, a little 17-year-old Alan sitting there, kind of staring, hallucinating....

So you became anti-social—

Very anti-social. Sociopathic.

Your parents couldn't even talk to you, I guess, after [all of that]?

Oh, my parents—I've got on great with them! I've always—until their deaths—I've gotten on great with my parents. I've got no problem with my parents; but it was the authorities, it was the government, it was the structure of everything.

So you already had the long hair and everything?

Not as long as it is now, but, yeah, during my final year at school my hair had become a bit of a bone of contention. I was constantly told to get it cut and I was constantly—

This is by the Headmaster?

And various masters who happened to take a dislike to you, really; you became sort of a target. But at the same time this kind of fitted in with the romantic, James Dean, *Rebel Without A Cause,* persecuted adolescent thing that I was plotting in my head back then. Yeah, but I'd always had delusions

of grandeur, and I don't know where I got them from. On my dad's side of the family there is a small, teensy, not really so you'd know touch of insanity. My paternal great-grandfather, Ginger Vernon, was mad as a snake. He was a great craftsman. He used to paint frescoes; he used to do the whole Michelangelo bit, hanging on a pallet painting church roofs. But he was also a ferocious alcoholic and a steeplejack. He would quite readily run up the side of a building to have a look at an interesting piece of brickwork around a chimney. He once turned down a managing directorship in what became one of the leading glass manufacturing companies in the country, because the managing director who had offered him a co-directorship said that it would be on the terms that Ginger stayed out of the pub for two weeks. And Ginger thought about it and decided that he didn't like being told what to do. And so, he declined [laughs] the directorship, he declined being a millionaire. And I'm glad he did, or else I would've been born into a completely different family and none of this would probably have ever happened.

Did you have any other siblings?

Yes, my brother Mike, who I still see every week, and who is also one of my best friends in the world.

What does he do now?

He works in a steel drum reconditioning place. He works really hard, you know, and he's bringing up these two sons who are great kids—him and his wife Carol. They work really, really hard—there's a real heroism, you know, in people who just work hard at jobs, which aren't necessarily terribly pleasant, just the kind of "bring home the bacon" sort of family all over. That's something I really respect. And he's also a lot funnier than I am. His sense of humor is devastating. He's one of the funniest people I know. So I always enjoy his company.

AMATEUR FANTASY FICTION.
Issue 2 / March 1971 / 11p /

CONTENTS:

THE DOG,
Robert J. Curran..........2
THE HAUNTING OF EDWARD
LATIMA,
Keith A. Walker..........7
SHRINE OF THE LIZARD,
Alan Moore..............11
HOMECOMING,
Edward P. Berglund......25
CORPSE-MAKER,
David A. Riley..........29
* * * * * * * * * * * * * *

POEMS: "The Feasters Of The Night" (David Riley), "The Vampire" (Colin
Lee) Page 6; "Night" (E.C.Bertin), "In The Catacomb" (D. Sutton) Page 34.

ILLUSTRATIONS: Cover by, David A. Riley / This page by, David Lloyd /
page 18 by, Alan Moore (Based on Lovecraft's 'Deep Ones).

EDITOR: James D. Oddey. The Contents of Weird Window 2 are Copyright (c)
1971 to the respective authors. It is published under the auspices of,
Shadow, fantasy literature review. The editorial address is; David Sutton
66 Watford Road, Kings Norton, Birmingham, B30 1PD (England).

WEIRD WINDOW 2 is a subscriber print-run only. No spare copies have been
printed. Of the fifty numbered copies,
This Is Copy Number: 2

INTRODUCTION by James D. Oddey.

With this second issue of Weird Window come five more stories of the bizarre and the supernatural, plus a few weird poems here and there. Response
to the first issue has been quite good, and it would seem that most of
you enjoyed what you read in that first number. This issue contains more
stories by David Riley and Robert Curran, two authors well-liked so far,
plus further tales from Keith Walker, Alan Moore and Edward Berglund.
The stories themselves are varied and I hope you will find sufficiently
horrific! As with the first WW, we would like you to vote on the contents
(contd page 35).

SHRINE OF THE LIZARD

This prose selection was written by Moore when he was
only seventeen. It's one of his earliest published efforts
which originally appeared in print within the fanzine
Weird Window #2 back in 1971 (the cover of which
featured an early illo by David Lloyd).

©2003 Alan Moore.

"Jewelled eyes of ice that glow with madness lurking in the hearts of
further suns."
—Death Song of the Blind Mage.

The night was deep and inhospitable, and a thin drizzle of rain
fell from vast black clouds that floated all but invisible in a sky equally
as black and unrelieved by moon or star. The rain mingled with newly
spilt blood on the stony battlefield of Morndrak Falls and rain in tiny
rivulets down the sides of glittering helmets that had but recently
shielded the heads of a tribe of wandering barbaric nomads. Now, but a
few hours and ten times as many lives later, after a short but bloody
battle, all were dead, and the bedraggled victors continued their way
northwards upon their grim pilgrimage.

The Deathwatch, from the air, resembled nothing so much as a
grotesque, luminous speckled snail, dotted by spluttering torches and
edging its slow and tedious way towards an unknown destiny. On
closer inspection the snail disintegrated into a score of mounted
warriors, if such they can be called, garbed as they were in the
makeshift armour which branded them unmistakably as mercenaries.

At the head of the small army of scavengers, Eng Crater, tall and
cadaverous, sat astride a scrawny black pony. Wiping the rain from his
eyes and then, absentmindedly wringing the water from his straggly,
dripping beard. All was black, he reflected. The night, the pony, his
beard, his soul and the overshadowed sockets he used as eyes.

Crater was a professional predator by trade, and he and his
Deathwatch eked a parasitical living from any foe which chanced to
find its unfortunate way into their all-consuming path. They destroyed
not through choice, but from necessity, and no spoil was discarded.
Helmets from the just fought battle of Morndrak Falls could be seen
covering the greasy locks of some of the ill-assorted band, alongside
similar headgear gained at battles of Gleidsung Crest, Chitters Dyke,
and amongst the older veterans, trophies could be seen of such historic skirmishes as those of Doompeak and Kraken Lake. Old Grigor
Squallspine boasted a helmet from the monumental battle of
Aviranaghore, but of course, this rusting relic had been handed down
from generation to generation for two hundred or so years and it was
now but an eggshell of corroded iron.

Not one complete or matching suit of clothing was to be found
amongst the degenerates save for the ebony tatters of Eng Crater

himself. He held the proud boast that Eng Crater needed no armour,
and that Eng Crater's fighting prowess was armour in itself. Even
with the chipped and flaking blade which hung by his side he was a
swordsman without parallel, it was true, but his boast was belied by a
dozen forgotten wounds which were carefully hidden under the dismal
black rage and flapping cape.

A grey cloud withdrew for a moment from the face of one of
Earth's moons, and then withdrawing this friendly act, drew once
more a silvery veil across the huge lunar globe. It was still raining,
and the ash-like infertile soil turned into black clinging mud. Crater
turned the collar of his cape against the wind and said, "Foolish is he
who hopes when even the weather despairs!" No one heard him.

Behind him, riding a horse which once had been white but was
now only noted for its unusually long neck, was Gode, third in command of the Deathwatch. His eyes were fixed upon Crater's back like
vampires, mentally willing the ragged man to death, for Gode was
ambitious. His mind, after a while, detached itself from the black and
damp surroundings, and drifted back to earlier days. He had been a
thief. He had been an assassin. He had been a spy. Now he was a
mercenary, a less glamourous occupation, perhaps, but it had not
dulled his skill with the bow, sword or dirk. His face still had that
deceiving innocence which had, in the past, lured maidens to his
chamber after nights of heavy drinking. Yes, his face held innocence,
betrayed only by his eyes. Those, twin slits of malefic cunning, were
indeed mirrors of the soul, if Gode possessed such a thing. He was
snatched from reverie by his horse, stopping in a small rain-filled hole
momentarily, and almost throwing him. The young man bent over his
horse a little more, cursed and went on his way.

In any conventional army the second in command would ride
before the third. However, Eng Crater was the only man who would
dare turn his back upon Gode. The second in command,
Thunderbludgeon, being no exception. Thunderbludgeon had been a
friend of Eng Crater since childhood, and in fact his father had been
the previous leader of the Deathwatch. Lesser men would have
harboured resentment at not being chosen as leader but the burly and
genial Thunderbludgeon, as herculean as Crater was scrawny, counted
himself as Crater's greatest admirer. He glanced casually around
through the darkness across the dark and dying world. As a child he
had had a big red history manual, handwritten by someone... someone

dead. Someone as dead as the world would be... the world was dark and days were a thing of the past. The world was pock-marked where meteorites had screamed down through an atmosphere too thin to burn them up. Demons flapped on scaly wings over the landscape, such as it was, with neither grass nor tree to relieve its black monotony. Harpies, vampires, Ghorblats and puddlebubbles roamed the cinder that was the Earth. The mountains crawled with mutants, vulpines, were-shadows and Affs. The night was a hundred years long... Thunderbludgeon blinked. Where... oh, yes. Rain and more rain. When would Crater call to pitch camp?

This then, these three men, as well as a good eighty fighting "soldiers," a mentally retarded witch, a warlock and an alchemist, this made up the grim and deadly carnival known aptly as the Deathwatch. Screwing up one eye as he peered upwards at the jet black sky, Eng Crater decided that now was the best time to set up camp, as a sudden calm in the air told him of the coming storm. He held up his hand and almost straight away the horses and caravans drew to a halt. Slowly, with an almost impertinent air of majesty, he wheeled the horse about face to the Deathwatch, the mask of indifference on his emotionless face, only pieced by the odd gleam in the eyes of Gode. He said one word—"Camp!" So they did.

They slept wrapped in furs beneath the caravans, which numbered four. Those not asleep also numbered four, being Crater, Gode, Thunderbludgeon and the witch, Elly Blacklungs.

Crater sat in his personal caravan looking through his collection of gems, staring with a childish wonder at the sparkling amethysts, chrysoprases and topazes. Suddenly a knocking at the door caused Crater to look up sharply. He slammed the gem-filled draw shut and bade the unknown personage to enter. The door swung open, and to Crater's revulsion, framed in its rectangle against the black and stormy sky which threatened an imminent cloudburst, stood the wizened form of the witch-woman, Elly Blacklungs.

Crater groaned mentally. Elly Blacklungs was a foul-mouthed, shrivelled, old crone whose toothless mutterings sounded to the untrained ear so much like a profound spell that she was, indeed, taken by all and sundry to be a witch of the highest degree. She, however, made up only half of the partnership which a gaudy sign on the side of their wagon proclaimed them to all who cared to look to be "Blacklungs and Stonebrayne." Ezra Stonebrayne was something of an enigma, supposed to be the demented hag's apprentice, yet in fact being of some considerable standing in the lore of magic. He was thought to be the illegitimate child of the Magus, Toziah Firebowels, a famous warlock. He was in fact the unwanted son of an out of work farm labourer, but he revelled in the rumour and supported it at every opportunity. And now, mused Crater, the fouler smelling half of this duo has for some reason sought council with me.

He reluctantly bade her come in and then resigned himself to listen to her jabberings.

"Mi'r Krader zur, win'be a blo'ne un a storm be a comin' un a paw rold woman gotta gew out ta fetch hurbs 'n spices fur a magic broo, and wivout a kloak, mi'r Krader zur, wivoud a kloak'n I got to wunerin...."

Crater had had enough. Although he would not be able to take his customary evening walk without his cloak, if this old crone kept mumbling at him he would go mad, kill himself, or more likely have her tongue cut out. He took off his cloak.

"Here, my good woman. Take this, and may it serve you well!"

Bowing and whining, clutching the black cape about her, the witch-woman backed from the caravan, closing the door. Eng Crater gave a sigh of relief and opened the draw to return to the perusal of his jewels. A crack of thunder—the storm had broken.

Drowned by the sound of the rumbling storm overhead, the reverberant snores of Thunderbludgeon went unnoticed as he lay in a deep sleep beneath one of the vans. Suddenly he jerked awake. He had the idea that something was wrong—something had happened, but... what? He turned over and tried to get back to sleep, but to no avail. Something had happened....

As Thunderbludgeon suspected something had indeed happened. Gode tiptoed stealthily through the night, undetected by all. Leaving the rough, slightly raised roadway, he slithered noiselessly to ground level, and then set off towards a small spinney of luminous trees, which glowed dimly through the omnipresent gloom. Once within the friendly shelter of the trees he stopped to collect his thoughts. Firstly he had an arrow, stolen from a sleeping Thunderbludgeon a few moments previously. He held it up in the half light and gave a cursory inspection to the "T" rune on it. What remarkable fortune that it was the custom amongst the Deathwatch to initial arrows for easier identification of a kill in a hunt. He would kill Crater, thus disposing of number one. Thunderbludgeon would be blamed—he had a motive after all—it was his existence which stopped Thunderbludgeon from what some might consider his rightful leadership. Thunderbludgeon would be executed for the murder, and he, Gode would be the leader. With a fighting force behind him... who knows? Perhaps he would ride to Drindia and sack the last stronghold... hmm. There was no value in speculation. First things first. With the arrow in his teeth and his bow over his shoulder, he clambered up one of the trees which glowed with a dim and eldritch light, and when nearing the top, dislodged a crook of a branch, shifting slightly into a more comfortable position. Soon Eng Crater would come for his nightly stroll and then.... He looked up. The rain was starting to fall. The storm had broken.

Elly Blacklungs felt pleased with herself and was pleased even more by the tattered cloak which was a symbol of leadership for the Deathwatch. She would go and pick herbs in the glowing forest. She needn't keep them, just throw them away. Got to keep up appearances....

Gode sat in his tree, his legs stiff, he felt miserable. He was soaking wet and the damned light from the trees was making his eyes sting. Crater had not appeared and the cold was attacking his fingers, and, the final indignity, his head throbbed with the beginnings of a severe chill.

Suddenly his blurred eyes focused upon a long awaited figure in a black cloak. Eng Crater. He smiled malefically, his moment of triumph had arrived. He alone, he, Gode, would claim victory. He notched the arrow into his bow and let fly. The black figure crumpled.

Elly Blacklungs was dead.

Back in his caravan, Crater had finished gloating over the splendid collection of gems and was awaiting the return of his cape. That witch-woman was a long time in gathering herbs. What if she'd been struck by lightning? He chuckled. No, that was too much to hope for. Still, the old crone was late. Perhaps he'd better organise a search. He would do it in a moment. Walking over to the window he stared out, looking at the impressive skyline. One of the gibbous moons had again revealed itself, and silhouetted against it, black on the skyline was what looked like a ruined castle or temple. Suddenly Crater shivered. He felt very cold.

Gode made his way from the twisted and fluorescent forest, feeling highly satisfied. Not wishing to remain too long he omitted

inspection of the body. Still blissfully unaware of his error he stumbled back towards the caravan encampment. His shoes kept catching in the wide breeches of Thunderbludgeon, which he was wearing. He looked slightly comical garbed as he was in clothes many sizes too big for him. His motive was far from humourous. Upon reaching the embankment leading up to the road the youth scrambled up taking care to smear mud on the jerkin. All would help upon reaching camp. Gode ducked behind the hospitable shelter of a caravan and carefully removed all clothing. Stacking Thunderbludgeon's discarded clothes in a neat pile he took them under his arm and slithered underneath the van. Voluminous snores told him two important facts. Firstly they told him that Thunderbludgeon was asleep, and secondly, exactly where he was sleeping. Like some huge snake, unheard and unnoticed, Gode slithered to where the dozing warrior lay, placing the soiled clothing at his feet. He then crawled back to his own sleeping place, careful to make sure that no one watched him. Once there, resisting the urge to sheathe his cold body in warm furs, he took from under his makeshift pillow of rolled clothing a small jar of bluish-grey ointment stolen four days previously from Pestel, the alchemist. As a final precaution he rubbed this deep stain into his ankle, then crawled into his aff-skin sleeping bag. He had done a good night's work, elevating himself with one swift bowshot to the post of leader. Leader of this carrion crew. He felt very pleased with himself. He would not have felt so content had he seen the scrawny figure that paced the floor of a nearby caravan, waiting for Elly Blacklungs to return with his cape.

In the forest lay a dead witch, her eyes reflecting the green-white light of the trees. Had her glazed eyes not been fixed in the steady gaze of death, they would have wept. A witch must die with flames about her, as did Vikings of old, not struck down by some unknown assassin and left spitted on an arrow as food for Saprocites. A vampire had started to nibble her foot but had left shortly for choicer food. A harpy swopping overhead saw the body, but, upon realising that it was dead, flew on, stray shafts of moonlight igniting its sinewy wings. Far below Elly Blacklungs still clutched the cloak proudly, albeit coldly. The arrow which pierced her chest was a silent epitaph to her passing: "Here lies one who was a most potent witch, yet potent only to herself."

By now a mile to the south the soaring harpy noticed below him some sort of ruined temple. Spotting no life therein he circled to the north and thus departed from those lands for a while.

The night wore a mask of tranquility which served to veil the activity and anxiety which went on beneath. Whilst a shrivelled body grew colder in the fluorescent forest, Gode was lying in the thrall of nightmare. Half-formed images mocked him from the outskirts of his consciousness, leering, mocking. And he knew with a horrible clarity that one of those phantasmagoric dream-shapes would eventually be his destruction. He ran the gauntlet of hazy universes not his own. Those fantasy things made all the more terrifying by the fact that they extracted the essence of character from faces known in his other life, his sphere of reality. And yet could this be a truer if more symbolic reality? The first creature reared before him grotesque and bloated, Thunderbludgeon. The portly man was pierced by thousands of arrows, as many as could accommodate themselves in his huge bulk. He resembled some gigantic pin cushion... more faces... Eng Crater, the matchstick man in black tatters... "You're dead," cried Gode, "I killed you!" And immediately the scrawny body was pierced by scores of arrows, even as the phantom Thunderbludgeon had been, these arrows obscuring the target from view. With a yell of joy, Gode began to pull

the arrows in huge handfuls from the body, wishing to expose... to see Eng Crater dead. At last the body was free, but it was not Crater. Rolling the body over Gode found himself staring at Elly Blacklungs. He started to run. One of these shapes will be my ultimate nemesis... which one? Crater, Thunderbludgeon, Blacklungs... who? Then he saw the shape that waited for him at the end of the misty corridor through which he ran, waiting to kill, to cut off my dreams of glory... who was it?... it wore a mask. Suddenly the two grappled, Gode trying desperately to unmask the dream creature who would be his doom... the mask was off... that face! That face beneath the mask with its child-like innocence, upset only by the greedy, evil eyes. Who was it? Why was it so familiar? He woke up screaming.

Eng Carter stalked throughout the grove of glowing trees, the lashing rain stinging his face and hands. He was angry. Angry with the elements, angry with the Gode creature whose eyes burned into his soul, and, at the moment, angry with the hideous little crone who had his cape.... When he found her he would punish her. He would.... He looked down. His foot had struck something yielding. Eyes that had taken on the quality of clouded marbles looked at him. No one would ever punish Elly Blacklungs again.

The night crept away in shame to some other hemisphere, drawing its cloak of twilight over its face as a disguise. But it was still light on the fluorescent forest, and night could not hide the wizened face of death, and thus the night crept away in shame to some other hemisphere.

Morning came. Gode sat by the smoldering embers of the fire of the night, whittling absently at a stick. Close scrutiny would have noted that the youth's hands occasionally slipped. They would have noted his shiver from time to time, even though it was not a cold morning. Gode was nervous. Even as he sat there paring bark away from the stick in a curiously abstracted way, his preternatural mind worked on twin levels. The tier near the surface was still numb with shock. Shock at meeting Eng Crater earlier that morning. Shock at finding who the black robed figure that had fallen beneath his blow the previous evening when he had seen the pall bearers carrying Elly Blacklungs to a nearby crossroads for burial. Shock at seeing his own face in a mirror... why what? The dream of the previous night had been borne away with the night itself.

A deeper layer of Gode's brain had gone past all shock and had returned to its interrupted course of evil ambition, plotting afresh the mastery of the Deathwatch. He looked from the knife in his left hand to the sharpened stick in his right... he would coat Crater's razor with poison... or he would tie strongly-scented harpy-bait inside Crater's cloak upon the next Aff-hunt. He imagined Crater's brittle-stick body being borne off aloft by the flapping sky-stalkers. He laughed. He laughed until tears were squeezed from his eyes. He laughed to banish the memory of the face in his mirror. His own face. Alien. Hostile.

Noon Came, and Ezra Stonebrayne was enjoying a newly found freedom. He had excused himself from Elly Blacklungs' funeral on the excuse of important duties, mainly that of having the van repainted. The "Blacklungs and Stonebrayne" sign had been glossed over to read simply:

> "Ezra Stonebrayne
> Wizard and Diviner."

He'd considered adding the words, "Illegitimate son of Toziah Firebowels, famous Mage," but had thought it perhaps a little ostentatious. In the future he would need an apprentice. He had even

considered an amalgamation with Pestel the Alchemist. "Pestel & Stonebrayne"... "Stonebrayne & partner"... he would ponder on it. But for the moment he would enjoy independence. The witch's meagre possessions had been buried with her, and every vestige of her existence had gone... the caravan still smelled. He stood up, careful to avoid a low beam and spread a pack of green cards upon the low table in front of him. He took one. The prophecy was in red, immediate future obviously. "Beware the first powers for they have influence." It then stated, "Black." He took a black card. Long range prophecy in white ink. "Shun the one whose face is as a mask!" There was no mention of any further card. The wizard sat down, and then stood up again, the light from the low, dangling oil lamp throwing highlights upon his porcelain egg-dome of a head. He sat down. "Well," he said, "well, well!" He gathered the cards together and put them away in his huge glass showcase alongside a tarot deck and a genuine two hundred year old ouija board. He turned about sharply, a look of mild consternation on his face. His hands were clasped behind his back and his bristling white eyebrows drew together in a frown. His voice was hardly audible, even in the silent van. "Well, well, well!"

Evening came and Thunderbludgeon had packed his belongings and slung them in saddlebags over his squat horse. He was hurt and he was crying. Tears splashed unashamedly down his broad face. Murder. Him a murderer. But it was his arrow in the body of Elly Blacklungs. He must face banishment. Crater had spoken to him in a voice devoid of friendship, and yet friendship had been there, sparing the ultimate punishment in favour of banishment. A tear trickled down Thunderbludgeon's face, to eventually become lost in his thick red beard. The Deathwatch was... had been... his reason for living. Rather a quick final death than a lingering empty life. Thunderbludgeon suddenly glimpsed a terrifying vision of an endless blank future, stretching to the ends of time, and him facing it... alone. He was alone now, more than he had ever been, and for why? Why? What had he done? He had not killed, nor had he plotted. Why, then? Who had fired the arrow that had ended two careers, one with death, one with life? Who? Gode! It had to be Gode. How? Thunderbludgeon was baffled. The youth could not have done it.... His ankle, deeply bruised, made it impossible for him to walk, he claimed, a rich bruise supporting his claim. Who then? Melancholy dulled his mind—he could not think. The moon was slowly beginning to rise as he rode away, not looking back. His horse's dragging hooves encountered a small lizard in their path. It scuttered out of the way, to where a few yards away was another small lizard, and another. On the horizon stood a ruin.

Night came once again, creeping stealthily so that none may notice its coming and remember other nights of shame and murder. A lone screechbat sang a one-note song from the fluorescent forest and then it was silent.

Gode slept, a mercifully dreamless sleep, and while his consciousness was divorced from this sphere he did not notice what was going on around him. Suddenly his hair trigger reactions reached to pluck him from the well of sleep. His blazing eyes flickered open. Sensations—cold. Wet. Lizards. His body was covered in crawling, frantic lizards. He screamed, pulling the tiny reptiles from his face and hair, in huge handfuls, crushing as he threshed and rolled about in blind panic. He felt the crush of reptilian bones beneath him, as in a frenzy of revulsion he struggled from beneath the van to find himself knee deep in the surging, wriggling tide. He screamed again for he was deathly afraid of lizards. His phobia had full grip on him now, for

swarms of kicking, miniscule lizards teemed over his person. All over the camp cries went up in the darkness. Lizards were everywhere and rapidly rising in numbers. Gode staggered like a man in living quicksand to Eng Crater's caravan.

Eng Crater woke to the sound of yells and a banging at the chamber door. Climbing drowsily from his cot he walked to the door and flung it open, still dressed in his customary ebon garments. There stood Gode, wild-eyed and frightened. At first Crater saw nothing unusual, but then as his eyes cleared he saw with terrible clarity. Literally scores of lizards clambered over the fear-stricken youth, squirming through the thin crop of hair, dropping onto the chest. The tiny green reptiles scaled his face and clung to the fabric of his clothes. They swirled like water about his waist. The youth was screaming, and Crater could easily tell that he suffered from shock.

Crater could see other figures now, threshing wildly about, their visible limbs festooned by clinging bodies, like some macabre ballet. He saw one stumble and plunge headlong into the masses of writhing creatures, not to rise. The scene was etched vividly by the silver moonlight, prancing marionettes in a sea of undulating cold-blooded bodies that grew deeper by the moment, boiling with hideous scaly life. Gode stepped into Crater's van against the pull from the masses without, and, muttering something soundlessly from lips that were convulsed by a paroxysm of terror, fainted. Crater buckled on his thin, rusted rapier and bounding over the prostrate Gode he hurled himself out into the torrent of lizards. Within moments he himself was smothered by a blanket of the things. Cursing and clawing he wrenched them from his face and chest in great wriggling handfuls. Through a haze of diminutive lashing limbs Crater glimpsed Ezra Stonebrayne making his way towards him, in some way unhampered by the lizards, his eyes glowing. Crater worked his self over to the wizard eventually getting near enough to speak. "Stonebrayne," he cried still tearing the clinging lizards from his person. "Where are they... they from?"

The wizard shouted to counter the screams of the people milling chaotically around him, "The primal powers... originals...." His voice faded momentarily as a loud uproar came from elsewhere in the crashing saurian ocean. Crater, struggling to free his bony limbs from the claustrophobic tumult, could only hear snatches of what the enchanter was saying. Words... even out of context... words which awoke forgotten superstition and gripped his stomach with icicle fingers.

"From the Valley of Krathoth... subterranean... Temple of Bokrug... dagon... old ones... we've got... trespass... this... Shrine of the Lizard."

Crater related these words until a terrible idea was formed, echoing in his brain. For a moment his thoughts were divorced from the hideous chaos raging about him.

The Valley of Krathoth, deep under the earth, where Bokrug, son of Tssathogua, father of Dagon, ruled with cold eyes and shining scales, said to make entrance to the surface world at the Temple of Bokrug, Shrine of the Lizard. "Jewelled Eyes of ice that...."

His train of thought shattered, and dimly remembered legend became horrible reality. The lizards threshed at chest height making it almost impossible to move, the stench of reptilian bodies permeating the heavy atmosphere.

Stonebrayne realised the predicament with all its implication. The leader of the Deathwatch was in a state of shock... a lizard crawled up the magician's face... and was in no state to command... the second-in-command was gone. Banished... the new second-in-command was nowhere to be seen. A scream came from the other side of the camp. A lizard clung to the wizard's ear. Where did the lizards... the Valley of Krathoth... the Shrine of the Lizard. His glowing eyes scanned the

horizon, coming to rest at the imposing silhouette of the ruined temple, the ruined Temple of Bokrug. He shouted at the stunned Crater, trying to make himself heard over the noise of the frightened... the dying... "Crater! The temple... we must reach it or die."

Eng Crater stirred, lizards up to his neck, an infinity of green and silver limbs. Slowly understanding dawned in his sunken black eyes.

Thunderbludgeon chewed the last of the aff that he had caught for his supper. Banishment had itself been banished from his mind by hunger, but now hunger sated, his thoughts returned to the Deathwatch. He turned his red eyes to the south, and suddenly caught an overpowering smell... like bad harpy-meat or... snakes... lizards. As he stood, puzzled, a blinding blue flash suddenly lit up the night sky, and continuing to give a blue radiance, Thunderbludgeon shook his head. What? What? Something of ominous portent was happening. He swallowed the meat.

Crater, Stonebrayne and two of the mercenary army battled their way up the hillside towards the temple against the tide of lizards. In the lead strode the magician, magical Greek fire pouring from his fingertips and scorching a broad pathway through the blockade of reptiles. Now a space was cleared about the four men, but, like a keen blade passing through wax, the lizards resealed the gash in their ranks as soon as the pyromantic sorcerer and his comrades had passed.

Eng Crater's initial shock had cleared, and now his crude blade was in his hand, in preparation for what they might face at the temple, which loomed ever larger on the horizon. Slowly they edged their way nearer... nearer... and as the derelict shrine grew taller over the horizon of lizards, Crater's fears, like a scream, increased in frequency. As a child he had seen, one clear and silent night, the altar stone of great Bokrug at the eldritch monastery of the brothers of the wand, and he had seen bones... still warm to the touch and the scores of bloated reptiles nearby. He had seen lizards, dismembered, growing new limbs... he had read strange passages in that certain old book kept by Ezra Stonebrayne... fear crested upon fear but now the Shrine of the Lizard loomed above them huge and terrible, the grotesque figures carved on its walls, the dreadful gargoyles, all thrown into a fearsome clarity. But something was missing... the lizards. A wide circle, free of lizards, seemed to have appeared about the ancient building, strangely ominous in that it suggested some... outside force. Ezra Stonebrayne, face grim as death, put into words what they all were feeling.

"The Shrine of the Lizard awaits our coming," he said. But more than this... something else disturbed the four men as they stood outside the crumbling, archaic vaults... something watched them, and an unearthly silence had descended. Whirling about, feeling eyes in their backs, the four faced a circle of lizards, bright ones shining with preternatural, cold intelligence and... anticipation.

Crater gasped, "They're watching us... watching...." One of the two armed soldiers, a red-headed Celt, agreed. "Aye... and waiting." Their words were short, as talking seemed out of place in the pregnant silence. Once more they turned towards the evil temple. And Crater noticed something that he hadn't before.

By the gaping entrance to the shrine stood two perfectly-shaped man-sized figurines... both of knights, wearing a strange garb and carrying great two-edged swords and yet, perfectly proportioned as they were... something was wrong about the heads and....

Ezra Stonebrayne had also noticed the two statues. He turned to find the master of the Deathwatch was also fixed upon the figures, his face puzzled, and also... fear. Crater had seen something, wheeling

about Stonebrayne faced not three animated beings but five. Crater, the two soldiers and two others. The knights.

Crater gaped as the nightmare unfolded before his eyes, slowly and with an air of unreality. The two statues lunged forward at the dazed men... dreaming... the knights stumbled silently forward drawing evil looking blades from their scabbards... dreaming their arms rose slowly into the air, twinkling in dual moonlight, the blade swept swiftly down.... A scream.

The spell was broken and Crater saw the Celt staring at the decapitated body of his comrade, before snapping out of the shock and leaping to one side before the second blade finished his life, as well. Uttering a Gaelic oath he drew his chipped battleax from the leather noose at his belt and then sprang forward to engage the creature in combat.

Crater, rusted blade in hand, hurled himself at the thing that had killed the first warrior. The creature was slow, clumsy, and decrepit though Crater's rapier was, it was in his hands a lethal weapon. The armoured being swung the sword in a wide arc, narrowly missing Crater's face. The thin man dodged nimbly, knowing that while he may be faster and cleverer, the thing in armour was huge, strong, invulnerable, an armoured juggernaut.

"Eng Crater needs no armour, Eng Crater's fighting prowess is armour enough." Crater wondered, as he dodged the sweeping blows upon the moonlit hillside, fighting in the shadow of the temple as thousands of lizards took the part of an audience, if he would survive this fight. He had to somehow pierce this being's armour before his own exhaustion overcame him. But how... suddenly the answer came. The thing swung its broadsword from left to right, tirelessly, but then Crater struck. Swiftly lunging forward, his rapier entering through the slit in the thing's visor, meeting resistance in bone and cartilage, and then, finally the creature fell, with its first articulate noise during the entire battle. A scream, not a human scream, culminating in the twang as Crater's blade snapped.

But Crater had no time to relax, overcome by his triumph, his fears vanished, he realised that the heart of the evil lay within the temple, not on this hillside. Overconfidence taking control of him, he ran, holding only the hilt of his sword, into the dark, beckoning shadows of the open archway leading into the temple.

Bloodmantle, the Celt, stood gaping in horror his gleaming axe had struck the creature square upon the head, severing his helm-straps, and sending the helmet spinning to the ground revealing the face beneath.

A squat skull, covered in glittering scales... a lizard, decked in armour... erect on its hind legs... eyes, deep, cold... a huge lizard... with horrible intelligence, the drooling mouth gaped wide revealing the porcelain teeth, leering in an inhuman manner at the stunned Celt.

Suddenly Bloodmantle realised that he was actually paralysed by fear and that his unhuman foe was taking this to its advantage, its razor-edged sword sweeping up towards his chest. Bloodmantle tried to dodge but then felt the steel, alien and cold, plunge, breaking the privacy of his body. He was wounded... dying....

Ezra Stonebrayne stood alone against the lizard which even now stated towards him. He lifted his arms and said eight words in an ancient tongue.

Eng Crater raced down the empty stone corridor, his confidence leaking away at every pace. Cold... lizard... cold. He still clutched the useless hilt of his broken sword, and was now realising how foolish he had been. He felt alone, and in the grip of some frightful, unseen influ-

ence. At the end of the corridor stood an iron gateway... and behind it... alone, helpless.

Crater reached the heavy door and began to pull it open. Why was he doing this? But now the gate was open wide revealing to Crater's astonished eyes the temple chamber of Bokrug.

The thin man gaped; green light filtered from the walls throwing odd shadows from the macabre artifacts and tapestries. In the centre of the chamber stood a dais, tall and carved with strange designs. Upon this pedestal sat a figure, emerald under the eldritch light. The priestess of Bokrug, her sinister eyes like coals, fixed upon the leader of the Deathwatch.

As Crater stood transfixed by her gaze, the priestess, radiant with an evil beauty, rose to her feet and, her wispy gossamer robes trailing about her, she began to descend the steps from the dais, all the time keeping her gaze upon the wide eyes of the gaunt, ragged figure.

Crater stood like a rabbit before a snake, absorbing with his eyes her slim, voluptuous body, lithe and peculiarly supple. The green radiance glistened upon her full breasts, cast stippled shadows on her legs... a woman... a beautiful woman.... Her face malefic, yet glorious... her slim tapered wrists... the fine aesthetic hands in which she gripped the sacrificial knife... a woman... antelope limbed... a woman... her eyes, pits of promise... a woman... full, sensual lips... those lips... parting... her tongue. Her tongue. Forked. Flickering.

The gaunt man screamed, "You're not a woman! Reptile! Filthy, obscene reptile!"

The spell was broken and the nightmare began in true. The woman-thing spit venom, enraged, and rushed, raising the knife in her hand for the plunge. But Crater was too fast, fear lending him speed. He rushed towards the doorway knowing that behind him ran a creature made all the more horrible by its semblance of beauty. A parody of humanity. He had to get away.... Suddenly his feet were caught, hampered by something. A tapestry. He stumbled and fell heavily, partially stunning himself upon the base of a marble pillar. Groaning he rolled onto his back, and looking up, found his eyes again meeting the fatal gaze of the lizard woman. But this time his eyes bypassed hers to rest upon the knife poised above him.

Stonebrayne stood above the corpse of the lizard knight, which lay at his feet, charred and smouldering suddenly he remembered his leader, the thin man. Shortly before he had seen Bloodmantle transfixed by the creatures sword he had seen Eng Crater run like a madman into the temple, brandishing the hilt of his sword. The Wizard knew very little of the cult of the Bokrug, yet what he did convinced him that the leader of the Deathwatch must now be in gravest danger, and yet help was easier thought of than executed. The greek fire that he had used upon the lizards—who still sat in their immense watchful circle—and the reptile knight, was now depleted. He was old but could still use a sword as well as the average man. Bending, he picked up the blade of the incinerated lizard warrior and, his heart thudding, entered the archway, finding himself confronted by a grotesque tableau. As if frozen at the moment of his entry he quickly saw and comprehended the entire scene, under the wild green light.

Standing with her back to him stood a strikingly beautiful, yet somehow, by the angles of her body, malevolent woman. Beneath her lay Eng Crater frozen in an attitude of intense fear and more important the viciously hooked knife held above him.

To Eng Crater prostate upon the chamber floor, things became a blur...events that only became distinguishable after their advent. He saw a flash of blinding silver metal that must have been the sacrificial knife...and then a superimposed memory...image...of the sorcerer,

clutching a bloodied sword...and then the images solidified into reality. The reptile woman's head bounced over the floor, and the body staggered and collapsed. At that moment, both priestess and lights died. The green radiance vanished, leaving Eng Crater enveloped in darkness. He climbed unsteadily to his feet and then heard the monotone of Ezra Stonebrayne, "Come quickly we must leave this place." The voice stopped and Crater heard the sound of the Mage's receding footsteps. Still stunned by the nightmare of the past few moments, he staggered in a daze through darkness towards the door. But then, just as he reached the gateway, he heard a certain noise...a scraping...

Ezra Stonebrayne stood waiting impatiently outside the temple. The lizards had gone, what was keeping Crater? Suddenly, he saw the angular form of the thin man coming towards him. It was only when Crater got nearer that he noticed the fear...the abnormal tension in the man's face. As soon as Crater caught up with him, Stonebrayne began to walk side by side with the leader of the Deathwatch down the hill. The ragged man was still frightened. Stonebrayne turned to him "What's the matter? There's something wrong" Crater kept on staring ahead, his eyes blank yet full of a hidden fear. "Noth..." he choked mid-sentence "nothing." He then remained silent. Something had happened that had affected him deeply, something, but what?

The next day passed quickly...anticlimactically. The Deathwatch once again took the road, and by that nightfall had placed many miles between themselves and the shrine of the lizard. Their numbers had been diminished considerably in proportion. Blacklungs, Thunderbludgeon. Twelve at the battle of Mordrak Falls. Bloodmantle and the other mercenary. Four dead of suffocation. But there would be other enlistments other mercenaries. After a few days the incidents had all been forgotten, and the smell of the lizards had worn away.

One night Gode was walking, plotting, as he strolled beneath the stars. Suddenly he heard the sounds of nightmare coming from a nearby van, to his surprise he found that it was the van of the Deathwatch's leader. He stopped, intrigued. He had never known Crater to cry out in his sleep before. Perhaps useful information might be gained, he listened, but it made no sense.

"Dark...sound...decapitated body, dragging itself across... uhh... agggh... across the floor... looking for its... and the giggling. Stop that giggling you're... stop that giggling". Gode shrugged, a nightmare, nothing more. He ambled casually away, scheming. The next day the monsoon broke and it rained for a long while, lasting many weeks.

VAINGLORY

7d

THE PICTURE STORY PAPER FOR BOYS No. 71 - NOV. 18th, 1963. EVERY TUESDAY

THE ARMY'S HEAVY ARTILLERY MOVED IN TO CHALLENGE THE MECHANICAL GIANT!

MOORTEK THE MIGHTY

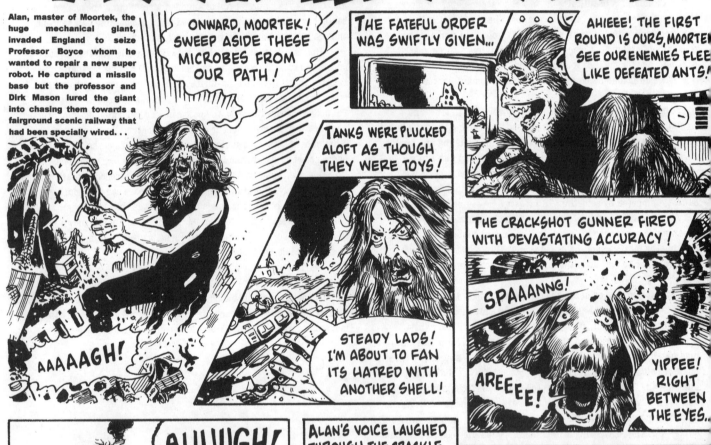

Alan, master of Moortek, the huge mechanical giant, invaded England to seize Professor Boyce whom he wanted to repair a new super robot. He captured a missile base but the professor and Dirk Mason lured the giant into chasing them towards a fairground scenic railway that had been specially wired. . .

ONWARD, MOORTEK! SWEEP ASIDE THESE MICROBES FROM OUR PATH!

THE FATEFUL ORDER WAS SWIFTLY GIVEN...

AHIEEE! THE FIRST ROUND IS OURS, MOORTEK! SEE OUR ENEMIES FLEE LIKE DEFEATED ANTS!

TANKS WERE PLUCKED ALOFT AS THOUGH THEY WERE TOYS!

AAAAAGH!

STEADY LADS! I'M ABOUT TO FAN ITS HATRED WITH ANOTHER SHELL!

THE CRACKSHOT GUNNER FIRED WITH DEVASTATING ACCURACY!

SPAAANNG!

AREEEEE!

YIPPEE! RIGHT BETWEEN THE EYES...

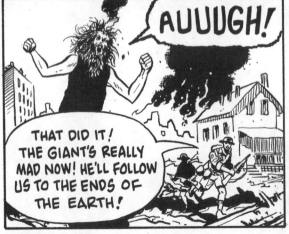

AUUUGH!

THAT DID IT! THE GIANT'S REALLY MAD NOW! HE'LL FOLLOW US TO THE ENDS OF THE EARTH!

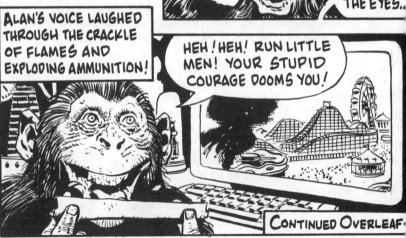

ALAN'S VOICE LAUGHED THROUGH THE CRACKLE OF FLAMES AND EXPLODING AMMUNITION!

HEH! HEH! RUN LITTLE MEN! YOUR STUPID COURAGE DOOMS YOU!

CONTINUED OVERLEAF

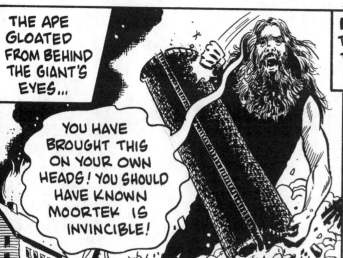

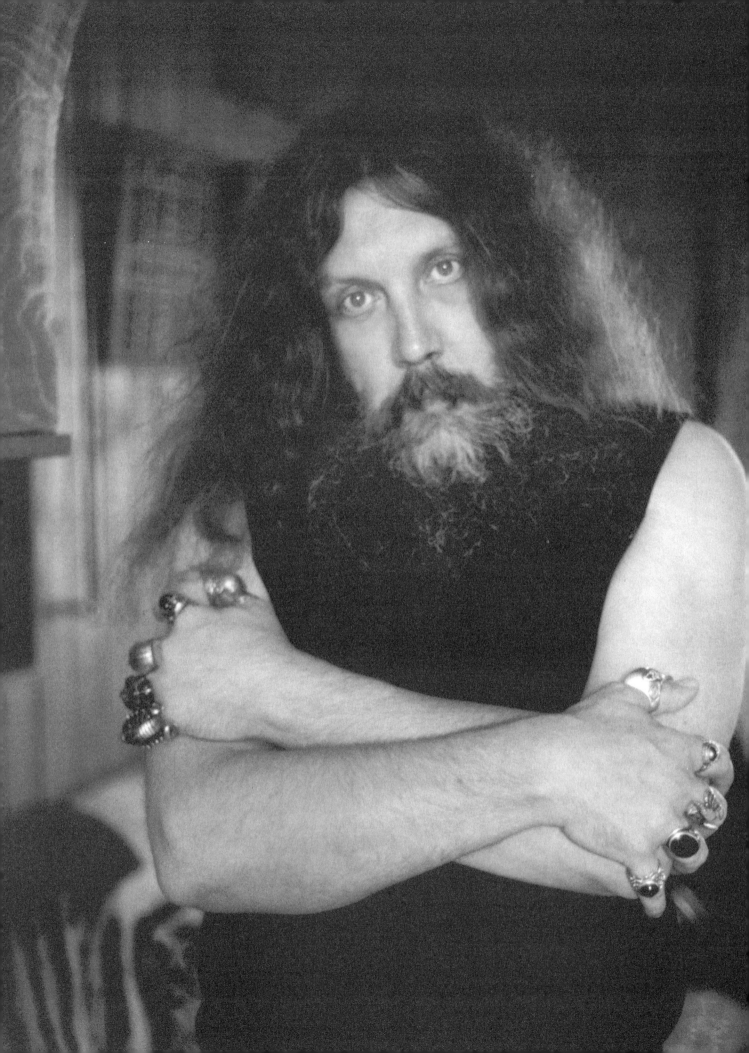

You mentioned before that in Northampton, nobody ever saw American comics—how did you discover them?

Well, let me think... I think that there was a market stall—it was called Sid's, in the middle of Northampton. In Northampton we've got the market square where you have an open-air market. It used to be every Wednesday and every Saturday, and there was one magazine and bookstore on the market. The stores are sort of like a wooden frame with canvas providing a roof for them, and they're taken down at the end of the day and the market square is emptied. But on Saturday, I'd go down there on my way to Sid's second-hand bookstore—what he'd have—there'd be bulldog clips hanging from wires strung between the struts of the shop in which there'd be all kinds of what we used to call "men's sweat" magazines. There were things like *True Adventures*, where you'd always have a group of women in their underwear with swastika armbands torturing some perspiring, teeth-gritted GI. They'd always have things like "Lesbo Love Goddess of Torture Island!" or "Fry the Krauts on Passion Bridge!" and all these sensationalist headlines and these painted spicy men's adventure covers.

So they'd be hanging up there; there'd occasionally be some of the very, very early issues of *Mad* magazine and then spread out on the main trellis—the main trestle—of the shop, there would be all these American comics, all held down by big, round, iron paperweights, which for some reason stick in my memory. And these comics were not like British comics. For one thing they were in color all the way through, and they've got these fascinating-looking characters on the front. Now I can't remember what the first American comic I bought was. It might very well have been one of the very early *Flash* comics.

You had *Mad* before you started reading the super-hero comics?

No, I had not read *Mad*. I'd seen them and they looked fascinating but I kind of sensed that probably they were a little too old for me; also they were too expensive. The magazines cost two and six pence back then, whereas the actual comic books cost nine pence, which was a lot cheaper. But I remember—I'd already picked up one of the very first *Flash* [comics]—it might have been the one with the first appearance of the Trickster, don't know—and I also picked up Batman in *Detective Comics*. I picked up one of those—it was one of those stories where you've got Batwoman and Bat-hound and Bat-Mite all in the story as well. It was that mad Dick Sprang era of Batman, which is actually one of my favorites. I've never really thought of him as a Dark Knight Detective, I've got to admit; he's a big

grinning guy who's got a dog with a mask. [laughs]

I bought all these early comics and I fell in love with them. It was the same as with the books I'd taken from the library, or the early books on mythology that I used to read. Because I found that very early on I had a taste for fantasy—the Greek myths, the Roman myths, the Norse myths—I read children's versions of these by the time I was six, and I loved stories of people who were incredibly strong or who could fly or who could do this or who could do that or who could throw thunderbolts.

And so, discovering American comics was like—it was the same thing, but it was in a modern setting and it was all illustrated and it was in color. So I read the DC comics that I could find—and this was by no means a regular comic-buying habit because we didn't get regular comics. The comics that were brought over to England back then were brought over as ballast by shipping companies. There was no regular distribution. So you wouldn't get comics, you'd miss issues, there'd suddenly be whole lines of comics that would be apparently discontinued for no very good reason. I just bought whatever I could find and started to build up what was the beginnings of a collection. I can remember the specific incident where I was ill once and my mother asked if she could get me anything. I said she could get me a comic. She didn't know what comic I wanted and there was one that I'd seen which was a *Blackhawk* comic. And I was trying to tell her which comic it was that she should buy for me; I told her it's got a lot of people in it who all wore the same blue uniform. And she went out and came back with, much to my disappointment, *Fantastic Four #3*,

©2003 Marvel Characters, Inc.

which I think was the first one where they were actually wearing the blue uniforms.

So I thought, "Oh dear, this isn't *Blackhawk,* and look at this artwork—it's all kind of craggy and dark and gritty-looking, and it's not all smooth and cuddly like the DC books." But of course I soon became completely infatuated with the Kirby atmosphere. The strange atmosphere

of that first *Fantastic Four* story that was nothing like any super-hero book I'd ever read. It was darker, and looking back now, upon those early days of Marvel, they seemed such dark, pessimistic stories in the context of somebody who'd only been reading DC. I can remember that first story—which I believe ended up with the Human Torch leaving the Fantastic Four—big violent rows. He goes and lives in a flophouse in the Bowery, this sort of dark, run-down Jack Kirby neighborhood. This wasn't the sort of stuff that happened to Superman and Batman. And yeah, it gave me a taste for the kind of dramatics that were possible in comics, but, you know, all this is at the age of seven and eight and I probably wasn't really thinking in those terms; I was probably just thinking, "Boy, I can't wait to find out what happens to the Fantastic Four next month!" From that point I began to live and breathe comics, live and breathe American culture. It was only about a year before I finally saved up enough money to buy my first issue of *Mad* magazine where I kind of—I didn't understand any of it; it was all making jokes about American things which I've got no knowledge of. But that didn't stop me repeating it to my parents in the hope that they'd find it funny. So I was telling them jokes about Jimmy Hoffa and Caroline Kennedy and Adlai Stevenson. I didn't know who these people were, my parents didn't know who these people were—but it was the beginnings. I was starting to piece together just from *Mad* satires and other references in comics—I was starting to piece together a picture of the world. It was probably quite sophisticated, given my environment and my age, you know?

I started to understand that, "Oh, right, I see, this Fidel Castro guy, he's like a Communist and the Americans don't like him; and this Nikita Khrushchev, he's Russian and they're like the Boss Communists; and guys who work on Madison Avenue, they all wear these square glasses and have crew-cuts and are sort of fake and trying to sell you something all the time." I started to pick up the cultural references, you know, through things like *Mad* magazine. It burgeoned, then snowballed from there.

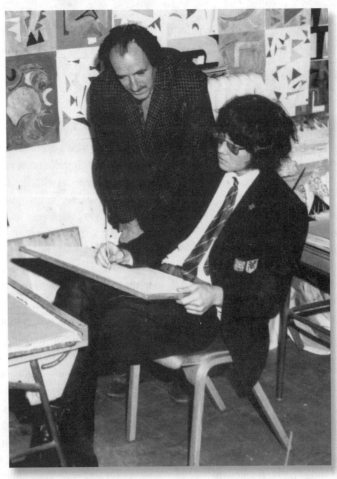

"Picture from local newspaper feature on the Northampton Grammar School, shortly prior to my expulsion. This is me and the only decent art teacher I ever had, Mr. Archie Gommon. I'm probably around 17 here."

By the time I was in my teenage period—around about 14, 15—I'd discovered the nascent form of British comic fandom, which was just starting back then. And I was lucky enough to hook up with one of its founders—although I'm sure that he would rather forget that now—Steve Moore, my oldest friend in the business.

This is by the time you got to the Arts Lab?

The Arts Lab. Well, I probably discovered comics fandom before I discovered the Arts Lab. I remember it was when I was about 14 that—well, over here there was a comic company called Odhams, and Odhams used to publish two or three British comics—they wanted to try and capture the success story of Marvel Comics in the States. So they rebranded themselves as Power Comics. They reprinted material from very early *Fantastic Four, Avengers, Spider-Man*—they reprinted these in black-and-white in these weekly comics that came out over here—and they also had homegrown material from brilliant artists like Leo Baxendale, Ken Reid—people that they'd kind of poached from D.C. Thomson who published *The Beano, The Dandy, The Beezer* and all the staple juvenile children's comics over here. Now they did these two slightly larger format titles called *Fantastic* and *Terrific*. I remember that drawing the Powerhouse pinups on the backs of the issues of *Fantastic* and *Terrific* was a very, very young Barry Smith—he hadn't signed them so I didn't find out until some years later. And I think that Steve Parkhouse had maybe done some sort of work there. Steve Moore, who was 16, 17 at the time and fresh out of school, had got employed as an office boy there and then rose to be an assistant editor or whatever. And at that time, Steve—16 or 17—he'd gotten a few friends who were into comics. They'd heard of the American comics conventions so they decided to try and put on a convention in England. And because Steve had this outlet with the Odhams/Power Comics—they had their lame, knockoff, English equivalent of the Bullpen pages with our equivalent of Smilin' Stan, and he'd talk about all the wonderful things happening in the wacky world of Power Comics, and he'd talk about their assistant

32

editor "Sunny" Steve Moore who was putting together this comic con with his friends and if you wanted to know more write to this address, so I did. And I went to, I think, the second British comic convention, which was 1969, and I must have really started that year—or perhaps '68, I don't know. I was relatively drug-free and fresh-faced and squeaky-clean when I started that year. But, yes, I went to the first or second British comic convention, started to buy the British fanzines of that period, and coincidentally ran into a lot of the people that I would later be working with. I got a fanzine called *Shadow* that I used to contribute to and so did David Lloyd; we never met each other—we both did illustrations for the same convention I went to. I think Jim Baikie—who had designed the convention badge—and our Paul Neary was the big name fan artist over here in those days. He's got this lovely kind of Carmine Infantino style that he could do to perfection; it was really nice. Yeah, that was a great thing.

And then some time later in '69—this was after I'd had my psychedelic conversion and I'd become a young beatnik—I was still at school, however, and like a lot of drugged-up teenagers of that period I was writing what I thought was poetry. Usually angsty, breast-beating things about the tragedy of nuclear war, but were actually about the tragedy of me not being able to find a girlfriend, that kind of good teenage stuff that we all

sort of dabble in at some time. But I'd done a few things, and there were some girls down at the local convent school who also did poems. And I think that I suggested that we put together a magazine, because this seemed like a good way to hang out with girls from the local convent school. So we put together a dummy issue of a poetry magazine called *Embryo* and then some more guys from the grammar school where I was at decided to join in, and I think we put out five or six issues of it eventually. I'm not saying that it was a very good magazine; we'd print anything that was submitted—well, almost anything—we did get some really, really bad poems that we had to turn down, but we tried to print everything that was submitted. And it

An essay on The Shadow written by Alan for the 'zine *Seminar #2*, around 1971 or 1972. ©2003 Alan Moore.

was after, I think, the first issue of that had come out that one of the people who was making contributions to that magazine also got—he was about the same age as me, but he was one of these kids who was much hipper and he'd already gotten some friends who were older and who were involved in this kind of spontaneous hippie-type organization called the Arts Lab. And he asked if maybe it might be fun if we went along to one of their meetings, which we did. These were older guys and women and I was a bit suspicious of them at first, but then, I was suspicious about everybody. I was convinced that everybody was out to get me. It was a paranoid time, but

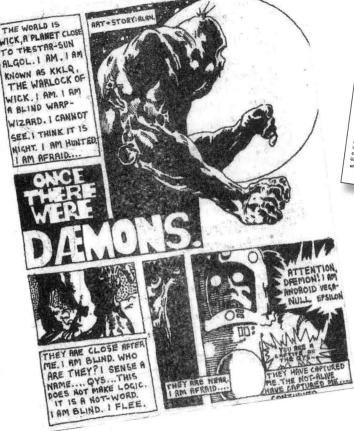

A page from *Embryo* #2 from a comic strip called "Once There Were Daemons." Published in 1971 during the days of Arts Lab. ©2003 Alan Moore.

A PLACE OF MASKS

My reflection drowns upside down in a tear-deep puddle
choking on the flute thin bones of dragonflies.
Cryptic drift the cries of a generations dead gulls
cryptic their notes long away and forgotten.
Blood is wept
by every emotionless gutter of steel
by every contact lense glass eye.

for this is a place of masks and even you may not
come within

Bone white are your eyes
Clean
You're fading softly
Euridice child,
It is as well.

for this is a place of masks and even you may not
come within.

Autumn advances in a deceptive tennis shirt
sipping lemonade
as he casually strolls through the
summer trees of Victoria park
We thought the park was full of summer laughter
Until suddenly we were alone with the madman in the grey tennis shirt
The sun vanished and it was very cold
and I could feel him watching me
from within the deepening shadows between the trees
as he came closer I found him to be deceptively old
as he came closer I found him to be deceptively old in his grey hair.

I think that it was you who first saw the leaf in his grey hair.
and so we decided to go home
not wishing to see the death of
the grass.
So thus you left.
Perhaps it was just as well.

for this is a place of masks and even you may not
come within

The dying moths looked like petals in the evening light
as the transparent spectres of smiles greet the promise of morning
as thoughtless waves eradicates each shell crisp crisp footprint
on yesterdays beach.
as a sacred song gathers dust in some twilight attic
a preserved piece of 1908.

On the walls the masks frown in contempt.
Cryptic drift the cries of a generation of dead gulls.

© Alan rupert Moore

This poem appeared in *Embryo* #3 in 1971 with a Moore illo in the backdrop. ©2003 Alan Moore.

after a couple of weeks we more or less fused with the Arts Lab. We carried on putting out *Embryo* and there was their magazine, which was usually called *Rovel* or some kind of variation on the term: *Rovel-Fitz-Rovel* or *Deliver Us From All Rovel*, or whatever. The Arts Lab was great. It was like a spontaneous kind of multimedia group where we decided that we were going to put on some performance, or we were going to put out a magazine, some event or whatever, and then we all just worked toward it doing whatever we felt like doing. And the results were mixed; some of it was awful, some of it was actually really good, but I did learn a bit about a wide range of disciplines—I learned about actually performing on stage in front of an audience; I learned about writing poetry, writing to read aloud. I think this was probably something that you can still see the effects of in my prose today. It's as if there's rhythm in my prose. That probably all comes from how keenly I became aware of rhythm when I was reading it out at poetry readings and I started to realize that certain rhythms had different

effects upon the audience. Sometimes if the piece is rhythmic enough it almost doesn't matter what you're saying, what it means, the rhythm alone will carry it. Yeah, I've learned various disciplines, worked with some people who had fine, experimental minds. People that would try anything first to see what happened, who would—even if they hadn't any natural talent in that they couldn't really draw, write or anything like that—but with their determination to contribute in some way would do these amazing things. I had a friend who built an early model synthesizer in a shoebox. I mean, it was a very simple synthesizer, but it was at a time when all synthesizers were fairly simple. You only had bands like Hawkwind or Pink Floyd that seemed to have one, but yeah, he built this sort of shoebox synthesizer and well, had these fantastic light shows that we would be devising to use with our live performances. It was great; it was a really useful time. And after I got sent out of school, I mean, I was working through these miserable jobs—

That was like the highlight of your day?

Well, the Arts Lab was what I was living for to a degree because, all right, I was kind of trapped in terribly miserable circumstances with no obvious way out. In the evenings I could write something that I was pleased with and then a couple of weeks later there'd be a poetry reading—I could go along and read it; maybe do some work with some musicians reading the poems to music or collaborating with musicians in some way. And that felt like that was taking me somewhere. That felt like that had a direction, and so all of my terribly formidable energies got thrown behind that and I was kind of determined that at one point in the future I was going to find some way to make a living out of what I'd produced artistically. Now I didn't know whether that was going to be as a performance poet, as a recording artist. I mean, there were a couple of early bands that we tried to get together.

You were a lead singer?

Well yeah, a lead singer, songwriter, and conceptual thinker or whatever. It was largely an extension of the Arts Lab. Thinking about doing multimedia type bands which seemed—there was a band that actually lived in a commune in Northampton—a place called Kettering—that were called Principal Edward's Magic Theatre, and they'd released a couple of albums upon John Peel's Dandelion label. Because they were local and friendly, the Arts Lab had gotten them over to Northampton. We put them on at the local Carnegie Hall and they were terrific. They were combining song, dance, theater, performances—and that was a model of the sort of thing that I wanted to do. So we'd make various attempts with varying

degrees of success. This was around the time when I was just turning 20, and I think I was—by that time I had gone on from toilet cleaning and sheep-skinning to office jobs, which weren't a lot more prestigious but at least they were dry and didn't involve that many dead animal parts, so I considered that a step up. It was around this time I met my wife-to-be, Phyllis. I think I was around 20 or 21. We decided to move in together into a little one-room flat in the Barrock Road area in Northampton. I think we lived there for about six months, and that was kind of cozy and sweet in the way those flats are. Then we moved to another flat, and it was at this point that I was starting to—my wife was working—I was coming to a point where I was by this time nearly what, 22? 23? 24? I was starting to feel that if I was going to do anything about making my living out of art in some way, I'd probably better make the move very soon, otherwise I was never going to make it.

And so, I think by this point we were—I forget where we would have been living—we'd have probably been living up at one of the new estates. We'd moved out to one of the estates in what's called the Eastern District of Northampton, which is a large area of former countryside that they turned into huge housing estates, which back then, weren't too bad, but you could see that they were going to become fairly nightmarish housing projects given another ten years. But we were living up there and I was working down at this office job for a sub-contractor to the local gas board and that's when I decided that I would quit my job and actually make a stab at trying to make a living from either drawing or writing or both or whatever. This was a point when my wife found out that she was pregnant and I'd already just given my notice in but the people I work with, they liked me, and they were saying that "We understand, and if you want the job back, it's yours." Now that put me in a kind of a dilemma, because it was a pretty stark choice. I mean, it would have been—oh wait, we hadn't got Margaret Thatcher in just yet, but we'd got the preceding Labor government, and things were pretty bleak. Unemployment was rising, and things were getting kind of nasty. And it did seem suicidal to actually throw off a job when you've got a baby on the way.

On the other hand, I kind of felt that if I didn't make the jump now, once the baby was born I'd never have the nerve to do it. Once I've got a pair of hungry eyes staring up at me saying,

"Roughly 18 or 19, experimenting with frilly shirts, fringes, and sudden mood swings. Actually, these were my first passport photographs, and they led to some hash-eating, surrender-monkey, Dutch Customs official saying that I looked like a girl, which is probably why I grew the beard, thinking about it."

"Feed me," then, you know, I'd probably stay where there was security. And also, if I did that then, that is what I'd be teaching my children. I'd be teaching my children that there was a ceiling to what they could do or what they could be. I'd be teaching them by example that they could go this far but no further. I didn't like the idea of that; that felt bad. I thought that I'd probably rather have a parent that was poor, but was trying.

Was your wife supportive of this move?

Yes, my wife was very supportive. She just said, "Well, do what you want to do. Do what you have to do." So I decided that, yes, I was going to—even with the baby on the way—yep, quit work and spend the next year, 18 months, with no very clear idea of what to do.

But it's tough to be creative under those kinds of circumstances, isn't it?

Well, it was kind of—I did various things. I'd seen *2000 A.D.* and I thought, "Oh great, science-fiction comics, yeah! I'll write and draw a brilliant continuing science-fiction story." And I've got it worked out; it was going to be an epic that I could've easily filled 300 pages with. A massive story that made *Lord of the Rings* look like a five-minute read. And I think about three months later—when I realized that I was still halfway through drawing the second page—I kind of realized that this wasn't practical, this was never going to happen. I did a couple of things like that, and when I started to realize that I thought, "Why would I start all of these epic projects that I know I'm not going to actually finish?"

And I thought, well, that must be the reason. It's because that if I'm never going to actually finish them, then I'm never going to actually send them in, and I'm never going to have to be judged, and I'm never going to risk somebody turning around and telling me that I wasn't any good after all. There was the temptation of simply not trying, not ever sending or submitting anything because then, at least, "I coulda been a contender." I could always have that or "I never made it as a writer but I could have done it if I'd just tried." And that struck me as a pretty sorry-sad consolation; I think it's one that a lot of people go for. A lot of people balk at the hurdle. They don't want to actually have their work judged. It's a fear that if they were told that it was rubbish, then they wouldn't even have the dream anymore. The dream

"Roscoe Moscow" part one. "Roscoe," an episodic strip, ran weekly from 1979 to 1980. ©2003 Alan Moore.

that they always could have been a writer would be spoiled for them. They'd know that, no, they'd never had the talent. And that was, I think, the reason why I was procrastinating so much, and putting off actually doing anything salable and sending it in. And then one day it just kind of clicked in my head. I thought, "Well, it isn't up to anyone other than me. I'm either going to do this or I'm not. If I don't do it, then I think that it's a fairly disappointed kind of life that awaits me. So I've just got to do it."

And it was funny, once I'd made that decision I did two episodes of this half-page strip for one of the music magazines, *Sounds,* which I noticed generally had two half-page strips but for the last couple of months they had only been running one. I thought that that might indicate that there was an opening there. So I did the first two episodes of a continuing half-page strip called "Roscoe Moscow," and sent it in to *Sounds* just purely on spec. I didn't have a telephone in those days, and it was a couple of days later we got a telegram, the first telegram I'd ever received, saying "Like strip—STOP—When can you

start—STOP—Phone this number—STOP" and it was the editor of *Sounds.* So I phoned and he said, yep, liked it, the first strip's great, the second one they weren't so sure about the content but if I could re-draw that, the job was mine at 35 pounds a week. And I was ecstatic. I mean—

That's more than the 18 pounds your dad thought you were going to get!

It certainly was, you know! Of course, inflation had—I think even my dad by that time was earning more than 18 pounds a week! [laughs] But it was still not enough to sign off the dole. The dole—the social security—it was paying us 42 pounds 50 a week and that was bare minimum what we needed to live on—paying the rent, the baby, all the rest of it.

That's sort of like unemployment?

Unemployment benefit, yeah.

Okay.

So then there was a local paper, the *Northampton Post,*

and I ended up offering them a five-panel gag strip "Maxwell the Magic Cat." They liked that, and I think I offered them another strip to start with, "Nutter's Ruin," which was more adult. It was a parody upon the kind of rural soap opera that we have over here, but that was too adult for the audience that they were looking at, so they asked me to do something smaller, and with a cat in it, because that was—cartoon strips, they're about cats; cats are funny. So I did this thing, "Maxwell the Magic Cat," which I did under the name of "Jill de Ray"—I was already working as "Curt Vile" for *Sounds*.

Why were you using these names?

Ahh... [laughs] actually, you're not supposed to work if you're claiming social security.

Oh, okay. [laughs]

I presume that there's a statute of limitations upon these things and—hell, let them find me and fine me; I can probably pay it now. So I thought that it was wise to use assumed names. So I used Curt Vile for the *Sounds* strip; for the

Northampton Post strip I used the name Jill de Ray. This is because they told me to tone it down and make it for children. Gilles da Rais was of course this French child-murderer. He was a close personal friend of Joan of Arc, actually, and it's never been sure if he actually did all the things that he confessed to or whether he was just very frightened of torture.

I knew that none of the people at the *Northampton Post* would have ever heard of Gilles de Rais, so it was me having a sardonic joke. But that they paid me ten pounds a week for. With the 35 pounds I was getting from *Sounds*, this meant that I was getting 45 pounds a week, so I signed off of social security and made an honest man of myself. And occasionally I'd get the odd other illustration job, or at Christmas I'd sometimes do a two- or four-page strip which would be a lot more money and—you know, little cartoon jobs here and there—but it was a pretty precarious living, and I was kind of aware of the limitations of my—oh, actually, we've missed something else here.

Before I did the strip for *Sounds*, while I was just kind of

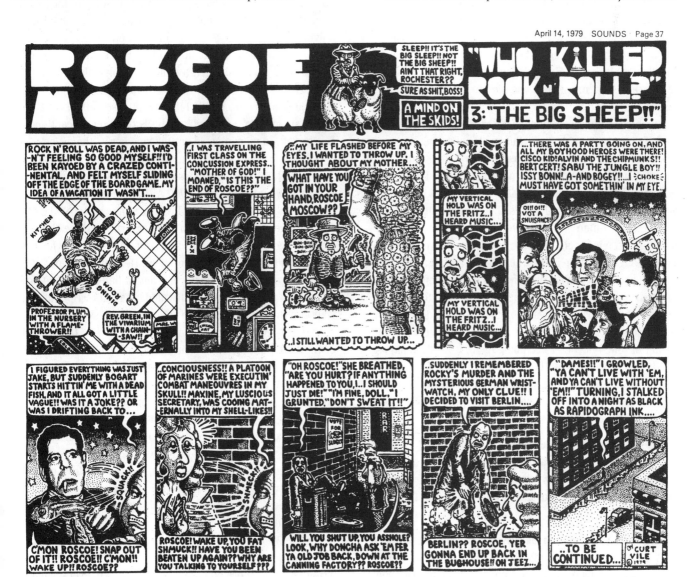

"Roscoe Moscow" #3—"The Big Sheep!!" by Curt Vile. From *Sounds'* April 14, 1979 issue. ©2003 Alan Moore.

unemployed and unemployable, some friends of ours who were living in Oxford got in touch with me saying that there was an Oxford underground alternative magazine being produced called *The Backstreet Bugle*. And they wanted some comic strips in it, and they happened to mention it to this mutual friend who mentioned me and so I said, yeah, sure. Even though it didn't pay, I figured that it would give me a lot of practice at drawing and meeting a deadline and also telling stories. So I came up with this character called St. Pancras Pandas, which was a kind of a cynical parody of the popular British children's character Paddington Bear. I used it to satirize whatever was currently happening—punk rock or some kind of political situation, things like that.

What were your influences in terms of your illustration style—was it R. Crumb or—?

Well, basically everybody was my influence. I'd use kind of Crumb shading—well, a rough, amateurish impersonation of it. I liked that rubbery look that Crumb gave all of his figures, so I kind of swiped some of that off of Crumb. In the "Maxwell the Magic Cat" strip it looks like it's kind of ham-fisted Charles Schulz or something. Some of the "Roscoe Moscow" strips, you can see that obviously I'd been looking at Steranko or this week I'd been looking at S. Clay Wilson. I remember I did a whole big full-panel—there was just one picture in that half-page episode that was a tribute to S. Clay Wilson—a big barroom fight with bikers, pirates, demons, blood everywhere. I mean, I was very impressionable and—this was true during the *Backstreet Bugle* phase and it was true during the other things that I did, which up until *Sounds* were things that I'd never been paid for—I was just doing it for the fun of it. This time I tried to be as experimental as possible, I tried different panel layouts, I tried different drawing techniques, different media—anything to see if I could do something more interesting with that half-page rectangle every week. It was sort of a challenge.

But, actually, I can't draw very well. I mean, after a couple of years I started to belatedly realize that if I wanted to draw fast enough to make a living out of it, I'd have to draw better. It's like I couldn't draw a picture that I was satisfied with in the amount of time I needed to be doing them. It took me almost the whole half-week to do this miserable little half-page strip for *Sounds* and most of that was filled with stippling to try and cover up how lousy I was as an artist; I'd kind of figured that stippling looked good.

You were never afraid of cancellation or...?

No, I always met my deadlines every week and apparently everybody liked it; it wasn't that it was bad but it's just that I realized that I was never going to be somebody like Dave Gibbons or Brian Bolland.

Was this when you started to take your writing more seriously?

Yeah, well I'd started to think if I'm going to actually ever be able to truly support a family, I need to come up with some alternate means of employment. And now, I'd known Steve Moore from age 14, and he'd been working writing comics—

Steve Moore's not from Northampton, is he?

No, Steve Moore's from London. He'd lived in the same house all his life up there in southeast London, and I got in touch with him when I was 14 and we became really close friends. I'm not exactly sure why, but possibly because we've got the same surname, I don't know. But Steve is probably my oldest and probably my best friend.

So he's one of the few people to have encouraged you from the beginning?

Well, yeah. Or at least didn't discourage me. And he was always helpful. If I asked him anything, he'd always tell me.

Could you also count on your wife for good feedback?

I could always bounce ideas off my wife and she'd listen patiently to things that I'm sure were incredibly boring for her. But she would listen and make comments and things like that. I've got people around me who were supportive, or at least not actively non-supportive. I was aware that Steve had made money writing strips—that he couldn't draw but he just made a living writing strips. So I asked him whether he could show me the basic mechanics of how to lay out a script, and he did. I went away and made an attempt at writing a "Judge Dredd" script. I sent it to Steve. Steve tore it to pieces, pointing out "this bit is overwritten, this bit duplicates something that you're showing in the panel, this bit is too long for captions.... You've got too many panels on the page here—the artist would be too cramped—lose a couple of panels." He was really savage with it in the best possible way. I rewrote it to his satisfaction and I sent it to *2000 A.D.* and I got it returned because they obviously had a brilliant writer in the shape of John Wagner. They didn't need another writer writing "Judge Dredd." I got a brilliant letter back from Alan Grant, who was the sub-editor, and Alan was brilliant. He really went out of his way to encourage people who he thought had talent. And he wrote back that we can't use this "Judge Dredd" script but I like your storytelling style. Perhaps if you were to submit a little short twist-ending story, that might work. And on the second or third attempt, I got the form letter back which had lots of robots giving the thumbs up, which means you've been accepted. At the same time I was submitting early stories to Paul Neary for *Doctor Who Monthly*, or *Doctor Who Weekly*, whatever it was called back then for Marvel UK. I started to get these accepted and I could generally be relied on doing a pretty decent job on short notice. I was okay. I could be trusted with short twist-ending stories. I augmented my drawing with that. For a while I kept up the drawing as a safety net because I didn't know if the writing was going to work. I kept up the drawing and thought that if I could get any work from *2000 A.D.* or *Doctor Who*—I'd grab a couple of short "Future Shock"s, twist-ending stories or whatever, and that was when the comic writing became more and more prevalent, until eventually I figured maybe I should give up the *Sounds* strip and let some-

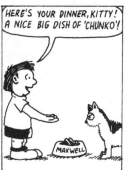

Under the pseudonym Jill de Ray, Alan wrote and drew "Maxwell the Magic Cat" for the *Northampton Post* from 1979 to 1986.

Maxwell the Magic Cat ©2003 Alan Moore.

Prior to "Maxwell the Magic Cat," Moore pitched "Nutter's Ruin" to the *Northampton Post*. It was deemed too adult, and thus there was only one strip produced. ©2003 Alan Moore.

and the right delivery, there was a kind of hypnotism that you could affect on the audience. They would get caught up in the momentum of the language. This was something that I soon realized didn't only apply to the spoken word, that in terms of my prose, that if I were to structure the prose in such a way that it had this rhythm then the readers would hopefully—at least subliminally— pick up that rhythm in their own heads when they were actually reading the work. So this is something, which is still with me to this day.

Dialogue is different. Dialogue has its own rhythm—it's not orderly. To make dialogue sound right, unless you're doing something Shakespearian, then you have to break from rhythm. Because the rhythms of natural speech are so much more undisciplined, have a different sort of music about them.

one else take it over—Eddie Campbell or Bryan Talbot or whatever. Because I'm better at the writing than I am at the drawing and it's more lucrative, it's more fun. I'd like to concentrate entirely upon the writing. Although I still dabbled from time to time with illustration and drawings for special purposes, or if I had plenty of time to do it, that was when I more or less settled into the mode of being a writer. Gradually the drawing stuff got less and less, and the writing stuff got more and more.

You mentioned it was important for you to be with the Arts Lab because it was there that you discovered the beats and rhythms of writing.

This was something that came about from suddenly plunging into a lot of different areas of art and performance that I never really considered before. The Arts Lab could encourage people to be as diverse as possible—to try their hands at as many different things as possible. One of the things that we used to do fairly regularly—because they were quite easy to put together—were poetry readings. I very quickly learned that there was a difference between the poetry that I'd written to be published in the magazine that the Arts Lab was putting out and the poetry written to be read at these events. If you were going to hold the attention of an audience, one of the things that I learned, was that rhythm would do an awful lot. Even if the actual content of the material didn't make an awful lot of sense. If you had the right compelling rhythm

"St. Pancras Panda" from *The Backstreet Bugle*. ©2003 Alan Moore.

But in my captions you'll still find that there's a lot of attention, per page, to the number of syllables, to the actual rhythm of the words. I sometimes will spend half an hour trying to trim one syllable from a line because it will clunk if I leave the extra syllable in. Probably the readers wouldn't notice it consciously but it would disrupt the rhythm I'm trying to create. There are some things—like *Lost Girls*—there's a chapter at the end of book one where I've taken that even further and the chapter takes place during the first performance of Igor Stravinsky's "Rites of Spring" at the Paris Opera House in 1913. And what I've tried to do, because obviously we can capture, through Melinda's artwork, all of the wonders of the stage sets, the costumes and the dance, but we can't get the comic strip to play music. So what I try to do is to actually structure the captions, the rhythm of the captions, so that it echoes the musical phrasing of Stravinsky's "Rites of Spring," which I think was fairly successful. We'll see when it comes out what everybody thinks. In terms of being able to subliminally create a rhythm, a beat, and a music in people's minds, that was a very important lesson and it's one that I wouldn't have learned unless I stood up in front of a crowd trying to read poetry, and finding that there were some words—which although they looked great when I typed them out—that you'd naturally stumble over if you attempted to read them out loud. This was just one of the things that the Arts Lab taught me. It was utterly chaotic, utterly undisciplined, utterly unstructured and it worked fine.

An S. Clay Wilson tribute with Roscoe Moscow, from the pages of *Sounds*. ©2003 Alan Moore.

This was one of the first opportunities you had to get feedback from a public.

Yes. That was very nice with the magazine. We were getting feedback—not all of it positive. The magazine got banned at the school because in the first issue one of the guys did a poem with the word "motherf*ckers" in it—quite an early usage in Britain, 1970 or whenever it was. The headmaster was outraged and demanded that we apologize publicly for using this word, or else he was gonna ban the magazine. And since I was the editor, I did the editorial in the next issue which just said that we were deeply, profoundly sorry for using the word "motherf*ckers" in our first issue. So he banned it. So we sold more copies than ever because we went semi-underground.

I learned a lot about performance. I learned a lot about mixing with different medias; I soon realized poetry went better if you had music behind it. And I realized that it went better still if you could work out visual elements to go with it, which is all material that has finally found fruit in my performance pieces that I'm doing at the moment.

So you'd play a record when you were reading poetry?

There are a lot of musicians in the Arts Lab, so I'd sit down and work out what music would go best behind a certain poem and sometimes we'd do it the other way around—they'd have the music and I'd work out the words to put in front of it. Some of it was very good. It all sounded very good. The main problem with all of that stuff was that I didn't really learn from the feedback that I was getting from the audience—which was, by and large, very good and very uncritical. The audience didn't know what was wrong with the work as clearly as I did. They thought it sounded good to them. I knew that, yes, it sounded good, but large chunks of it were fairly meaningless. It was great language, a very dramatic, creative, wonderful atmosphere. But what it was actually saying, you couldn't quite put your finger on. I learned an awful lot about style and not very much about substance, because I was a callow youth. I was 17; I was still in school when I started work on the Arts Lab, and thus knew absolutely nothing of life. It would take another few years before I would learn to actually combine that rhythmic sonorous writing style, that easy fluid phraseology, I had learned with something that actually meant something.

The intro page to the four-page story "Ten Little Liggers." Story and art by "Curt Vile." Printed in *Sounds'* December 27, 1980 issue.
©2003 Alan Moore.

Something that was actually talking about something clearly, where I was actually conveying what I meant to say—when I had something to say. But that took a few more years. The natural techniques—yeah, a lot them were shaped in those early Arts Lab days. A lot of my attitude towards authority, towards the art establishment could also probably be traced back to those times as well.

Once, against my advice, the rest of the group decided to ask the art council for a grant because we had been putting out magazines, doing performances, we'd been doing performances at mental hospitals, things like that. We were doing it off of our own backs and financing the whole thing ourselves. So the rest of the group wrote a letter asking if there was going to be

any Art Council money available and after we'd written out a detailed account of all of our activities for the last two or three years in a phone book-sized report. They finally said they could allocate five pounds. If I had been a lesser man, I might have gone around crying, "I told you so." In fact, as I remember, I did. These things convinced me that if you want to do anything it was probably best to do it yourself. Don't look to the authorities or anybody to necessarily support you. Do the show right here. Just put it out in some half-fisted amateurish way. If it's any good then the energy will convey what it was you were trying to communicate.

You mentioned that at the age of eleven you felt you were smarter than your dad. Did you ever feel you were condescending towards him when you were younger?

I probably felt that I was smarter than everybody, because I knew that my parents had never been educated to even the standards that I had by the time I was eleven. Of course, being eleven I was pretty stupid and, as I said, didn't really know anything about life at all. By the time I realized that academic evaluations of intelligence meant absolutely nothing, then it was plain to me that my mum and my dad had got a different sort of intelligence that had been hard-earned—a simple folk wisdom that was about as near the lower orders were gonna get to an IQ test. My dad would never have thought that I condescended to him, because I didn't.

In 1973, there was a glam rock/glitter rock band called Cockney Rebel, which I'm quite fond of. I remember that one of their first songs was the magnificent, sweeping number called "Sebastian," which had the chorus "Somebody called me Sebastian." And as I was talking to David Jay once, I said to him that my dad used to call me Sebastian, not all the time, but occasionally. Dave asked what that meant and I explained to him that it kinda meant that if you called someone Sebastian, it was almost implying that they were swottish and poetic, probably a bit girlish, liable to be reading a slim volume of Mallarmé when they should have been out playing rugby football. It would be "Sebastian, put that book down and come out and move this furniture." Dave said that his dad was pretty much the same. Dave's dad used to call him the student prince. It was a working class thing. My dad used to read an awful lot, but at the same time, I think, had a residual working class suspicion of intellectuals. It's a funny thing—it's also a sad thing—but intellect is the only thing that is ever going to help the working class out of their situation. Being tougher, stronger, more enduring... these things are not gonna help. Being smarter—

that would help. But there's this ironic mechanism—or plague—in the British working class that if anybody does attempt to improve their intelligence, then there's a major suspicion of them. If they use a word that has more than two or three syllables, then most of their workmates make astonished "woo" noises. They generally make fun of them.

My dad was a very intelligent man, certainly more educated than my mother was. My dad had been offered a scholarship because of his abilities with math. But he didn't really have that much of a choice. The family was dirt poor; there was no way they could afford to further his education. So he went to work instead and brought money home to his parents. Like I say, he was a furious reader, anthropology seemed to be quite a big subject. He was an emotionally undemonstrative man. He would genuinely be sitting with his nose stuck in a book. Sometimes there'd be some racy, pacey Harold Robbins pot-boiler, but quite often it'd be a book about a recently discovered tribe in Africa or South America, and their customs and habits.

My mother didn't really read at all. She used to knit and that was pretty much her main diversion—other than watching television, which is kind of a curse for the working class. In many respects it killed conversation. There were couples like my mum and dad—who undoubtedly loved each other—I know that they spent most nights of their lives sitting in absolute silence, not talking to each other, because the television was on. It did kill something at the core of the family. I've had television nearly all my life. I was born in 1953 and most places over here got their television in 1953, so they could watch the televised coronation. I think that we probably got a set around 1957. It was a tiny little set that just showed BBC, which was the only channel. And it had wooden doors on the front so that you could close the doors over the screen when the television wasn't in use, which was actually quite nice because it meant that the TV didn't dominate the room that it was in.

Illustration by Moore from a *B.J. and the Bear Annual.*
©2003 Grandreams Books.

No, I don't think my parents ever thought that I conde-scended to them. They probably felt that I was heading down a path along which, beyond a certain point, they would perhaps have trouble understanding me. Not that I think that worried 'em an awful lot, but they realized that the direction I seemed headed in, which was towards weird material, weird ideas.... They realized that there was only so far along that path they

could successfully follow me. My dad never read any of my work. He would nod approvingly if I showed him a new book. My mum eventually read about two or three of my *Swamp Thing* books, and she liked them. I was incredibly surprised because there have not been many books that she had ever read since childhood. But she actually liked it. I might have been an oddity, a curiosity, and a "funny wonder"—that's what my mother used to call me. That was okay. There was room in the working class families back then for "funny wonders."

What's the difference in age between you and your brother?
Mike's two or three years younger than me.

Was he your sidekick when you would get into trouble growing up?
No. To hear him tell it—and he's very unfair in his tales of my childhood—he does claim I would psychologically torture him by making up really scary stories. When we were up on our bunk beds at night, I would tell him some ghastly story about something that had happened in the school, or some-thing that had happened in some other place that we both knew, and he'd believe them. And would be scared to death. I remember once telling him that there was a purely decorative bell tower at the school. I pointed this out to him and told him there was no doorway that led to that bell tower, and didn't he think that was strange? And yes, he did. I extemporized the story from this, telling him that the doorway that led to the bell tower had been bricked up after the previous school caretaker had one night gone to the bell tower, tied the bell rope around his neck, and had hung himself. And the only thing that alerted people to his body swinging in this ghastly fashion in the bell tower was the miserable doleful clanging of the school bell. Bong. Bong. It terrified him. That's if I actually did it, which I swear I didn't. This is just his overactive imagination.

Our sense of humor was the same—still is. He's funnier than I am. He occasionally comes out with a devastating one-liner. He was also prettier, which was a big source of resentment. He had blue eyes and blonde, curly hair. Jealousy of my gorgeous, younger brother was probably a deep part of what fueled my attention seeking: Look at me, I've written a good story. Look at me, I drew a nice picture. When you're uglier you have to compensate, that's my philosophy. Me and Mike, we were very close. We'd play in the house all the time. If we weren't going out we'd play together quite happily. We did have a very similar sense

Another strip by "Curt Vile" called "The Stars My Degradation." ©2003 Alan Moore.

of humor from a very early age.

As both of you grew up, did you and he not share the same interests?

When we grew up I became a hippie. Mike became—for a brief while, he was a skinhead. This was before skinheads were associated with far right politics and racism. This was when you still had black skinheads. We always had a respect for each other. His interests were very conventional. British men's interests: football and all the rest of it. Mine were in obscure books, poetry, performance, drawings, comics... and we didn't have a great many interests in common. Now we see each other once a week, it's very regular. We both look forward to it. He'll bring his lads along, who I get on very well with. We weren't an emotionally demonstrative family but I think that we were very close. We were fairly solid as a family. The only problems ever caused in the family were generally caused by me and Mike. Me getting thrown out of school for acid. Him getting thrown out of school for perpetual truancy, vandalism and being a delinquent—which you'd never have thought to look at him with that angelic blond hair and the blue eyes. I always claimed that he was far worse than me. We debate this endlessly, but without a good lawyer to settle it, we'll probably never get it straight.

What kept your interest in comics while growing up? Was it the works of Kirby? Weisinger? Kurtzman?

It seems that at first it was the Weisinger period DC stuff and then when Marvel appeared in 1961, I instantly switched my alliance to Marvel. By the time I was getting to the age of 13, I was much more aware of the various artists and writers than I was of the characters and the story. I was more aware of the craft that was going into these things, and I was also discovering comics fandom, as it was then, and we're getting a more educated viewpoint upon the material. By the time I was going towards 13 and 14, I was involved in the early rudiments of fandom over here. I was becoming more educated in what comics were about. That was keeping my interest up; also it was a great time for comics. It usually is apart from some dismal period during the '70s, there's usually some great stuff around. One of my first comic conventions, one of the biggest areas of excitement was when one of the fans there had just come back from America and had got some early copies of the first couple of the Jack Kirby issues of *Jimmy Olsen*—which everyone was stunned by. It was fantastic. Right after that there was *Creepy*... there was *Eerie*. There were the science-fiction magazines that at the time were using an awful lot of comic book talent where you'd occasionally see something

illustrated by Steranko, Vaughn Bodé, people like that. The whole culture seemed to be very exciting, very alive; there was lots of stuff going on. Give it a few more years, I was probably 15, 16, starting to move on into my hippie period, starting to discover underground comics, and underground comics were something that sustained my interest that abides and endures to this present day. There aren't any underground artists and underground comics around in the way that there used to be. All the artists from those times that are still working are all still worth hunting down and checking out, because they're still doing great material. That was the stuff that kept my interest. I still pick up the comics to see what's happening. Occasionally there would be a good comic or two amongst them—something that I could enjoy. I remember Don McGregor and Craig Russell's "Killraven," which at the time was fresh and interesting, like they were trying some new things. And various other books from either company, would have something special about them. I really liked what Neal Adams was doing with "Deadman" and things like that. Or the Steranko books—what you might call the psychedelic fringe of mainstream comics—they fascinated me. By the time that the undergrounds were starting to vanish, I was starting to actually do some cartooning of my own— doing these attempted underground cartoons for things like *Backstreet Bugle*, an Oxford underground paper, and a couple of other things.

When did you start to draw?

Well I'd been doing little cartoons here and there since school. Not much of the stuff got published. I don't remember the exact order that things happened in. I really started to get serious about my cartooning—this was after I had quit work—I'm about 24 by this point. There had been comics around to sustain my interest—one form of comics or another—over all the years since I'd been seven. There had always been something there that kept me coming back to comics. By the time the undergrounds were on their way out, in the very late '70s, I was already starting to make some attempt at becoming a cartoonist. It's hard to remember exactly the order of events. At some point there was a very short-lived Northampton alternative paper that I did a strip in for two or three issues, which wasn't a very good paper. It wasn't a very good strip; it was very forgettable.

The *Backstreet Bugle* was much better quality. It covered local political issues, the local music scene; there

were various cooperatives that existed in the area. It was generally a good alternative newspaper. They were looking for a cartoonist and I told them that I could produce a page every two weeks of this ongoing cartoon strip which was called "St. Pancras Pandas," and that seemed to go down quite well. And also I found that having a bi-weekly deadline was a tremendous aid to sharpening my drawing and storytelling abilities. Because if I had to get this strip done in two weeks, I'd always find a way of doing it and getting it over to them. This is where I met Dick Foreman, who was the other cartoonist on the *Backstreet Bugle*, and did a half-page strip called "Moeby Palliative." Me and Dick became close friends. We both had a great interest in comics—perhaps even the same comic. We were both fans of underground comics, and so Dick became a very close friend during that period. At the same time I was still hanging around with Steve Moore and I think at some point Steve Moore suggested me and him could collaborate upon a strip for a rock monthly magazine. It wasn't a big magazine. I don't think the contributors were paid. It was a magazine by West Coast rock music enthusiasts that was called *Dark Star*. They were looking for a comedy science-fiction strip and Steve Moore had written a strip to be told in four episodes of one page each that was called "Three Eye McGurk and His Death Planet Commandos," which Steve wrote and I penciled and Steve inked. Which was always the deal, because Steve didn't want to have me do huge amounts of work without pay, so he offered to ink it. But then I turned neurotic about my work. I found that the pencils that I did on it were insanely detailed, I was even penciling the stippling. I was penciling the black areas. Steve had to go over laboriously and ink all the little dots of stipple, but we got it done. It's got a kinetic energy to it, which I think attracted Gilbert Shelton to it when he decided to run it in his English edition of *Rip-Off Comics*.

Do you remember the first time you saw yourself in print?

The first time I saw myself in print was when I'd some illustrations and things that appeared in a couple of other fanzines when I was about 14. When I was 15, I did a weird druggie illustration, a melting plastic child holding balloons that were giant eyeballs. I can't remember what it was about, but I think that was before I discovered drugs. So it must have been trying to look druggie and psychedelic with no experience. The proprietor of Dark They Were and Golden Eye—which was the first comic book/science-fiction bookshop in Britain, at least to my knowledge—he liked the

Moore provides a fill-in for his pal Dick Foreman in this detail from the strip "Moeby Palliative," which also ran in *The Backstreet Bugle*.
©2003 Dick Foreman and Alan Moore.

Alan's first printed work was an ad for
one of England's first sci-fi/comics shops,
in the 'zine *Cyclops*. ©2003 Alan Moore.

illustration and used it as an advertisement in a British tabloid underground paper called *Cyclops* that I think produced four or five issues in the very late '60s, early '70s. It was fantastic and they had some wonderful stuff in there—most of it by homegrown British talent.

Was that the first time you were paid for something?

I wasn't even paid for that, but it was in print. Then *Embryo* and *Rovel*—the Arts Lab magazine—I did stuff in there that was in print even though it was blotty, stencil printing. It still counted.

So it was gratifying to see these things in print despite not getting paid.

That was it! For the *Backstreet Bugle,* I didn't get paid. The stuff we did for *Dark Star*, I didn't get paid for. It was worth it just to see my stuff out there, to see what it looked like and to be able to see its weaknesses. The first thing I ever got paid for was.... A guy from Northampton—he was attached to the same kind of scene that I was attached to—a guy named Neil Spencer. He had gone to become the editor of *New Musical Express* in the late '70s and he asked if I wanted to submit a couple of spot illustrations. One laborious spot illustration was Elvis Costello and another one which I did was Malcolm McLaren and Johnny Rotten. I sold those but there weren't any other jobs forthcoming there.

So I just really needed a regular gig, and that was when I approached the other, more downmarket music paper which was called *Sounds*. By this time I'm 24, 25 and I'm living with Phyllis in a new estate in Blackthorne—which was at the time genuinely a new estate; it had only been built the year before. There were very few families in there, most of the people that had been moved in were old people who were given ground floor flats at the center courts so that they would be the center of the community, and/or married couples with babies on the way like us, or parents with toddlers or children in push chairs. It was all very nice but you could tell.... I remember saying to Phyllis that we really want to be out in ten years at the very longest. All these cute little three-year-olds were gonna be disrespectful 13-year-olds; all the lamps in the underpass

would be broken and not replaced; and as for the pensioners on the ground floor, the community would probably see them as prey. Nowadays we look at those estates and we refer to them as "sink estates." They're depressed social areas where the disadvantaged generally get shoved out of the way. Very much like the Hoop in "Halo Jones." See, we were all living in Blackthrone in this prefabricated, just built, just built, very quiet housing and existing at the mercies of Social Security which are few and far between.

Was Phyllis from Northampton?

Phyllis is from Northampton, yeah. She was born and raised in Northampton.

Did she go to the school you went to?

Well she had gone to the girl's grammar school; I had gone to the boy's grammar school. Phyllis had gone to the girl's grammar school, which was your basic single-sex school that was a mile and a half apart from the boy's grammar school. They did fraternize, but not officially. Single-sex schools always sounded really strange to me because the schools that I had grown up in, it was always boys and girls, and that seemed healthy. You'd have friends that were little girls and little boys. But this divided up the sexes at the age of 11 and 12. That always struck me as strange. It led to an intensive, stale, masculine atmosphere around the school; you got testosterone build-up and stuff like that.

So we both lived in Northampton all our lives and we'd been pretty much part of the same crowd. When the Arts Lab

Elvis Costello illo for *New Musical Express*. Among Moore's first professional sales. ©2003 Alan Moore.

broke up—I forget when this would have been. 1972? When the Arts Lab broke up, there were some young kids, a couple of years younger, who had not been part of the original Arts Lab but liked the idea of it and had stepped into the group and formed something called the Arts Group, which went on for another couple years. And I hung out with them because the Arts Lab had got a bit stale and wasn't really functioning anymore. I still wanted to be able to perform and contribute to the magazine. I did meet Phyllis through one of the Arts Group poetry readings where I think we were doing the second half of the show—me and a couple of guitarists, we'd done a musical set and some poetry and things like that. Pretty soon after that we moved in together in a little one-room flat where

we lived for about six months, and then after that we got married and got a basement flat that was slightly bigger but more prone to slug infestations. Then we got to this full-sized house on the new estates when we had a baby on the way. And that was where I would sit with a drawing board on my knees, doing these weekly comic strips for *Sounds*, earning 35 pounds a week for this strip that I was putting everything I had into, and I was trying out different art styles, doing some episodes in pencil, doing some episodes in wash or using dot screens. Just experimenting because it seemed I had a platform that allowed for that kind of experimentation, so I might as well take advantage of it. The people at *Sounds* didn't care what I did as long as it was funny and looked okay. And so there was still a space every weekly. If I wasn't making much money out of it, I was going to make sure that I got as much experience as I could out of it.

At around the same time, I got the five-panel cat strip for the *Northampton Post*. I had met a representative who told me they were looking for a cartoonist and who promised me a job. And I'd done a sample strip and then found out that this guy had been fired by the newspaper because he was a pathological lair who was going around promising people things that he didn't have any power to back up. But I was able to use the fact that he had asked me to do these strips on the basis of being an employee of theirs to guilt trip them into at least taking a look at the strip "Nutter's Ruin," and they did. They decided they liked the drawing style but it was too adult; it was a parody of *The Archers*, which was a radio soap opera that had been running over here since the 1940s. I had done this comic strip version about these sinister or deranged, inbred, rustic characters living in this quite freaky village called Nutter's Ruin. The humor was a bit strange, a bit adult for what they wanted. They told me they were looking for a children's comic strip. I thought that if I at least pretended to be a children's comic strip artist, then maybe I could do something with that. We had a cat, at the time, this black-and-white cat who was called Tonto. And I basically used the look of the cat—this strange little Hitler moustache marking it seemed to have—and we came up with the name Maxwell the Magic Cat. And because I was being made to do a children's strip, I asked if I could use the pseudonym Jill De Ray. They just thought it was an interesting eccentricity that I should be calling myself by a woman's name. At the same time I was doing the *Sounds* strip under the Curt Vile. This was largely because I was still

drawing social security benefits. I didn't want my name turning up in the national paper and alerting somebody to the fact that I was drawing benefits while receiving a very small amount of money on the side. But once I got the "Maxwell" strip landed, that meant I was now earning 45 pounds a week. So I was able to sign off of the social security and make an honest man of myself. At that point I was actually supporting myself for the first time from my work and it felt terrific!

We were broke and we had a baby—Leah had been born—and we were living up there in this increasingly fragmented estate with increasingly psychotic neighbors. But it felt terrific just to know—even if it didn't last, which I was sure it wouldn't do. I was sure that I'd be back with the gas board, or something like that, in a year. But I just felt so fulfilled. At least for a few months, a few weeks, maybe a year, maybe two years if I got really lucky, I was gonna be able to support myself with

Alan's first contribution to *Dark Star* was "The Avenging Hunchback," where he used his "Curt Vile" alias. ©2003 Alan Moore.

about visual storytelling, I could probably write a comic strip. I was much more confident about my writing abilities than I was about my drawing abilities. I wasn't really sure how many ribs people had or where the muscles were in the arms and legs. I was hopeless. The writing—yeah! I could describe somebody with words and you could see them absolutely flawlessly.

"Kultural Krime Komix" from *Dark Star* #20, which features most of Moore's early stable of characters, including Yukio Suzukio. ©2003 Alan Moore.

something I always wanted to do. That felt so marvelous, once I actually made up my mind and decided to do it, and then it all worked perfectly. And, yes, it was tough, but having done at least that much, having found that I could set my mind upon something and accomplish it, I started to raise my sights higher. I was gathering confidence. It got to the point that I realized that I couldn't actually draw well enough to make a living out of drawing. I was doing the *Sounds* strip, "Maxwell the Magic Cat," and I was doing illustration for *Sounds*.

You never really indulged yourself with material things and items of luxury?

I've never really thought much about material luxury. That was kind of where I was starting from. My family had never had anything. It was never as grim as it sounds because it was normal, in context of what I was used to. We were getting by, not with ease, not with comfort, but we were getting by. Leah had enough to eat. Me and Phyllis would occasionally buy a record or a book. We would buy clothes occasionally.

No matter how bad things got you always got by.

Yeah. And that was fine. Once I managed to crack the cartooning world, to make the very modest living that we were making, I gained income. Then it came to the point that I realized I wouldn't be able to draw well enough to make a career out of it. At the same time I realized I had learned quite a bit

In 1983, Moore (singing under the pseudonym "Translucia Baboon") recorded "March of the Sinister Ducks" and "Old Gangsters Never Die" as a 45 rpm record. Kevin O'Neill provided the cover art (above). The inside sleeve includes an 8-page comic adaptation of the song "Old Gangsters Never Die," as shown on the next page, with art by Lloyd Thatcher. Cover ©2003 Kevin O'Neill. "Old Gangsters Never Die" story ©2003 Alan Moore and Lloyd Thatcher.

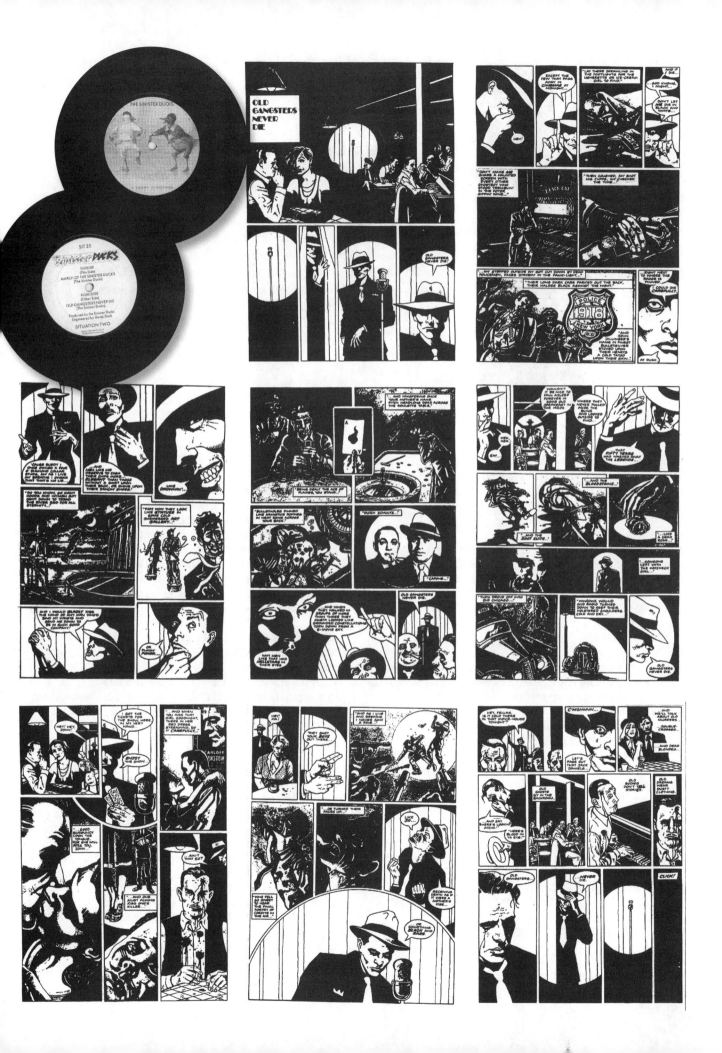

Judge Dredd by Bolland.
©2003 Rebellion A/S.

THE JUDGE DREDD SCRIPT

Moore's first foray in making the gradual move from comic strips to lengthier comic book tales was this "Judge Dredd" script, which was written with a little guidance by Steve Moore. Although **2000 A.D.** editor Alan Grant didn't buy the script, he saw enough potential in it to hire Alan and let him write for other **2000 A.D.** strips. Ironically, Alan never got the chance to write a story for "Dredd," England's best known comic landmark; this script remains their only encounter.

©2003 Alan Moore.

The first page should be layed out with panel 4 filling the whole page as a splash with panels 1-3 inset somewhere near the top, quite small. The 'Judge Dredd' logo and title lettering would probably look best at the bottom of the page. (See sketch.)

1.

We are looking at a crowd of Mega-Citizens. The f/g figures, who are in close-up, wear a mixture of expressions. Some look awed, some frightened, some generally excited. We cannot see what they are looking at. It is night-time.
BOX: MEGA-CITY LAWMEN DON'T EXPECT TOO MANY QUIET NIGHTS. THERE'S ALWAYS SOMETHING...

2.

Same shot as panel 1. At the rear of the crowd, quite small, we can see Judge Dredd and Judge Pepper, pushing their way through towards the front. The people around them are hastily falling back to clear a path, although the foreground characters, unaware of the Judge's presence, have the same expressions as in the previous panel.
BOX: SOME NIGHTS IT'S A MURDER, A BOMBING OR A SHOOTOUT. SOMETIMES IT'S A KIDNAPPING, A ROBBERY, MAYBE A LITTLE ARSON. SOME NIGHTS IT'S SOMETHING ELSE...
DREDD: ONE SIDE, CITIZEN...

3.

Same shot as preceding two panels, but now Dredd and Pepper are in f/g, the rest of the crowd having fallen back respectfully. Pepper's expression is one of worried amazement. Dredd's face, as ever, is totally inscrutable.
BOX: TONIGHT, IT'S VERY DEFINITELY SOMETHING ELSE!!
PEPPER: MY DOK!! DREDD, WHAT IN THE CURSED EARTH IS THAT THING?
DREDD: I DON'T KNOW, JUDGE PEPPER...

4.

Extreme long shot from elevated point of view showing the 'HENRY

WINKLER' plaza, a vast open square ringed by soaring futuristic tower-blocks. Huge, teeming crowds are pressed up against the emergency riot-barriers which have been erected at the outer edge of the plaza. Here and there we can see the Mega-City fire-engines, ambulances and Judge wagons attempting to get through the dense wall of humanity. Large banks of elevated spotlights, similar to soccer floodlights, have been erected with their beams trained on the centre of the plaza and the massive object that dominates the entire scene. It is a gigantic alien spacecraft. It has crashed with its "nose" embedded in the concrete, deep earthquake-fissures snaking away from the point of impact. It should look very, very alien and absurdly big. A street sign in the f/g reads "WELCOME TO HENRY WINKLER PLAZA—OUR FAIR CITY'S QUIETEST NEIGHBORHOOD!"
DREDD (AMONG CROWD): ...I JUST DON'T KNOW!!
BOX UNDER: ...BECAUSE TONIGHT THERE'S
MAIN TITLE: SOMETHING NASTY IN MEGA-CITY ONE!!
(If possible, the word "NASTY" should look as if it has been sculpted from decomposing flesh... vile, worm infested and just about to crawl off of the page and into the readers lap.)

5.

We are right up close to the ship now, the hull soaring up and away from us. In the extreme b/g we can see part of the crowd, very small, being forced back by bulldozer-like Judge wagons. In the mid-distance, facing away from us, we can see part of a cordon-ring of judges with guns at the ready. Standing gazing up at the immense bulk of the ship is Judge Pepper. Just behind him we can perhaps see a little of the strange ramp-like construction described in the next panel, with a judge crouched down and examining it with strange electronic equipment. In the f/g is Dredd. He is running one hand over the smooth surface of the ship as if examining its texture.
BOX: ...AND, AS THE RIOT-WAGONS BREAK UP THE AWE STRICKEN CROWD...
PEPPER: IT'S VAST...LIKE NOTHING I'VE EVER SEEN BEFORE! WHAT DO YOU MAKE OF IT DREDD?
DREDD: I'M LOST, JUDGE PEPPER. ITS WHOLE DESIGN IS SO ALIEN!

I'M NOT EVEN SURE IT'S MADE OF METAL!
DREDD: HOW ABOUT YOU HENRY?

6.
Judge Henry is kneeling by the ramp, now in f/g, which he is examining with the complicated-looking equipment mentioned in panel 5. The ramp looks more like a piece of contorted avant-garde metal sculpture than any conventional ramp or ladder. In the b/g we can see Judge Pepper, and behind him Judge Dredd, listening attentively.
HENRY: NEGATIVE, JUDGE DREDD. THIS HERE IS SOME SORT OF RAMP AT A GUESS, BUT AS TO WHAT SORT OF LIMBS IT'S DESIGNED FOR...I DON'T EVEN WANT TO THINK ABOUT IT.
HENRY: THIS THING HAS COME A LONG, LONG WAY...

7.
Dredd is in f/g, staring pensively out of the pic. Behind him, Judge Pepper addresses him, his brows knotted in an anxious frown. Maybe in the b/g we can still see Judge Henry and his devices, but this is not essential.
PEPPER: I DON'T LIKE IT, DREDD. THIS THING IS OBVIOUSLY BUILT TO HOLD SOME FORM OF LIFE, BUT OUR SEARCH TEAMS SAY THAT IT'S TOTALLY EMPTY. THE ONLY FACT WE KNOW ABOUT WHATEVER WAS INSIDE THIS THING IS THAT...
DREDD: ...IT ISN'T INSIDE ANYMORE. WHICH LEAVES US WITH ONE IMPORTANT QUESTION...

8.
The scene switches to the underground car park of the Barbara Cartland block, a shadowy place sparsely illuminated by a few strip-lights. In the f/g, walking towards us, is Judge Curtis. Behind him is Judge Foreman who is pointing to the walky-talky radio he has in one hand. The stance of both men should be fairly relaxed. They are on a routine patrol and not much is happening.
BOX: (CONTINUED FROM DREDD'S DIALOGUE OF THE PREVIOUS PANEL.)
"...WHERE IS IT??"
FOREMAN: HEY, CURTIS! DIDJA HEAR ABOUT THE BIG SHAKE-UP OVER AT HENRY WINKLER? SOUNDS PRETTY EXCITING!!
CURTIS: I CAN LIVE WITHOUT IT, JUDGE FOREMAN. THIS ROUTINE PATROL IS PLENTY OF EXCITEMENT FOR ME.
CURTIS: THE WAY I SEE IT, WHATEVER'S COOKIN' OVER AT HENRY WINKLER...

9.
Curtis is now in the b/g, walking away from us. He is totally unaware that behind him, in the f/g, Judge Foreman is being dragged into the shadows by three massive, two-fingered hands. (See Appended sketch.) Foreman is in head and shoulders close-up. His helmet is falling off, but all we can see of his face is two terrified eyes staring out from between the misshapen fingers. One giant hand is clamped over his mouth.
CURTIS: ...IT DOESN'T CONCERN US, RIGHT?

10.
Close-up head and shoulders of Judge Curtis. He still has his back to us, but is peering back over his shoulder, 3/4 face.
CURTIS: ...I SAID "RIGHT," JUDGE FOREMAN?
CURTIS: (SMALLER LETTERING) ...JUDGE FOREMAN???

11.
Judge Curtis is in the mid-ground, a look of mingled shock and disbelief on his face. One hand, by reflex, is already clawing for his blaster. In the foreground, too close to be really comprehensible we can make out

a huge looming figure. All we can really see of it is a claw or a tentacle. (See sketch.)
BOX UNDER: THE JUDGE'S HAND CLAWS FRANTICALLY FOR HIS BLASTER, ONLY INCHES AWAY FROM HIS DESPERATE FINGERS...
CURTIS: (VERY SMALL LETTERING): OH MY DOK...

12.
Smallish panel. Close-up of Judge Curtis' boots. They are about eight inches above the ground and kicking wildly. Maybe we can see a hint of a tentacle, wrapped around his leg just below the knee...
BOX: ...HE DOESN'T MAKE IT!
CURTIS: EEEEEEYAARRRGHH...
SOUND F.X.: SNAPP!!
(Possibly the "SNAPP" could be arranged to fit across the scream, cutting it off sharply.)

13.
The scene shifts back to the plaza, where Dredd and co. are still examining the crashed space-ship. Dredd is in f/g. In the middle distance we can see another judge, a despatch rider, who has just pulled up astride his bike. He looks slightly nervous. Dredd looks angry at the interruption.
BOX: ... AND, AS THE LONG NIGHT CRAWLS SLOWLY TOWARDS MORNING, BACK AT HENRY WINKLER PLAZA...
JUDGE: JUDGE DREDD...WE GOT A CALL FROM H.Q. COUPLE OF JUDGES OVER AT BARBARA CARTLAND BLOCK AREN'T ANSWERING THEIR RADIOS! WE THOUGHT YOU...
DREDD: DROK IT, MAN!! WHAT WE HAVE HERE COULD BE A THREAT TO THE WHOLE CITY!! TELL H.Q. THEY CAN GO AND...
DREDD: ...NO...WAIT A MINUTE...

14.
Close up of Dredd's hands. One of them is spreading out an insanely complicated looking map labeled "MEGA-CITY ONE. SOUTH-WEST SECTOR." The other hand is tracing a route with one finger.
DREDD: (OFF-PIC): BARBARA CARTLAND BLOCK LEADS OFF THE PLAZA JUST HERE...IF WHATEVER HAS THIS SHIP NEEDED SOME PLACE TO HIDE, THEN MAYBE...JUST MAYBE...

15.
We are looking over the shoulder of the despatch rider towards Judge Dredd who is striding towards his own bike, parked in b/g.
DREDD: TELL H.Q. I WANT A RIOT-WAGON AND PLATOON OVER AT BARBARA CARTLAND IMMEDIATELY!
DREDD: I'LL BE WITH THEM IN FIVE MINUTES!

16.
Change of scene to outside the entrance of the Barbara Cartland Block car park. There is a sign above the mouth of the tunnel reading "Barbara Cartland Block: Vehicle Enclosure. Entrance W.23." Beneath this a smaller sign reads "Max. Headroom: 20feet." Although this need not really be visible at this stage. In the f/g stands Judge Giant, the huge negro judge from the 'Judge Caligula' episodes. He has his helmet under his arm and is mopping the sweat from his brow. Behind him, Judge Dredd is screeching to a halt aboard his bike.
BOX: FOUR MINUTES AND FIFTY–EIGHT SECONDS LATER...
DREDD: FOUND ANYTHING YET, JUDGE GIANT,
GIANT: YEAH, BABY! AN' DON'T JUST WISH WE HADN'T!!

17.
With one hand, Giant is settling his helmet back on his head. With the other he is indicating a team of medics, who, in the b/g, are loading a

stretcher on to an ambulance. The figure on the stretcher is invisible beneath the white sheet pulled over its head. In the f/g, Dredd stares at medics emotionlessly.

GIANT: WE FOUND JUDGE FOREMAN AND JUDGE CURTIS...GREASED, BOTH OF 'EM! MAN!! YOU SHOULDA SEEN THE LOOK ON JUDGE FOREMAN'S FACE...

DREDD: AND JUDGE CURTIS?

18.
Both Dredd and Giant are fairly close to us. Dredd is in Head-and-shoulders close-up, his mask-like face staring silently out of the panel. Behind him, fastening his helmet straps, Judge Giant stands in a 3/4 length shot, addressing him.

GIANT: JUDGE CURTIS DIDN'T HAVE NO FACE, BABY...

19.
Dredd and Giant are walking through a crowd of assembled judges, all busy checking and loading guns, fastening their body-armour etc. If we can see her badge, her name is Judge Jewel.

JEWEL: JUDGE DREDD... ACCORDING TO OUR MONITORS, NOTHING'S LEFT THIS VEHICLE ENCLOSURE IN THE LAST HOUR. SO WHATEVER IT WAS THAT TOOK OUT FOREMAN AND CURTIS...

20.
Dredd is talking to his radio, not looking at the woman judge who still stands in semi-attention posture.

DREDD: ...IS STILL IN THERE! THANK YOU, JUDGE JEWEL.

DREDD TO AUXILIARY UNITS: SEAL OFF ALL EXITS TO THE VEHICLE ENCLOSURE EXCEPT W.23...

DREDD: ...AND THEN START PUMPING IN THE RIOT GAS!

21.
The Judges are in the f/g, with Dredd and Giant prominent. They are looking away from us towards the mouth of the tunnel w.23, guns levelled expectantly at the opening.

BOX: TENSE MINUTES TICK PAST...

GIANT: IF THERE WAS ANYTHING IN THERE, BABY, IT'S EITHER STONE DEAD OR IT'S LEARNED TO BREATH RIOT GAS!!

DREDD: O.K., GIANT. GIVE IT TWO MORE MINUTES AND THEN WE'LL...

JEWEL (OFF PANEL): JUDGE DREDD!!

22.
The judges, with Dredd, Giant and Jewel in f/g are staring out of the panel at us. Judge Jewel is pointing, one hand almost covering her mouth in anxiety. Giant looks totally horrified. Even Dredd's mouth is open in surprise.

JEWEL: LOOK! COMING OUT OF THE TUNNEL!!

GIANT: (SMALL LETTERING) ...MAMA...

23.
Straight on shot of the tunnel mouth. The inside of the tunnel is mostly in shadow, but slowly, emerging from the darkness we can see a little of the creature...a few tentacles, an arm or three, maybe the tip of its beak. The bulk of it, however, is still hidden. What we can see is that the creature is having to stoop as it emerges. The sign above the entrance reads "MAX. HEADROOM: 20 FEET."

JUDGE (OFF PANEL): MY GRUD! LOOK AT THE SIZE OF THAT THING!!

24.
Similar to Panel 22. The lawmen are still staring at what is emerging from the tunnel. One or two are starting to raise their guns.

BOX: MEGA-CITY LAWMEN HAVE SEEN IT ALL. MUTANTS, KLEGGS, KILLER SPIDERS, LABORATORY FREAKS...

(NO DIALOGUE.)

25.
The creature is now fully visible, standing at the mouth of the tunnel. One of its four arms is raised to shield its eyes from the glare of the spotlights. From the bar of shadow thrown across its face two small eyes glare out balefully.

BOX: ...THEY'VE NEVER SEEN ANYTHING LIKE THIS!!

BOX UNDER: AND, FOR A MOMENT? THEY FREEZE...

(NO DIALOGUE.)

26.
Large panel showing all of the Judges rushing the creature at once. Some are firing their weapons to absolutely no effect. The creature is fighting smoothly and efficiently, its various body parts acting in apparent independence of one another. Its beak, claws and tentacles dispatch lawmen right, left and centre, while its thrashing tail brings down still more. Dredd, in f/g, is rushing towards the creature, gun at the ready, looking back over his shoulder to bark an order to the judges behind him. (UNSEEN)

BOX: ...BUT ONLY FOR A MOMENT!!

DREDD: HIT IT!!

27.
Close-up of the action. Dredd, in f/g, is firing his blaster. Giant, slightly further from us, is wrestling with an enormous tentacle coming from somewhere off the panel. He is shouting across to Dredd. The rest of the panel is a tangle of lawmen, claws and tentacles.

BOX: FIFTY MEGA-CITY LAWMEN, EACH ONE TRAINED TO THE PEAK OF PHYSICAL PERFECTION. EACH ONE A LETHAL FIGHTING MACHINE. FIFTY OF THEM...

GIANT: WE CAN'T HOLD IT, BABY! IT'S TOO STRONG...TOO FAST!!

BOX UNDER: ...IT'S NOT ENOUGH!!

28.
We are looking upwards. The judges, head and shoulders, are in the bottom f/g. The creature has broken free of them and, digging its claws into the solid plasteel is climbing straight up the wall, away from us. The Judges fire impotently at its retreating form. Dredd is prominent.

BOX: SHAKING OFF THE JUDGES AS IF THEY WERE NOTHING, THE CREATURE SINKS ITS CLAWS INTO THE SOLID PLASTEEL OF THE WALLS AND...

DREDD: MY DOK! IT'S GOING STRAIGHT UP THE SIDE OF THE BUILDING!!

29.
Some of the judges are still firing at the creature which is by now off panel. In centre f/g, Dredd peers upward with one hand shielding his eyes. Behind him, Judge Jewel is removing a map from one of her uniform pouches.

DREDD: THAT'S ALL WE NEED... IT'S BROKEN THROUGH A WINDOW ON LEVEL 18! JUDGE JEWEL, WHAT DO WE HAVE ON THAT LEVEL?

30.
In the b/g, Judge Jewel is looking towards Dredd with a look of pure horror on her face. Dredd, in f/g, is looking towards us with one side of his mouth curled back in a pained sick expression.

JEWEL: JUDGE DREDD...LEVEL EIGHTEEN...LEVEL EIGHTEEN IS THE CHILDREN'S HOSPITAL!!!

BOX UNDER: NEXT WEEK: THE NIGHTMARE ON FLOOR EIGHTEEN.

THE COMICS PAGE

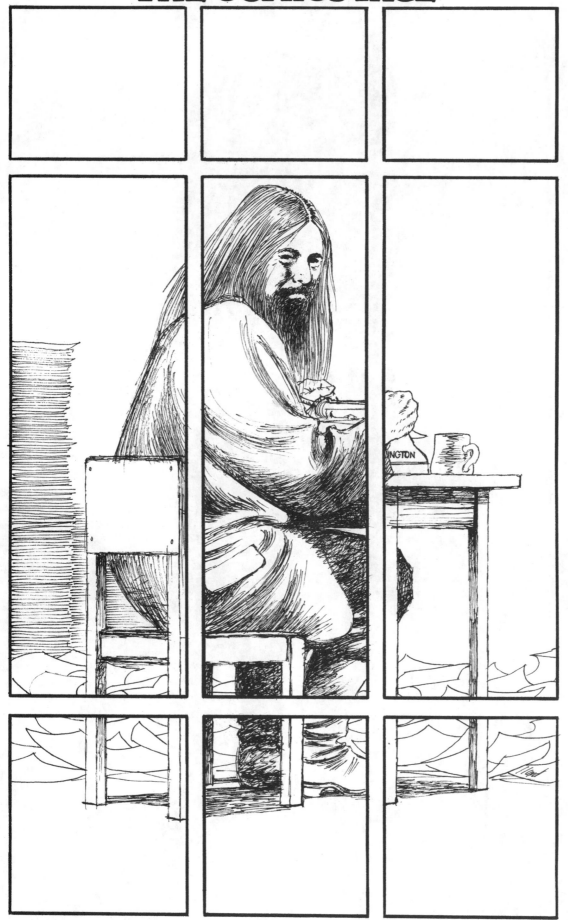

(In *Kimota! The Miracleman Companion*) Alan Davis mentioned something about being at the *2000 A.D.* office when somebody had been handed a script that you wrote and that particular artist couldn't make anything out of it, so the editors gave it to Davis, because he'd worked with you before. Do you remember anything like that?

It's nothing that I ever heard. I mean, certainly, I think if you look at my work for *2000 A.D.*, yeah, I was doing lots of strips with Alan Davis, but at *2000 A.D.* I was working with—

Just about everybody.

—with nearly everybody. You know, if that's what Alan said, maybe it happened. But I'd be surprised if he was seen as the only person who could comprehend an Alan Moore script. That makes my scripts sound incoherent, and I don't actually think that's what they're famous for. They're famous for being long and detailed.

Maybe they were young artists who couldn't make anything out of the script, or that were struggling or something with the art.

I have no idea. I don't know who that would have been. It might be true, I'm not denying it but....

Didn't it seem odd to you that you were doing the only two super-hero strips in the UK at the same time? You basically had a monopoly at that point. Did that seem a little weird?

Well, yeah.

I mean, you were "THE" super-hero writer in England. [laughs]

It did seem a bit odd, but then, on the other end, that seemed to be how it had worked out. I was probably one of the first super-hero writers to emerge from Britain successfully. And so, I guess when they thought, "let's do a super-hero," they just automatically thought of me.

There was just you and no one else.

Yeah. Although we did try to make "Marvelman" and "Captain Britain" as different as possible—and as for "D.R. & Quinch," that was different again.

Did either publisher ever have a problem with you working for the competition?

Anybody could do it, George. "You're working for our rivals, therefore you can't work with us." That

makes a lot of sense, doesn't it? It's sort of, "I'm worried about you working for my rival, so I'm going to forbid you to work with me." Nah, you know... as long as I produced all the work, produced it on time, and produced it well—which I think me and all the artists did do—I never had a problem. I'm a freelancer, which means that I can work wherever I want. That was pretty much my understanding of the term. And that was always my understanding that I wasn't under contract to anybody. They didn't necessarily have any obligations to me; they could fire me at a moment's notice or drop me from a strip. I recall seeing that happen with other writers. So if they didn't have any loyalty to me, then as long as I was doing the work that I was paid for them, my loyalty ended there. If I was doing a good job for them that was worth the money they were paying me, then that was all that they could ask of me. I know the situation that used to prevail over in America was sort of people working for Marvel under an assumed name in case DC found out or stuff like that. But no, I didn't work during those times. I can't say how I would have reacted to them, but it doesn't really sound like me.

When you got back to Marvel UK, you started doing *Daredevils*, where you really started to write not only comics but also essays and reviews.

During *Daredevils*' short run, Moore not only wrote the lead "Captain Britain" story, but he also wrote essays and reviews. ©2003 Alan Moore.

I really liked Bernie Jaye, who was the editor. Everybody liked Bernie Jaye. She was really nice. And she had been given a pitiful budget to turn the *Daredevils* into an exciting Marvel UK comic magazine. So what we did, me and Alan Davis would give her more artwork or more scripts for the same money. And, yes, she got the stuff that she had to reprint from America, which was pretty good stuff. It was Frank Miller's early *Daredevil* stuff, so that was no problem. And she got the "Captain Britain" strip in there, that was fine. If you tore out the rest of the pages—me and Alan suggested to Bernie that we could do features very cheaply, text features of various sorts. We could have a "Night Raven" text story with pulp illustrations, which I could write cheaply. We could have fanzine reviews, which again I could write for next to nothing. We could have opinion pieces, which again I could write for next to nothing. And in this way, we could have lots of openly intelligent pages. We could fill out the magazine very, very cheaply with good, quality material. So that was basically why me and Alan and probably all the other people there were turning out a lot of work for Marvel. It was purely because we liked Bernie.

Did you like that kind of writing, doing some journalism and criticism? I don't think you've ever done that kind of stuff.

"Night Raven" front piece by Moore and Alan Davis from the pages of *The Daredevils*, for the Marvel UK line in the early 1980s.
Artwork ©2003 Alan Davis. Night Raven ©2003 Marvel Characters, Inc.

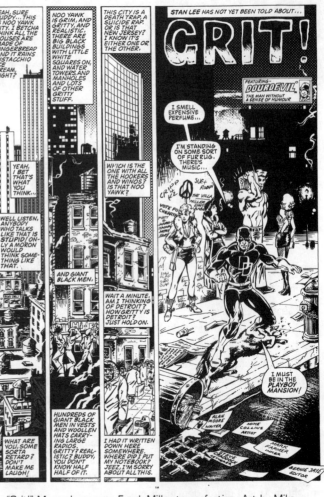

In "Grit!" Moore lampoons Frank Miller to perfection. Art by Mike Collins and Mark Farmer from *Daredevils* #8, 1983. ©2003 Alan Moore, Mike Collins and Mark Farmer. Daredevil ©2003 Marvel Characters, Inc.

I was a music journalist, briefly, for *Sounds*. When I was working with *Sounds*, I used to supplement the money that I made doing the comic strip by doing the odd interview. And I found that I was too dishonest for journalism. If I actually met somebody and had a cup of tea with them, I couldn't go away... whatever I thought of the music, I couldn't go away and write something bad about them. And I thought, well, I've just not got the killer instinct that is necessary for journalism, so I'd better stick to fiction. But at the same time, I enjoyed writing some of those pieces for the *Daredevils*. I mean, that "Invisible Girls and Phantom Ladies," which was one of, I think, the earliest pieces by a man *or* a woman to address the specific issue of sexism in comics. I enjoyed writing that. And Bernie thought that was a good idea, as a woman. So she didn't take much selling on it. I think we got a three-part article out of that.

I think that Stan Lee piece you wrote, if folks had noticed it, Marvel USA would have problems with that.

Aaaah, Marvel USA didn't read the Marvel UK product, I'm pretty sure. I think Marvel USA had no interest, if truth be told, in what was happening at Marvel UK. That was what I was banking on, and we certainly got no criticism or feedback

over that relatively savage Stan Lee article, so I can only assume that nobody over there ever gave a damn because they hadn't read it. The only relationship between Marvel UK and Marvel America at that time seemed to be that they had the same name.

When you were doing those fanzine reviews, was that the first time you encountered Eddie Campbell's work?

The fanzine reviews... yeah, I believe it *was* the first time I encountered Eddie's work. And that was a good thing, because with those fanzine reviews, yes it filled space for Bernie, but it also filled the purpose of allowing me to give some encouragement or draw some attention to magazines or people who I felt deserved that attention. And the stuff that Eddie was doing, some of his early kind of fast fiction books, really impressed me. I thought his storytelling style was tremendous and I was quite a big Campbell booster. This was a little while before we actually met, of course, when he completely destroyed all of my illusions. But I remember doing quite a few bits.

I think you reviewed him two or three times. [laughs]

Well, he was a favorite. And he wasn't even sleeping with me or something. I just did those reviews out of the goodness of my heart, because I genuinely loved his material. And, yeah, I could pick people like Ed Hillyer or Phil Elliot. And sort of draw attention to any of the mainstream comics fanzines that were coming out in England at the time. Put people in touch. It was only a little bit of effort every month to do all those fanzine reviews or comic features, but I think it might have introduced a number of people in this country to the basic idea of comic fandom and the comic community. Don't know, don't know.

How did you start getting ongoing strips for *2000 A.D.*? How did that happen? Like "D.R. & Quinch" and "Skizz" and....

I think it all kinda happened at the same time. I can't even remember in what order it happened. It might have been that when they knew I was doing ongoing strips for *Warrior* and "Captain Britain," *2000 A.D.* decided to give me this *E.T.* knockoff idea of "Skizz," which I did the best I could with. It may be that I had "Skizz" before I had "Marvelman" or "Captain Britain," I really can't remember. But I know that generally there was a—

Warrior was definitely first, because it seemed like after Warrior, that was when everything started happening.

Although when the things actually came out might not actually reflect them all being done. But I remember that what was generally happening was that everybody wanted to give me work, for

fear that I would just be given other work by their rivals. So everybody was offering me things. So, yeah, I did "Skizz" for *2000 A.D.*, and it was great working with Jim Baikie, who is a wonderful artist. It was interesting to have an ongoing strip in *2000 A.D.* where I could explore character development and maybe press a few unusual buttons for *2000 A.D.* But he kind of really whetted my appetite for doing something better, where I came up with the whole idea myself and was not just being instructed to knock off a popular feature film.

"D.R. & Quinch," how did that start? It all started with just one strip, right?

One strip, one story, and I think that me and Alan both found the characters amusing.

But was it about "D.R. & Quinch Have Fun on Earth" that struck a cord, that it deserved its own ongoing strip?

There was a very good reaction to it. Me and Alan thought it was funny. I think the editors thought it was funny. I forget whether it was us who suggested that we do another story with the same characters or whether it was them who suggested it. I can't remember.

But you enjoyed working on it...?

The success of *E.T.* inspired *2000 A.D.* to let Alan Moore and Jim Baikie to handle an alien named Skizz. This strip was Moore's first regular ongoing comic strip.
©2003 Rebellion A/S.

The lovely Miss Halo Jones... a woman of compassion and action. The strip can be described in many ways, but mostly it's an anti-war story with a strong and inspiring female hero. Art by Ian Gibson. ©2003 Rebellion A/S.

At the time, I did. There came a point where I looked at it and thought, "Well, this is humorous in kind of an *Animal House* way, socially irresponsible kind of way, but I'm not really that comfortable about making jokes about nuclear weapons...." I probably got as many laughs out of it as I could.

Of the work that you did for *2000 A.D.*, the obvious gem was "Halo Jones." That was the most personal one for you?

That was the one that worked best for me. It was something where I wanted to write something about women. I wanted to take a character, imagine a future situation for her, and then let it all unfold naturally from there, see how it developed. And it developed beautifully. Ian Gibson's artwork was stunning. It was a very believable world, with very believable characters in it. It was certainly the most sophisticated thing that I did at *2000 A.D.*, with the possible exception of one or two of the better "Future Shock"s.

Originally you were supposed to do more episodes of "Halo Jones." What exactly happened with those plans?

Well, as with a lot of the companies that I've worked for, it got to a point where I kind of realized that I was doing a lot of work for the company. I was creating characters for them that they were making quite a lot of money off of, and they were getting not just more than me, but what seemed like an unreasonably greedy amount more than me. And I started to not feel very good about that. I started to feel pretty bad about all of the Titan Books that were coming out, as did most of the contributors of *2000 A.D.* I started to feel bad about the fact that Titan Books was supporting their entire operation upon this line of *2000 A.D.* reprints for which the artists and

writers involved all were paid peanuts.

And then they exploited you when *Watchmen* came out, wasn't it? They collected your work for them?

We were exploited.... Publishers down the line tend to exploit as much as they possibly can.

Titan doesn't pay royalties?

Not proper royalties, no. It's some ridiculous token amount. But this is not just my gripe; this is the gripe from nearly everybody who's ever worked for them. And it's not just Titan, obviously it's *2000 A.D.* who were at the center of all this. They're the ones who had made the deal with Titan. And that's *2000 A.D.* as it was, and it's *2000 A.D.* as it is. Every four or five years, there will be a change of editorship at *2000 A.D.* and I'll get a phone call. "Is there any way that you can come back and work for us?" And I'll sort of stay with "Give me back Halo

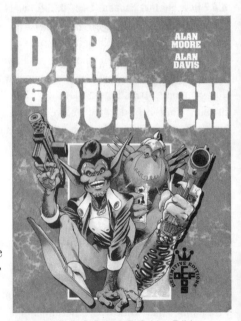

Cover to *D.R. & Quinch Definitive Edition*.
©2003 Fleetway Publications.

From the 1983 'zine *Fantasy Advertiser*, a page from the final "Moonstone" adventure. Art by Mike Collins and Mark Farmer. ©2003 Alan Moore, Mike Collins, and Mark Farmer.

Jones. Give Halo Jones back to me and Ian Gibson." And then, in the past, I would have been prepared to actually do a new book of Halo Jones and to let *2000 A.D.* publish it. But they're never going to give me back Halo Jones, because if they did that, then they'd have to give Pat Mills and John Wagner Judge Dredd. And if they did that, then they'd just be a bunch of largely talentless chancers who happened to find themselves in possession of all these other people's famous characters and wouldn't have any market or characters anymore. So it's never going to happen. It's a waste of my time to even consider it. And even if they did offer me Halo Jones back now, I don't want to ever do anything for *2000 A.D.* again. Its sort of... they've burned that one. And they have contributed, as have a great many other people, to a gradual disillusionment and demoralization that has kind of crept over my attitude to the comics industry.

Before ABC, didn't DC used to do the same thing, too? Once a year you would get a phone call or something saying, "Are you coming back?" Would you get something like that?

Yeah, pretty much. Or more often there would be some weird maneuver, like when Awesome was going under and I got a phone call from Jeph Loeb or somebody saying that

Awesome could be saved as a company. DC was willing to move in and order the company and save it, but only if I w part of the deal. And I thought, well, that sounds like they' about to buy a whole company to get *me*. Which is ridiculou But at that time, because I hadn't signed any contracts or an thing, I was still free to say "no." When they eventually bough Wildstorm, I had already signed contracts, I had already made obligations to people, and I was no longer free to turn it down. Yeah, I'd sort of get phone calls from Karen Berger, and it's always lovely to talk to Karen. I think Karen would kind of know that she wasn't going to get any real response out of me, so she'd really be calling up to chat and see how I was and everything, which is.... Like I say, it's always lovely to talk to Karen.

But when you get Paul Levitz on the phone, that's something else?

No, I never get Paul Levitz on the phone. After I parted company with DC, I think they understood that there was nobody at DC other than Karen Berger or Richard Bruning who it was entirely safe for them to call me. No one wants me being unpleasant on the other end of the phone, least of all me. So Karen, who I will always have respect and fondness for, is pretty much my only liaison at DC.

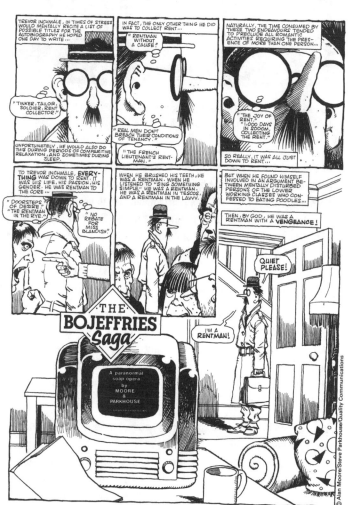

Working class heroes. More "Bojeffries" by Moore and Parkhouse from the pages of *Warrior* #13. ©2003 Alan Moore and Steve Parkhouse.

Moore and David Lloyd team up for the 1980 *Doctor Who Weekly* back-up strip, "Black Legacy."
Doctor Who ©2003 Respective holder.

Of the first things that you've done, which would you say is the most important, that helped you develop as a writer? It seemed to me that "V" was pretty important to you.

They were important in different ways. "V" was very important, that taught me a lot. But "Bojefferies" was important in that it was one of the most personal things that I've done. Among other things, I know that "Bojefferies" seems weird—

Especially to Americans. I still don't get it! [laughs]

Well, it looks very surrealistic to Americans, whereas, to me, it's a thing that I've done that I've come closest to actually describing the flavor of an ordinary working class childhood in Northampton. And the inherent surrealism in British life. Yeah, that's a very important strip to me.

Why weren't there more "Bojefferies" strips, or is it a difficult strip for you to write?

It was very difficult. In some ways, the nearest equivalent to "Bojefferies" that I'm doing today is something like "Jack B. Quick," where you can't do that many because the humor is so peculiar. But you can't just turn it out on a formula. The humor is strange little bits of observation, or odd little ideas, and

you'll know them when they're right. Humor is a delicate thing, especially with strips like "Jack B. Quick" and the "Bojeffries," which have such quirky humor. That's why there are so few of them. I still entertain the idea that I should at some point in the future... me and Steve Parkhouse have talked about doing another "Bojeffries" strip, after the Blair government has worked its magic upon British society. The family's probably completely broken up and Ginda Bojeffries is probably one of the Blair babes, Labor new women M.P.s. The son of the family is probably a Booker Prize-winning author who spends most of his time at the Groucho Club, having reached fame by writing what people take to be witty, magic realist stories about his working-class upbringing. Yeah, there's a lot of stuff that we could do. That we still might do. But we have to wait until we've got something that's good enough.

How did you start working at *2000 A.D.*?

I sent a "Judge Dredd" script in to *2000 A.D.* where I was lucky enough to have it read by then sub-editor Alan Grant, one of the gentlemen of British comics, who really did put a lot of time into his job. If there were people who had talent, he would encourage them. And he wrote me a letter right back saying, "We don't want this script,

ALAN MOORE

JUDGE DREDD WEEKLY.

"THE BADLANDER", EPISODE ONE. FIVE PAGES.

1.
I figure these first two frames could be page-width...shallow and horizontal. They both show more or less the same scene, and it's an establishing shot of the Cursed Earth in the strip as I figure that the Cursed Earth itself will be almost as much a character in the strip as the title figure himself, I reckon we ought to try and take the opportunity to demonstrate at every conceivable opportunity just how incredibly bloody weird the place is. John has established this in Judge Dredd as a place where literally anything can happen, from ghosts to garbage empires, and I'd like to keep all that up as well as possible, rather then have it gradually deteriorate into a normal-looking desert were odd things happened every once in a while. If I think of any bits myself as I go along..things that can be dropped painlessly into the b/g or f/g without disturbing the flow of the strip..then I'll drop them in. Otherwise, whoever ends up drawing this should feel free to stick in any bits of appropriate strangeness that appeal to him. Okay...In this first frame we could perhaps have the corroded and lichen-spotted remains of a late Twentieth Century American streetsign jutting up from the desert floor at a drunken angle. Part of it has been melted presumably by the thermonuclear blast that spawned the Cursed Earth, so maybe there are long dribbling stalactites of once-molten metal stretching down to the ground like a strange and skeletal metal sculpture. Maybe a hot over-ripe insect drifts lazily through the foreground, and maybe we can see a burrow giving the streetsign the look of a strange and skeletal metal sculpture. Maybe a hot mud with a couple of points of light inside it..none of this is essential, just do the b/g and fits. There should be some low foothills or mesas or something suggested in the b/g
BOX :"IT USED TO BE CALLED HOBOKEN, NEW JERSEY. THAT WAS BEFORE THE WAR. NOW IT'S
 CURSED EARTH, SECTOR FIFTEEN..."
BOX : "JUST ANOTHER STRETCH OF THE BADLANDS."

2.
Same shot, same angle. A dust cloud is being kicked up just behind a ridge in the b/g, so we can't see any Whatever's making it has not breached the top of the ridge, so we can't see any in the f/g a long bifurcated tongue whips out of the burrow and wraps around mutant insect, which thrashes in wriggly insect terror. GROWS HERE..."
BOX : "BADLANDS. NOTHING GOOD GETS BORN HERE, NOTHING GOOD GROWS HERE..."

3.
Up to you how this frame would look best. Either you could break the static opening frames by moving in closer on the dust cloud and the three Cursed (For it is they) as they come stumbling over the ridge, or you can drag suspense a little by keeping the picture almost exactly the same and sho.. contents in long-shot as they come up over the nearby ridge.. how the kicking legs of the doomed insect vanish.. SLABJACK and MR. EIST, and I'll

because we've already got John Wagner, who does brilliant 'Judge Dredd' scripts, and we don't need any others." Which I should have realized. But he did say, however, there's stuff that I like about your storytelling, why don't you write some short "Future Shock"-type things?" So I did. I think I had another one rejected because it wasn't very good. Well, I sent in some synopses for ideas, and there was one of them that Alan said sounded like a goer, so I wrote that up. And he suggested one change to it. I made that change. He accepted it. The "Future Shock"s were a bit few and far between to start with, it was just when they needed one. At the same time, Paul Neary was offering me little back-up strips of *Doctor Who*. I was still keeping up doing the drawing, but I was able to augment the money by doing more and more regular writing work. So the situation began to improve. It would be a few years until I would actually feel confident enough to drop the *Sounds* work, and it would be a couple more years before I would eventually drop "Maxwell the Magic Cat," because, truth be told, it didn't take a lot of energy to do. I quite enjoyed it. It wasn't the money then, but I quite enjoyed the discipline of a five-panel strip. So I was probably still doing "Maxwell the Magic Cat" even when I started work at DC, but more out of nostalgia's sake than anything. It wasn't a vital part of my income, but it was something that I had fun with, and something that I could do very quickly at a local level. I could respond very quickly to anything that was on the news. If Chernobyl erupted, I could immediately do a lot of little strips about a talking nuclear death cloud and it could be in print two days later. That was fun. They overlapped—my period of doing artwork and the beginnings of my writing career—they overlapped for a few years. When I stopped doing the comic strips, I still

Page from "The Collector: Profits of Doom," this photo strip was printed in *Eagle* #12. Photography by Gabor Scott. ©2003 Rebellion A/S.

liked to keep my hand in with drawing. For a few years I was doing posters. I did a lot of posters for the local Green Party when they were putting on rock gigs to raise funds. I did a run of posters for them, various posters for bands and things like that around town just because it was fun and it's nice to do things for your own immediate community. But that was pretty much what the drawing was down to. By then I was very much focused upon the writing.

There was something you told Neil Gaiman that sounded kind of funny, it was something about the Phantom of the Mezzanine?

The Phantom of the Mezzanine? Ohhh... I talked about that with... that was at the Grand Hotel.

That was when you worked there?

Yeah, when I worked there. I think his name was Bob. He was this elderly Glaswegian. He was very short, and he'd got the most impenetrable.... I mean, I know people from Glasgow, and I never had any trouble knowing what they were saying. It's a thick accent, but it's certainly lucid. But this guy, it was incomprehensible. Nobody could understand a word of what he was saying. I knew it was the Scottish accent, but the words and the phrases were completely lost. And he was the general kind of clean-up man around the hotel, and he would

A sample image and script page from "Badlander"—which Moore wrote and Mike Collins illustrated—that was never published. ©2003 Alan Moore and Mike Collins. Badlander ©2003 Rebellion A/S.

...the sun. A beautiful character from "Halo Jones." Art by Ian Gibson. ©2003 Rebellion A/S.

...ing out in the mezzanine, a little half-floor between ...re we kept all the trash enclosures, the dustbins, and ...ere wasn't any lighting, as I remember. So there would ...mumbling little shape, shuffling around between the ...ns. When you'd take a fresh bin to put in the enclosure. ...you'd be into working in the Grand Hotel and suddenly ...e was someone rapping at the glass doors, and you'd turn ...ound and he'd be on the other side of the glass door, gestic-...ating at you obscenely and shouting something that sounded very heartfelt but which was completely indecipherable, and then he'd run away. And I started calling him the Phantom of the Mezzanine just because I wasn't even sure that the people who ran the hotel knew that he worked there. For all I knew, he could have walked in from the streets and was just in the crawlspaces of the hotel.

Was it your inspiration for the Glyph character you had in "Halo Jones"?

No, that was.... Because people noticed Bob. You couldn't really help but notice him. In "Halo Jones," that was more of a general emotional observation of certain people that I noticed. There were some people who weren't even low-key personalities, they were almost invisible. They obviously were very shy or retir-ing. They lacked confidence, they lacked this, and they lacked that. For whatever reasons, they never said anything. If they were in a group, nobody ever really said anything about them. It was like they were fading into the wallpaper. And I just decided to take that a few steps further, to create the Glyph. And I remember we got some heartbreaking letters at *2000 A.D.* after we published that first story with the Glyph in it. That was from people living in bed-sits, actually written to the character saying, "I know what it's like, I'm like you."

That was my favorite character in "Halo Jones."

It touched a nerve. It did touch a nerve. I mean, maybe everybody's felt like that at some time. Some

of the letters were painful to read, that you can't put them away because you didn't want to think of your readers as hurting. I didn't want to think of anybody out there hurting and alone and I didn't know whether actually doing that character helped or made the pain sharper or what. But it did feel good to know that I had connected in some meaningful, emotional way. That I'd said something that stated some kind of emotional truth that people recognized. And I think I've always tried to seek out those kinds of areas. The ones that perhaps *are* a bit

For *Scream* #1 Moore and the artist known only as Heinzl gave us the horrific "Monster" tale. There never was a sequel in this case. ©2003 Rebellion A/S.

painful, difficult, but perhaps are the most human moments. They are the moments, the times, when we are our most human. And I gravitate towards that sort of strip because humans knock me out. I'm astounded by them.

There's something you always say, that you never write beneath people. Even when you're writing one of those *2000 A.D.* stories, you always try to do your best. You never underestimate that somebody's not going to get something you write.

I remember that *I* was always pretty smart when I was a ten-year-old kid, when I was younger. So it's only courteous to assume that all of us are pretty smart—all of us. If you assume that people are idiots, you create idiots. This is most television programming. They assume that most people are

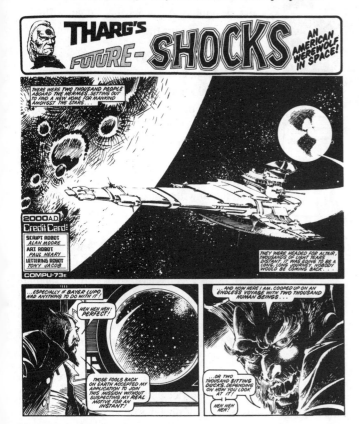

Moore and artist Paul Neary delivered the sci-fi/horror tale, "An American Werewolf in Space!" for *2000 A.D.* #252. ©2003 Rebellion A/S.

subnormal. They give them subnormal television programs and pretty soon that's the normal audience. So I've always tried to... I've always believed that if you could write something intelligent in plain language, then that will raise people's consciousness. You can give them an idea that they may not have already had, if you write in a form that they can understand and comprehend and accept. Then you may be, instead of producing a generation of morons as your audience, you might be able to wake people up a little bit, raise their expectations, get them to demand more intelligent fare. Get them to actually realize that they have a right to intelligent material. Which I think would be good for everybody, if that were the case, if people *were* a little bit more demanding. If they *didn't*

just reward the same formulaic pap over and over [...] their attention. I think I've always tried to treat the [...] as being at least as intelligent as I was. I mean, I ha[...] interested in the story myself. I'm a very intelligent p[...] the story is not intelligent, it's not going to interest m[...] doesn't interest me, I'm not going to be able to write i[...] I've always tried to write about things that do very mu[...] interest me. Hopefully that does communicate to the re[...]

You never write for the sake of writing, for meeting a deadli[...] something?

No, no... a deadline will prompt me to sit down at the [...] Like, for example, Jim Williams needs the script for *Prome[...]* #23, or at least the beginning of it, by Monday. This is the [...] part of the Kabala story. It's the one that actually will need [...] some quite heavy-duty imagining. Maybe some magic ritual, [...] I'm not sure yet. This is going to happen over the next coupl[...] of days. And, yes, it's because Jim wants it on Monday, but [...] I'm having to apply myself to it over the weekend.

So you were saying that you needed to make this for Jim because he needs pages?

He needs pages, and that's the criteria that I work upon. If an artist needs pages, then I'll get them to him. So, yeah, I am writing this *Promethea* this weekend because there's a deadline, but I'm not writing it *for* the deadline. I might only get two pages written that I'm happy enough with to send to Jim. I might get half of the book written. But that is not dependent upon the deadline, that is dependent upon how well I think it's coming out. So, yeah, I do work to deadlines, but the deadlines don't affect the quality of the work. I'd like to have had another couple of weeks to prepare for this final thing, but that's not how it works, and I've got to have the stuff done when Jim's got the previous issue finished. So it will be

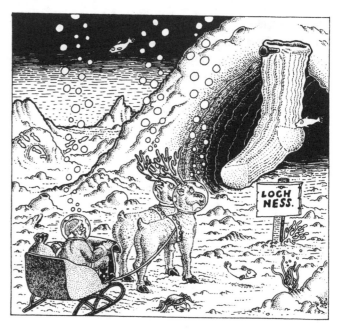

In 1979 Alan wrote and illustrated a two-page Christmas strip that was his first assignment for Marvel UK. ©2003 Alan Moore & Marvel UK.

Before *Watchmen*, Moore and Gibbons worked on several *2000 A.D.* stories, among them this domestic "Future Shock" entitled "Return of the Thing!" ©2003 Rebellion A/S.

it also was the first toe in the door of mainstream British comics publishing.

But did it hurt you when the editor didn't call you back for more work?

Oh, no! It didn't hurt. It was a one-off thing anyway. And at that time, I was trying to sell myself as a humorous cartoonist, and I knew that there wasn't that much work for humorous cartoonists at Marvel Comics. So, no, it didn't spoil me and it didn't hurt me. Not that I've had to suffer a lot of rejection, but it didn't bother me at all if anything was rejected or if people didn't ask me for more work. I was just grateful for any work that I'd get without looking around for the next likely opportunity.

When you were at *2000 A.D.*, you never got to write... Judge Dredd was the flagship character, but they had you write the "Twisted Tales"....

The "Future Shock" things. But I understood that perfectly. There was no reason why they would ever want me to write "Judge Dredd." Basically, John Wagner had done a tremendous job on "Judge Dredd." They didn't need me to write "Judge Dredd." It was John's character, as far as I was concerned, so I didn't have a big desire to write "Judge Dredd." I was quite happy. The "Future Shock"s were great, and I still say that they are the best way to learn to be a comic writer: short, twist-ending stories. Or just short stories.

What did you read as an influence when you were writing the *2000 A.D.* stories? Did you go back to reading the old EC comics?

Well, EC Comics were obviously a good model. I read a lot of short science-fiction stories and things. I always had done. Short stories are one of my favorite forms of literature, so I knew how short stories were constructed. Then it was just a matter of applying that sensibility to comics.

But for the most part they were all morality plays, right?

Not really. Doing the "Future Shock"s, I started to learn that there are different sorts of stories. I started to learn a few formulas. I even came up with a few formulas. Sometimes there'd be stories that were generated by a single storytelling gimmick idea. Like, I did something called, "The English/Phlondrutian Phrasebook," which was done in the form of a phrasebook. And the form of the phrases gave you a very clear idea of what sort of nightmarish holiday you might have on this alien planet. And there were stories where I might do them in the form of an advertisement for a particular sort of job. And there were some stories where they revolved around a single joke or pun. These would be very short. Little throwaway,

done. It will be done.

I think you told Neil [Gaiman] as advice that you should always have unreachable dreams. Do you still agree with that?

Yeah. I think it's always a good idea. You should always have some ultimate goal that is absolutely impossible to fulfill, otherwise you might find that you've fulfilled most of your goals and end up a bit directionless. So, yeah, I've still got plenty of goals, plenty of things that I haven't done, that I probably never will get do, but the striving is three-quarters of the fun, literally.

***Frantic* was the first time you had something published by one of the major comic houses in England, right?**

I guess so.

Was that a big deal at the time for you?

Not a huge deal, but it was... I was thinking this is a one-off for British Marvel. That's not that important in itself, it's not going to bring me a large amount of money, but it does mean that I can say, "Yes, I've worked for *New Musical Express*, *Sounds*, British Marvel comics." It sounded better in a CV. And

two-page things. There would be some stories where... I'd generated the character Abelard Snazz, a character who—someone has written something about my work and said Abelard Snazz is the first of my too-clever-for-their-own-good characters, and that's probably true. And having come up with this character that was engagingly funny, I was able to do an Abelard Snazz story from time to time, when I thought of a new one that would suit the character. So there are different ways of generating stories, and different types of stories. Some stories would be what I called "list stories," where you'd think of one central concept, and then list a lot of interesting, funny, or otherwise engaging secondary concepts. An example of that, there was one story that I did called "A Place in the Sun." The basic central idea was the idea that there were areas on the surface of the sun, electromagnetic fluke areas that were actually cool enough to live on. So you've got this holiday resort on the sun. That was the central idea. Then I just made a list of other associated ideas. If you lived on the sun all the time, maybe it would be fashionable to not be suntanned. So you'd have "pallor parlors" where people would go to lose their suntan. I thought about, you wouldn't be able to watch the sun set on the sun. From the sun, you'd have to watch the Earth set, which would probably happen only once a year. Not particularly strong, brilliant ideas, but if you've got enough of

them, and they're all kind of vaguely entertaining or tickle the mind in some way, then you can string them together into a story that will keep people entertained and engaged for four or five pages. At the end of those four or five pages, there would be a couple of little concepts, which would have tickled them. Sometimes I'd try stories that had got a different kind of emotional power. Ones that were perhaps a bit sadder or grim or bleaker. Sometimes a story would practically write itself. Probably still one of the best stories that I've ever done was "The Reversible Man," which was a strip that I did in *2000 A.D.*, which was a little "Future Shock" or "Time Twister." The basic idea was what if time was running backwards, or what if our perception of time suddenly reversed? What if we lived backwards? The world would still make as much sense, but it would be running backwards. So we started off with a man, the first thing he remembers is becoming aware that he's laying face-down on the pavement with his nose in an ice cream cone, and he's got this pain in his chest and his legs. And then he's suddenly transporting upwards, back to his feet, with the pain getting stronger in his chest and his legs, and the people around him are starting to back away. And then he's standing upright and he realizes that this ice cream cone that had been broken is now whole again and in his hand. The pain is fading away, so he starts to walk backwards, and all the people around him are walking backwards away from him. We've got faces growing less concerned. And he's spilling cold milk from his tongue into the ice cream cone, which is getting very full. So he takes it over to an ice cream man and gives it to the man behind the counter, who gives him some money in exchange for it. And then he carries on backwards along the street until he backs into the home that he finds he shares with his wife, who's a person a lot like himself, and his two sons. And you saw him go backward through the course of his entire life. Through un-having the babies, un-marrying his wife, un-meeting his wife. Eventually he goes back to school to unlearn everything, and finally as a toddler that has to get pushed everywhere, he's taken to the hospital with his mother and is, we assume by the last panel,

"They Sweep the Spaceways" (*2000 A.D.* #219), the first pairing of Alan Moore and artist Garry Leach.
©2003 Rebellion A/S.

Classic *2000 A.D.*—"The Reversible Man" (*2000 A.D.* #308). Art by Mike White.
©2003 Rebellion A/S.

Page from "Final Solution" (*2000 A.D.* #189), with art by Steve Dillon. ©2003 Rebellion A/S.

pick their papers up, notice each other. And apologize, laugh and carry on walking from the station together, chatting. And this is the beginning of their relationship. So when you play that backwards, him and his wife have already gone through a marriage ceremony, after which they've had to go and live separately with their respective parents. But they still see each other most evenings. And it's one evening when they're on their way to work, they're walking backwards up the hill to the train station on their way to work, talking really excitedly. And then they get to the station, and all of a sudden, they both very gravely start to spread out the pages of their newspapers on the platform floor. And while they're doing this, he looks at her. And he suddenly thinks that she's the most beautiful woman that he's ever seen. And then they stand up, and they kind of bump together weirdly. And then all of the pages flutter upward from the floor of the platform and reassemble themselves into newspapers in their hands. And then they back away from each other, not looking at each other, and they never see each other again. It's quite affecting, quite choking. Just an ordinary little scene of two people meeting, their first meeting. But reversed, it becomes their final departure. And those are just stories that you happen across by chance. You do something to see what will happen, and the results surprise you. Doing

unborn. It's ever so simple. Once you have the basic idea, you just take someone's ordinary life and just play it backwards. But the emotional effect of that story, that was great! That was one of the ones where I was told that all of the secretaries who used to work at IPC—and they would read *2000 A.D.* during their lunch hour—the day that came out, it had all the secretaries weeping. There was just something moving about it. The ordinary events of a human life, which are so familiar to us that we don't think about how emotionally charged they are, but when you run them backwards, it will look totally different.

It looked surreal to folks?

Yeah, it makes you see it in a new light. These kind of little moments. In normal forwards perception of time, for the main character, there's an incident where he obviously meets the women who's to be his wife. They're both commuting home one evening, they don't know each other, but they bump into each other, literally, while they're both walking along, reading their evening papers. They bumped into each other, dropped their papers on the floor, and while they're bending down to

the "Future Shock"s for *2000 A.D.*, like I say, it was a great playground for experimenting, trying things out. Different sorts of stories, different sorts of characters, different sorts of formats or concepts. I really think that the comic industry in America is the poorer for its apparent contempt for the anthology comic. I mean, you hear this—I don't know, a lot of fan opinion pieces—"Well, I don't like anthology comics, anthology comics are rubbish. You can't get into anthology comics." Every great comic book that I can think of offhand was an anthology, or came out of an anthology. I mean, Spider-Man started out in an anthology comic. Superman started out in an anthology comic. Batman started out in an anthology comic. EC Comics were anthology comics. The underground comics were anthology comics. The very first newspaper reprint comics were anthology comics. And also, back during the '60s, '70s, at DC, you had *House of Mystery*, *House of Secrets*, and the war books. Anthology books, where you could test out new writers. Most of the writers of that generation at DC, they came in through the anthology books.

People like Len Wein, Marv Wolfman. Most of the writers, they would be given crappy little assignments on *House of Mystery* or *Our Army at War* or something like that, and they'd have to learn their craft writing these little five- or six-page stories. They'd probably much rather have been doing three-issue continued series runs of *Batman* or something like that, but they were just coming in the door, and they were given these little, fairly inconsequential stories, the same as I was given at *2000*

Before the film *A.I.*, Alan Moore and artist Redondo presented Timmy, the boy robot, within the story "One Christmas During Eternity!" (*2000 A.D. #271*). ©2003 Rebellion A/S.

A.D. And I think that if you can learn how to write a five-page story, and if you can learn how to write a lot of different five-page stories until you've really got the hang of the five- or six-page story, then whatever you're asked to do in your later career, whether it's a 24-page book or a 12-issue series or a 600-page graphic novel, you'll have the basic craft and the basic notions of structure already in place. It's the best way to learn. Start with small little stories, but you have to create *all* of your characters, you have to create their entire world, you have to set the story up and bring it to a conclusion, all in six pages. You have to do all of the things that you're going to have to do in a graphic novel, but in much less space. And that forces you to make some tough decisions. It forces you to learn economy. It forces you to learn when you're padding something. It tells you how to pace a story. Do you want to pace it so that a lot happens in a very few pages, in which case, tell it mostly with captions? Or do you want people to be more involved in it, so that perhaps very little happens in the course of the same number of pages, but they feel more immersed in it, in which case you *don't* use captions. You start to learn little things like that. And that will be an immense help in any subsequent career that you have.

There was a story that you said—I think you might have taken it from somebody else, "The Return of the Two-Storey Brain." Was that subliminal?

Yeah, that was a story that was one of the chapters of Abelard Snazz, that when I wrote it, I thought, "Yeah, let's

have him go to this gambling casino where there's people messing around with probabilities and odds." And I wrote this story where he cheats and wins using some probability-skewing device, and then has all of his winnings taken from him by a cloak room attendant, who's using the same sort of thing. And when I finished it, I kind of delightedly... I think I was rereading an anthology of R.A. Lafferty stories and suddenly realized to my horror that I had swiped the entire idea. I mean I've got a very good memory. And I retain no end of stuff. Almost every story I've ever read or written is somewhere in the soup back in my head. That's the only example that I can think of immediately, there might be others, but just occasionally you'll come up with an idea and you'll think, "That's brilliant! That's a great idea! It must be mine!" And you don't recognize it as, "Now, wait a minute, that's a story that I've read by somebody else." Once I'd realized that, I had to make a full public confession and never have had the story reprinted, because the original R.A. Lafferty story was much better. That was an error. When you're having to write to deadlines and turn out a lot of stories, you have to think fast. And maybe if I'd have had a couple more days, I'd have remembered the R.A. Lafferty story. But, no. I've got to do it quick, the idea came to me, I banged it out, and it was published. And then, only some weeks later, did I suddenly realize what was naggingly familiar about this story. But, yeah, these things happen. It's only if they happen a lot that you have to worry. If you find something like that happening, then for f*ck's sake, point it out before everybody else does. 'Fess up to it.

For example, we had a Booker Prize-winner over here, doing a book... I think it was called *How Lare It Was, How Lare.* And he won the Booker Prize for this account of someone's ashes being taken to their final resting place. And

Character sketch by Bryan Talbot for the proposed "Nightjar" series. This Moore-scripted story never made it to the pages of *Warrior*, the publication it was intended for. ©2003 Bryan Talbot and Alan Moore.

somebody, after he'd won the Booker Prize, pointed out that this was actually William Faulkner's *As I Lay Dying*, right down to the structure of individual chapters. At which point the author then said, "Well, of course! Faulkner was an influence. It was an homage to Faulkner." Now, as soon as I'd realized what I'd done, I made a full confession and apologized and said that I didn't want the story reprinted in any anthologies, because it wasn't mine. These things happen. But once it happens once or twice or whatever, you have to become a lot stricter on yourself. You have to be a bit more rigorous in checking your ideas, just to make sure you haven't been influenced or something.

Was it at *2000 A.D.* that you became friends with Dave Gibbons?

I think I'd already met Dave at some of the Westminster comic marketplaces that they had every two or three months. I met Dave through Steve Moore. I met Dave and Kevin O'Neill, Brian Bolland, a couple of the others. And these were people I didn't think I'd ever get to work with, because they were established stars at *2000 A.D.* And then I went one week and saw Dave and he told me that he'd just been given one of my scripts for "Future Shock" to do the art for. It was some silly thing about a computer dating service in the future and some guy ends up... the computer falls in love with him and ends up stalking him. It wasn't much of a story, but Dave did a brilliant job on it. And I think that in later months, years, when there was a chance for me and Dave to do a quick "Future Shock" together, we'd take it. There was a chance to do a "Time Twister" with Dave, and since I knew it was going to be with Dave, that's when I did "Chrono-Cops," which was another one of the best of the "Future Shock"s that I've done. And because I knew it was with Dave, I could talk to Dave about what I planned to do and I could pitch the level of humor where I knew Dave would appreciate it or Dave would have fun with it. And that was the best thing that we'd done together up until that point. And when we both ended up at DC that was probably one of the things that led to... we knew we worked well together. And we both came to the idea of working on a big, four-color DC book together.

When you worked for *2000 A.D.*, was that one of the places where you had to take the script there literally, or did you just send it in the mail or something?

I sent it in the mail. You'd go down and just sort of meet the people at *2000 A.D.*, get together for a drink with them every few months, or you could check up on stuff or talk about your new projects that were in the planning stages.

But for a long while, all you wrote were those short stories.

Yeah. But that was what I would expect. I was getting more and more work doing the short stories, and what I was hoping was that I'd get offered a series. And I forget exactly how it broke down, whether "Skizz" was the first series I was offered—

Yeah, "Skizz" was '82 already.

Was that before *Warrior*?

I think it's all at the same time. I think '82 and '83 is when you really started to do a lot of stuff.

Warrior #12 back cover ad, listing Quality Badges you could purchase—most featuring Moore characters.
©2003 Respective holder.

It all started to happen at the same time. Once somebody offered me a series—

It's almost like, when you did *Warrior*, it seemed like you had more work than you could handle!

Well, yeah. I think it kind of worked that whoever it was who gave me the first was... perhaps it was "Skizz"?

I'm almost positive it's *Warrior*.

Well, in that case, say it was *Warrior*. And say they said, "Okay, you can write these scripts." I started to write the scripts in *Warrior*. Once *2000 A.D.* and Marvel knew I was being given series work by somebody else, they became more inclined to give me series work as well.

Looking at my copies, "Skizz" stories came out around the same month that "Marvelman" came out.

It might have been... I can't remember which came first. It might have been "Skizz" that I was actually asked to do first. I started working upon that around the same time that Dez Skinn was putting *Warrior* together. Maybe that's because

he knew that I was doing a series for *2000 A.D.,* and that made him more inclined to trust me to do a series for *Warrior.* Don't know.

Did that excite you, having all this work come in?

Well, I didn't know where it was all going to go. I mean, for all I knew, it might have all exploded messily, it might never have gotten to print. There were projects that you tried to work on that would not end up going anywhere.

You pretty much went from being a writer who would occasionally get calls, to being a writer that everyone wanted to work with in the UK comic scene.

I was starting to realize that I was in demand. And that, to some degree, I could pick and choose. By no means was I in an infallible position, but my position was getting better. It meant that if I do good jobs on "Captain Britain," on the *Warrior* strips, on the stuff I was doing for *2000 A.D.*—if I could do good jobs on them, I would probably be in an even better position. I didn't at that time think that if I do good jobs on these, I would get noticed in America, because I wasn't even thinking about America. Brian Bolland, who was an artist, was getting work in America.

But for a writer, it's like, all of a sudden you feel needed. That's sort of what you wanted.

Yeah, I wasn't thinking about America at all. I was thinking, "This is great, I'm doing what I've always wanted to do. I'm doing a regular series for British comics. In fact, I'm doing four regular series for British comics." I could handle the workload, it wasn't too demanding. I think at that point I was still drawing the strip for *Sounds.* That was probably when I started to... yes, I know that I was drawing the strip for *Sounds,* because I know that we did at least one "Pressbutton" Christmas strip where I've got Laser Eraser, who was from the "Pressbutton" strip in *Warrior.* So, yeah, I was still doing "The Stars My Degradation" for *Sounds,* I'd still been doing "Maxwell the Magic Cat," and I was writing all these things as well. So, yeah, all of a sudden there was more money, more creative opportunities.

You now had acceptance. That must have felt good.

Well, by that time I was starting to feel a lot more confident. I was starting to know how good I was or could be. So the fact that the audience actually liked these things, yes, it *was* a confirmation, but it was a confirmation of something that I already felt. I became more confident of my own ability to judge a story. Other people's opinions became perhaps less important. Now, that may sound arrogant, but that would be how I felt about

a story at the end of the day, as if my own opinion were the only thing that mattered. This is why it's never going to matter how many people tell me that their favorite work of mine is *The Killing Joke,* or whatever. It is about my least favorite work. Nothing to do with Brian's artwork, which is wonderful. It's a joy to look at. But I don't feel that I did a very good story. And, ultimately, it's my opinion of the work that is the only one that's really important to me. So, yes, it felt like a validation. I'd always believed that I had the imagination and ability to do that kind of work, and now I was getting a chance to prove it. That felt good. It felt that I was validating myself, to a certain extent.

Actually, another good question. I was looking through all the interviews you've done for *Wizard,* and they always ask you the same question. Do you know what that is?

Which one? They ask me a lot of silly questions.

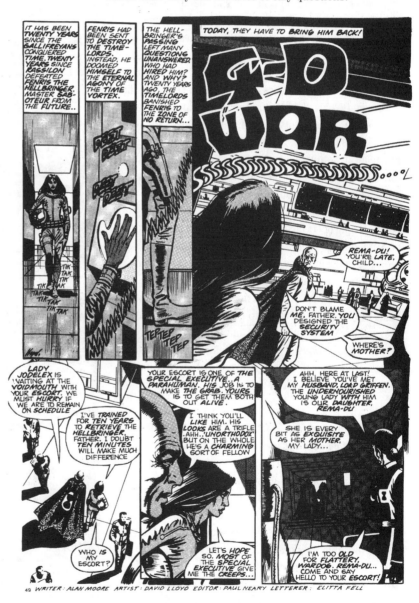

Before "V for Vendetta," Moore and David Lloyd collaborated on many Doctor Who back-up strips, including this one from *Doctor Who Monthly* #51.
Special Executive ©2003 Marvel Characters, Inc. Doctor Who ©Respective holder.

"When are you coming back to *Watchmen*?" [laughs]

Oh, yeah, they always ask me that, yeah, yeah.

Watchmen, and when are you going to work for Marvel? Do you ever get tired of that?

Well, yes. Obviously. [laughter] But I'm English and I'm very polite, so I try not to show when I'm bored and certainly try not to show that I think the interview is perhaps intellectually lacking if he hasn't been able to figure out the answer to these questions from my previous thirty interviews on the subject. I think sequels are a bad idea, generally. I have no intention of ever doing a sequel to *Watchmen*, and I think that if anybody gave that a moment's thought, they'd be able to see exactly why that is.

Sequels always take away from the originals, right?

Well, yeah, generally. They're also artificial. Generally, sequels are done for no other reason than to make money out of a concept or franchise that turned out to be unexpectedly popular. There are no other stories to be written about the Watchmen universe, there was just that one story. Just like Charles Dickens never had to write *A Tale of Three Cities*. I suppose Shakespeare did do *Henry IV, part II*, but what the hell, he probably needed the money. But generally sequels are a dumb idea. The only possible motivation behind them is financial, from my point of view. I'm not saying that other people might not have perfectly valid motives for doing sequels of a popular work that don't involve money. But if I were to do a sequel to *Watchmen*, it would be purely cynically. It would be purely to try and part my faithful readership from as much of their money as possible. It would be kind of cashing in any bond of trust that there was between me and my readers. And, anyway, it's not my job to give the readers what they want. It's my job to give the readers what they need. So they might want me to go to Marvel and work on *Fantastic Four*, or they might want me to do *Watchmen II*. But those are really stupid ideas. I mean, the readership will just have to trust me. That is not what they need.

Alan, is it true that Alan Grant once told you to cut down your scripts by 50% because there was too much?

Not specifically that I can remember. He might have said, "try and put a few less balloons in" or something or had criticisms about one way or another that a specific early story... I think I sent two or three stories in and got progressively more favorable feedback from Alan as a result. And he accepted it. I've certainly got no memory of being asked to rewrite a story because I'd made it twice as long as it should have been. I'm very professional and I've always known that if a story is four pages long, then that is

about 24 panels tops. There are a certain number of balloons that can be fitted into those panels at a maximum. I had comic companies who printed stories with the last page missing because they'd lost a page of the script. There are a lot of editors who only printed half of the story, but that's just because they've lost the last few pages of the script and haven't really read the story enough to figure out that it ends oddly halfway through. So I've never had anybody.... And I'm not talking about Alan Grant, who's a responsive professional for that. But I've never had Alan Grant or anybody else trim my stories down by half because I had written twice as much as was necessary.

When you started working in comics, you did some licensed comics. What were your feelings toward that, was that something you wanted to do? You did some *Star Wars*.

Star Wars and things like that... *Doctor Who*?

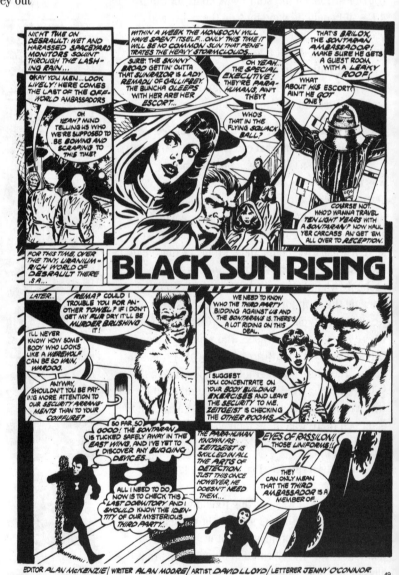

From *Doctor Who Monthly* #57 are characters like Wardog and other members of the Special Executive who would play a bigger role in Moore's "Captain Britain" work. Artwork by David Lloyd.

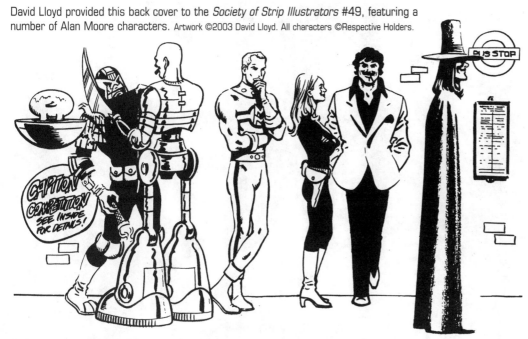

Yeah, and some *Doctor Who*.

Well, no. I was just happy to get any work that I could. Personally, I have no interest in *Star Wars*; I have no interest in *Doctor Who*. Nothing against those who have, but I thought *Star Wars* was an utterly dreary film. And I'm not even considering the fact that I remember watching the first one when it came out, and I'd eaten a huge lump of hash in the hopes of making it more exciting. But I can't remember anything except that shooting through space or whatever it was, lots of lasers going up. The plot was far too complicated for me to follow, I'm afraid. I wasn't that impressed and didn't see any of the subsequent follow-ups. Licensed characters, with the possible exception of *Twin Peaks*, which I might be interested in, there's no licensed characters that I have any great attachment to. Even if they were characters that I might have liked, say, on television or whenever they first appeared. Like, say, *The Prisoner*. A wonderful series. But I don't think doing a comic, and certainly not *me* doing a comic about it, would add to it in any way. It was pretty much perfect as it was. So, no, I've got no interest in licensed characters. I was writing them, I was trying to have as much fun as I could with characters that weren't very appealing to me, but that was my general strategy back in those days. Don't turn anything down. If it isn't something that's interesting to you, then try and do something clever with it that will *make* it interesting to you. So that was the theory behind me dallying with the *Star Wars* and *Doctor Who* characters back then.

When you worked on the back-up strips for *Doctor Who*, a lot of times you were uncredited. Why was that? And sometimes, they would just put "Moore," knowing that Steve Moore was writing the lead story.

Well, Marvel back then, British Marvel was never the most coherent or organized of comic companies. I don't think

there was any big, sinister conspiracy to leave my name off things; it was just that they sometimes forgot. It didn't bother me. I was getting paid for the stories. Yeah, I can see that it did probably get confusing, just putting "Moore" for a story, but it was more disorganization on Marvel's part than anything else. There were sometimes some very sloppy moves back then. I can remember that I had one letterer, who had I think taken over the strip from someone else. And his first name started with the same letter as her first name, so he had managed to save the time that it would have taken him to write one letter by only lettering a patch to fit over the last part of her name. That's just how it was at Marvel. I know some great people at Marvel. Bernie Jaye was terrific, and so were various others, but there was also kind of an endearing sloppiness about the operation, so that was probably why some of that early *Doctor Who* stuff didn't get credited or that *Star Wars* stories that got printed with the last couple of pages missing, which I just referred to. The Darth Vader one, "Dark Lord's Conscience" or something. I forget what it was called. That was about a chess game. There was no last page, so there was no payoff to the story, it just ends halfway through a panel. So, yeah, Marvel... not the most professional of outfits, at least the British version, back then. There was something quite endearingly charming about it, and sometimes that kind of amateur enthusiasm would produce some really good comics. But, yeah, there were a lot of mistakes that got made back then as well.

When you worked with David Lloyd the first time (in *Doctor Who*), was it that he told you that he wanted you to drop the use of captions and thought balloons?

No no no, I think that....

That was starting with "V"?

That started with "V." *Doctor Who* was when I first was assigned Dave Lloyd as an artist, which I was very excited about. Dave's polish was certainly not of a nature that would put him in the same easy-to-like league as what you might call the first division of British artists. You know, Dave Gibbons, Brian Bolland, Mick McMahon, and so on. But Dave's storytelling has got such strength... and also, I remembered his name. I remembered his name from a horror fanzine called *Shadow*, which was published in the late '60s, early '70s, and

David Lloyd's cover to the Warner Book's *V For Vendetta* trade paperback. V For Vendetta ©2003 DC Comics.

A musical collaboration between Alan and David Jay gave us the "V for Vendetta"-inspired track, "This Vicious Cabaret."

©2003 DC Comics.

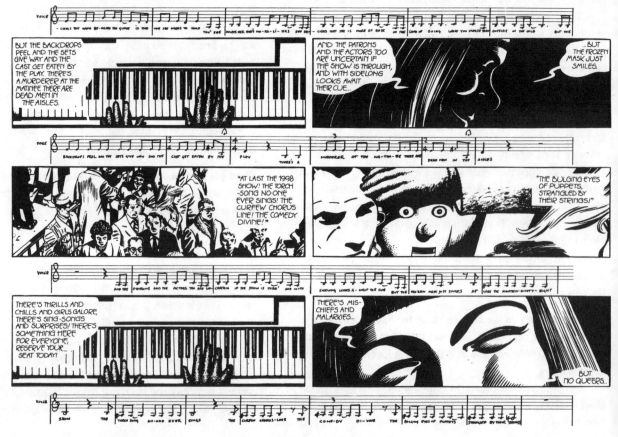

which I contributed some poems and illustrations, some short stories, too. And I remembered that there was a young fan artist—well, young as far as I knew—called David Lloyd, who had submitted a couple of illustrations at the same time that I was working for them. And I phoned up Dave and asked if he was the same person, and indeed he was. And we hit it off. I think that we both enjoyed talking about the craft of comics, and even on those first two or three *Doctor Who* stories, we were trying to do as good a job as we could within the limited space available. And when we got the chance to take it a bit further, into "V," yeah, it was then that Dave started coming up with all of these formal ideas, like leaving out captions, leaving out thought balloons, leaving out sound effects. Which I thought was challenging, if not impossible at first, but which

HE MADE A DEAL, TOO.

Radiant panel by David Lloyd. ©2003 DC Comics.

I soon came to see the wisdom of, and pretty rapidly adapted/absorbed into my regular style. Probably the aesthetic quality of the story-telling in "V" was probably taken a step further in *From Hell*. In *From Hell*, we got rid of even the third-person thought captions. It was stricter than "V," and consequently took a lot longer to tell the story, because there's none of that handy, economical use of captions available. But yes, I think I found in Dave somebody who had an experimental bent that was complementary to mine. And we kind of messed around and made some small experiments in those first few *Doctor Who* stories, but then, when we got the chance to do "V," we were able to push that to an extreme and try some peculiar experiments. Is it possible to do a story that has no dialogue other than incidental dialogue from two or three TV channels? You know, the various other sorts of stylistic experiments that we did in "V." Is it possible to do one episode as a song, with music? I think Dave used to like that kind of stylistic experimentation just as much as I did, and that was evident from the very first strips we did together.

Do you remember when you met Dez Skinn the first time? Did it have something to do with *Warrior*, when it started?

Probably. I think that the first time I met Dez Skinn was when he was a fanzine editor back in the late 1960s, early 1970s. And I remember him being the editor of two or three fanzines, *Comic Collector*, *Eureka*, a couple of those. And I think I'd seen him then, although I probably hadn't necessarily met him, as such. And at some point after that I was introduced to him briefly when I had done a couple of pages of Santa Claus jokes for *Frantic*, which was British Marvel's *Mad* knock-off. I did a couple of pages of lame, silent Santa Claus jokes for him. I think I met him during that period. And then, when he was putting *Warrior* together, he'd seen an interview that I'd written in the *SSI Journal* (that's the Society of Strip Illustrators). David Lloyd, who I think might have even been president or secretary of the SSI at that time had asked me if I wanted to contribute to this special writers issue he was doing and if I'd answer some questions in the form of a brief interview. And I'd done this, I'd mentioned in response to the last question, which was, "Is there any strip that you'd partic-ularly like to do," I'd mentioned my desire to revive the 1950s British character, Marvelman. Dez Skinn got in touch with me and said by a remarkable coincidence, he had been planning to revive Marvelman, and would I be interested in writing it? And yes, I was. And this would be in the company of people like Steve Moore and Steve Parkhouse, who were also working as writers on the magazine. And people like Garry Leach, David Lloyd, and Steve Dillon, who were people that I already knew and was friendly with. So, yeah, it sounded like a nice little project. As indeed, at least in its early stages, it turned out to be.

Right from the beginning, how did "V" become part of *Warrior*? If he hired you for "Marvelman," how did you start "V"? Or was that already in the works?

Well, he was trying this magazine that would pay its contributors very little but would give them editorial freedom over the things that they created. And ownership. Which sounded fair enough. So I think that his plan was—if I under-stand this correctly, I might be doing him a disservice—but I think Dez Skinn's main plan was to recreate, in some measure, the line-up of his previous (to his mind) great success, which was I think the British Marvel publication *Hulk* weekly, where he had had some homegrown strips, including the Celtic fantasy Captain Britain/Black Knight strip that Steve Parkhouse had written and drawn. He had Steve Moore doing a couple of strips, including, I think, "Nick Fury, Agent of SHIELD," by Steve Moore and Steve Dillon. And also he'd had Steve Moore and Steve Dillon doing "Absalom Dark"—that's Doctor Who. He had Steve Parkhouse and David Lloyd doing a 1930s pulp adventure strip called "Night Raven." And he had various other strips, which he wanted to recreate in *Warrior*. He wanted to try and recreate that line-up. He had "Marvelman" by me and Garry Leach as the lead mainstream super-hero strip. And he had "Pressbutton and Laser Eraser" by Steve Moore and Steve Dillon, which was a kind of substitute both for the "Nick Fury" strip and the "Absalom Dark" strip. He had me

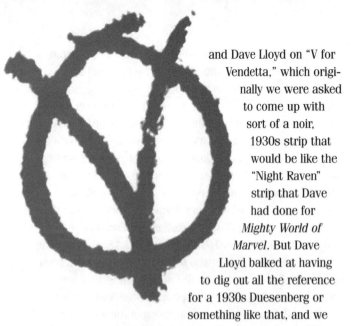

and Dave Lloyd on "V for Vendetta," which originally we were asked to come up with sort of a noir, 1930s strip that would be like the "Night Raven" strip that Dave had done for *Mighty World of Marvel*. But Dave Lloyd balked at having to dig out all the reference for a 1930s Duesenberg or something like that, and we decided that we could get 'round that by just setting it 10 or 15 years in the future rather than 20 years in the past. So that was it. We were all approached, we all said that we were interested, then we all began writing our individual strips.

If you were such an unproven writer, like he says, how come he was willing to take a chance on more than one strip in *Warrior*?

Just out of the goodness of his heart, I suppose. It certainly wasn't to do with the fact that I was working cheap, or that I was already being offered series and things like that from the other companies. No, I suppose it was just his benign and patrician qualities that made him decide to take a chance upon this struggling, young hopeful.

But you yourself took a gamble, because I think when you started *Warrior*, you'd already started doing less work for *2000 A.D.*

I don't think I did less work for *2000 A.D.*....

You had stopped doing the short stories. You were focusing more on bigger things.

Yeah, I think I was probably doing *more* work for *2000 A.D.* by the time I started *Warrior*. And I was also doing "Captain Britain" within a couple of issues of starting *Warrior*, and also I was doing "Skizz" and still doing "Future Shock"s for *2000 A.D.* I was also doing a lot of the other incidental things in the *Daredevils*. I think that when I started working for *Warrior*, I was suddenly offered a lot more work by both *2000 A.D.* and Marvel, because they'd realized that this was popular and now I could obviously work for pretty much who I wanted. So they tried to offer me bigger and brighter and more tempting things each. So, yeah, I was working on quite a lot of stuff back then.

Sure.

If it worked, great. If it didn't work, then at least I had a lot of fun and would have been able to try out some things that I might not have gotten the chance to try elsewhere for a few years. I'd been able to learn a bit more about comic story-telling and its possibilities or been able to experiment. So the worst that could happen was that *Warrior* would die the death within a few issues, and I'd just carry on working—as I did do anyway—with Marvel UK and with *2000 A.D.* So, yeah, it did pay off in terms of the development of my work and the raising of my profile, but it wasn't really that much of a gamble. There wasn't anything that I was putting at risk with that.

What type of reaction did you get from the readers? Was "Marvelman" more popular than "V for Vendetta" initially?

I don't know. I think both "Marvelman" and "V for Vendetta" were very popular. It was kind of neck and neck, as I remember. I don't remember exactly what the overall reader response was like. I think all the strips were well liked. I don't know. I think that maybe the fact that "Marvelman" had the super-hero thing going for it might have given it an initial edge, but then it was such a strange super-hero comic that it was not really guaranteed to draw in the conventional super-hero fans. And with "V for Vendetta," it very quickly established a strong following. From what I can remember, people liked both of them more or less equally.

Everyone has a different take on "V." What exactly is it for you? Some people think it's adventure, romance, or politics. It touches so many genres, but what exactly were you trying to do when you were doing it?

Well, what I was trying to do, originally, was to follow my initial brief of doing a '30s noir mystery character, and then eventually we sort of, "Oh, let's not set it in the past, let's set it in the future. And let's play upon the British tolerance, at least in comics, for criminals as heroes." Which goes back to Robin Hood, Charlie Peace, and Dick Turpin. All of these British criminals that actually are treated as heroes. So I thought, well, we can maybe come up with this character that is one man—a terrorist, essentially—against a corrupt and evil old fascist state. And originally it was just thought of purely in terms of an adventure strip. As was *Watchmen*, later to a certain degree, just thought of as an unusual take upon the super-hero strip. So we wanted

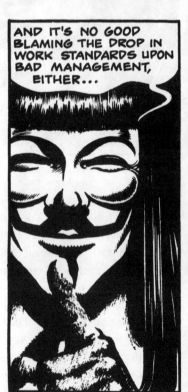

The fan-favorite V preaches to the British television viewing public. Art by David Lloyd. ©2003 Alan Moore and David Lloyd. V for Vendetta ©2003 DC Comics.

to do a shadowy adventure/thriller with the proven formula, one man battling the odds in a fascist future Britain. And once we'd gotten the look of the character and the style of the character, then different possibilities for things that we could do in the strip started to present themselves. I realized that we could bring up some quite interesting ambiguous moral issues, because, although the artwork was very black-and-white, with no shades of gray, I thought that one of the most interesting things about the strip itself was that morally there was nothing *but* gray. We were asking the reader to consider

V FOR VENDETTA

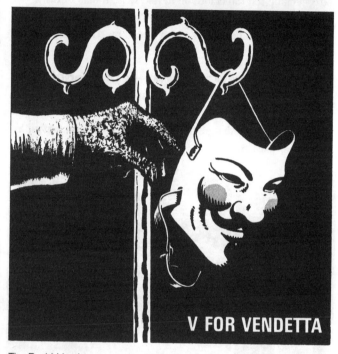

V FOR VENDETTA

The David Lloyd cover to the "V for Vendetta" single.
©2003 Alan Moore and David Lloyd. V for Vendetta ©2003 DC Comics.

some interesting questions. Is it all right for this character to kill people indiscriminately just because he is the hero? And that's something that the readers ultimately have to make up their own mind about. And we started to realize that the strip was turning out all of these possibilities for things that hadn't been there in the initial conception, but which we could then explore and exploit. We started to realize that it could include lots and lots of different elements. All the ones that you mentioned: it *could* be a love story, it *could* be a political drama, it *could* be, to some degree, a metaphysical tale. It could be all these things and still be a kind of pulp adventure, a kind of super-hero strip, a kind of science-fiction strip. And I think that we were just interested in letting it grow and seeing what it turned into without trying to trap it into any preconceived categories. And, as such, I think it grew into something that surprised and delighted both of us.

I remember in the introduction for *V for Vendetta*, you mention

that you were thinking about abandoning the U.K. to raise your children in the States. You normally stand by your convictions. That's one of them you didn't follow.

Well... I said I was thinking about it. If anyone is really interested in why I didn't follow that through, the main reason why I was saying that was because at the time I was writing that introduction, this was around about the same time, people remember, that I was also doing *AARGH!* And the reason I was doing *AARGH!* was because the British government had just brought in very tough anti-homosexual legislation. Now, at that time I was living with my wife Phyllis and our girl-friend, Debbie, and our kids, completely openly, in an unusual and experimental relationship. It seemed that both my immediate family and a lot of our friends were being menaced by the new political legislation that was coming in, and which the conservatives had been very, very serious about. Now, for that reason, it struck me that it might not be a bad idea to get my family out of the country in case something politically bad did happen. As it happened, some short time after writing that introduction for *V*, my family broke up. I separated from my wife and from Debbie and the children, with them going to live up north and me staying here in Northampton. Now, obviously, as it stood with just me on my own, there was suddenly no need. The only reason I'd been thinking about getting out of the country was because I felt that my family was threatened. Since I suddenly was, shall we say, unencumbered by family, there was really no reason, suddenly, to follow that through. It wasn't a matter of principle; it was a simple matter of practical things that were going on in my real life. So my thinking about getting out of the country when I wrote that introduction was very real at the time, and I meant it. My circumstances changed pretty soon thereafter, which would have made me leaving the country and leaving my family behind here kind of pointless, I would have thought.

But it bothered you at some point that you were living in a country with such issues?

Oh, yeah! And they still do. There are lots of things about England which I find abhorrent—about the way that it's formulated its laws, about the people who run it. On the other hand, it could be worse. I could be living in America. I have nothing but contempt for the political leaders and political structures of both of our countries, George.

How long did you last living alone, after your wife left?

Me and Melinda, although we're partners and we see each other two or three nights a week, we live separately. We live in the same town; we're perhaps 20 minutes apart from each other. We've both got our own space. Neither of us have to compromise on how we live or how we decorate our houses or anything like that. I prefer to live alone, to tell the truth. It was a bit unusual at first; it takes some getting used to.

You were married for quite a long time—

For 13 years.

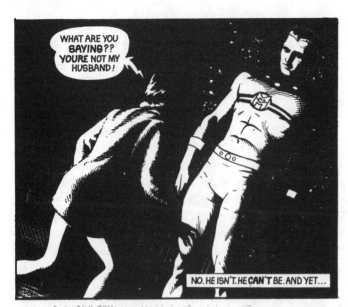

From *Warrior* #2, Liz Moran is still in shock by her husband's transformation. ©2003 Alan Moore and Garry Leach. Marvelman ©2003 Respective holder.

It must have been hard at first.

And before that, I lived with my parents. I moved out from living with my parents and my family and moved straight in with Phyllis when I was about 20, something like that. We got married, we had the children. Yeah, I was with her for about 13 years, something like that. It was a bit odd at first. You can feel lonely rather than alone. And there is a distinction. It's okay living alone. For a little while, you feel lonely. You miss having other people in the house. But actually, I found that I really do enjoy my own company. I really do enjoy the tomblike silence of my living quarters. It's lovely to see people. It's lovely when my friends come and visit, or I go and visit them, or when Melinda comes around. But by and large, as a writer, I think that solitude, silence, have a lot to recommend them.

When you were married, I guess, when you would write, you were always by yourself; you were basically alone, anyway.

Yeah. That's it. I know there are some people who can apparently write with a roomful of people and a radio on and a television or stuff like that. I can't imagine how they do it. I can't have any sound in the room while I'm working, I can't have anybody in the room with me. I mean, yeah, I can do mechanical things like typing when there are people around, because that doesn't really need any brains, or it doesn't need that part of the brain that can get distracted. When I used to draw, I found that I couldn't have anybody in the room or anybody with me if I was penciling. But inking, I find that I could have people around, I could talk to people, and I could have the radio on or the television on. Because with inking, it's like it wasn't your brain, it was your wrist. The inking—and this is no disrespect to the inkers, but there's a different sort of consciousness. Your hand is somehow doing the thinking. Your mind is free to wander into all sorts of areas. I know there is

more to inking than just following the lines, yes. But I'm convinced that it has a particular, different set of neurons that it uses, as opposed to penciling. And writing is more like penciling. At least the composing part of it is. Inking doesn't seem to require those parts of your brain, typing doesn't seem to require those parts of your brain. But the actual composing of images or words, that's something that always really needed silence. Even when I was a child, back down St. Andrew's road, my favorite time to draw or write was on Sunday afternoon when my mom, dad, and brother would be in the front room watching television, my gran would have gone to sleep in her armchair in the corner of the living room, and I could sit in a silent living room, alone at the table with the nice, cozy-looking red tablecloth on it, and write things or draw things or do whatever I wanted in more or less complete silence and solitude. So it's always been pretty much the way I have preferred to work.

What you were doing on "Marvelman"—was that everything you wanted to do when you were a kid? Was that every story you had to tell about a super-hero? Had you not done *Batman* and *Superman*, all that other stuff, would you have been content with your super-hero stuff?

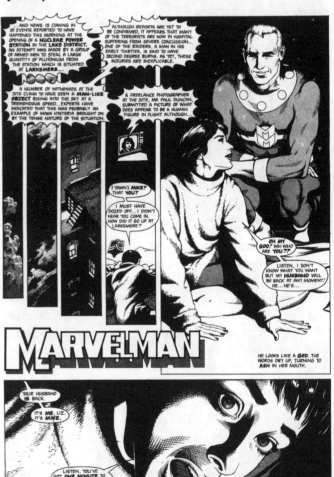

An alluring page by Garry Leach of Marvelman from *Warrior* #2. ©2003 Alan Moore and Garry Leach. Marvelman ©2003 Respective holder.

Oh, I don't know. "Marvelman" was... I suppose if I had been offered something else instead of "Marvelman," I'd have taken it just as willingly, and probably tried to do some things as interesting with it. But it was just that I did happen to have some vague ideas that had been floating around since I was quite young that related to a kind of new way that you could do "Marvelman." Almost like a Harvey Kurtzman-type comic, but done seriously and for dramatic effect rather than for comic effect. And I see how I could make that really poignant and sad and moving. So, yeah, I got a lot of the things that I wanted to do with super-heroes out of my system with "Marvelman," but of course doing "Marvelman" suggested a lot of other things and other directions in which super-heroes could be taken. So I probably wouldn't have been satisfied to call it a day after "Marvelman," because I'd had a few more ideas in the course of doing "Marvelman" about how you could do a story and do it like this, or you could do it like that, which would eventually lead to things like *Watchmen* and all the rest of it. "Marvelman" was pretty much the sum of my idea of a new way that you could do super-heroes at the time, but the idea kind of grew in the telling.

I think "Marvelman" is the only thing that allows readers to witness the progress that you made from the beginning towards the end. It's sort of a window, where people really see how it evolved over eight years, and see you evolve. It's an interesting work, because I think it's the only thing you've ever done that's taken that long. Do you see that when you read it?

I've not read the "Marvelman" story for a long time, because I haven't even got copies of all of it. I don't keep my books in very good order, as you probably remember. [laughs] I've got no idea where "Marvelman" is.

When you're working on the last issue, were you thinking, "When I started this, I was completely somewhere else, and now I'm here."

Well, yeah.

I mean, because it took such a long time, people can actually see your progression.

It took a long time. It was probably the longest that anything had taken me up unto that point. Of course, since then we've had *From Hell* (ten years), *Lost Girls* (13 years), but back then.... Yeah, I suppose I was very aware, especially when I was doing that last book, which stylistically was very different from the two that had come before it. And that's because I'd got John doing it, and because the storyline had moved on into different areas, different preoccupations. I was very conscious of the fact that, yeah, I was a different writer than the person that started writing "Marvelman." I'd evolved or devolved or something or other in the intervening seven or eight years. But then, that's a kind of ongoing process. You find yourself stopping and catching yourself every so often,

suddenly becoming aware that five years ago you couldn't have written this, wouldn't have had any inclination toward this, whatever it is that you're doing at the time, that ten years ago it would have been unthinkable. You can measure the evolution of your preoccupations, your style, and certainly a strip like "Marvelman" that, as you say, was at that time the longest thing that I'd done, you can see the evolution. I think with "Marvelman," actually, it's a lot smoother, as a whole, than some of the strips that I did that *didn't* take so long. Like, the "Captain Britain" stories were done over, what, two or three years?

Mm-hmm.

Yeah, looking at the Marvel collection of them, I was very much aware of how you can see the kind of learning curve in operation, especially during the opening chapters. If you look at the level of competence and restraint between the first chapter and the last one, you can see that in those two or

I DON'T LIKE THIS.

I DON'T LIKE THIS AT ALL.

Dr. Emil Gargunza, Miracleman's creator and adversary. Art by John Ridgway.
©2003 Alan Moore and John Ridgway. Marvelman ©2003 Respective holder.

three years, I had come a long way, at least in my own terms. I polished my style, I trimmed it down, and I cleaned it up a little bit. I got the timing a bit more spot-on. The dialogue's better. "Captain Britain" just provides an interesting snapshot, or series of snapshots, of what was probably quite an important growth period. With "Marvelman," because there was this huge gap in the middle (as with "V"), it's probably not such a continuous series of snapshots. You've got the big gap halfway through book two, then you've got that finished off as close to the style of book two as was possible, but, again, different, it's moved on, there's different artists. And then you've got book three, which was again trying to do something that was fresh and new to me, something that would make me excited about Marvelman as a character again, where the character would have become dulled or predictable by the previous five or six years of his history. Where I could somehow do something new, with John [Totleben] as an artist, to do something new that would make him work again and make him fresh and exciting for me, which is pretty much how the third book,

Olympus, came to be.

These books, when both of them stopped, were you kind of worried that you were never going to be able to wrap them up?

I don't think I was honestly worried. I felt that if it was meant to be, the chance would arise at some point in the future. Also, by then I was already doing other work, which I was just as excited about. So I can't say that I ever thought, "Oh no, if I don't get to finish 'Marvelman' or 'V,' then that's the whole project, my entire career down the toilet," or whatever. I just thought, "Oh well, these things happen. If I do get the chance to finish them, that'd be great. If I don't, there's always other stuff that I can be getting on with.

Was it smooth at the beginning?

It was fairly smooth, relatively smooth at the beginning. But things started to arise. I can't even remember most of them now and don't really feel a great urge to drag them up again, because it was things like... speaking only for myself, where I started to doubt exactly how the thing was going, I didn't necessarily feel that we were being treated fairly, I didn't feel that we were being given the kind of freedoms that we'd been promised. A general disenchantment that sort of gradually settled over the book. Misunderstandings between various creative teams, which all kind of added to a generally miasmal atmosphere over the book. I forget exactly when, but I remember sort of just quitting and just saying that I didn't want to do any more of it for *Warrior*. And then that was it, for a couple of years, until the strips found other homes.

I think when you started *Warrior*, it allowed you to tell the stories you wanted to do pretty early in your career.

Mm-hmm.

Were you spoiled, or were you lucky? Compared to somebody like Steve Moore, who had worked twelve years, already, in the business? He hadn't gotten to that liberation that you got sort of soon, when *Warrior* came in doing stuff like that.

I don't know that I felt spoiled. We were having to work really hard to get every little breakthrough to win an inch of ground. No, I don't think that I felt spoiled or privileged.

But you've always been able to tell the stories that you wanted to tell. Not necessarily being told what to write, or do, by your editors or publishers.

The thing is, I find that if you do a good enough story, everybody who reads it will think that's a good story. They're not going to turn around and say, "This is not the story that I asked for." If the story's good enough, then it's pretty much bulletproof. That's not to say that you won't get people screwing around with it, very often just to impose their authority. But I've always known when I was doing something good. I've always known the value of the stuff that I've done. I've always been prepared to argue my corner if I think I've got a point. I don't think that I'm unreasonable. Others may disagree with that, of course, but I think that generally, my instincts and my opinions of what is conceivable, what is permissible, I think they're pretty good.

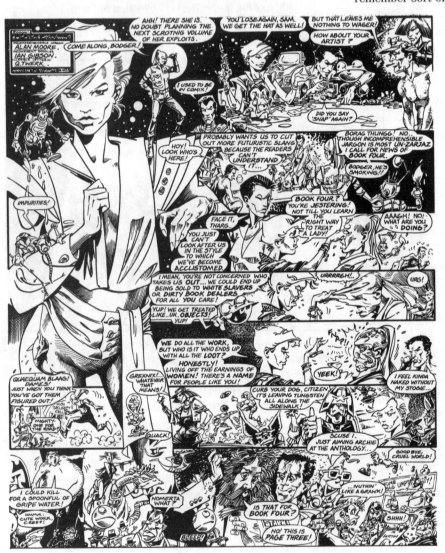

For the 500th issue of *2000 A.D.*, Moore and Ian Gibson reunited for "Halo Jones" and gave the administration at *2000 A.D.* something to think about. ©2003 Rebellion A/S.

When did you start to lose faith in *Warrior*? When did you feel like it was going to end?

I think we all kind of started, well, at least the majority of the talent on the book, we all started to get kind of pissed off around about the same time. I don't remember exactly when that was.

They've not really failed me yet. So right from the beginning I suppose I've taken a certain position. But I've always tried to back that up by doing stuff which lives up to the hype, where I've done it my way, but I've made it work, and it works better than it would have if I'd done it any other way. Like I say, that's kind of self-validating, self-justifying. If I'd done all those radical things with *Swamp Thing* and it had been an unreadable mess that had lost readers, then I don't think DC would have kept me around very long. But I *didn't* write *Swamp Thing* so that it became an unreadable mess. I wrote *Swamp Thing* very well. And it worked, and it gained readers. And like I say, that becomes its own justification. People were suddenly able to see that whatever it was that I was doing, it clearly worked. That they enjoyed the stories as editors or publishers, that readers apparently enjoyed the stories, that I was certainly enjoying the stories. So it's not a matter of having to throw tantrums and insist that everything is done your way. If the way that you're suggesting to do things is the right way, then everybody will go along with it anyway. Or, at least, that's what I tend to find. There's no real requirement to be a *prima donna* and insist upon this, this and this. Just do it right, and if it is right, people will agree with you. And if there's a flaw in your thinking, then people will say, "This is nearly right, but

The "Bojeffries Saga," a surreal comedy by Alan Moore and Steve Parkhouse landed the cover of *Warrior* #12.
©2003 Alan Moore and Steve Parkhouse.

are you really sure about that?" Which, if there is some problem there, you can adjust it accordingly.

How did the "Bojeffries" come along?

I think me and Steve Parkhouse liked the idea of doing something together, and we came up with the "Bojeffries." I think that, like you said, "Marvelman" and "V" had been going down very well. There was no real resistance to doing the "Bojeffries." So we were able to indulge ourselves with this very eccentric strip that I think fit perfectly into *Warrior*. It was totally unlike "Marvelman" or "V for Vendetta" or anything else in there, but in its way just as experimental, it was just being experimental with the idea of a humor strip rather than a dramatic strip.

You left Marvel U.K. around 1980, but I think you told me that you came back because Alan Davis managed to convince you to go back to help him do "Captain Britain" because Dave Thorpe was leaving it. Is that true?

I know that I said I didn't want to work on *Doctor Who* anymore after I thought that they'd perhaps treated Steve Moore less than...

Fairly.

Fairly, yeah.

But you were open to anything else?

I had no problem with working for the other books that Steve had never been involved in. I don't remember exactly. I can't remember who it was that asked me. I can't remember whether it was Bernie Jaye or Paul Neary who asked me to do it, or whether it was Alan Davis. I don't know if I'd have been working with Alan Davis on "Marvelman" before we started "Captain Britain." We'd done one story together, but I can't remember in what order things happened.

It seemed for a while, for two or three years, that Davis did a lot of your strips. He did "D.R. and Quinch," he did "Captain Britain." Was he your official artist at that point or something?

It's just that I seemed to end up... Alan was a very prolific artist who could turn out as many pages of artwork, almost, as I could turn out of script in a day. We worked upon "Captain Britain," we worked on "Marvelman" together, and I still can't remember which one was first. We were both regulars working on *2000 A.D.* as well, and we'd done a couple of "Future Shock"s together. And I think *2000 A.D.* were looking at *Warrior*, looking at "Captain Britain," and thinking that it might be quite a coup if they were to get us to do a strip for them. Obviously, we worked well together and the strip was popular, so I think that they might have suggested—and if anyone's got any different recollections of this, then they're probably right rather than me, because my memories of this are very, very blurred—but somehow it just came up that we could carry on with these characters that we'd invented, maybe do a few more stories about them. So "D.R. and Quinch" developed into what it eventually became.

Alan,
It's been
a real honor
and a privilege
having been able
to work with you
over the years, not
to mention a complete
blast as well. Your work
continues to inspire, enlighten
and entertain, and here's hoping
that your freak-flag waves high
for a long time to come!
You da man! Yer pal,
John Totleben

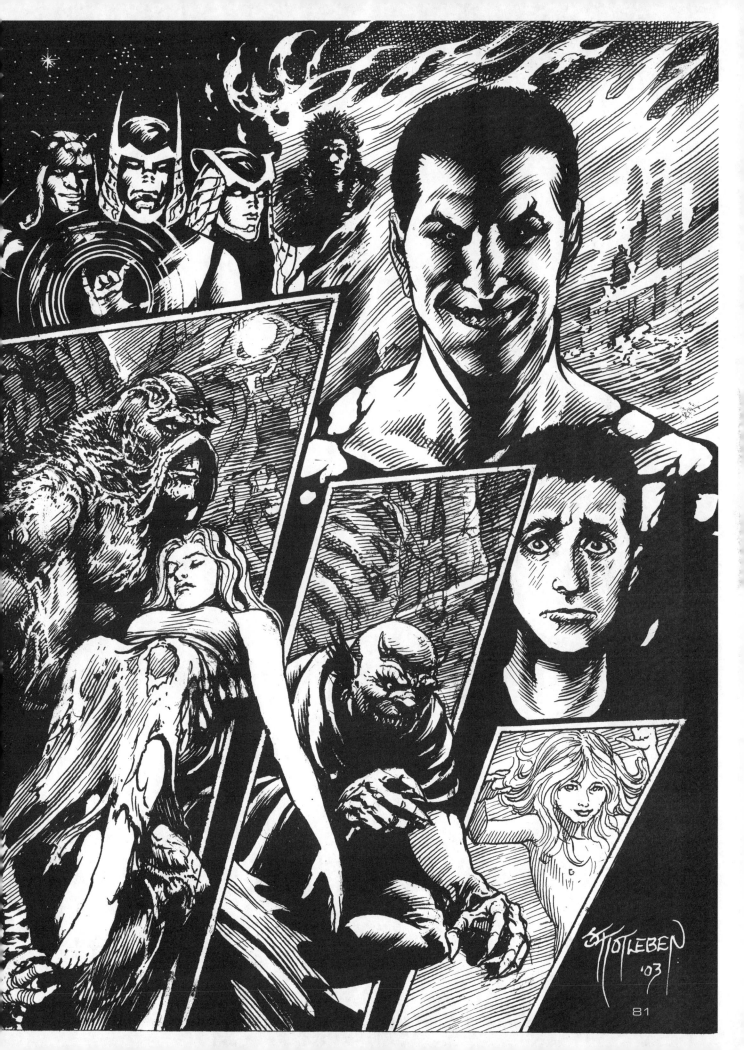

Do you remember how you were contacted for *Swamp Thing*?

Yeah, I was—let me see... I would have been, ah, living at the address in Wallace Road, that me and Phyllis lived at when Leah and Amber were both quite small. I think it was one evening around mealtime and there was a phone call from Len Wein, who just put to me that they were looking for a writer on *Swamp Thing* and that he'd read the stuff that I'd been doing in *Warrior* and elsewhere and was interested in giving me a trial on the series and seeing if I could come up with anything.

So, I said, "Sure, send me everything that's been done in the current series and give me a week or something to sort of get an idea together and get a proposal together and then I'll kind of map out the way I see the series moving." Now oddly, about no more than six weeks before, probably less than that—it might have just been a couple of weeks before that phone call—I'd been sitting working in my room upstairs and during an idle period I'd been thinking about what my strengths were as a writer. And it occurred to me that probably one of my strengths was that I could take almost any idea thrown at me and do something interesting with it. And I thought, "Well, how true is that? If you were ever offered an American comic character, just at the drop of a hat, would you be able to come up with workable ideas for it?"

And I thought, well, let's see. Let's just think of the most unlikely character that I could ever be offered, just off the top of my head, and then come up with some rough proposals. And the character that popped into my head, as the most unlikely character that I could ever be offered was the Heap, the Hillman Comics swamp monster. So, that was the first name that popped into my head, so I started thinking about what could be done with the Heap.

I thought, "Well... he's largely a massive vegetable matter as I understand it, so there's probably a lot that could be done—visual tricks that could be done using the character's camouflage possibilities. That we could have, for example, a scene where actually part of the main character is visible in the foreground for five panels, and it's not until it moves that

Moore's debut—*The Saga of the Swamp Thing* #20.
Swamp Thing TM & ©2003 DC Comics.

you realize that it is part of the living being, rather than a moss-covered stone or something. I thought about other various things that could be done playing up the aspects of the character that were more plant-like and less animal-like. So, this was just as an intellectual exercise, a creative exercise, and I kind of ran through a few ideas to convince myself that, yeah, I still have it, that I could still turn out some interesting variations upon an idea at the drop of a hat. And then, it was a couple of weeks later when Len called and when I found myself putting the *Swamp Thing* proposal together. I'm not even sure if I remembered my thoughts about the Heap of the few weeks previously. It wasn't until shortly afterwards that I thought, "Well, that was strange, that I should have been working out what to do with a swamp monster character just before I was called and offered one."

When he [Len Wein] hired you to work on the series, were you given very little time to prepare for the first story? From what I understand I think John [Totleben] might have mentioned that might have been the case.

I think it was pretty tight. I think that the previous issue was already on the stands or something like that or was just coming out. And I was supposed to take over in the next one. Yes, it was very tight, but then again, I'd been used to working—I mean, over here we have weekly comics, so I'd been used to working upon tighter deadlines. Like I said, I'm pretty good at sort of catching things on the bounce.

Did you feel that the revamp that Len Wein wanted had already begun with Steve and John having taken over the book a little bit?

Well, I mean—Steve and John—when they sent me all of the issues, I thought that Tom Yeates had done a fantastic job on the artwork. I've got no problems with any of the artists. I mean, obviously Steve and John offered a lot of possibilities that

were unique to them. But, I mean, Tom Yeates had done a fantastic job. I was kind of called upon to analyze the script and critique it, to try and see why, in my opinion, it didn't work; and to try and think of ways that that could be turned around. There was a lot that was very, very good about that second run of *Swamp Thing*. Marty Pasko had done some very good stories; he was obviously putting quite a lot of intensity into the writing. But nevertheless, there was something, when I looked at those issues that I still felt was missing regarding the character. I felt that there was a kind of flawed premise that was preventing the character from evolving into the more interesting kind of entity that I could imagine.

You were attracted to this character right from the beginning when Len and Bernie [Wrightson] were doing it?

Well, when I first read—yes, was that 1972-73, something like that?

1973, I think.

Yeah, well I remember reading the very first Swamp Thing story—the one that was in *House of Secrets*?—the one that we later reprinted and I managed to bring into continuity. This was a one-off story that was set in the 19th century with basically the same story—you are aware of this George, yeah?

Swampy and Abby enjoy *Superman Annual* #11 (an issue Alan wrote) on this lovely fanzine cover by John Totleben.
Artwork ©2003 John Totleben. Swamp Thing, Abby Arcane ©2003 DC Comics.

From *DC Comics Presents* #85. Art by Rick Veitch and Al Williamson. Superman, Swamp Thing ©2003 DC Comics.

Yes.

It was basically the same story—it was a trial run if you like—but it was set in the 19th century. I'd read that and then a few months later (or so it seemed to me) I was surprised to see this book *Swamp Thing* appearing that seemed to be the same character, and yet was set in the 20th century. That took me a while to puzzle out, you know? It was a bit confusing at first but—yeah, I mean I thought the stuff that Len and Bernie were doing upon that first run at the time—I thought it was wonderful. These were classic, gothic horror riffs delivered with real verve and gusto, you know. I thought the only problem came when—I mean the initial premise of the character was certainly strong enough to carry it through that handful of original stories—

Michelinie was one of the writers. I think [Gerry] Conway might have written a couple of issues.

Well, you know, there were various talented people working on it—I mean, I tend to think that, the premise as it originally stood—to a certain extent it had a shelf life. There was only so long that you could continue to follow that original premise

before it would start to break down.

It's sort of like that *Fugitive* premise.

Yep.

Eventually he has to find the killer.

Exactly. Eventually, you know you have to find the killer. But it's just that flawed premise that you find in such a lot of television [shows], comics, and things like that—that if the premise were actually realized, it would be the end of the show.

Did you feel that to understand the character that you had to deconstruct him completely? Literally break him to find out what he's all about?

I think that my initial proposal for *Swamp Thing*—I forget how long it was, about 15 pages, something like that—I believe

that it was quite well received; I think it was quite intelligent. I was just trying to look at the character in as cold and analytical a light as possible. So saying that, basically, you had to try and see what the problems were with the strip. And I was saying that one of the problems is that as he sounds at the moment, the Swamp Thing is a largely nondescript character, in that he's not very interesting. I mean, if you look at him—look at the character physically—other than being a bit lumpy and kind of greenish, the only thing that you can say about him is that he's very strong. Which in the DC Universe—which back then had lots of people who could play ball with planets—being quite strong was vanilla, really. I mean, most of the characters in the DC Universe had preternatural strength, so the fact that Swamp Thing was quite strong didn't really cut it.

In fact, he seemed more limited in some respects than ordinary humans, because even if he was stronger than humans, he was a lot slower. This was another point that struck me, that we had to come up with a better way for the Swamp Thing to travel around, rather than constantly moving around the country upon freight trains or in the boot of a car or in some truck. It was—

There's nothing super about that!

[laughs]

It was tedious. So, it struck me that, physically, despite the fact that Swamp Thing was actually a vegetable life-form, that because those aspects had never been explored or exploited, that basically we had a character that was a kind of mud man who was a bit stronger than an ordinary human being, and in terms of the character's motivations, seemed to be even weaker. That this—the character's quest to regain his lost humanity—would have been very poignant in the first few Wein/Wrightson issues, but had tended to succumb to that "*Fugitive* syndrome" that you mentioned; that it was obvious to even the slowest reader that Alec Holland—the Swamp Thing—was never going to find some way to turn himself back to Alec Holland because the moment he did, that would be the end of the series. It was a kind of false premise that was largely dissatisfying; you knew that whatever shred of hope Swamp Thing might

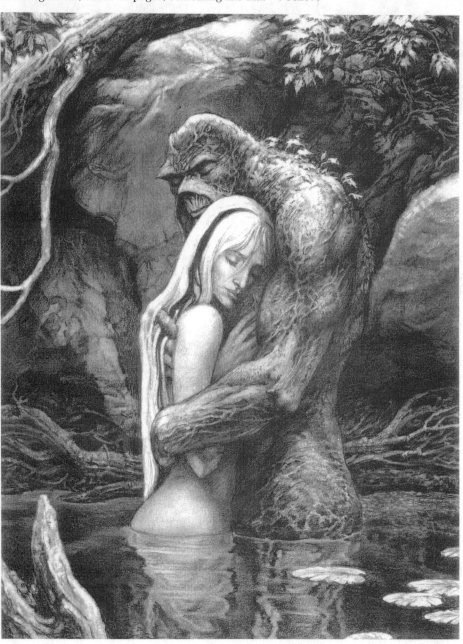

Lavish illustration (and a reinterpretation of the cover to *Saga of the Swamp Thing* #34) by master artist John Totleben. Artwork ©2003 John Totleben. Swamp Thing, Abby Arcane ©2003 DC Comics.

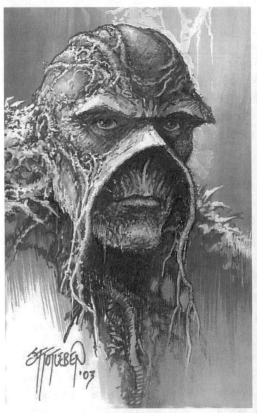

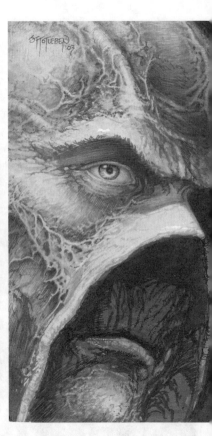

Recent Swamp Thing art by John Totleben. Swamp Thing TM & ©2003 DC Comics.

follow relentlessly for a six-issue story arc, or whatever, that at the end of it, he wouldn't have been taken any nearer to his goal because his goal was not really commercially feasible; it would have been the end of the comic book.

So there were lots of things about the character—I think at one point I described him as being very much like Hamlet covered in snot—that this was a character who really wasn't that physically appealing and just walked around feeling sorry for himself most of the time and getting involved in supernatural malefic occurrences, more or less by accident. So, having taken apart the character and deconstructed him if you like, or analyzed the character to try and see what bits didn't work, I then started to think about ways that they could be altered, turned around, made to work. I thought that the idea of following up the concept of this character actually being a plant was something that was quite fruitful, potentially fruitful. I read in one of the early Wein/Wrightson issues—I think that's the first one where Arcane appears—that they actually had the character x-rayed and found that he's purely made of plant matter, which is really never mentioned again. So, I began to sort of think of ways in which I could alter the character completely without doing anything which would contradict previously established continuity, because I tend to think of that as cheating. If you contradict previously established continuity to some degree you're destroying the reader's accumulated trust in the narrative. A reader who had perhaps read every previous issue of *Swamp Thing*—if only to then come along and say

that it didn't happen, and the new version is like this—then that reader, I think, would have every right to feel that his or her time had been wasted. If the energy, the emotional energy that they'd invested in reading those original stories now turned out to have been misplaced, if those stories never happened, were consigned to the void, you know, they were no longer part of continuity—no, this never happened to those characters—then that's the sort of stuff which erodes the reader's faith in the comic medium.

I doubt that Sherlock Holmes would be such an important fictional character today if halfway through his series of Holmes stories Arthur Conan Doyle had suddenly decided to change vital parts of his already established history. I mean, continuity mistakes are one thing—they can happen dead easily, and I'm sure Arthur Conan Doyle and many other great writers have made them. But where a piece of continuity is deliberately papered over or ignored, that is something I don't think does the industry or the particular comic book in question any favors at all. So what I wanted to do was to come up with a way of completely changing what *Swamp Thing* meant but without changing any of the previously established points of his history and character continuity. And it struck me that what I was therefore looking for was a kind of re-definition, rather than a revamping. By that point—I can't remember whether I was talking to Steve and John before doing the proposal or whether it was just after. I tended to think that I had to get that first proposal in very quickly.

I'm pretty sure that's accurate, because if I remember correctly, they feel that they didn't contribute to the stories until after the first run, you know, the first year.

In fact, I probably didn't speak to Steve and John. I wasn't really put in contact with them until after I'd turned my proposal in. So I'd kind of suggested that I might have thought of a way in which *Swamp Thing* could be re-defined without changing any previously established plot points.

It was a sort of vague notion that had somehow congealed in my head; I'd been reading about planarian worms and how by taking them to run a maze and then killing them and centrifuging their bodies and feeding the puree to uneducated worms, the worms that had been fed with their smarter

colleagues would then be able to run the maze, which struck me as interesting. It also struck me that, really, there's no way that Alec Holland could have possibly survived that dynamite blast. He was about four inches away from it when it went off.

Sure.

So therefore, he could not have fallen into the swamp and had his life sustained by this fluid that was only ever meant to work on plant life anyway. So, I was able to find some logical inconsistencies in the original story, which my solution actually made more sense of, because if I could suddenly say, well yeah, Alec Holland, he was dead, he was killed by the explosion but his body went sailing out into the swamp where there was all of this bio-restorative formula and the plant life absorbed his body; the plant life had been altered and mutated by the formula and it absorbed his mind as well in the manner of planarian worms. That struck me as something that didn't violate any kind of previous continuity but which suddenly moved the character into new and exciting unknown territory. That psychologically, he would be brought to a point where he would realize that his entire previous desperate search for humanity had been an illusion; that he wasn't in fact Alec Holland, and never had been. I figured that this would—after we'd had the character broken down in the anatomy lesson, and explained from the "bottom-up" if you like, scientifically, then in the following issues we had the character mentally breaking down. That he's coming to terms with the fact—mainly in that long dream sequence in what, number 22? He comes to terms with the fact that he's never been human, that that was an illusion, that he's something else. Those first few issues, it was quite a methodical process. In issue 20, it struck me that the best thing that I could do was to tie up all of Marty Pasko's storylines; characters that I was perhaps not interested in continuing with could be moved out of the way; characters that I was interested in exploring—like Matt Cable and Abby—they could be moved closer to center stage and I could sort of give the issue a sort of visceral punch by providing the first step to my recreation of Swamp Thing, which was killing him. So, yeah, that was issue 20. In issue 21 we had kind of the physical re-building, and the conceptual re-building of Swamp Thing in the "Anatomy Lesson." In issue 22 and 23, we had—ah—23 was the last Woodrue one, was it?

A killer page from the memorable, "Anatomy Lesson," *Swamp Thing* #21, which served as the launch of the classic Moore, Bissette, and Totleben creative combination.
Swamp Thing TM & ©2003 DC Comics.

Yes.

Over those first two or three issues and the Woodrue storyline we had Swamp Thing go through a breakdown and then emerge with a new sense of identity—that he's given up on being a human being, he's got over the shock of finding out that he never was a human being, and he's now looking forward to exploring his new identity as this totally unprecedented swamp creature. And so we are then able over the following issues to gradually build the character up. We start to identify him with a kind of elemental earth force. We start to explore his relationship with the green soul of the planet's vegetation, a kind of landscape that he can move into. We made the landscape that he was actually living in a lot firmer and more solid. I mean, a lot of American comics—and a lot of British comics as well—they never really make any use of the locations that their characters are supposedly set in. I mean, I've read *Swamp Thing* for ages, but I really hadn't gotten a clear idea of which swamps he was the Thing of. I didn't really have a sense of geographic location, which was something I wanted to bring to my run on the character. So we decided it was definitely set in Louisiana, and I began to educate myself about Louisiana, its history, its geography, its layout, its wildlife, so that I could *use* the location, so that I could get interesting images or atmospheres from it. Because if you don't use the location, you're wasting a tremendous resource. It just becomes a painted backdrop—and not a very convincing painted backdrop—against which you have your character performing. Whereas if you sort of treat every detail of the strip, including where it is set with a great degree of seriousness then you can really create some fantastic atmospheres—story concepts that spring purely from the place where the book takes place. So we started to build up the supporting cast, Swamp Thing's relationship to the DC universe—that was something I was very concerned to establish, because it struck me that Swamp Thing was fairly marginal. Swamp Thing and the other supernatural characters—of which there were very few left by the time that I started working on *Swamp Thing*—I think *Swamp Thing* was about the only supernatural title left.

I think it was the only horror title for a long time.

Yeah, and given that DC had all of this rich history of great supernatural characters, and Swamp Thing was the only one left. And in the interaction between Swamp Thing and the rest of the DC universe, Swamp Thing was kind of marginalized. He didn't seem to fit in the same world as the Justice League, say.

He understood more about humanity than Superman and Batman ever did.

Well....

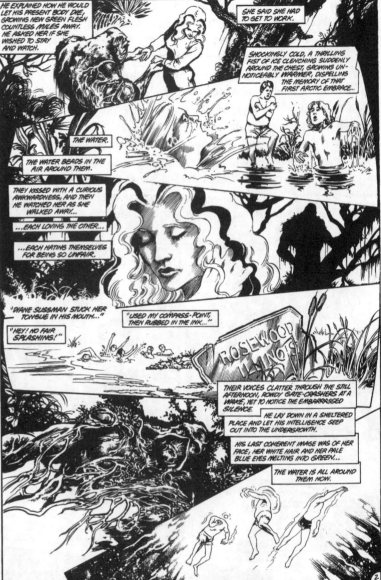

Page from *Saga of the Swamp Thing* #38. Art by Bissette and Totleben.
Swamp Thing TM & ©2003 DC Comics.

In the way you saw it.

Well, the way I'd wanted to do it was that, I wanted *Swamp Thing*—I thought that Swamp Thing would probably do better as a character than do better as a title creatively and commercially, if he was more integrated in the DC universe. So I wanted to show that, yes, Swamp Thing could function in a story with the JLA which is why I did that sequence in #23, where we have deliberately brought in the super-hero aspects which had pretty much been kept out of *Swamp Thing* before that because they would have clashed with the atmosphere. I wanted to try and show that you could do anything with *Swamp Thing*. I mean, in possible ideas for the future on *Swamp Thing*, I thought, "Well, this could be a super-hero character, it could be a horror character, it could be a science-fiction character—there are a lot of potential areas here that could be explored." And I wanted to try and show that the

concept was as versatile as I had portrayed it to be. I wanted to show off the versatility of the character.

Also, since the roster of the DC supernatural characters were not being used, I thought that *Swamp Thing* would probably make a good place to sort of start a revival from. So, we very consciously sort of tried to include the main players of the DC supernatural universe from early on, you know. With the Demon turning up, and then in that annual, with the Phantom Stranger and the Spectre and the whole Deadman—you know, the whole bunch of DC supernatural characters. I

Love the Nukeface! Amazing art from Bissette and Totleben in *Saga of the Swamp Thing* #35. Swamp Thing TM & ©2003 DC Comics.

was trying to create a DC supernatural milieu, if you like, a world in which all the supernatural characters knew each other and they all kind of made sense in terms of each other. I wanted to expand this to include Cain and Abel, who were at

that time second-string horror hosts from a couple of vanished mystery books. But, you know, I always thought the characters were interesting, so it'd be good if they could be rehabilitated, brought into the mainstream continuity.

So, over those first 15 issues or so of *Swamp Thing*, I think that there were various things that I was trying to do. Yes, I was trying to integrate *Swamp Thing* more thoroughly in the DC universe. I was trying to have the character slowly evolve into a kind of vegetable god. I was trying to show the versatility of the character. I was trying to give the readers a better sense of the kind of world in which he physically existed. I was trying to sort of relaunch the idea of other supernatural characters as a viable alternative to mainstream super-heroes. I was trying to do stuff that I thought that Steve and John would enjoy drawing. By that time I had spoken to them, and even if I'd been able to pick up on any of their additional ideas at that point, I at least knew—there were some things—like their ideas for doing a more visually radical *Swamp Thing*—that fitted in perfectly with the way that I wanted to kind visually distinguish the book.

Did you feel a synergy with them? Like, when you were working, you all were on the same page?

Oh, very much so—yeah, yeah. If I have any real talent at all in comic writing, that talent is probably the talent for collaboration. I don't think there're many comic creators that I couldn't collaborate with and at least make a decent fist of it. I try to be sensitive in feeling out what the artist really wants to draw, what they would be really good at drawing. I try to understand the artist's style and thus the artists themselves through their style. I try to sort of see what kind of energy they have in their work and then I can craft my stories to most perfectly bring that out. Because that's to everyone's advantage. If the artists and the writers are having incredible fun and doing what they have to do, then that's going to benefit everybody.

So yeah, there was certainly a synergy. If *Swamp Thing* had been drawn by Dave Gibbons, it wouldn't work any better than if *Watchmen* had been drawn by Steve and John. There was a kind of frenetic, organic quality to the work that Steve and John did that was perfectly suited to the kind of fetid, steaming swamp environments that the character was most used to. There were qualities in Steve and John's work that I'd tried to come up with stories that would bring out those qualities.

I think there's a case when—right before you started "Love and Death," you were supposed to do "The Nukeface Papers" but for some reason, Karen Berger at the last second thought that was

maybe the wrong direction, and I think she rushed you into starting *Love and Death*. Do you remember that?

Ahh… I—now I thought—hang on—this must be completely wrong, because I knew that there was some reason why—"Love and Death" was #29?

Yeah, #29.

And "The Nukeface Papers" eventually came out around, what, #30?

#37, 38, around there.

I can't remember, I really can't remember. I knew that I did have a ridiculously short amount of time to write the whole *Swamp Thing* #29. I think I did that one in two days, written and typed.

I don't think she remembers too well either, but I think she seemed to think that you had to develop the relationship between Abby and Swamp Thing first before you went anywhere else.

Hmm… can't remember exactly why—I can't remember if it was "Nukeface Papers" that we were planning to do.

Right after the Demon issue, yeah?

I can't remember exactly what the thinking was on that one, George. Karen said, "Look, can you do something else for #29 and can you do it in three days?" Because—"Yeah, actually I can." I mean, Karen didn't know that—she'd been working with me for a few issues. The ridiculous one was #33. Was that the *House of Secrets* one?

Yeah. It's right before the "Rites of Spring."

Yeah, yeah, yeah—I remember I did #29 in two days and thought it was great. I was really pleased with it; I thought it was one of the best-written issues that I'd done for a long time, which considering the speed I'd done it at, it didn't seem rushed. The writing is very detailed and delicate and intense, you know, and it was a very scary little story! So yeah, we did that one and then #29, 30, 31—that was the Arcane trilogy—

Yeah, but—that's one of the things we should talk about: The thing about the incest between Arcane and Abby. What did you want to do to Abby exactly?

Well, I mean, what I wanted to do was to get her husband out of the picture. The main thing is that—I'd always liked the Abigail/Abby Arcane/Abby Cable character. Not that she'd ever really stood out that much as a character, but I liked the hair. It's distinctive; the white hair with the black stripe. Yeah,

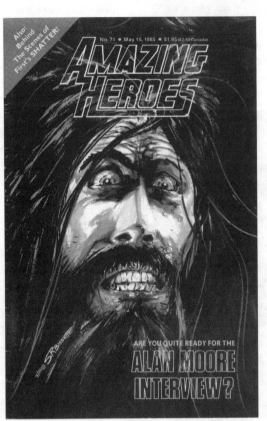

Moore's first major American interview was highlighted by a Stephen R. Bissette cover that graced *Amazing Heroes* #71. Artwork ©2003 Steve Bissette.

that looks good. So there's no reason why she couldn't be made into a much more interesting character. But I also wanted a love interest for Swamp Thing and it struck me that Abby seemed to be the most likely, the most natural—well, if you can use the word "natural" when you're talking about the relationship between a woman and a vegetable—the most natural love interest. During—at least during my reading of Marty Pasko's run—I kind of felt that Matt Cable didn't really seem like a very nice person. Also, he'd suddenly gotten these psychic powers from nowhere.

I didn't know what that was all about. I really had no idea why Marty's given him psychic powers, but it was something that had to be resolved. And it struck me that, yeah, maybe Arcane had entered into Matt Cable without anybody else knowing. Maybe he'd taken Matt over, and this was partly because it would give me a way of explaining why Matt Cable suddenly had all these powers. It would give me a way of explaining the change in his personality. It would give me a way of getting rid of him. It would give me a way of bringing Arcane back in a new way—having established that Arcane was dead, I thought it would be quite good then to bring him back. Because he was also the classic *Swamp Thing* villain. So I figured I had to do at least one Arcane story during my run. Then I'd thought it through and realized that, yeah, actually he's Abby's uncle, so if he's been inhabiting the body of her husband all this time then that is—well, even down South that's still incest.

Yep. [laughs]

No offense intended to any Southern readers down there, of course; I realize that these comics stereotypes must wear thin after a while—but that was just the way the story seemed to be going. Incidentally, the really, really clever symbolism in issue #29, where people pointed out how brilliantly I'd used insects as a symbol for incest—which is an anagram of insect, as I believe intellectual favorite A.S. Byatt also did in her book *Angels and Insects*—I've got to put my hand up and say, "No, I'm not really that clever." I didn't actually notice that until the story was finished—"Oh yeah! Incest/insect—that's good!" People give me a lot more credit than I'm actually due. Or perhaps it's just that sometimes I'm so brilliant that I don't even notice how brilliant I'm being.

No, I've really got no idea that there was that clever little

verbal connection there until after the story was completed. But yeah, I think that when we'd done it I kind of realized that it was quite powerful. I don't think that I was consciously doing a story that was pushing the boundaries because I knew that if there was only two days until the deadline then pretty much Karen will accept everything. I don't think that I was consciously doing that. I think I was just trying to get a story written in two days; I don't think I was sort of consciously thinking, "Ah well, they're going to have to accept whatever I write, so I'll do an extra-filthy, extra-horrible story." Again, I don't think that I'm that clever; I think that's just the way it turned out. There was the rest of the Arcane trilogy, and then that seemed to lead quite nicely into that annual. And then, what was it—"Pog" in #32?

Yes.

I mean, the annual was good. I really enjoyed doing the annual because that was probably where we first tried to roughly map out the DC supernatural universe.

It's sort of your Dante's *Inferno*?

Well, it wasn't particularly based upon Dante's *The Inferno*; it hadn't got the sort of the rings of Hell. I mean, I guess, yes, it did involve both Heaven and Hell. So I guess it's bound to have similarities to *The Divine Comedy*. But, no, it was more like thinking, "Well, let's try and explore the DC supernatural realms." Is there a Heaven in the DC universe? Well, yeah, there seems to be. I think I can remember various stories where characters have gone on into some sort of wonderful afterlife. Is there sort of a Limbo or Purgatory? Well, yeah—Deadman probably hangs out around there. Where is the Spectre? Where does the Phantom Stranger hang out? Is there a Hell? If there's a Hell—there must be because there's been demons, so what's the setup in Hell? And how do all these places stick together? Can you get from one to another? What route do you take?

So, you know, we were trying to do a preliminary map—a rough map—of the DC supernatural territories in that issue. And it was a lot of fun.

Did you feel like, around this time that the love story between Abby and Swamp Thing became the center of the book?

Yeah, well, as soon as I'd gotten Matt out of the way—as soon as I'd got him crippled and comatose and all the rest of

it, safely in nursing home somewhere—then I wanted to move on to the meat of the relationship between Abby and Swamp Thing. And I thought that having Swamp Thing retrieve Abby from Hell would be very romantic, you know? I figured that buying a girl a box of chocolates is one thing, or taking her to see a movie, but if you actually go and rescue her from Hell, you know, she'd pretty much have to go out with you, wouldn't she? [laughs]

So even if you were kind of made of mud and earthworms and things then, yeah, rescuing someone from Hell, you're pretty much guaranteed a steady date from then on. So we did all of that. I mean, we kind of gave hints at feelings between Abby and Swamp Thing before that. I think in, what is it—

Gene La Bostrie, a Moore doppleganger, appeared in the author's final ish, *Swamp Thing* #64. Art by Tom Yeates. Swamp Thing TM & ©2003 DC Comics.

#28, "The Burial"?

Yeah.

There's some chemistry between them.

A little flirting....

A little bit. It's just friendly, but it was to set up possibilities for later. Then we have the annual, which—yeah, I was very pleased with that. That worked well. We used the extra length to tell a story of grander scale. We took the readers on quite a journey and so I mean, after that, I believe that we—"Pog" was an inventory story. I think I'd written it around that time, but it might have originally been intended as an inventory story if Steve slipped with the deadlines.

Okay.

And—I might be completely wrong here, George, but since you're relying upon a very fragile memory—

I think they might have been behind, actually. That's what it was, I think.

Well, in any case, it was intended as an inventory story. I think that Karen made it clear that this is an inventory story but we're going to use it for the next issue. I did that one because that was one of the things I'd made a note of on my initial list of possible *Swamp Thing* ideas. I'd made a note—something like all the characters that live in swamps—and I just put Pogo.

Then I thought, "Well that would be pretty cool, if you could kind of have Pogo meet Swamp Thing. That they happened to be hanging out in the same part of the swamp." And then I thought, well how would you actually do that so that you've got the flavor of *Pogo* and make it a good tribute, but at the same time not completely disrupt the continuity of *Swamp Thing* with a lot of funny animals? So "Pog" was a result of that. And I was very pleased with that one. It was surprisingly touching.

That seems to be one of the stories that got the most reaction from your whole run. Are you surprised? It was just supposed to be an inventory issue—

Well, children and animals—people have got a strong sentimental streak and although I didn't really intend that story to be sentimental—yeah, it's a bit of heartstring tugger.

Yeah, I mean it was a surprise. It's sort of my environmental stance with *Swamp Thing*. I used that story to extend it—to make sure people know that I was talking about the animal kingdom as well as the vegetable kingdom. That there were big problems in the way we treated most parts of the natural world. And so, yeah, I used "Pog" to sort of get that out. Now I think that I had issue #34 written to go out immediately after "Pog." I think that at that point Karen phoned up and said Steve wasn't going to be able to get it done in time. and we were going to have to go reprint. And if I remember correctly, what I said to Karen was, "What if I could think up something completely brilliant that would get us out of trouble?"

I didn't like the idea of the book suddenly going reprint. On the other hand, I think I asked Karen how many days I've got—when was the deadline on the book—and I said, "Well, what about that *House of Secrets* story—has that ever been reprinted?" And Karen said, "No, because it's out of continuity." And I said, "Well, how many pages is it?" And I think she said about twelve, or something... eight, twelve, something like that. So I said, "Right. If I could do something really clever, and bring that into continuity, so that we could reprint that story and make the whole of the rest of the issue a framing device around it, is there an artist that you've got on hand who could do about twelve pages or whatever it was in two weeks?"—which I think was the deadline that Karen had said we had before it went out. She said, "Yes, Ron Randall." So, I mean, I had no idea what I was going to do, but I think I got all twelve pages done in about 24 hours.

Okay.

And I worked out how the original, initial "Swamp Thing" story could be included in that and made a part of this story. Also, that this would kind of include the earlier, 19th Century "Swamp Thing"—it would bring it back into continuity. So I worked out a way in which I could include that initial story in continuity, and it could open up possibilities for future *Swamp Thing* stories and get us out of this deadline hole. But I was very proud of that one because, like I said, that was the quickest of the entire run. From Karen phoning up saying we had a problem to me getting that finished was about twelve hours. Yeah, that was some fast thinking.

When Steve and John left the book, did you think about leaving? Were you starting to think about it?

Well... let me think. I mean Steve and John, they—

This was the *Crisis* issue.

Yeah, I'm trying to think when that was. I mean, we did— "Rites of Spring" came out—that was probably one of my favorite issues of the entire run. Steve and John—particularly Steve, I think—they did a few issues where we'd had to have fill-ins. I'd launched into the "American Gothic" storyline, which I knew was going to be running for quite a long stretch. When did that start—"American Gothic"—which issue was that?

I think its #40 or #41.

Right, so I'm just trying to think from about #34 onwards. What did we do in those?

"The Nukeface Papers."

Yeah, "The Nukeface Papers," that was—right, #35-36 for the "Nukeface Papers." I used that to actually kill off Swamp Thing because that would be dramatic; also to try some experimental storytelling which, you know, that was something I very much enjoyed during those particular two issues. That *Rashomon*-type storytelling that was more—I think *Chronicle of Death Foretold* by Gabriel Garcia Marquez was the main template for that one; the same event told from different

The debut of John Constantine, from *Saga of the Swamp Thing* #37. Art by Rick Veitch and John Totleben. Swamp Thing, John Constantine TM & ©2003 DC Comics.

was to sort of try and take a pretty standard roster of horror—werewolves, vampires, zombies—and this included a number of suggestions from the original list that Steve and John had made—and I decided to sort of string these together into a kind of an odyssey through American horror. I wanted to explore these kinds of standard horror figures but try to do it in a new way, so that I could connect these kinds of icons of horror with horrors of the real world. And I thought that that would be a way of giving them an extra edge, an extra bite.

If they could be made relevant to the world in which the readers existed, symbolic of things bigger than just another vampire story, another werewolf story, then that could yield rewards. Now I think that the whole thing of having to tie in with the tedious *Crisis* crossover—I say that with no disrespect to Marv Wolfman or George Pérez—I think that the idea of trying to connect up all of the disparate books in a line is a fairly ridiculous one; there's no point in it other than conning the reader into buying books that they otherwise might not pick up. But, we were told we had to include it, so we tried to do as good a job as possible, and I tried to write our mandatory *Crisis* issue with as much style as possible.

Did you feel that that was your worst issue of *Swamp Thing*?

No, no. I thought that we actually managed to get some quite good imagery out of the, you know, this sort of *Crisis* thing. There's some quite good writing in that issue. We were having to try harder! To try and make it work with all of those intrusive elements. It wasn't my worst issue—no, there were ones that I did where I haven't really got even the excuse of intrusive elements. Considering what we were dealing with we did a pretty good job.

There were a few issues I'd done, like the zombie issues where—nobody's fault but mine—I didn't do a very good job. So those are my least favorite issues. No, that *Crisis* one—it was regrettable, I wish we'd never had to do it, it was disruptive, but we did as good a job as possible; we acquitted ourselves honorably. No I don't remember—that would have presumably been when Steve and John said that they weren't going to be doing the book on a regular basis anymore.

But they still stayed part of the book?

Yeah, yeah. I think that they were still around. And also by

points of view until you've got the whole story emerging. But we used that one to kill off Swamp Thing and this would be what I would use to introduce this new ability of re-growth, which I would eventually be able to use to get over the traveling in freight cars and trucks problem that I mentioned earlier.

So it was in #37 that we began "American Gothic." #37 was where Constantine turned up for the first time. I knew that with "American Gothic," what the plan was to run through a lot of stock cliché horror formats because one of the things that I thought that Len and Bernie had done on the original run that was so good was that they'd taken sort of very stock horror standards and had done interesting things with them— "The Patchwork Man," things like that. So what I decided to do

that time, Rick Veitch had pitched in and helped out so many times that Rick was part of the team anyway. He seemed like a natural to replace the regular artist. I forget which issue it was that Rick actually came on board for.

As a regular artist—#51 maybe?
Was it the one immediately following the *Crisis* issue?

Yeah.
I mean, and that was Rick and Alfredo....

I think it's #51, because I think then Stan Woch—
Yeah, Stan Woch did a couple of issues, yeah, yeah.

But Rick Veitch was always there at the beginning except that you didn't know—
Oh yeah, that's it. But I'd been aware that Rick had done stuff—Steve had told me that Rick had helped out on some of the stuff from the very beginning, so Rick was part of the team really, and it was quite natural to make the transition to him. And anyway, it wasn't like Steve and John were quitting over a point of principle or something. As far as I remember they were—I mean, unless you've heard anything different.

They had just done the book for three or four years— they might have been a little tired of the monthly grind.
That's what I'd figured. I wasn't tired of the book and I was in the middle of a quite long-running story-line, so there was no reason why I should think of quitting the book.

But when you did leave the book, what exactly was the story behind that? Because from what I understand, you had one storyline that you actually wanted to tell that had something to do with Abby's death?
No.

That's not true?
Not at all. I don't know where that's from; it's a complete fabrication. I mean, I'd already done Abby's death and brought her back again. That would have been pretty redundant to do that, and anyway, I actually quite like my characters, you know? But the reason why I quit *Swamp Thing* was because I was doing lots of other stuff by that time. I mean, at one point during that I was doing *Swamp Thing*, I was doing *Watchmen*, I was writing "Marvelman," I was probably writing "V for Vendetta," I might have been doing "Captain Britain," "Halo Jones" and "Maxwell the Magic Cat." I know there was one point where I seemed to be doing everything at once. And by the time I'd finished *Swamp Thing* I'd done nearly all of my original ideas on the book, all the ones that Steve and John had contributed to, all the ones that I'd subsequently come up with—I'd pretty much done everything that I'd wanted to do with the character. By then, *Swamp*

Thing was at the peak of its sales; it would have been quite lucrative to carry on. But if I'd carried on it would have been stale—there wasn't any real creative reason to do so. It would have gotten stale, and it would have to some degree tarnished the work that we'd already done.

So I'd figured that "Okay, we'll do this big space storyline and I'd get all of my science-fiction *Swamp Thing* ideas out of my system and at the end of that, I'd wrap it up with a kind of 'happy ever after' ending." Which is what I wanted for the characters: Swamp Thing and Abigail just go and grow them-selves a fairy-tale household in the swamp and, as far as I'm concerned, they live happily ever after. You know, this fairy-tale couple in their vegetable home—it's a perfect love story. That was what I'd always imagined the ending of *Swamp Thing* to be. And as far as I'm concerned, to a certain degree that's what the ending of *Swamp Thing* was. No disrespect to

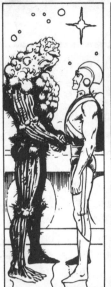

It's hard to say goodbye. Moore also demonstrates his gift for alien languages in this page by Rick Veitch and Alfredo Alcala.

Cheated by this invisible interloper my optic display rippled with mad lights, an agitated brilliance that flashed from screen to screen finding nothing, while all the time I felt that spectral fireball crackling nearer, nearer, white hot and spitting . . .

At the moment of impact a shockwave of foreign sounds and images rang through my being and in that startling, concussive instant I caught the briefest mental glimpse of the invader.

It was symmetrical, its optic canopies two burning wounds in the darkness of their surround. Beneath that, its features were a jumble of indecipherable organs and components for which I had no name. And yet those eyes, those eyes transfixed me, skewered me with their intensity, their great passion . . .

The vision faded almost before it had formed, the intelligence behind it entering the rootclusters and cogs and deep cables of my substance like grounded lightning.

Almost subliminally I noted that there was a fold in the fabric of time at this juncture, and knew that some point in my future would find me performing a chronofracture, but this minor revelation was driven from my mind as my probes grasped blindly for some tangible evidence of the intruder.

There was none.

The intruder possessed no body. He was a ghost.

A ghost that swam through clockwork.

Swamp Thing #60—"Loving the Alien." An elaborate experiment in which John Totleben provided multi-media art, and to which Moore would put words and make a story out of thin air. Swamp Thing TM & ©2003 DC Comics.

experimental it was. Nearly every issue—there's something new that we tried. Some new idea that we'd sort of played out, and seeing how the audience reacted. Sometimes they were wildly experimental. I mean, I think that "Rites of Spring" was a fantastic breakthrough in what I did with John. "Loving the Alien"—that was wonderful. The Gotham City storyline with Batman—that was one I really, really enjoyed. That was kind of spectacular. And in fact, the fight between Batman and Swamp Thing was about the least interesting part of it. It was just the whole idea of the city transformed by vegetation that was the real muscle of it.

But at the end of it I'd had one great run. I mean, I think that *Swamp Thing* is probably the longest run I've ever had upon any comic.

Did you feel—when you'd done your run—this was like you'd just finished university or something?

Well, I felt—I'd done some quite good things before *Swamp Thing* that I was quite proud of, but *Swamp Thing*, it was an intensive work experience in that I was having to do this every month and I was having to keep up a standard that I had set for myself. By the time I'd finished that I figured that I could handle pretty much anything in the comic industry.

Sure, you had these bumps in the road and you survived.

Well, yeah, that's it; I mean it was very fast. We had that one issue that we had a bit of a reprint, a small reprint. Which, if we could have avoided that we would. But even so, we got around it pretty elegantly and I was very pleased in that something like, what, 45 issues I did, something like that?

Yes.

So yeah, that was the longest run I'd done on any title—certainly the longest I'd ever wanted to do—and the overall standard of *Swamp Thing* was very high. No real issues where—even the ones that weren't my favorites, compared to most of the other stuff that was around at the time, they were still pretty good.

Overall the standard on *Swamp Thing*—I was very pleased with it; we'd done some wonderful, innovative work, some beautiful work, told some beautiful little stories, and it

what Rick did with the character afterwards, but that was Rick's vision of the character, it wasn't mine. I mean, there probably wouldn't have ever been a baby if I'd carried on writing the character.

When you sort of chose Rick to follow you—

Yeah, I chose Rick. I think that what Rick did was great.

He managed to keep the tone at least.

Yeah, and he did some fantastic storytelling; he kept up the experimental thrust of the book. Because one of the things that I was proudest of with *Swamp Thing* was how relentlessly

had been a great experience. It had taught me a lot. It had brought a lot out of me, under the pressure, and it had taught me a lot about what I was capable of. And it had given me the urge to—just being given a character blind, like I'd been given with *Swamp Thing*, if I could then go on and turn out this fascinating story, with a character that I hadn't created, that I hadn't had the chance to set up his world in advance, things like that, then what if I had complete control over a world, a set of characters, something like that, and it was done in a much more controlled way, with a given number of issues to tell the whole story? To be much more structured, planned—this was the kind of thinking that eventually led to *Watchmen*.

What if Len at first had told you that he wasn't completely accepting of the fact that he [Swamp Thing] was going to be a plant and wanted to stick more to what Marty had done? What would you have done?

I would have had to re-think the entire character. I would have done it.

I'm pretty sure you would have.

If Len had suddenly decided not to follow that particular thing, then I would have had to come up with something just as radical that would enable me to do the things that I wanted to do but which didn't go down that particular route. I don't know. I don't know what I would have done. Like I said, that first proposal I'd done—I don't know if anybody at DC's still got it. I certainly haven't, but it was pretty good. It has a logic to it that was very difficult to argue. That was my first exposure to the American industry. I couldn't imagine anybody writing back and saying, "No, your ideas are all wrong," you know? Because I made a pretty persuasive argument. Like I said, I don't know whether Karen would actually still have that piece of paper.

From *Swamp Thing*: Chester Williams— who was that character based on? Was that based on Bryan Talbot's character?

Bryan Talbot tells me it was. That's not how I remember it; it's like—from what I remember—and you're perhaps better off asking Rick or Steve—no, Stan Woch who did that episode, wasn't he?

Yeah.

As far as I remember, in my script I asked for the standard hippie guy. Sort of an old hippie guy, give him a ponytail, maybe kind of granny glasses. And he's just a sort of an old Grateful Dead fan. The name Chester, as far as I remember, was just a name that I probably got from *Gunsmoke* as much as anywhere else. But for some reason I had a conversation with Bryan Talbot recently; he was funnily enough, telling me his Chester Hackenbush character had a new edition coming out—he wanted a

Never let them see you sweat! Batman bluffs Swamp Thing in this memorable page drawn by John Totleben in *Swamp Thing* #53. Batman, Swamp Thing TM & ©2003 DC Comics.

IT'S JUST A QUESTION OF FAITH, THAT'S ALL.

Beware of the edible tubers, from *Swamp Thing* #43. Art by Stan Woch and Ron Randall. Swamp Thing TM & ©2003 DC Comics.

like, the way that the character ended up looking like Chester Hackenbush was purely down to the artist. I certainly haven't asked the artist to make it look like that character and if I wasn't directing the artist to make it look like Bryan's character then it seems unlikely to me that I would've given him that name—as a reference. But, like I say, it's a long time ago; I can't really remember. It was a very minor character. I think I used the character two or three times, you know, in certainly minor roles as a kind of back-ground character but, as for that, my version of it is that as I can remember, it was just purely— I needed a hippie character for that Tuber story.

But I think Stan Woch based it on a friend of his. I think John Totleben told me about that.

Well yeah, that sounds most likely to me. That's how I remember it. But like I told Bryan, you know, he remembers it differently. I'm not going to go insane, but that's not how I remember it. I'm not saying that Bryan's wrong. I would have thought that if Stan says that he based it on a friend of his rather than upon Bryan's Chester character, then that would sound like the most likely explanation to me. Like I say, Stan's the one to ask on that one.

quote from me saying I'd based Chester in *Swamp Thing* upon Chester Hackenbush, and I said, "Well, I don't think I did Bryan. As I remember it..." and I told him the story that I just told you. But Bryan was insistent that I'd actually said this to him on some occasion—that I'd done a tribute to Chester Hackenbush in *Swamp Thing* which I really don't remember. So at the end of it I said, "Look Bryan, the only thing I can actually say if you want a quote is 'Bryan Talbot tells me that'—and then I said "You can put whatever you want. And at the end of that put that I have no memory of this."

I said, "That's the only thing I can say, Bryan: Bryan Talbot tells me that I based Chester in *Swamp Thing* on Chester Hackenbush but I have no memory of this." To which Bryan said, "Oh well, that'll do me." He wrote down the quote and—I'm not saying that Bryan's wrong but just that I genuinely have no memory of, as far as I remember, everything—I mean

LUST
(presented on the next 8 pages)

Of the many short stories that Alan has written, **Lust** was the one that stood out tall upon his recollection (and the one he personally requested for inclusion in this book). The story was originally published by radical British publisher Knockabout Comics in 1989 as the corresponding evil in their **Seven Deadly Sins** book. The late Mike Matthews provides the brutal imagery of a world gone mad with his intense artwork. And although the Cold War might be over, the message of this tale still rings very true to this very day—the appetite for power will always lead to senseless war and death. ©2003 Alan Moore and Mike Matthews.

99

THEY WERE RELUCTANT... AT FIRST... BUT WHEN WE APPLIED PRESSURE TO ALL THEIR MOST SENSITIVE AREAS THEY BECAME ONLY TOO WILLING TO COMPLY!

IN THE ENSUING ORGY THEY DID THINGS TO EACH OTHER THEY'D ALWAYS WANTED TO, BUT NEVER DARED SUGGEST!

THINGS THEY'D KEPT BOTTLED UP IN SECRET CAME SPILLING OUT!

ONE FEMALE AQUAINTANCE I'D INVITED TO TAKE PART PROMISED TO RAVAGE THE OBJECT OF MY DESIRES WITH CERTAIN DEVICES, IF I'D PIN HER DOWN WHILE SHE DID IT TO HER...

THE IDEA WAS TEMPTING... BUT I HAD MORE LURID PLANS...!

THE TIME THAT FOLLOWED WAS A BLUR OF FEVERISH ACTIVITY! I PRESSED INTO 'SHE-WHO-OBSESSED-ME' FROM THE FRONT WHILE ANOTHER TRIED TO ENTER HER FROM THE REAR...

...BUT WAS SPENT TOO QUICKLY.

MORE THAN ONCE, I FELT AN INTRUSION AT MY OWN 'BACK DOOR' THAT ONLY SPURRED ME ON...!

EVENTUALLY... THE OTHERS FELL AWAY... UTTERLY DRAINED... TILL ONLY SHE AND I WERE LEFT.

DAVE GIBBONS REMEMBERS...

THE FIRST TIME I MET ALAN MOORE!

IT MUST HAVE BEEN ABOUT TWENTY YEARS AGO, AT A SMALL COMIC CONVENTION IN SOUTH LONDON.

I WAS QUITE WELL KNOWN AS A COMIC ARTIST, HAVING WORKED ON 2000AD AND DR WHO.

I WAS SIGNING COMICS AND DRAWING SKETCHES WHEN WRITER STEVE MOORE INTRODUCED ME TO HIS TALL, THIN, LUXURIANTLY TONSURED COMPANION.

THIS IS ALAN MOORE. NO RELATION.

I SHOOK ALAN BY THE HAND BUT WAS TOO BUSY BEING MILDLY FAMOUS TO TALK. I NOTED HIM MENTALLY AS "STEVE MOORE'S WEIRD FRIEND. NO RELATION."

SINCE THEN, OF COURSE, WE'VE GOT TO KNOW EACH OTHER QUITE WELL.

WE'VE CREATED SOME COMIC BOOKS TOGETHER, TALKED FOR HOURS ON THE PHONE, TRAVELLED THE LENGTH OF THE BRITISH ISLES, FLOWN THE ATLANTIC, EATEN MANY A MEAL, AND DRUNK MANY A BEER AND CUP OF TEA ...

WE'VE BEEN ON PANELS, GIVEN INTERVIEWS, HAD OUR PHOTOGRAPHS TAKEN, COLLECTED AWARDS AND SHARED EACH OTHER'S UPS AND DOWNS.

YES, ALAN AND I HAVE BEEN THROUGH A LOT SINCE THAT DAY TWENTY YEARS AGO WHEN WE FIRST MET. MANY THINGS HAVE CHANGED SINCE THEN. BUT ONE THING'S THE SAME...

I STILL THINK OF HIM AS STEVE MOORE'S WEIRD FRIEND.

NO RELATION.

ALAN MOORE - a birthday tribute

from *Brian Bolland*

IT WAS ABOUT 1980. IT WAS IN, IF MY MEMORY SERVES ME CORRECTLY, THE ROYAL HORTICULTURAL HALL, VICTORIA IN LONDON. I WAS ALL AGLOW WITH FANBOY GLEE BECAUSE I HAD IN MY HANDS A PRINTED COPY OF MY FIRST STORY FOR DC - IN A BRIEFLY REVIVED *MYSTERY IN SPACE*. IT WAS WRITTEN BY *ARNOLD DRAKE* WHOSE WORK I'D LOVED IN THE *DOOM PATROL*.

A COUPLE OF GUYS CAME UP TO ME. ONE WAS *STEVE MOORE*. I'D JUST DRAWN A *ZIRK* STORY WRITTEN BY HIM. THE OTHER ONE, A TALL, HAIRY, DOPE-SMOKING (IN MY ESTIMATION) HIPPY TYPE (UNTIL RECENTLY I'D BEEN ONE MYSELF) TURNED OUT TO BE CALLED *ALAN MOORE*.

THEY DIDN'T LOOK LIKE BROTHERS TO ME.

THE TALL HAIRY ONE SAID, IN WHAT AT THE TIME I TOOK TO BE A BRUMMY ACCENT, SOMETHING LIKE: "I JUST WANTED TO SAY HOW MUCH I LIKE YOUR WORK". I THANKED HIM AND MUTTERED SOME REMARK ABOUT THEM BOTH BEING MOORES. I'VE NEVER BEEN KNOWN FOR MY WITTY ONE-LINERS -- ESPECIALLY AT COMIC CONVENTIONS.

APOLOGIES TO *STEVE*. I CAN'T REMEMBER WHAT YOU LOOKED LIKE AT THE TIME.

THEN THE DELUGE CAME OF DAZZLING, INVENTIVE AND FUNNY STORIES. *DR & QUINCH*, *CHRONO-COPS*, THE PRICELESS *BOJEFFRIES SAGA*, THE DARK AND BRILLIANT *V FOR VENDETTA*. HE EVEN MADE A RECORD, *"THE MARCH OF THE SINISTER DUCKS"*. I, OF COURSE, STILL HAVE THE COPY HE GAVE ME AND PLAY IT TO ANYONE WILLING TO LISTEN.

THEN....HIS NEXT STEP INTO INDUSTRY-SHAKING MEGA-STARDOM WITH *WATCHMEN*. *DAVE GIBBONS* USED TO BRING NEWS OF ITS PROGRESS TO THE MONTHLY PUB-NIGHTS WE HAD WITH OTHER EX-2000 AD CRONIES AND WE KNEW THIS WAS GOING TO BE SOMETHING SPECIAL. I DON'T NEED TO LIST ALL THE THINGS ALAN HAS DONE. WE ALL HAVE OUR FAVOURITES.

I SPENT SOME TIME WITH ALAN AT A CON IN GRENOBLE IN THE FRENCH ALPS (WHERE *SERGIO ARAGONES* SAVED MY LIFE...BUT THAT'S ANOTHER STORY).

ALAN WAS BURSTING TO TELL ABOUT A STORY HE WAS WORKING ON. SOMETHING ABOUT JACK THE RIPPER AND THE HAWKSMORE CHURCHES. THE INFORMATION POURED OUT OF HIM IN A SEEMINGLY ENDLESS FLOW. HIS FASCINATION WITH THE SUBJECT UTTERLY INFECTIOUS AS THE INTER-CONNECTEDNESS OF IT ALL UNFOLDED BEFORE ME. BY FAR THE BEST WAY TO EXPERIENCE AN ALAN STORY IS THROUGH THE LIPS OF THE GREAT RACONTEUR HIMSELF.

...NOT THAT YOU'LL GET THE CHANCE NOW, PROBABLY. AFTER *GRENOBLE*, (OR WAS IT *ANGOULEME*, AN OCCASION WHEN I FOR ONE FELT ASHAMED TO BE BRITISH)... AFTER ONE OF THOSE CONVENTIONS ALAN SEEMS TO HAVE GIVEN THEM UP. I CAN UNDERSTAND WHY. HIS CREATIVE ENERGY FLOWS OUT OF HIM - EVEN ON THE LEVEL OF CONVERSATION - IT FLOWS OUT OF HIM AND INTO US. THERE'S AN UNSPOKEN UNDERSTANDING BETWEEN HIM AND US THAT HE GIVES AND WE RECEIVE. LET'S FACE IT, HE'S MORE INTERESTING THAN WE ARE!

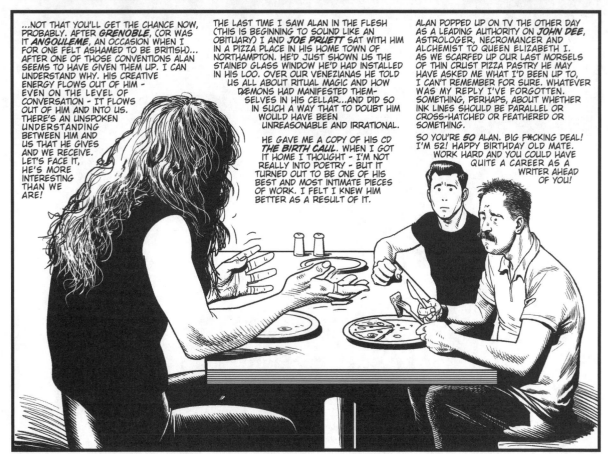

THE LAST TIME I SAW ALAN IN THE FLESH (THIS IS BEGINNING TO SOUND LIKE AN OBITUARY) I AND *JOE PRUETT* SAT WITH HIM IN A PIZZA PLACE IN HIS HOME TOWN OF NORTHAMPTON. HE'D JUST SHOWN US THE STAINED GLASS WINDOW HE'D HAD INSTALLED IN HIS LOO. OVER OUR VENEZIANAS HE TOLD US ALL ABOUT RITUAL MAGIC AND HOW DÆMONS HAD MANIFESTED THEM-SELVES IN HIS CELLAR...AND DID SO IN SUCH A WAY THAT TO DOUBT HIM WOULD HAVE BEEN UNREASONABLE AND IRRATIONAL.

HE GAVE ME A COPY OF HIS CD *THE BIRTH CAUL*. WHEN I GOT IT HOME I THOUGHT - I'M NOT REALLY INTO POETRY - BUT IT TURNED OUT TO BE ONE OF HIS BEST AND MOST INTIMATE PIECES OF WORK. I FELT I KNEW HIM BETTER AS A RESULT OF IT.

ALAN POPPED UP ON TV THE OTHER DAY AS A LEADING AUTHORITY ON *JOHN DEE*, ASTROLOGER, NECROMANCER AND ALCHEMIST TO QUEEN ELIZABETH I. AS WE SCARFED UP OUR LAST MORSELS OF THIN CRUST PIZZA PASTRY HE MAY HAVE ASKED ME WHAT I'D BEEN UP TO, I CAN'T REMEMBER FOR SURE. WHATEVER WAS MY REPLY I'VE FORGOTTEN. SOMETHING, PERHAPS, ABOUT WHETHER INK LINES SHOULD BE PARALLEL OR CROSS-HATCHED OR FEATHERED OR SOMETHING.

SO YOU'RE *50* ALAN. BIG F*CKING DEAL! I'M 52! HAPPY BIRTHDAY OLD MATE. WORK HARD AND YOU COULD HAVE QUITE A CAREER AS A WRITER AHEAD OF YOU!

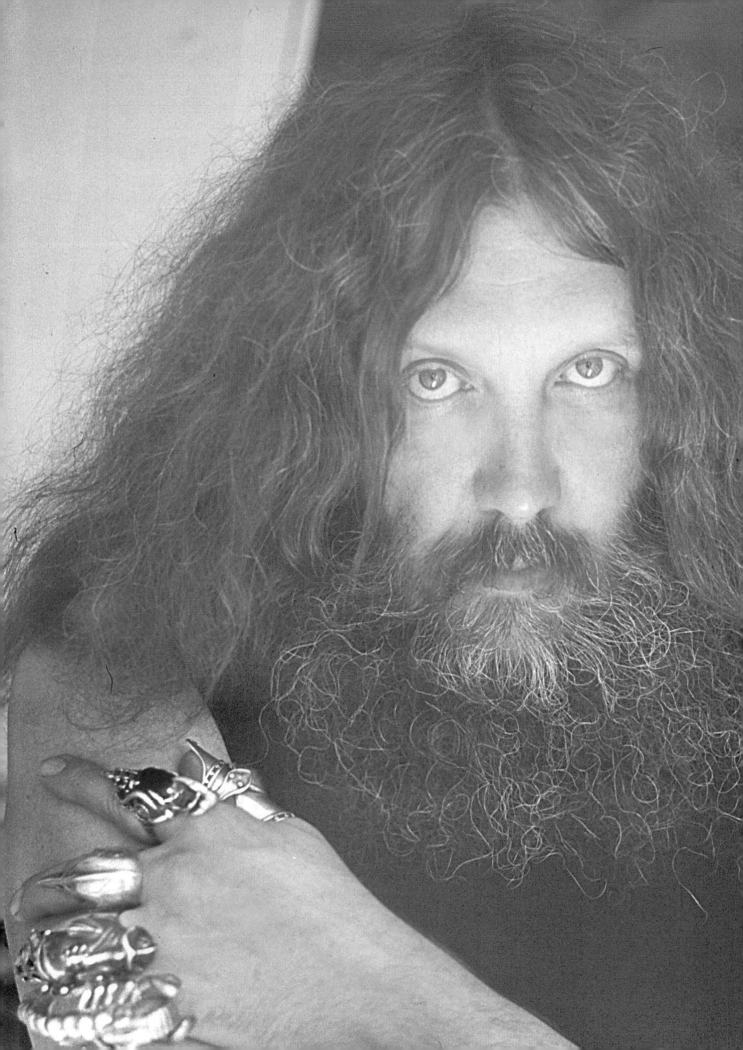

Let's talk about *Watchmen*. What started the initial proposal?

I think that what started *Watchmen* was me and Dave Gibbons had done some work together on *2000 A.D.*; we'd done some very enjoyable little "Future Shock"s together, and we liked working with each other and when we met up we got on well together. Since we both found ourselves working for DC, I think we came up with the idea of doing something for DC and we batted around a couple of different ideas—I know that at one point we were thinking of doing the *Challengers of the Unknown*. Another point Dave got as far as doing the rough pencil sketches for our version of *Martian Manhunter*. There may have been other ideas kicking around, but eventually one of us suggested—and I think that Dick Giordano had just acquired the Charlton characters—either Dick himself suggested it or Dave suggested it, or I suggested it—I can't remember whose idea it was—but the idea was, "Let's come up with a new treatment for the Charlton characters."

Now at this point, I remembered a vague story idea that I'd had floating through my mind for years. I knew that it would entail having a whole continuity's worth of super-heroes. Not a large continuity's worth necessarily, but it would have to be several characters and I'd originally, I think, come up with the idea as related to the Mighty Comics characters. I really wanted sort of second-string super-heroes if you like. I didn't want these iconic figures like Superman, Batman, and Captain America—I wanted more average super-heroes, like the Mighty Crusaders line. I think I had some vague idea that it would be quite interesting to take a group of innocent, happy-go-lucky super-heroes like say, the Archie Comics super-heroes, and suddenly drop them into a realistic and credible world.

I think my original idea had started off with the dead body of the Shield being pulled out of a river somewhere. And this sort of sparking a kind of murder mystery plot. So when the idea came up to doing the Charlton heroes, I remembered this and thought, "Well, yeah, you've got a sort of plausible but not

too large cast of sort of third-string heroes that you might conceivably be allowed to do some radical things with." So we came up with the initial proposal which, as I remember it, named the Blue Beetle, and the Question, all of these characters and then we were told by DC that having just acquired the Charlton characters they really didn't want—much as they thought that the series looked interesting—they really didn't want to do it with the Charlton characters because a couple of the characters would have ended up dead or dysfunctional.

And so, they suggested that we come up with other characters, new characters.

So this was pretty much what we did. Although it was probably a bit reluctantly at first, because I'd hoped to have that kind of nostalgic background aura that using 1960s established characters would have given me. Once I stopped seeing that as a minus and started seeing it as a plus—the possibility of creating new characters—then it kind of flowed from there. That said, the ideas kind of evolved, but over the couple of months that me and Dave were putting the ideas

The aftershock of *Watchmen* continues to be felt in the industry. *Watchmen* was a triumph in storytelling and art direction. The cover to #12 (right) only brings that conclusion home. ©2003 DC Comics.

together, you know, the characters came into sharper focus—more extreme in a lot of cases, because we realized that if we weren't tied to the Charlton characters anymore, then we could make the characters more extreme. We could take them to their limits more than the Charlton characters had been taken to. Dr. Manhattan is a lot more interesting than Captain Atom, and it's taking the idea of a nuclear-powered super-hero but then moving it into very uncertain quantum territory. And coming up with a very different character as a result. With Rorschach, I—the Question was never really a right-wing character in the way that, say Mr. A was. So with Rorschach, we were able to take the basic concept of the sort of the trenchcoat vigilante, the sort of the Ditko vigilante. We were able to sort of mix in a lot of extremism of the Mr. A character, but taking it several stages further. So yeah, it pretty soon became a plus handling those characters and having come up with new characters rather suddenly became an advantage.

And the story kind of took on a kind of life from there really.

Was *Watchmen* one of the first books DC solicited from you after *Swamp Thing*?

Well, I can't really remember exactly the order of things. I know that once they'd seen *Swamp Thing* was doing well, and they were keen on having me create something. And since me and Dave were both planning on working together on something, they figured, "What the hell, might as well let them do it." And, you know, it progressed from there. But I think that *Watchmen* was one of the first things. I can't remember whether I'd done any fill-in stories or—I think I did the *Superman* stuff later—and *Batman*. But the order of things is a bit broad.

I think that once they saw the first issue script—we didn't really have a synopsis of *Watchmen*; it's probably got the plot in there, but I doubt it's got the actual texture. The stuff that makes *Watchmen* radical is not really the stuff that's in the plot. It's not dark treatments of the super-heroes—I mean, that had been done before. I mean you could even say that Stan Lee and Jack Kirby were going for a gritty, darker treatment of the super-heroes back in 1961 with the *Fantastic Four*. More shadows in the artwork, kind of depressed slum dwellings in the backgrounds, more realistic dialogue and character interaction. I don't think that the dark take on super-heroes was the most radical thing about *Watchmen*; the most radical thing about *Watchmen* was the storytelling, the ideas behind it, things that only really emerged in the telling.

I think that when they saw the first script, they were, I think, kind of impressed, because it was a good script. And when they saw Dave's artwork for it I think they were very excited. I did hear that somebody at DC only saw the cover of *Watchmen* #1 when it had already gone to the printers, but otherwise they would have objected to it, because it was too radical. They couldn't see how doing a close-up of a smiley badge and putting the logo sideways and things like that was a smart move. So they would've—if they'd seen it beforehand they would have objected and they would've put a regular cover on it. But luckily, they didn't! And of course, once it came out and sort of—people were impressed by the whole thing—the design, the thinking that had gone into it. But we really didn't hear anymore from that quarter.

Is Dave Gibbons one of your favorite collaborators? Because with *Watchmen* you certainly needed someone you could see eye to eye with.

1985's *Superman Annual* #11, with art by Dave Gibbons. ©2003 DC Comics.

It's not like I really have favorite collaborators. Dave was somebody who was a dream to do work with. But then, most of the people who I work with are in that category. The thing is that—the reason it seems so smooth and eye-to-eye on *Watchmen* is the same reason it seemed so smooth and eye-to-eye on *From Hell*. It sort of—both of those works—or any of this stuff—these were works that were conceived with the artist in mind. I mean, I knew Dave's style, I knew Dave as a person, and as an artist. I had an idea of what Dave's interests were, what things he might like to try; I knew what Dave's capabilities were, I knew that we'd talked about how we wanted to handle the art style. I think that we probably settled upon the kind of Wally Wood "Superduperman!" style. You know, super-heroics, lots of details, heavy blacks, of a distinctive style, something like that. Dave might say differently on that one because obviously he has a better idea of how his art style came together around the thing.

But, as I remember it, it was something like that; we were thinking that probably the best super-hero stuff was the *Mad* parodies of it—that super-heroes never looked better than when Wally Wood was parodying them. So we decided to sort of take some of those elements from the *Mad* parodies—you know, we were having massive amounts of background detail but it wasn't sight gags; it was, sight dramatics, if you like. And background details that worked in service of the story in the same way. Yeah, we were giving these very weighty-looking heavy blacks, shadow-sporting super-heroes just set against this world, and I was thinking about—with every panel, I was

imagining it drawn in Dave's style to try and have it clear in my head. Is this something that Dave would have fun doing? Is it something that Dave could do? And would be interested in? So the end result is that I'm working very hard to make the story work for the artist, just like the artist is working very hard to do what I suggested in the script. The script has been written with me working very hard to fit it to the artist so that the end result will look as seamless as possible.

So that you could almost think of it as the work of one person, except that—actually in practical experience, I mean, there's no one person who could have ever done *Watchmen*.

I read that initially you weren't planning such a highbrow comic, but that it all just happened.

We had a ton of intellectual ideas, but it was just around about issue #3 when we suddenly noticed that something interesting was happening with the storyline. It was just borne out by the fact that Dave was capable of putting in all of this incidental detail and that I was capable of writing narratives that have more than one strand to them, and that this suddenly gave both of us kind of increased capacity; there was suddenly new things that we could try— new effects. Then straight away with #4 we tried to exploit these new techniques we were starting to discover.

We started to get clever with symmetrical stuff in the Rorschach story, gradually. During the course of the series we explored most of the possibilities of the new forms of story-telling that we originated especially for *Watchmen*. So no, we didn't have any idea at the beginning. It was something which just emerged from the story as we were telling it. The story seemed to demand a specific way in telling it, a specific way of seeing the world. It had to be seen all at once rather than in a strictly linear way. We wanted to show all these different characters. None of them were more important than any of the others, they're all important. All these tiny, little moments, coincidences, linkages—that all boiled up into this sort of complex tapestry or piece of machinery. It turned out very

The first page from the *Watchmen* proposal, back when the characters were supposed to be the former Charlton heroes. ©2003 Alan Moore.

much like a piece of watchwork. It was like—well, there was a kind of Swiss watch feel to the structure of it, as though it was sort of jeweled flywheels and everything all completely in place in their elaborate settings.

At the time, did you feel that this was one of the biggest things you'd ever attempted? The more you kept writing, the more the story kept growing—

By the time I'd done issue #4, we both knew that it was pretty awesome, that we were doing something big here, and that nobody had ever done it before and that it was going to have some effect and make some ripples. I think that there were times where—up around issue #5—we were pretty certain of

111

that. But it was just a matter of bringing the baby home, sort of keeping up the quality. And at one point—I think that when *Watchmen* #1 came out or something—I think we had a sort of a friendly phone call from Howard Chaykin or something, or we'd heard that he had said something where he'd said that—to let us know that—he'd heard it was really fantastic and he'd give it to issue #4 before the quality dropped off. He said that it was such a strong beginning that he doubted that we could keep it up beyond issue #4. So yeah, we were quite pleased to sort of—if we only proved Howard wrong, then that was an accomplishment.

It seemed that one of the biggest things that contributed to its success were its design and pacing.

Yeah, well the design elements, we wanted the thing to look as different as possible. We couldn't see any point in making it look like everything else on the overcrowded comics rack. We wanted—let's put the thing sideways, why can't we do that? Let's not have action scenes on the cover; let's have these tight close-ups, and let's make them the first panel in a sense so that the story starts from the front cover to a certain degree.

Let's have this progressing watch hand on the back with blood trickling down. Most of these were Dave's ideas, I think, but I know that we both talked about how we wanted *Watchmen* to look and the differences in the style. I mean the storytelling of the actual comic itself, as opposed to the design. It's not just the pacing, although that's obviously a part of it, but it's more a sort of—there are some sequences that you've got two or three separate narratives all going on in the same sequence and occasionally linking up with each other in ambiguous ways or non-ambiguous ways. We were sort of trying out a whole new repertoire of things that hadn't been attempted in storytelling. One of the things which—I think it worked great in *Watchmen*, but I've tried to avoid it ever since— was the changes of scene, bringing upon some fragment of something that somebody had said, or upon an image with another image like it in the following panel. That was one of the things that tended to get imitated after a while, but, you know, there were some interesting bits of storytelling in there. There was the whole *Black Freighter* narrative, you know, the way that reacted with the rest of the plot.

All these things were very important in that they were, as far as I knew, the first time anyone had ever done anything like that. Even things like the back-up features—the stuff that's usually letter pages or dead space for advertising space—the fact that we were able to do these little sort of bogus articles and writings to flesh out the backgrounds of *Watchmen*. I don't think anybody had done that before. We were just on a creative roll; we were thinking of lots of new ideas, and I think that

There's nothing funny about this Comedian. Killer promo art for *Watchmen* series by Mr. Gibbons. ©2003 DC Comics.

every part of the comic we approached with a "Well, why does it have to be like this—could we do it some other way?" And *Watchmen* was the result.

It was also the first time you did the comic *within* the comic device.

Yep. There'd been things where—I think I'd probably done the chapter of "V for Vendetta" where I'd had V—the one where he's storming the television studio, and there are television programs showing while he's attacking the TV studio. I'd found that you could get some interesting effects by having one story, like the television program or comic, within another story in such a way that the two could sort of spark up with each other. So I think that the initial idea might have very well come from "V for Vendetta." But I could see that there were some interesting possibilities in having one narrative embedded in another, so that you could strike interesting sparks between

the two. *Watchmen* was the first time I'd really taken that idea and had run with it. For the story of the pirate comic, we had to come up with a genuine story that actually worked and was interesting in itself, and then I worked out how it can also relate to the overall *Watchmen* story. Yeah, it seemed like a very useful idea in *Big Numbers* that I had several fantasy levels to the narrative, because I wanted to take the idea further.

Even in *Lost Girls*—a large part of that of that is this pornographic book that is available at the hotel where the characters are situated. And we keep showing excerpts from this book, which is in the bedside table of every room in this hotel in much the same way that Gideon's *Bible* is in every bedside table in real-world hotels, you know? But yeah, it's the same idea from *Watchmen*; there's something quite delightful about narratives within narratives and the possibilities that that allows. That said, it's probably a thing that you wouldn't want to overuse, you know. I wouldn't want to do it forever—

Lost Girls, that's about it. It's nothing I'd ever want to do in every book that I ever did.

One of the things you said in your proposal was that you wanted to see elements that were real. That you didn't want this comic to parallel our world, but be somewhat different from our reality. Why?

I think because—one thing it gave us was freedom. We were saying right up front, "Look, this is not our world." We know there was no real Dr. Manhattan in this world, but this is not our world. This is a *realistic* world where there was a Dr. Manhattan, a world where this other stuff happened. And we also wanted to have a world which made for a more interesting backdrop. We realized that a lot of the story would probably have people walking up and down the streets, standing around in rooms talking. Then we thought that it would at least be interesting if we made those streets, those rooms, and the dress of the people standing in them, somehow more interesting. It's a similar thing that we've done with the ABC books, for slightly different reasons. If you can be consistent enough and sort of inventive enough, you can come up with a recognizable version of the real world that is visually very different to the real world but still packs the same kind of emotional clout. And I think that, yeah, that was something that we were very definitely consciously exploring with *Watchmen*.

Is Rorschach the protagonist of the book?

No, I don't think there is a center of the book. I mean, part of what *Watchmen* was about is that all of the characters have got very, very distinctive views of the world. They've all got very distinctive views of the world, but they're all completely different. Rorschach has got this fiercely moral view of the world—everything in Rorschach's world is seen in fiercely moral black and white terms.

The Comedian has got a fiercely cynical view of the world. He's perhaps as violent as Rorschach, and he probably does have his own code of behavior but it's not necessarily a moral one. It's based upon a kind of cynical, scornful view of the world and of morality. Dr. Manhattan is somebody who is completely beyond earthly considerations. He used to be human, and that's about the best you can say for him. He's got a kind of quantum view of the world in which cynicism and morality really don't have a part; they're not relevant to the kind of particle level of existence that Dr. Manhattan is mainly fixated upon. Adrian Veidt is... an enlightened human. He is fiercely intelligent, and he believes that— he's almost like a Nietzschean character—he believes that it's the individual man taking responsibility for his circumstances that can change the world. Unfortunately, he perhaps believes in taking that kind of belief to its extreme and you end up with an arrogance that borders on delusions of godhood. A lot of the people who messed

"You know what I wish? I wish all the scum of the Earth had one throat and I had my hands about it."
RORSCHACH (1975)

A 12 ISSUE DELUXE SERIES BY ALAN MOORE AND DAVE GIBBONS

Rainy days, lonely nights—Gibbons captures the mood of Rorschach's struggle.
©2003 DC Comics.

our planet up the worst saw themselves in their minds as heroes who were saving us. Whether they were saving us from the Jews or the black races or the Communists or whatever.

And in the end Veidt realizes that his plans have failed.

Well, he realizes he's left with some ambiguity and he's also left with an incredible dark weight upon his conscience. And there is the ambiguity of Dr. Manhattan's parting line, you know? "Nothing ever ends." There is not an outcome. The fat lady hasn't sung yet, she perhaps never will. In the real world, everything is not parceled into stories; it's a continuum. Yes, you might find out who killed Roger Ackroyd or whatever, but then something happens the day after you've found that, and the day after that—life goes on. It's all one big process; there aren't any endings except in fiction. Which kind of leaves Adrian Veidt with his bad dreams, with the sudden appalling discovery of a conscience. Yes, he has bad dreams; he dreams that he's swimming towards the big black ship, towards the

Beautiful Dave Gibbons Rorschach painting for the French edition of *Watchmen*.
©2003 DC Comics.

ship from *Tales of The Black Freighter*. He's as damned as the narrator who also ends up swimming towards the big black ship to take his place aboard its dreadful crew now. And that's where Adrian Veidt ends up.

I mean Dan and Laurie; they're the most human characters. Dan's a romantic and Laurie is hardheaded, practical, slightly embittered. So they're all different worldviews, and there is no central one. The whole point of the book is to say that none of these characters are right or wrong. They are all humans or former humans who are doing the best according to their lives and according to the circumstances as presumably do we all. I didn't want to make any character the one who's right, the one whose viewpoint is the right viewpoint, the one who's the hero, the one who the readers are supposed to identify with, because that's not how life is; that's not how my life is.

Ultimately it's the reader who has to make the choice. It's the reader's decision, it's the reader's world, ultimately, as I say in the last panel, I leave it entirely in your hands. That it's up to the reader to formulate their own response to the world—sort of—and not to be told what to do by a super-hero or a political leader or a comic-book writer, for that matter. I think that was the thinking behind *Watchmen*.

You also have Adrian Veidt's desire for utopia, you've hit on that utopian theme various times. I think you sort of say that basically a utopia is a falsehood.

Well, I think I said that the *détente* at the end of *Watchmen* is kind of—yeah, America and Russia are now buddies and the world's a safe place—I think I said that that was a falsehood. That this was based upon a lie, based upon a sort of an incredibly destructive hoax, but, yeah, I'd say that in my work in general, there are things that I'm talking about that are generally projections on the human condition. I will project the human individual into extreme states. What if it was a quantum demigod who experienced all time simultaneously? What if we were vegetable creatures who knew everything that was happening in the environment as if it were happening inside our own bodies? What if we were Victorian serial killers with some strange, Masonic beliefs in ancient patterns of order that must be reinforced? What if? And as well as taking individual characters and projecting them to some extreme point, there's also the world that they still inhabit and you can project that world to various extreme points.

Now there are really only two extreme points that you can project the world to. One of them is Utopia, the other is Apocalypse. I mean, in actual real life, we'll probably muddle on somewhere between the two [laughs],

probably for thousands of years yet. But I don't have thousands of years to wait and I'm a writer of fiction, so I can project, I can extrapolate, I can speed the process up, I can bring about the situations in my fiction where there's a chance to examine the human world and human beings in very extreme situations. I mean, like, with "Marvelman"—what if the super-heroes turned up and fixed everything for us? What if they made it an absolutely magical world where everybody's dreams came true and everything was lovely and there were no problems? Then, what would that be like? Would that be as much fun as it sounds? Or would it be kind of a bit uncertain and uneasy and anxious and would there be a feeling that we'd lost something, you know?

I mean, I also project various apocalypses—whether it's Kid Marvelman in London or whether it's Adrian Veidt's fake alien in New York. Whether it's the limited nuclear war that happens before the first issue of "V." These are all attempts to see human beings in the human world, to extrapolate people and the places that they exist in to some future extremity. Little thought experiments to see what happens to people in our culture—if this were to happen or that were to happen. I mean, it's not uncommon in writing—certainly not uncommon in British writing.

You've got J.G. Ballard over here, a fantastic writer—the greatest living Englishman—and his early works, it would seem—he would end the world by different means in every book. In *The Drought*, it stops raining. In *The Drowned World*, it doesn't stop raining. There's ones with gigantic winds that bring society to a halt; there's *The Crystal World* with jewels growing over everything. But, they're all basically about the end of the world; they're all projecting human culture to an extreme point. And then having a look at what that does to the characters, what that does to their culture. And yeah, I've always certainly been a big fan of the British apocalyptic writers like J.G. Ballard, like Michael Moorcock and his Jerry Cornelius stories and, yeah, I can see why they have a fascination with utopias or dystrophies with Armageddon. It's interesting territory.

One of the quotes I liked that I read somewhere you said, "It's dangerous to have heroes." And that was one of the things you were trying to prove with *Watchmen*.

Well, that's true. I think it *is* dangerous to have heroes. For one thing, most of the people who we consider heroes who sort of single-handedly overpower enemy machine gun nests—then it would seem evident to me that those people are actually psychotic. It's not a matter of being heroic to run into a hail of bullets; there is something wrong with your ideas about your

Who watches the Watchmen watch? One of many Watchmen products produced in the late '80s.
Watchmen ©2003 DC Comics.

own mortality. That is not natural for any animal to do.

There's also the thing that we only really get *allowed* certain heroes. I remember I did a program for Rapido TV over here, and they've got an interesting line-up of people talking. There was—I think it was called "Heroes"—and they've got Sting, Bob Geldorf, the Dhali Lama, Benazair Bhutto, J.G. Ballard, various people and me and a couple of others and Alan Ginsburg. There were a few others. We didn't get to hang out—I didn't get to hang out with the Dhali Lama and Benazair Bhutto in the Green Room afterwards, unfortunately, you know; I was quite looking forward to that, but they filmed us all separately. But in that, I was kind of making the point that we only get the heroes that we're allowed.

I was talking about—I think they asked whether I thought that the Chinese guy in Tiananman Square who ran in front of the tanks and stopped the tanks for a while was a hero. And I was saying, "Well, yes, it's hard to deny that somebody who walks in front of something as scary as a tank for reasons of morality and politics, yes, that's very brave." But it's also worth pointing out that this is very much like, say, Jan Palach, who was the young Czech patriot who set himself on fire in front of the tanks as they rolled into Prague in the late '60s. Now the thing that Jan Palach and the guy in Tiananman Square have in common is that they are both *anti-communist* heroes. You know, over here, during the Thatcher regime, we had an unemployed man from up North, who drove down to London, parked his car at the bottom of Downing Street, which is where the Prime Minister's address is, and set fire to his car with himself inside it, as a protest against the economic policies that had destroyed his life, robbed him of his job, his dignity, and everything else.

This was shown on the early evening news on the day that it had happened. It wasn't shown on the later evening news, it was not referred to on subsequent days; I think about a week later they showed a shot of his widow standing at his gravesite looking a bit confused. The thing is that I can't really see any huge difference between what that man had done and what Jan Palach had done in Prague. They were both people who set themselves on fire protesting against the regime that was being imposed upon them. The only difference is that one of them was protesting against the Communist regime that was being imposed; the other was protesting against a free-market capitalist regime that was being imposed. We weren't allowed to have one of those people as heroes, we were only allowed to have the Tiananman Square guy or Jan Palach. I'm not taking away from Palach or from the guy

in Tiananmoon Square. I'm not saying that they weren't heroes, but I'm just saying that they were heroes that we were allowed because they were protesting against the "Evil Empire" and whereas, obviously anybody who's fighting against us or protests against us, because we're the good guys, they must be mad or evil and certainly shouldn't be treated as heroes. That seems to be the general attitude. And heroes are dangerous because we like them too much.

I think I pointed out at the time that the people of Germany in the '30s—Hitler was their hero. He was the man that—the one heroic man who was going to put everything right—a bit like Bruce Wayne. That one good man that could still turn it all around. And that was how the German people saw Hitler. That he was heroic, or at least he talked a good heroic struggle. He was going to rescue them from their woeful economic plight after the treaty that had been imposed at the end of the first World War, the Treaty of Versailles, and he was going to get rid of all these awful Jewish bankers who were controlling the

world and corrupting pure Aryan boys and girls. And they were so wrapped up in worship of their hero that they went out and trampled over half the world. Destroyed six million people in this staggering, unbelievable holocaust because their hero told them to. And yeah, most of our leaders—you don't have to look as far back as Hitler. Most of our leaders in the world today—I can think of a few of them—who strike heroic poses, but whatever their personal lives may have been like, whatever their personal history may have been like, they'll rattle their sabers, they'll try and look steely-eyed and firm-jawed, and would talk of themselves as heroes who are prepared to get out there and really take on the villains in this world.

Generally, it has to be said, you know, that most people are, through no fault of their own, incredibly stupid. Most people, they are suckers for a firm jaw and a steely glint in the eye even if the person is an absolute paranoid psychotic who is intent upon dragging the nation or the entire world screaming to the brink of Armageddon—if they look heroic we'll generally not only let them get away with it, but will follow them enthusiastically, waving flags every step of the way.

That's sort of how we got George W. Bush.

I'm not going to mention any names, but yeah, we have the same problem over here with Tony Blair.

That's why Adrian [Veidt] would be the perfect guy—he was blond, he had the white teeth, the perfect teeth—

That's it. He's good-looking, he's—television is to blame for a lot of it—the fascism of pretty. If we had a brilliant politician, a brilliant moral thinker and if he or she was the single greatest political intellect and moral intellect ever to have been experienced upon the surface of this planet, but if they were fat, or if they had a bad complexion or if there was some bad hair— if they didn't look good on television, basically—then they'd be unelectable. I mean, this is ridiculous. This will mean that eventually Jennifer Aniston will be President. I mean, why not just elect somebody pretty; it obviously doesn't matter whether they have got a brain in their head, whether they've ever had any moral thoughts at all. If they're kind of decent-looking, and can trot out a string of platitudes at least semi-professionally, then yeah, let's let them lead the free world, let's let them lead the country, let's go to war in defense of their honor. Yeah, that makes sense. Quite frankly I'd be happier with cartoon characters or domestic pets running the country than most of the bozos that we have at the present, you know? And they've been elected because of their surface gloss which the majority of the voting public it seems cannot see any further than.

What exactly does the smiley face mean to you? Does it mean that the happy days are over?

Well, I guess so. I don't think we knew why we

Originally appearing in *Heartbreak Hotel* #1, this one-page strip, written and drawn by Moore, summarizes his third and final journey to the United States. ©2003 Alan Moore.

116

were putting it there. Dave had put this... smiley badge on the Comedian and when we were planning the first issue, I thought maybe we should—I forget who it was who suggested it—but we thought that perhaps we should maybe make something out of that. I think that perhaps when we thought, "Hey, it'll be good if we have that on the first issue's cover." And that led to us coming up with the idea for the first page. And so we'd got this smiley badge with a little splash of blood over one eye and it's a very compelling image, considering how simple it is. It wasn't until further on in the series that we actually started to understand the history of the smiley badge and why it made such an effective image with that little blood splash over it.

Intense scene from the end of *Watchmen* #12, as Sally Jupiter kisses a photo of the Comedian.
Watchmen ©2003 DC Comics.

Apparently from what we heard, there were some tests that were done upon babies—if you lean over a baby's cot and smile, the baby will respond. If you hold a photograph of you smiling over the baby's cot, the baby will smile back. If you hold a drawing of you smiling over the baby's cot, the baby will smile back. It doesn't even have to be a very detailed drawing; they tried simplifying it as much as possible and they found out that a yellow circle with two black dots for eyes and a black smile drawn in was the simplest design that will elicit a response from a newborn baby.

So in some ways, you could say that image is the ultimate scientifically tested image of innocence. I think it came about during the '60s. That's certainly when it came into prominence, and of course that was an age of innocence, a lot of childlike qualities. So, by putting that splash of blood over the eye, yeah, it's sort of saying, the age of innocence is over. If you like, the good times are over. That is not the world we're living in now. Wake up and smell the brimstone [laughs].

Super-heroes are also an image of innocence that young people respond to. There's a similarity there. Just as the smiley badge gets bloodied up, it's a symbol of innocence that has been bloodied up—then the same is true of these innocent,

simple nostalgic kinds of super-heroes in *Watchmen*. That their image is bloodied up. That innocence is no longer possible. I suppose that was also stuff that we were trying to say with that cover.

Why, at the end of *Watchmen*, does Sally Jupiter kiss the photo of the Comedian?

Because I wanted—that was something that I thought long and hard about.

He raped her, didn't he?

He raped her. He raped her and she still had Laurie with him some years later, when she was married to someone else; she had consensual sex with him some years later. And I was trying to think, is this psychologically credible? And I could see that it was—I certainly didn't want to say, "Ah, she secretly enjoyed being raped," or something like that. But I wanted to say that it might be more complex than that; it might be more complex than it looked on the surface. That there might have been, despite his behavior, there might have been some part

of her that responded or that she felt guilty about the response; it might have been very complex. And I think that at the end of the thing, where Edward Blake is dead, I think she loved him. I think she loved him despite the rape and probably without even being able to understand herself why she should feel like that. I think there was some part in her that loved the guy even though nobody else did. And that that made it so that it wasn't as clear-cut. It just felt right, I suppose, is the short answer.

I certainly wouldn't want to have to defend my thinking upon the character. But it felt right, I suppose, is the only ultimate answer that I can give. It struck me that it wasn't as simple as just that one scene that we see in *Watchmen #2*. That yes, that happened, and it was a dreadful thing, and time passed, and maybe things changed, and she changed, and he changed, and that despite it all there was some unpredictable, inexplicable spark of love there. So I guess that's why she kisses his picture.

Despite all of that, she had their daughter.

Mm-hmm. I don't think that she would have even known why she'd had her brief affair with him and—I don't know if Blake ever knew that there was some sort of chemistry between them even if he was a complete bastard. It's—I don't know; people sometimes do some funny things, I suppose, is the best thing I can sort of say in my defense on that one, you know? It seemed counter-intuitive but then people's behavior often is counter-intuitive, particularly when it comes to sex and love.

It's like sometimes people don't understand why a woman would return to her abusive husband over and over again, you know?

The introduction page from the memorable *Superman #423*, the last Superman story in a pre-Crisis world. Art by Curt Swan and George Pérez. ©2003 DC Comics.

The last stand of Superman, from *Action Comics #583*. Art by Curt Swan and Kurt Schaffenberger. ©2003 DC Comics.

Exactly. Or they'd say, "Oh well, it must be because she's frightened of him!" Yes, that could be the case a lot of the time, but sometimes it's probably because she loves him, even though he hits her, even though he rapes her, even though he humiliates her. There are some things in human chemistry that—I'm not saying that it makes it right for him to do those things or that she is right to return to an abusive partner, but I'm saying that it happens, that it's a real part of how humans fit together. In stories, you can understand the motivations of everything that everybody does, because it all has to fit together. Sort of like a neat puzzle. But I mean, I don't know if I've got any friends or people close to me even where I could say that I understand exactly why they've done everything that they've done in their lives; I couldn't even say that about myself. It seems to be—that kind of x-factor, that random urge—seems to play a huge part in human makeup. Some things we do and we've got no idea why we're doing them other than the fact that we feel that we've got to. That was the kind of situation that I saw with Sally Jupiter and the Comedian.

That seems to be something that people don't understand about super-heroes—there is no perfection, you know? You can't be Superman unless you *want* to.

Well I think being Superman—I mean to even be a superior being—it's not actually to do with having powers or to believe. You've already got powers. All of us have incredible abilities, talents, things that can achieve miraculous things. Most of us, yeah, we've got all of these superpowers and we never do anything; we sit down on the sofa and watch TV, and drink beer and zone out—and I suppose that if we had got telepathy or super-breath or the power of flight or invulnerability, we'd probably still sit on the sofa and watch TV and drink beer. It's like, most people, it wouldn't matter whether they did rescue a dying alien, jet rocketing here with babies from an exploding planet, or find the magic flying ring or whatever, it wouldn't matter, because it's not heroism or super-heroism or just simply being a decent person. It's nothing to do with gaining special powers to do this with.

If you are a fully aware and awake human being, you will see the quite marvelous powers that you, as an ordinary human being, already have at your disposal. And you'll see how you are using those powers or not using them. Now, I mean, there's plenty of people on this planet—I mean, in terms of what they could accomplish—how much below the fictional Superman does, say, Bill Gates rate? Bill Gates has this superpower of immense wealth. Now, you've got that much money, am I right in thinking that you could probably pretty much do anything?

Sure.

And Bill Gates is not the only sort of fantastically rich person on the face of the planet, so these are people who have superpowers. When have they saved the world, ended hunger, done magnificent, massive gestures—did they ever even save a snoopy girl reporter from falling out of a window? They didn't. We have people with superpowers on this planet and they're not necessarily superior people. On the other hand we have some people on this planet who would seem to be completely disadvantaged and not have anything going for them and yet they've accomplished fantastic acts.

I'd like people to actually think about, what does heroism mean? What is power? What are super-powers? Does Stephen Hawking have a super-power? I mean, he would seem to me upon the available evidence to be much smarter than, say, Superman or Braniac 5. He completely outstrips every comic-book genius. And he's even in a wheelchair, so he could join the *X-Men* or the *Doom Patrol*, or any of those kind of— differently-abled friendly super outfits.

The super-powers don't really matter at the end of the day, it's the characters that are important. Just as it doesn't really matter whether me or you or the reader ever gain the ability to run faster than light and get a neat costume. That won't make any difference to us. If we're an asshole now, all we will be then is an asshole in a neat costume who can run faster than light. This is not going to really improve the universe any, you know? The important thing is that ordinary human beings are fantastic. They are fantastic in what they can do and what they can be. They can do fantastic things to their world for good or ill. They don't need powers. They don't need outfits and chest insignia. With things like *Watchmen* and a lot of my subsequent work I've tried to sort of suggest that. That having superpowers wouldn't necessarily make you a nice person and that ordinary human beings are what we've got to work with; we don't have any super-heroes here.

So live your life.

Live you life, and that's heroism. Live your life, try and do the right thing. Try and be the best person that you can be. *That* is heroism. That is super-heroism. Don't hang around waiting, standing near a big rack of chemicals waiting for the lightning bolt, because that's not going to happen. And if it did, it wouldn't make any difference; you wouldn't be any happier. In fact you'd

The classic "Mogo Doesn't Socialize" story from *Green Lantern* #188. Art by Dave Gibbons. ©2003 DC Comics.

119

probably be electrocuted and dead. That's my guess anyway.

What did you feel that *Watchmen* accomplished for you? Personally and professionally? Did it open doors that you didn't want opened?

It opened doors for me in that I suddenly became aware of what I might accomplish in the future. With *Watchmen*, me and Dave had done something which had gone beyond the limits of what I expected to be able to accomplish in comics, which meant that there weren't any limits.
It meant that anything that I could vaguely imagine accomplishing I could probably do. So, it was very liberating in those terms, and the response to it fixed a place for me and Dave in comic book history. I mean it was the first book of it's kind; it was a major book then, and it's still a major book now. It still sells very well, even after 16, 17 years or whatever. The only thing that I didn't like about *Watchmen* was the effect that it had on the industry.... What I'd seen *Watchmen* as being was something radically different that was taking lots of chances and trying to do something that had never been done before. So the idea of people doing things that were like *Watchmen* was a contradiction in terms. If it had been like *Watchmen*, then it wouldn't have been like anything else. It's like with Kurtzman. He did *Mad* magazine, which was probably one of the best comic books ever, and because it was so good, everyone thought, let's do something like *Mad* magazine. And so they'd come up with magazines that were named after some form of mental illness or other and they all had "Scenes We'd Like To See," and movie parodies and things like that, because they thought they were being like Harvey Kurtzman, like *Mad*. But, if it really wanted to be like Harvey Kurtzman or like *Mad*, they would have come up with something that nobody had ever seen or thought of before.

That's the way to emulate your heroes, not by doing pastiches of their works, and I kind of hoped that after we'd done *Watchmen* people would have looked at it and not said, "Oh wow, we can do super-heroes but more violent and with more sex and swearing." I really hoped that they would look at it and think, "Hey, there's interesting story possibilities here; there's storytelling techniques that maybe we could adapt, or change a bit, or come up with some new ones." We were trying to say that, "Hey, you know, there's a world of possibilities out there. *Watchmen* is just us exploring one of those possibilities." That there's a world of possibilities and everybody should explore their own.

Spot illo by Eddie Campbell from his *Escape* article, "Out on the Perimeter." ©2003 Eddie Campbell.

But instead, you got these retreads of *Watchmen*. People trying to graft dark sensibilities upon characters that had never been designed to carry those kinds of sensibilities. Any poor wretched innocent Golden Age character that hadn't just washed up on Vertigo for a period—it was pretty certain that they were going to be re-imagined as a sort of dark, psychopathic monster from the edges of human rationality. Even if they were something like, I don't know, if it were Stanley and his Monster or something like that, you know, things where it just wasn't appropriate. Whoever said that all super-heroes have to be grim, oppressive, and dark? That's never been true of any books that I've done. I mean, in *Watchmen*, yeah, you've got Rorschach, you've got the Comedian. I don't think that Dr. Manhattan is dark; I don't think that Night Owl is dark. In *Swamp Thing* there was lots of dark material, but there was some very bright, quite ecstatic joyous material in there as well.

I kind of get the urge to tell some of these people there are notes at the other end of the piano as well. If they just moved their stools they'd be able to reach 'em.

If it weren't for comics likes *Supreme*, *1963*, and *Marvels*, we'd still probably be stuck with these dark and gritty comics.

With *Supreme*, with *1963*, what I wanted to say was that, yes, you can do grim super-heroes, but there's plenty of fun to be had with super-heroes that aren't grim. Even without psychosis or ulterior motives and all the rest of it. Super-heroes are still an excellent vehicle for the imagination. You can play in this wonderful funhouse of ideas with super-heroes. And that's great. That's great not only for kids, but imaginative fiction is something which is perfectly fine for adults. I suppose with things like the ABC work, with *Supreme*, with *1963*, it was kind of an attempt to say, "Look, you know, get over *Watchmen*, get over the 1980s." It doesn't have to be depressing,

Brian Bolland inked a Moore photo for a British radio program in 1986. Artwork ©2003 Brian Bolland.

miserable grimness from now until the end of time. It was only a bloody comic. It wasn't a jail sentence.

That was the thing that I most regretted about *Watchmen*: That something that I saw as a very exciting celebratory thing seemed to become a kind of hair shirt that the super-hero had to wear forever after that was—yeah, super-heroes from now on, they've all got to be miserable and doomed. And if they've got to be psychopathic as well, then so much the better. That was never what me and Dave intended.

So, that was the only thing that I regretted about *Watchmen*. But the book itself I think was wonderful, you know? Working with Dave was wonderful and—

What about the experience with the public?

Yeah, well I didn't like the way that the attention seemed to come. You get tired of that stuff real quick.

It's okay the first time. [laughs]

Yeah, it's sort of okay the first time, but even then, I was a bit creeped out by fame and exposure by that point and it sort of—that big convention in England around the time that *Watchmen* had just finished when "Watchmania" was at its highest—that was when I kind of decided that this is where I have to back off, I have to handle this. I can't just... drift along; I have to make definite moves to cut down my exposure.

What about DC? What did they want from you? Did they want more work or—?

Yeah, I mean—

Intro page from "In the Blackest Night," from *Tales of the Green Lantern Corps Annual* #3. Art by Bill Willingham and Terry Austin. ©2003 DC Comics.

Watchmen II?

Well, there was that. I think *Twilight* was the *Watchmen II* sort of proposal. Something that would do—it was just this big crossover. I think that was when they offered me a big crossover and I just said, "Well, yeah, I could do a crossover but you'd have to do it in a very special way, because crossovers don't usually work." But if you did it like this, this, and this, and then I did the *Twilight* proposal. But I guess that they were very pleased by the success of *Watchmen* and were pretty much—I think we could have done more or less whatever we wanted.

Besides *Swamp Thing* and *Watchmen*, did you enjoy the rest of the work you did for DC?

A lot of good stuff. I mean, some of those little things were quite good. I liked, obviously, the Superman books, both the one with Dave and the two-parter with Curt Swan. That was fantastic to work with Curt Swan on that last Superman story. That fulfilled an awful lot of childhood ambitions, and I thought we gave Superman a good send-off. I do still tend to think of that as the real last Superman story; it's just my personal fancy, but as far as I'm concerned, yeah, that was the story that was the end of the character that had been around since the end of the '30s. And I liked that, and I loved Brian Bolland's art on *The Killing Joke*—didn't like my story very much. The best Batman story I ever did was the one with George Freeman, that Clayface one, that was good.

It's some of the little things that I did, that *Omega Men* one that I did with Kevin, that was good—I like doing short stories. And so yeah, the "Green Arrow" ones with Klaus Janson—I'm not saying that any of these were great stories but I fondly remember them as jobs that were well done. The *Vigilante* stuff with Jim Baikie. Vigilante was a character that I really hadn't any kind of empathy with, but that two-parter with Jim, we were able to move into some quite charged areas and tell quite a powerful little story. It was quite nice to be offered some odd, little back-up story or something that I could just have a bit of fun with a character I might not have used before. Some of those *Green Lantern Corps* back-up stories with Dave or Kevin, Bill Willingham, people like that.

With *The Killing Joke*, what did you not like about it? I kind of think that it captures the characters [of Batman and the Joker]—it's always going to be this cat-and-mouse chase and it's never going to end.

What I don't like about it—really, you know I should apologize to Brian, because I've always tried to stress that Brian's artwork is wonderful on that book and it was lovely to see it. The only problem I've got with it is my writing. And I think that the problem was that I wrote it while I was writing

THERE WERE THESE TWO GUYS IN A LUNATIC ASYLUM...

FNAP

ALAN MOORE ♣ BRIAN BOLLAND ♦ RICHARD STARKINGS ♥ BRIAN BOLLAND ♠ DENNY O'NEIL
WRITER ARTIST LETTERER COLORIST EDITOR

Batman: The Killing Joke teamed up Alan Moore and Brian Bolland for the first (and so far only) time. ©2003 DC Comics.

Because it was supposed to be a regular *Batman Annual*?

Well it wasn't supposed to be a *Batman Annual* but it was—how long was it, 48 pages, something like that?

Yeah.

I mean there's never been such a thing as a 48-page graphic novel.

There's never been anything like a 15th Anniversary, either.

Well, that's it, you know? The word graphic novel had just been thought of by somebody at DC's marketing department and they wanted to cash in on it by calling everything a "graphic novel." I think my point was, "To call *The Killing Joke* a graphic novel is meaningless because it's just like a big Batman story; it's like a *Batman Annual*." That was what I meant, that in terms of its size—it wasn't even as long as an 80-page Giant. It was just an oversized Batman story, and I didn't like the idea of the word "novel" being made completely meaningless. It was just a marketing term. And so anything could be called a graphic novel, which is what happened. Immediately you've got people that were sort of—they've got a six-issue run on some lame DC or Marvel character and they thought, "Ohhh, if we can package all these together, we can say it's a graphic novel."

I was just reading about that this morning—they had this concept about just repackaging things and calling it soft graphic novels or something like that.

Something like that—that you'd get six issues of, I don't know, *She-Hulk* or something, and would be kind of put together and they'd say yeah, this is the *She-Hulk* graphic novel. No it's not! If "graphic novel" is to mean anything, then the word "novel" must have some meaning as well as the word "graphic." Or anything with pictures in it is a graphic novel. So it was the way that *The Killing Joke* was pushed—and also I felt that it was too nasty. I thought I'd made a cardinal error by making it so grim and nasty, because it's okay to be nasty or grim or terrifying if that is in service of making some important point.

There's lots of nastiness in *Watchmen*. But with *Watchmen* you're talking about kind of the universal issues; there's a payoff. There's some nasty stuff in *Swamp Thing*, but with *Swamp Thing*, again, it's fine to talk about something that's important in a lot of those stories. If you're going to play the

Watchmen, or just after. But, I was still too close to *Watchmen*, I was bringing the same storytelling approach to Batman as I had for *Watchmen*. I was also bringing the same kind of quite grim, moral sensibility to Batman. I think that the reason I'd ended up doing the Batman story was because the original idea had been, "Do something with Brian." I knew that Brian—I think he said at the time that he fancied doing a Batman story but that really what he fancied was a Joker story. So I did my best to come up with what I thought was the quintessential Batman/Joker story. I think that the fact that it was being taken as a graphic novel also got on my nerves.

122

nasty card then you have to make sure that you've got a good reason for playing it, that it's not just gratuitous. That it's not just there to make an otherwise, perhaps, dull story more exciting. Don't do something horrible and nasty just because you couldn't think of anything interesting.

Sure.

That's easy and cheap. And I think that that's probably, at the end of the day, what happened with *The Killing Joke* because there's some very nasty things in *The Killing Joke* and ultimately at the end of the day *The Killing Joke* is a story about Batman and the Joker; it isn't about anything that you're ever going to encounter in real life, because Batman and the Joker are not like any human beings that have ever lived. So there's no important human information being imparted. Now, that said, I know that I've slagged *The Killing Joke* pretty remorselessly since it first came out. I mean, when I go into a sulk about something, you know, it lasts for decades. On the other hand, I've seen some of the other—there've been worse *Batman* books than *The Killing Joke*. *The Killing Joke* is probably not as bad as I've painted it. There have certainly been worse things done with Batman or with a lot of other super-heroes for that matter.

So in context, *The Killing Joke* wasn't as bad a book as I've said it was, probably. That in terms of what I want from a book from my writing, yeah, it was something that I thought was clumsy, misjudged and had no real human importance. It was just about a couple of licensed DC characters that didn't really relate to the real world in any way.

It was about two psychopaths.

Yeah, a couple of psychopaths, and unlikely psychopaths at that because, yeah, there are plenty of psychopaths in the real world but we don't have any that dress up as a circus clown or a bat. So, like I said, you're not going to encounter those people on your next trip to the 7-11 or whatever, and knowing that their psy-choses are a mirror image of each other is not really going to improve your life any. So that was what was wrong with *The Killing Joke* from my point of view.

What were some of the factors behind why you left DC?

Well, it was a combination of things. The main one, I think, was that I was starting to realize that DC weren't necessarily my friends. That I had been told when we were signing the contracts for *Watchmen* and *V for Vendetta* that there was this great little clause which would mean that the rights to these books would revert when they

were no longer in print.

At that point, there had never been a comic book collection that had stayed in print for more than a couple of years. Certainly there hadn't been one that had stayed in print for nearly twenty years. It seemed to us at the time, as if, you know, this seems fair. Once DC aren't publishing it any more then the rights revert to us; it's not like we're doing work for hire, here. We're sort of signing a legitimate contract just like anybody else would where there is a specified cut-off date. It was only later that we realized that, of course, if DC kept it in print forever, then they would have the rights to it forever. Which seemed to us as if we were being punished for having done a particularly good comic book. If we had done a slightly

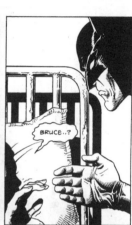

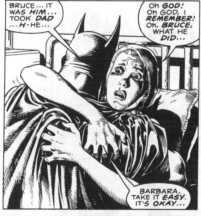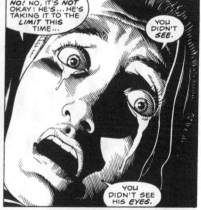

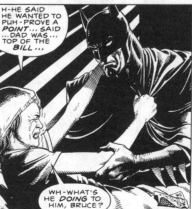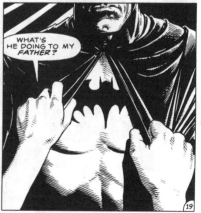

Originally designed to be a *Batman Annual*, *The Killing Joke* has become one of Batman's most cherished tomes—with over ten printings to back it up. ©2003 DC Comics.

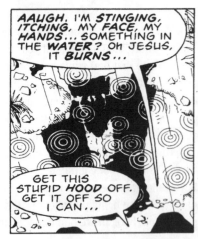

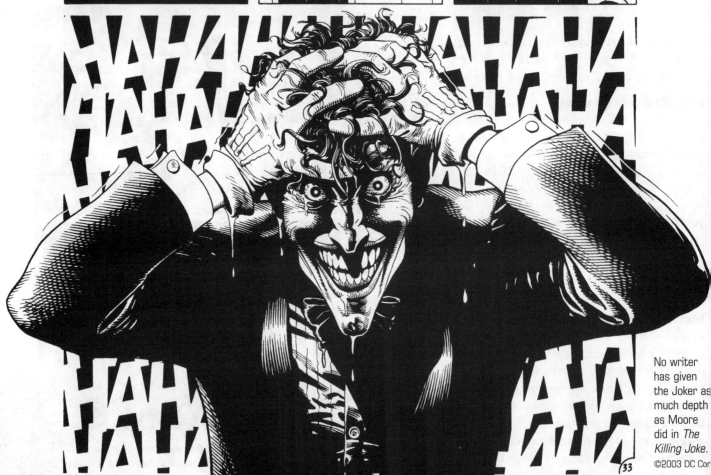

No writer has given the Joker as much depth as Moore did in *The Killing Joke.*

less profitable book for DC, if we'd had hacked out the kind of usual jobs that people were doing back then and sometimes still do, then no doubt we'd have the rights to it by now.

That because we did something which actually brought DC and the comic industry in general an immense amount of attention, where it brought acclaim which the comic industry in general did not deserve—it brought all of these articles in trade magazines and highly respected journals saying, "This is it, comics have grown up, everyone should be reading comics; there are mature themes and adult sensibilities now." Meanwhile, at the comic companies, you've got their marketing departments who could only see another fad to be exploited and effectively driven into the ground, milked dry.

So in order to meet this increased expectation on the part of the public as to what a comic was or could be, they rushed out collections of their ordinary crappy comic books but with the glossy covers, the price hiked up and the word "graphic novel" somewhere on the front. And really, I mean *Watchmen* certainly was not the only book that brought all of that attention to comics in the 1980s, but it was one of two or three that actually brought all of that attention and money and prestige and acclaim. And I think that it was the fact that I saw these shoddy business dealings as a kind of a hangover from this near-criminal era of American publishing that, for the rest of the publishing world, was over in the 1940s or 1950s, more or less. But in comics, it seems to have hung on.

I mean, you'll forgive me for saying this but my perception of American business—as I reach the end of my twenty-five-year flight through that landscape—is that American business, because it is powerful and because it can jiggle the rules, it can mislead, deceive and it's got the muscle to bully people into accepting its terms. This is certainly the impression I receive from the American businesses that I have dealt with. I've got to say that it seems to me that American businesses tend to represent, what, American foreign policy?

Yes.

In microcosm. And I've gotta say that—with the greatest respect and affection in the world—if the way that your businesses treat people is the same as the way your government treats other countries, then you really perhaps shouldn't be that surprised when once in a while they get cross with you, you know? That's all I'm saying. Because you can get away with something, because you're big and strong and tough and bullying enough to get away with something, because it's legal what you've done, that doesn't mean that it was right. That doesn't even mean that it was acceptable to any ordinary human being with ordinary moral values. And if it's not acceptable— yes you might have got away with it in terms of you got the money, you cheated the person out of whatever was rightfully his or hers, and there was nothing they could do about it then, yeah, I suppose you could say in a very limited, simplistic, ignorant view of the world, that you got away with it. But you've left all that resentment in your wake. You've left things

that haunt and harm your company, your industry, or maybe your country. They will haunt and harm them for years to come, decades, centuries, who knows? It was this kind of perception that I was starting to get from DC. I was starting to realize that we'd been screwed out of things like *V for Vendetta* and *Watchmen*, which were nothing to do with DC—DC had no part in inspiring or creating any of those scripts. They were purely me and the two respective Daves. And of course, you know, all the letterers or other colorists that had been involved. But other than us creative people, nobody else had any moral right to those works.

But DC could get away with it; it was legal, you know? They could show us the bits in the contract which under American law—which is the only law that anybody's concerned about— it's all perfectly legal. They can get away with it, you know? This led me to resent other things as well. Like, for example, I started looking at all the *Swamp Thing* reprints that were coming out. And I was thinking, "Sure, well, I didn't actually create the character Swamp Thing, and I didn't create the name Swamp Thing, which—with respect to Len and Bernie— it's not the most original name in the world. The character of Swamp Thing after I'd worked on it with Steve and John and all the other guys—Rick and everybody—it was a completely different character in all but name. I'd sort of fixed the origin around, we'd made it into a completely unprecedented charac- ter; it was like nothing that DC or any other company at that time had seen before.

And because it was successful, the style of *Swamp Thing*, that kind of led to Vertigo where you could kind of factory farm a particular mood or ambiance because it proved popular. Well, like I said, by this time, smarting a little from having realized that I'd sort of sold my babies to the gypsies in the case of *V for Vendetta* and *Watchmen*, I was also starting to feel a little bit put out and used in the fact that I had revamped DC's entire occult line, and *Swamp Thing* in particular, and that this had turned into a small industry for them. What was originally just the way that I liked to write stories—perhaps a little darker, perhaps a little more poetic, perhaps a little more concerned with real events of the day that were relevant—this had become an industry, this had become a house style. And I was getting reprint fees—$20 a page, or less than that—sort of some pitiful amount. I'd done, along with the artists, as much work on those as I'd done on the books that I was getting royalties for. But, no, it was these little bits of meanness. Well, really, to make one happy would have cost a few thousand dollars. And they would have kept my good will, and the fact that they haven't kept my good will I'm sure has lost them more than a few thousand dollars over the years.

Once I was starting to move into this antagonistic relation- ship with DC where I did feel that I was being screwed—and I felt that sometimes I was being screwed by people who would smile and pretend to be my friends, which is again perhaps something that is completely common in the world of American

business, that maybe this is a perfectly legitimate tactic: smile at people, pretend to be their friends, ooze over them enthusiastically, flatter them, charm them as best as you can manage, then screw them. Perhaps this is some form of etiquette which I fail to understand. But it upset me. And consequently, when—there were these various factors when it came to it and I think Frank Miller rang me up and was saying about this labeling fiasco and he was saying about let's have a petition to say that we don't like this labeling stuff.

And so I said, "Fine, I'm pissed off at DC anyway, and I've got a lot of objections to these kinds of labeling ideas, this rating system." So yeah, I sort of put my name to this petition that was going to be published. I think that DC's response was just more or less, "Well, we're going to do all of this stuff anyway, and we don't care what this list of creators say." I think at that point, if I remember this correctly, the fan press were—like the *Comics Journal*—were calling me up and I think probably some of the other main signatories of the thing asking us what we were going to do now. So I said, "Well, if they're going to insult us by completely ignoring our protest on this, then I'm quitting. I'm not going to have my stuff published." I was serious about this and I can remember the other signatories were, and it had just been signed, and I was insulted—I can't work for them anymore.

At this point, I was hearing that there were comments in the DC offices that were, "Oh, they're children, ignore them, they'll get over it." That's another thing which rankles with me; I don't like being told that I am childlike or childish by somebody who I probably feel has half the intellect that I have. That rankles. I think I would decide who is more child-like in these circumstances.

And I don't know whether—I think that probably I was about the only person of the list of signatories who said, "Well, in that case I'm quitting." I don't know what happened to that—what actually happened there, not sure. But I ended up quitting, you know, because I'd actually meant it. And so, that was it really. DC made lots of overtures to try and get me to reconsider, but reconsidering things is not really generally one of my strong points.

It seemed like they never really understood that creators are what drive these characters, because otherwise they're just really empty.

Well, the thing is that none of the comic companies can afford to see it like that, because actually, you might reasonably say that if it wasn't for the enthusiasm that decades' worth of writers and artists have invested into, say, Batman, then what's so great about Batman?

Exactly.

What's so great about this character? Some guy whose parents have been killed and dresses up as a bat to fight crime. And well, it's not Tolstoy, is it? And like, the same with *any* of these characters—they are empty vessels of no particular importance or relevance. The only thing that elevates them

above that is the sheer energy that the various creators have invested in them over the years. I can remember when Frank [Miller] brought out *Dark Knight* #1; I remember that the buzz in the DC marketing department was that what had made *Dark Knight* #1 a success was the format. Not Frank's art, not the storytelling, not Lynn's coloring, nothing like that—the approach to super-heroes—what had made it a success was the only thing which the marketing department had contributed to, which was what size it was and what kind of cover stock it had. So it would be inconceivable that they would say, hey, you think that *Dark Knight* thing—do you think it sold because of the quality of the material?

They could not even consider that concept; it had to be something that they had done. This is why you've got—they suddenly invented a name for this—Prestige Format and I think you perhaps remember they brought out a couple of other books in the prestige format which weren't quite as prestigious as *Dark Knight* had been. So I don't know what the flaw of their thinking was there, but obviously, the star of the show, or at least as far as they were concerned, was the cover stock and the actual size of the pages. That was what people were buying it for. They probably didn't actually even read *Dark Knight*; they just thought, "All these thousands of people bought it," and said, "Hey, look at this cover stock!" [laughs]

"What an interesting size!" The comic executives are largely divorced from reality—or at least that was my perception of DC back then. And I was kind of sick of it, you know, so I decided to say, "Okay, no problem." If you don't like something, walk out.

Did it feel liberating doing that?

Yeah, very much so.

DC probably thought you would have changed your mind in a week.

Yeah, yeah. I mean like, I was talking about this with Karen Berger just a few weeks ago when I was saying that actually I would be finished with mainstream comics in twelve months time. All being well, I would never intentionally return to them again. And Karen said, "Well never say never," or, "You can't say never." And like I said to her, "Actually, Karen, I can," and she agreed that yes, actually, I can. I mean I think someone once said that the main difference between America and England is that in England a hundred miles is a long way, and in America a hundred years is a long time, you know?

That's the main difference. If I say "never" then it's only going to be trickery, skullduggery, or the most desperately manipulative measures that are ever going to get me to go against that. We're not talking about ABC yet, are we? So, yeah, that's pretty much how I bowed out of mainstream comics back around the end of *Watchmen*, you know, after I finished *V for Vendetta* and all that stuff. As a minor point, I remember that when I announced that I was quitting DC but that I would honor my contract and I would finish up *V for Vendetta* and I would do all this stuff, I remember that one of the DC apparatchiks—one of their little editors—went on the

What rays do, they climb as high as possible

then drop, rutting in free-fall to the poisoned lake below. If it's timed right, they separate before they hit the water, carried off at angles by the great momentum of their coitus, overshooting distant banks to catch a sapling with their tails, the whole tree bending as it breaks their flight, leaves fluttering, settling, 'til the rays hang swaying gently, off to sleep already in their wings, black fruit that dreams upon the branch. Of course, if they mistime the drop, they're dead.

He entered her at fifteen, maybe twenty miles an hour, the slap resounding from the furthest shore. They hung there, frozen, then they fell, arriving naught, towards the reservoir.

I didn't breathe. Nothing was moving now except my hand, except the falling rays. And I thought "There Death, look at that! See? That's how much we care for you Death. Man, we're fucking in your face and we don't care about your acid lake; your Bomb; that big black future you keep threatening to hit us with, 'cause we're alive, and you can *sit* on it."

They fell, they fell and just before they hit the water, peeled apart, a splash that never came, but oh God I did.

I did.

One of George Khoury's favorite Moore short stories is the lavishly beautiful "Act of Faith," illustrated by Stephen R. Bissette and Michael Zulli fro *Puma Blues* #20 (1988). ©2003 Alan Moore, Steve Bissette and Michael Zulli.

know? All of these things contributed to me to see the DC comics in particular, and probably mainstream American comics in general, as being corrupt, desperate, vampiric, carnivorous— that would take talented men and women, suck all the juice out, and then throw the skins away when they're finished with them. And when those sucked-dry husks of skin have finally died, then they could do some sanctimonious black-edged obituary or memoir—one of those Bullpen pages. They could bring out a classic hardback collection of that person's work and get some more money out of it. Have they no f*cking shame? I think *that* basically summed up my attitude; I really could not bring myself to deal with these people anymore. They stank. I have got—you've seen my house, George?

Yes, I have.

It's a mess. [laughs] I'd be the first person to admit that. I'd be the first person to admit that perhaps my standards of physical hygiene are somewhat lacking. My standards of moral hygiene, however, are impeccable. I know when something smells and I prefer not to remain in that kind of diseased atmosphere, because if you stay around those kinds of places too long you're going to catch something. So, I got out, while my precious bodily fluids were intact.

Net or something and announced that Alan Moore was really doing new work for DC, he was going against his word, because there'd been all these *V for Vendetta* scripts that had turned up. And, this was something else where I thought, well, these are people without any honor, in my definition of the term, and yet they are attempting to besmirch mine.

And again I think that this was because no one could prove anything that isn't illegal; they got away with it, you

Photo ©2003 Jose Villarrubia

IN PICTOPIA!

"In Pictopia!" is a premonition, a bad dream of things to come and an elegy to the once much beloved medium of funny-books. Written by Alan right after he finished *Watchmen* in 1986, its concept is fairly simple: the world of sequential art (mostly the comics industry) is a city where all the characters from different strips live (and die) together. Pictopia is fenced, so nobody can get out, but some characters and even entire areas of the city are disappearing, while others are appearing out of the blue. The main character, a magician named Nocturno, wakes up abruptly in the first panel. As we follow him in a around the town, his stroll reveals both the nature of the city and the mystery taking place.

Seven years after writing this story, Alan decided to become a magician himself; not of the parlor trick variety, but of the shamanistic one. And then, two years later, he wrote the last chapter of his first novel, *Voice of the Fire*, in which, like Nocturno, Alan goes for a walk full of revelations about his hometown, Northampton. Perhaps life does imitate art, and vice-versa.

All of the characters in this story, including the background figures are based on others from comic strips and comic books: Nocturno is Mandrake the Magician, Flexible Flynn is Plastic Man, Red is, of course, Blondie, etc. Alan has used stand-ins ever since he wrote "Marvelman," which, in turn, was inspired by the *Mad Magazine* parody "Superduperman," a lampoon of Superman. By not using the "authentic" characters, Alan is free to give them "realistic," or more likely unflattering, qualities that they were never supposed to have, freeing the story to actually make points that are not completely sugar-coated.

This was the first time that he fully explored the concept of crossing over incongruous characters, drawn and written in completely different styles. Donald Simpson, of *Megaton Man* fame, did an incredible job rendering a world that is both believable and extremely expressive. Aided by Mike Kazaleh and Peter Poplaski, the story flows effortless from scene-to-scene; "Pictopia" means, etymologically, "the land of pictures," and its pictures are, indeed, superb.

This story anticipates several trends that have been ailing the comics industry. First of all, yes, the immoral, violent, garish super-heroes that were taking over Pictopia then, now, seventeen years later, rule it. And, yes, the animals of Funny Town never came back, and the black-and-white comic strip characters have kept disappearing. You may say that the writing was on the wall back then ("Who Watches the Watchmen?"), but its degree of accuracy is unsettling, nevertheless.

The concept of mixing fictional universes continued after this, both in popular media (*Roger Rabbit, Cool World*) and especially in Alan's own work (*1963, Lost Girls, League of Extraordinary Gentlemen, Supreme, Tom Strong, Top Ten,* etc.). Alan also used the dramatic structure of "Pictopia" in other stories exploring socio-political topics: "Brought to Light" and "The Mirror of Love."

I jumped at the opportunity of re-coloring this story, when I found out it was going to be reprinted in this volume. Using a combination of digital and hand-painted textures, I thought I could bring an extra dimension to this narrative. Like MGM's *The Wizard of Oz* did, I am trying to utilize state-of-the-art technology to further enhance this, by now, classic fable.

So, go ahead and enjoy "Pictopia": Read it once and you may cry, like I did the first time I read it. Read it a second time, with a reference book like *The Smithsonian Collection of Newspaper Comics* by your side, and if you do a "Where is Waldo" with it, you will cry with joy to discover (or rediscover) the almost forgotten comic strips yielded by the last century.

José Villarrubia, Baltimore 2003

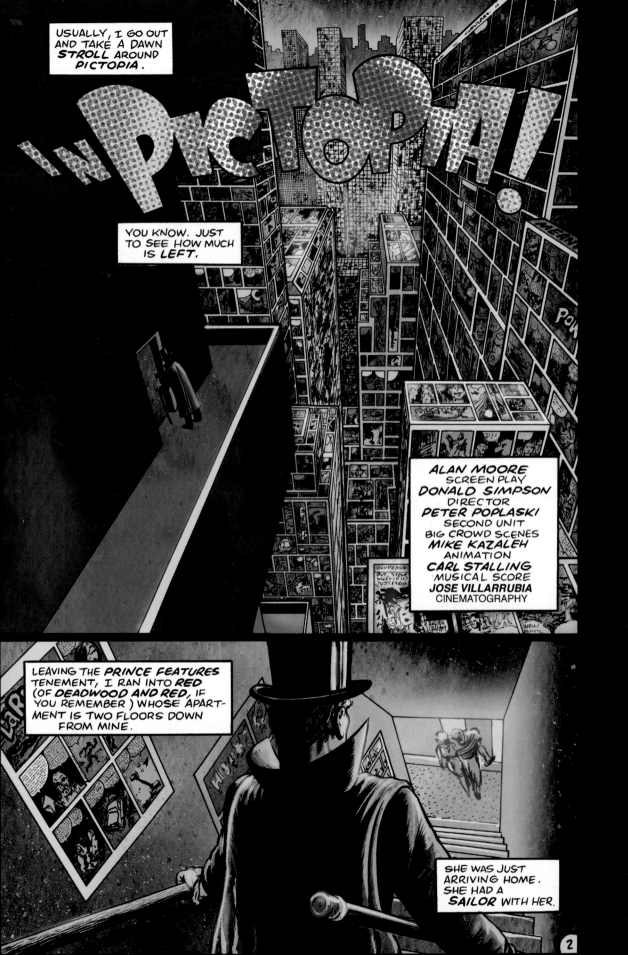

USUALLY, I GO OUT AND TAKE A DAWN *STROLL* AROUND *PICTOPIA.*

IN PICTOPIA!

YOU KNOW, JUST TO SEE HOW MUCH IS *LEFT.*

ALAN MOORE
SCREEN PLAY
DONALD SIMPSON
DIRECTOR
PETER POPLASKI
SECOND UNIT
BIG CROWD SCENES
MIKE KAZALEH
ANIMATION
CARL STALLING
MUSICAL SCORE
JOSE VILLARRUBIA
CINEMATOGRAPHY

LEAVING THE *PRINCE FEATURES* TENEMENT, I RAN INTO *RED* (OF *DEADWOOD AND RED,* IF YOU REMEMBER) WHOSE APARTMENT IS TWO FLOORS DOWN FROM MINE.

SHE WAS JUST ARRIVING HOME. SHE HAD A *SAILOR* WITH HER.

2

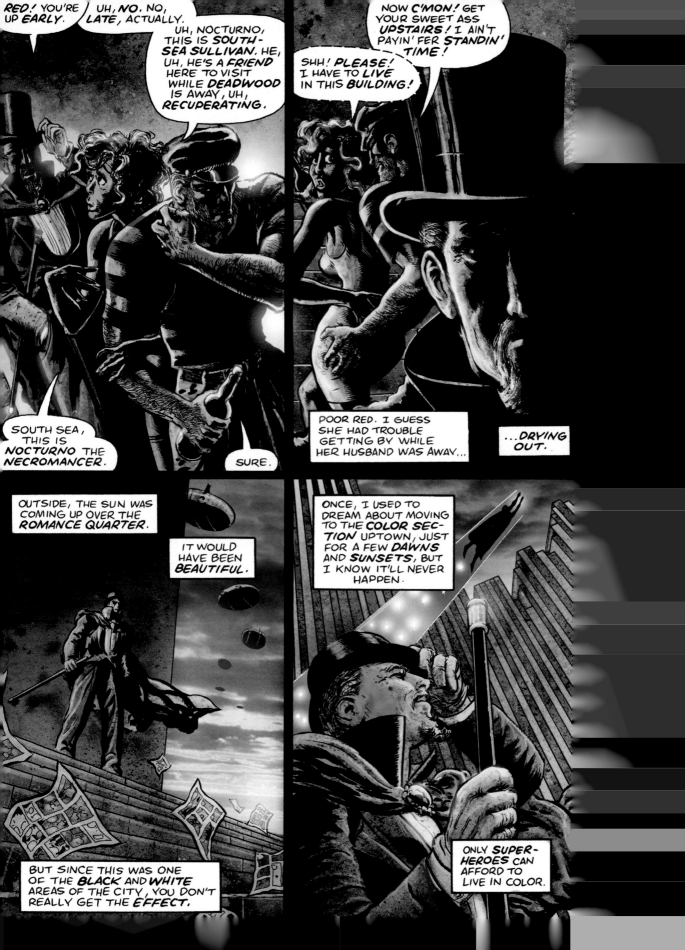

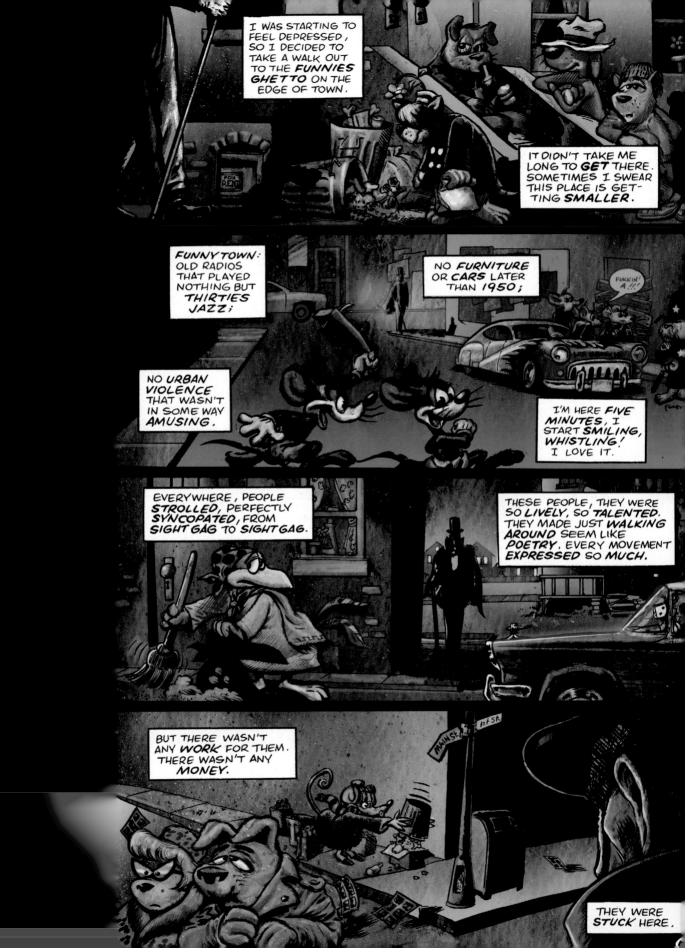

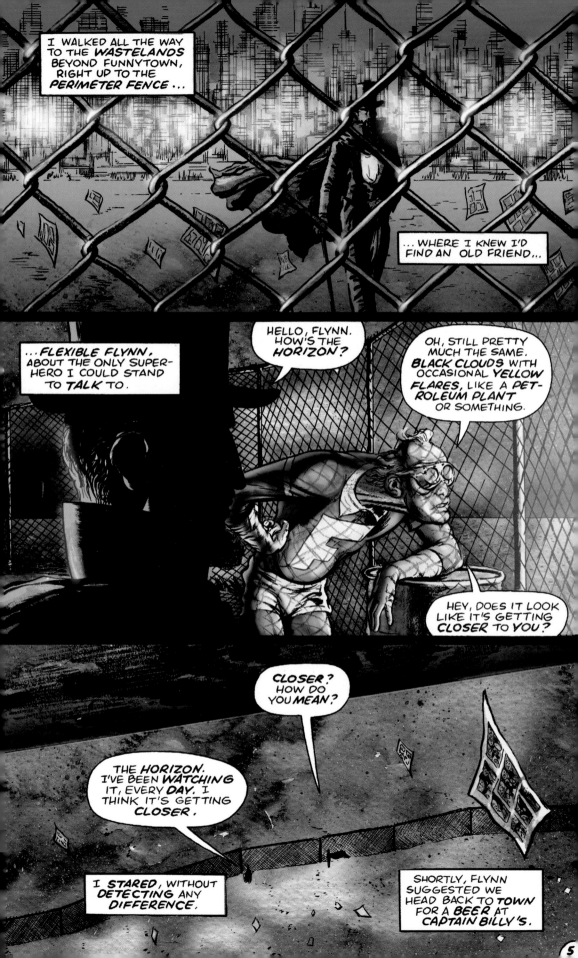

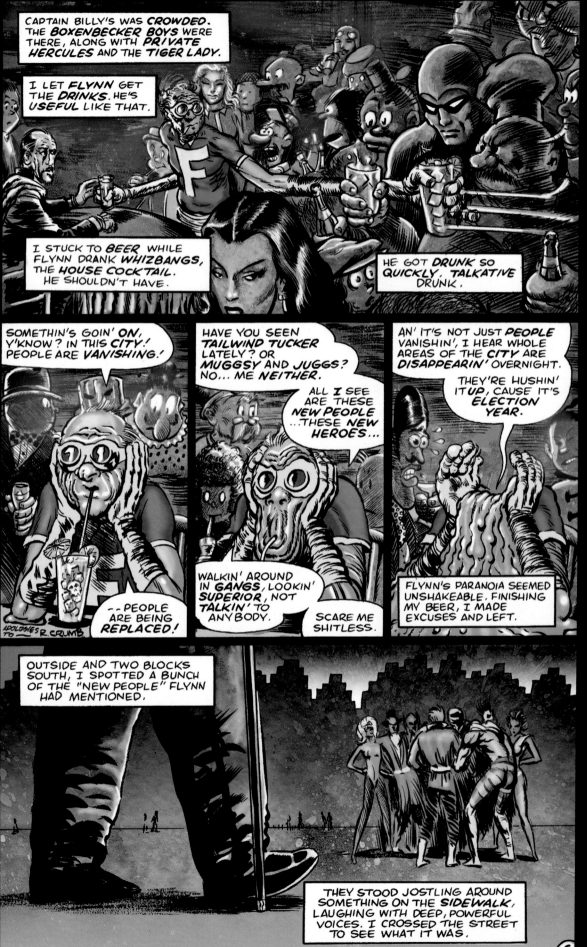

CAPTAIN BILLY'S WAS **CROWDED**. THE **BOXENBECKER BOYS** WERE THERE, ALONG WITH **PRIVATE HERCULES** AND THE **TIGER LADY**.

I LET **FLYNN** GET THE **DRINKS**. HE'S **USEFUL** LIKE THAT.

I STUCK TO **BEER** WHILE FLYNN DRANK **WHIZBANGS**, THE **HOUSE COCKTAIL**. HE SHOULDN'T HAVE.

HE GOT **DRUNK** SO QUICKLY. **TALKATIVE** DRUNK.

SOMETHIN'S GOIN' **ON**, Y'KNOW? IN THIS **CITY**! PEOPLE ARE **VANISHING**!

--PEOPLE ARE BEING **REPLACED**!

HAVE YOU SEEN **TAILWIND TUCKER** LATELY? OR **MUGGSY** AND **JUGGS**? NO... ME **NEITHER**.

ALL **I** SEE ARE THESE **NEW PEOPLE** ...THESE **NEW HEROES**...

WALKIN' AROUND IN **GANGS**, LOOKIN' **SUPERIOR**, NOT **TALKIN'** TO ANYBODY.

SCARE ME SHITLESS.

APOLOGIES TO R CRUMB

AN' IT'S NOT JUST **PEOPLE** VANISHIN', I HEAR WHOLE AREAS OF THE **CITY** ARE **DISAPPEARIN'** OVERNIGHT.

THEY'RE HUSHIN' IT **UP**, CAUSE IT'S **ELECTION YEAR**.

FLYNN'S PARANOIA SEEMED UNSHAKEABLE. FINISHING MY BEER, I MADE EXCUSES AND LEFT.

OUTSIDE AND TWO BLOCKS SOUTH, I SPOTTED A BUNCH OF THE "NEW PEOPLE" FLYNN HAD MENTIONED.

THEY STOOD JOSTLING AROUND SOMETHING ON THE **SIDEWALK**, LAUGHING WITH DEEP, POWERFUL VOICES. I CROSSED THE STREET TO SEE WHAT IT WAS.

6

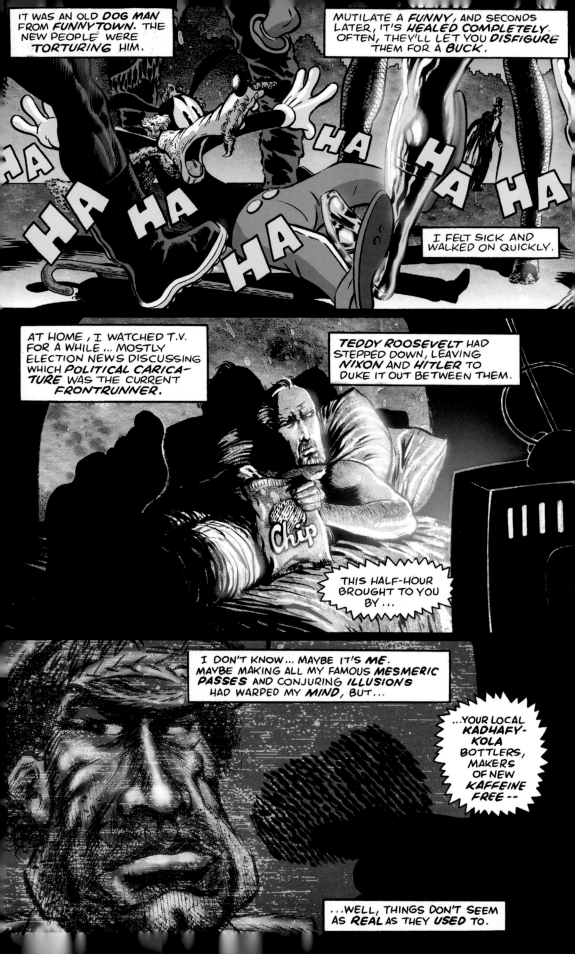

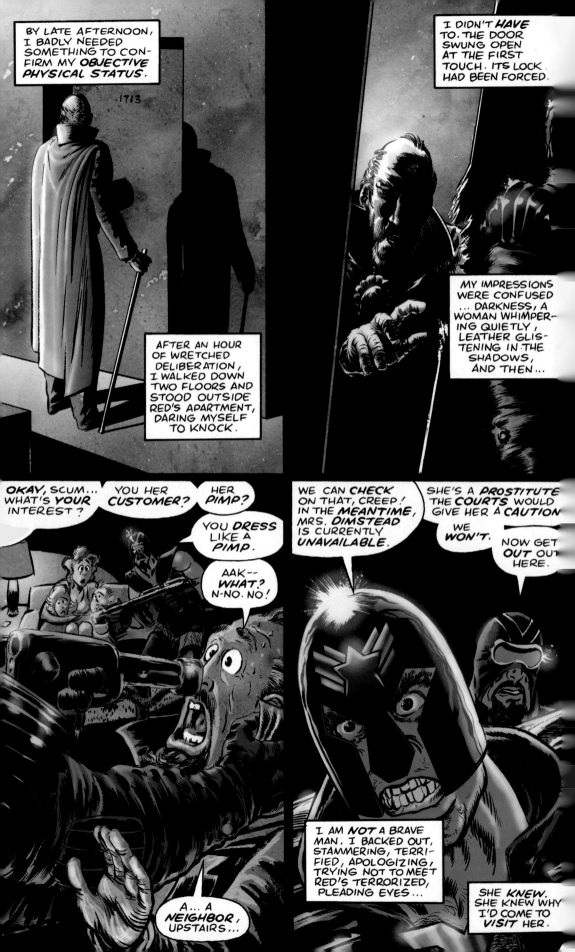

BY LATE AFTERNOON, I BADLY NEEDED SOMETHING TO CONFIRM MY *OBJECTIVE PHYSICAL STATUS.*

1713

AFTER AN HOUR OF WRETCHED DELIBERATION, I WALKED DOWN TWO FLOORS AND STOOD OUTSIDE RED'S APARTMENT, DARING MYSELF TO KNOCK.

I DIDN'T *HAVE* TO. THE DOOR SWUNG OPEN AT THE FIRST TOUCH. ITS LOCK HAD BEEN FORCED.

MY IMPRESSIONS WERE CONFUSED ... DARKNESS, A WOMAN WHIMPERING QUIETLY, LEATHER GLISTENING IN THE SHADOWS, AND THEN...

OKAY, SCUM... WHAT'S *YOUR* INTEREST?

YOU HER *CUSTOMER?*

HER *PIMP?*

YOU *DRESS* LIKE A *PIMP.*

AAK-- *WHAT?* N-NO. NO!

A... A *NEIGHBOR,* UPSTAIRS...

WE CAN *CHECK* ON THAT, CREEP! IN THE *MEANTIME,* MRS. *DIMSTEAD* IS CURRENTLY *UNAVAILABLE.*

SHE'S A *PROSTITUTE* THE *COURTS* WOULD GIVE HER A *CAUTION* WE *WON'T.*

NOW GET *OUT* OUT HERE.

I AM *NOT* A BRAVE MAN. I BACKED OUT, STAMMERING, TERRIFIED, APOLOGIZING, TRYING NOT TO MEET RED'S TERRORIZED, PLEADING EYES...

SHE *KNEW.* SHE KNEW WHY I'D COME TO *VISIT* HER.

THE PEOPLE IN HER ROOM HAD BEEN COSTUMED TYPES I DIDN'T KNOW. *NEW* PEOPLE.

FLEEING THE PRINCE FEATURES BUILDING, SICK WITH SHAME, I RESOLVED TO HELP RED, DOUBTING ALREADY THAT THIS WAS *POSSIBLE*.

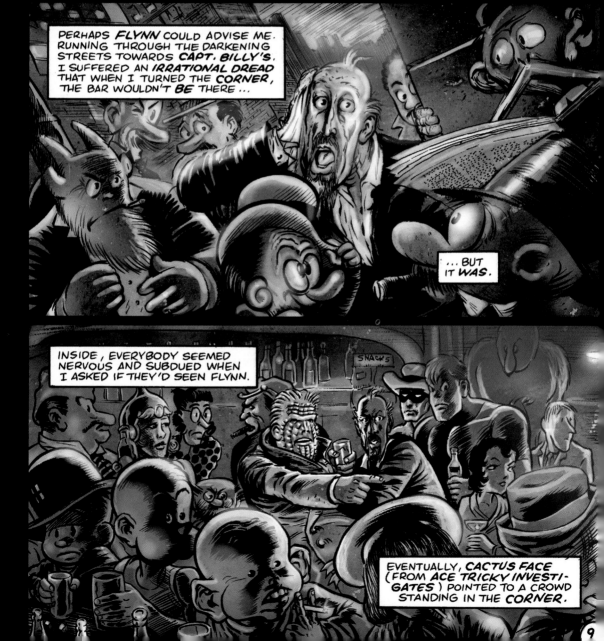

PERHAPS *FLYNN* COULD ADVISE ME. RUNNING THROUGH THE DARKENING STREETS TOWARDS *CAPT. BILLY'S*, I SUFFERED AN *IRRATIONAL DREAD* THAT WHEN I TURNED THE *CORNER*, THE BAR WOULDN'T *BE* THERE ...

... BUT IT *WAS*.

INSIDE, EVERYBODY SEEMED NERVOUS AND SUBDUED WHEN I ASKED IF THEY'D SEEN FLYNN.

EVENTUALLY, *CACTUS FACE* (FROM *ACE TRICKY INVESTI-GATES*) POINTED TO A CROWD STANDING IN THE *CORNER*.

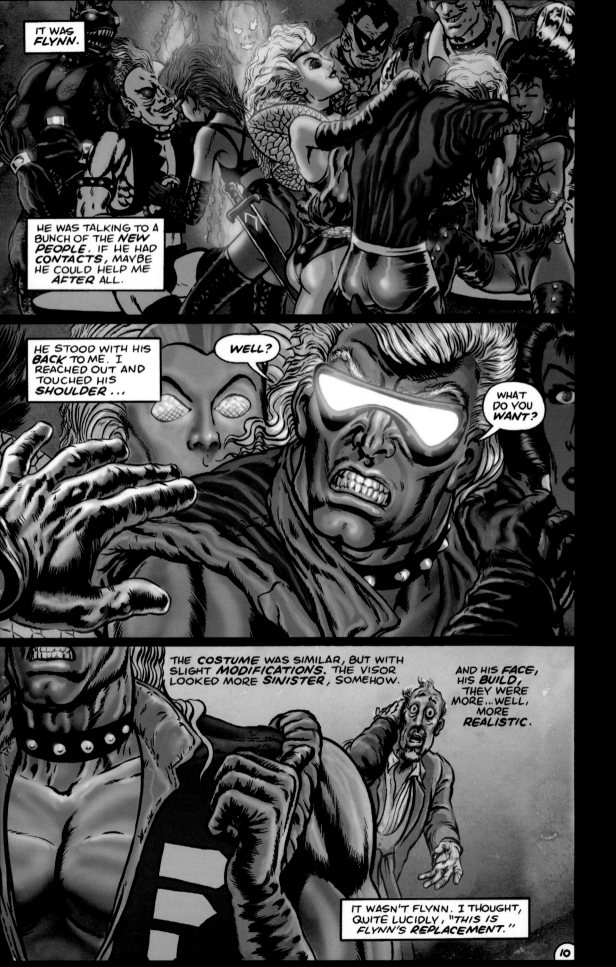

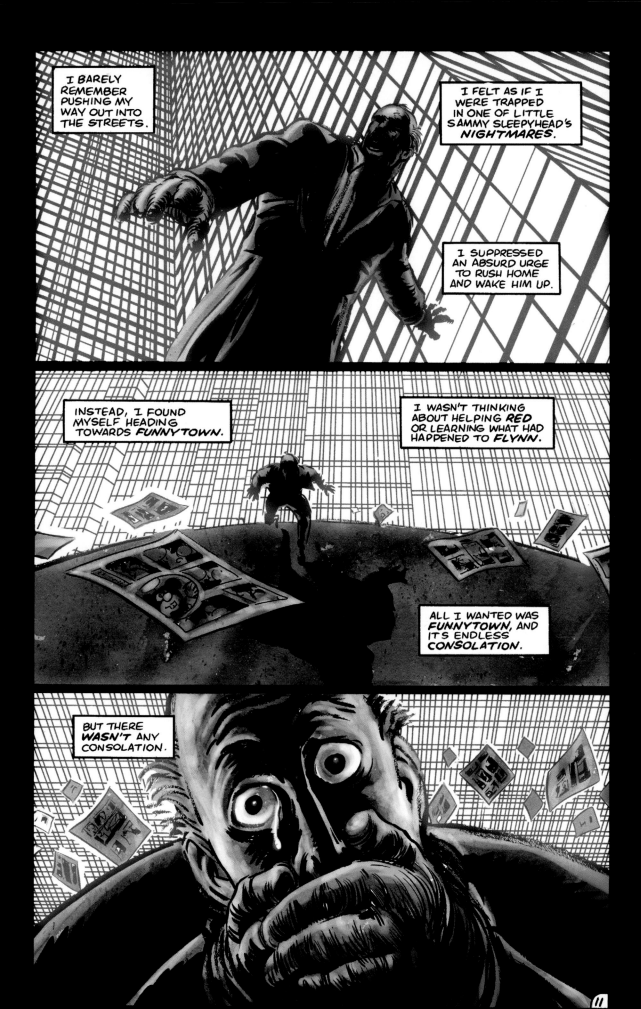

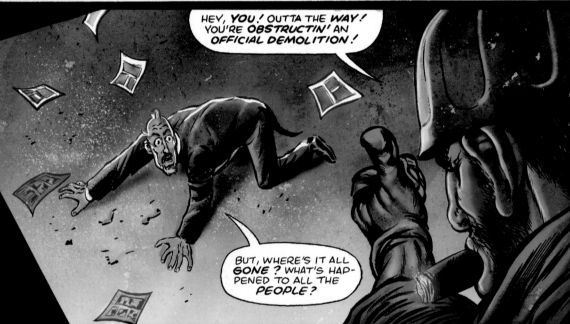

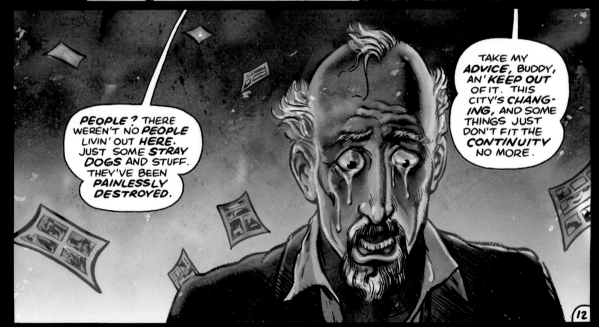

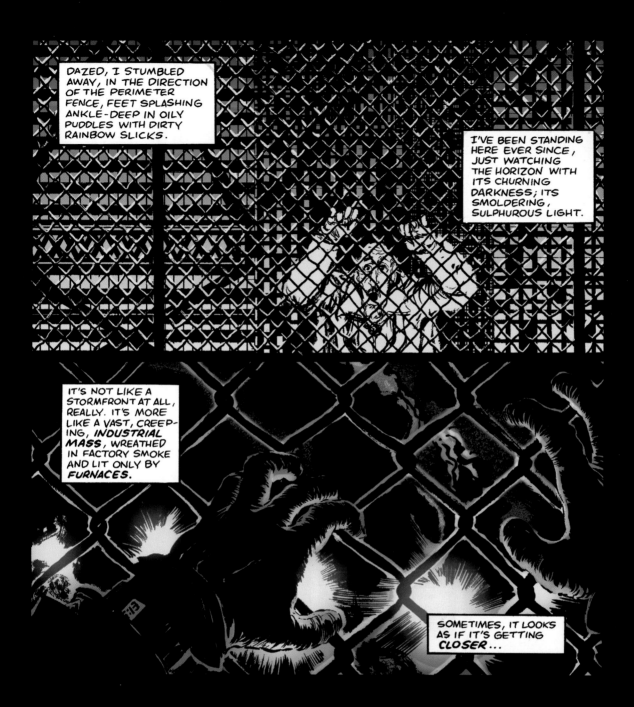

DAZED, I STUMBLED AWAY, IN THE DIRECTION OF THE PERIMETER FENCE, FEET SPLASHING ANKLE-DEEP IN OILY PUDDLES WITH DIRTY RAINBOW SLICKS.

I'VE BEEN STANDING HERE EVER SINCE, JUST WATCHING THE HORIZON WITH ITS CHURNING DARKNESS; ITS SMOLDERING, SULPHUROUS LIGHT.

IT'S NOT LIKE A STORMFRONT AT ALL, REALLY. IT'S MORE LIKE A VAST, CREEPING, *INDUSTRIAL MASS*, WREATHED IN FACTORY SMOKE AND LIT ONLY BY *FURNACES*.

SOMETIMES, IT LOOKS AS IF IT'S GETTING *CLOSER*...

...BUT THAT MAY BE AN *ILLUSION*, BORN OF THE *DISTANCE*.

END.

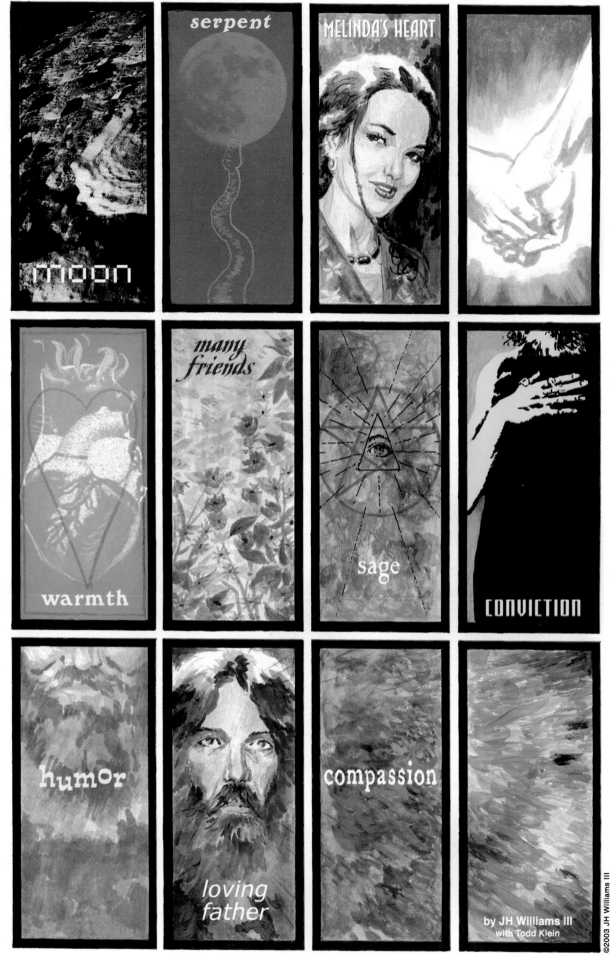

moon

serpent

MELINDA'S HEART

warmth

many friends

sage

CONVICTION

humor

loving father

compassion

by JH Williams III
with Todd Klein

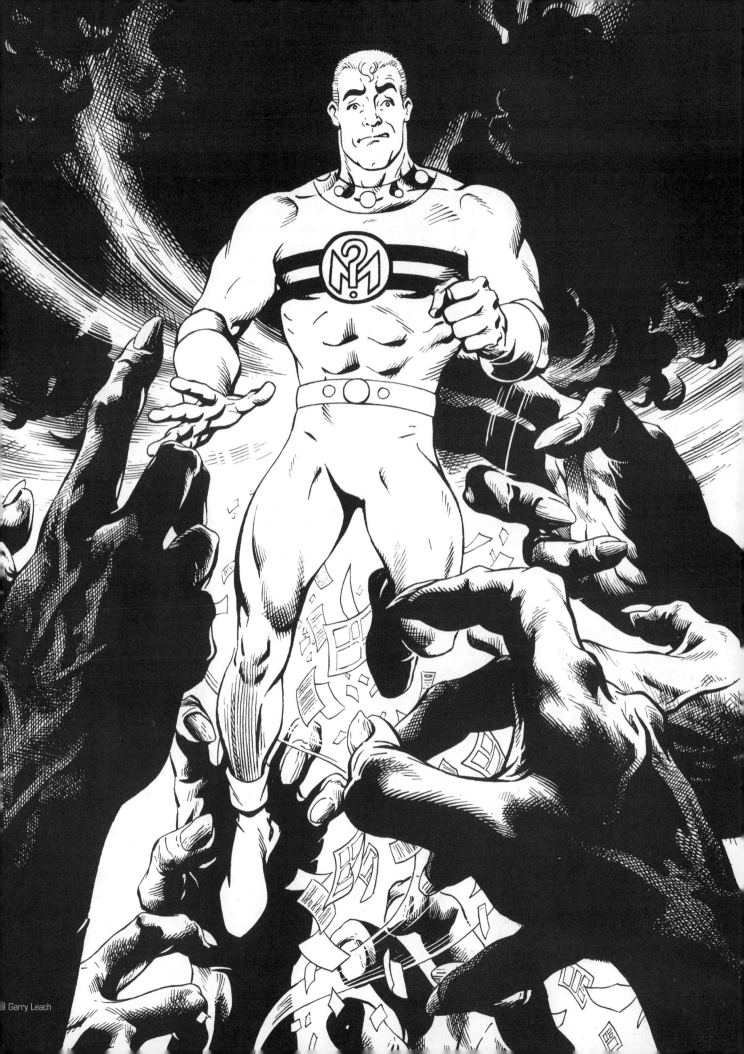

MIRACLEMAN INTERLUDE

THE SEEDS OF "MARVELMAN" WERE PLANTED WHEN AN UP-AND-COMING WRITER WAS ASKED A QUESTION BY THE SOCIETY OF STRIP ILLUSTRATORS FOR THEIR MAY 1981 ISSUE.

Q: What ambitions do you have for "strips" as a whole?

ALAN MOORE: There's such a lot of things I'd like to see happen to comics over the next few years that it's difficult knowing where to start. I'd like to see less dependence upon the existing big comic companies. I'd like to see artists and writers working off their own bat to open up space for comic strips in magazines which might not have considered them before. Secondly, I hope that kids' comics in the Eighties will realise what decade they're in and stop turning out stuff with an intellectual and moral level rooted somewhere in the early Fifties. Stories concerning the daring escapades of plucky Nobby Eichmann, Killer Commando, decimating the buck-toothed Japs with his cheeky, Cockney humour and his chattering sten gun don't have a lot of immediate relevance to kids whose only exposure to war is the horrible, morally grey mess that we've got in Northern Ireland.

I'd like to see an erosion of the barrier between "boys" and "girls" comics. I'd like to see the sweaty, bull-necked, masculine stereotype and the whimpering, girly counterpart pushed one inch at a time through a Kenwood Chef. I'd like to see, and this is pure whimsy, a return to the old-fashioned, little studio set-ups like Eisner-Iger had in the Thirties and Forties. This would give the artists and writers a greater autonomy, since they'd be selling their stuff to the companies as a sort of package deal. It would give them a stronger claim to the merchandising royalties. And I should imagine that some editors might be quite pleased to save time in commissioning one complete job rather than hassling 'round trying to commission two or three separate people.

I'd like to see an adult comic that didn't predominately feature huge tits, spilled intestines or the sort of brain-damaged, acid-casualty gibbering that *Heavy Metal* is so fond of.

My greatest personal hope is that someone will revive "Marvelman" and I'll get to write it. KIMOTA!!

TERRY I THINK HE TOOK A LIKING TO, ALLOWING HIM THE GREATER LICENSE THAT A VILLAIN'S ROLE PROVIDES, AND STEP BY STEP LEADING HIM ON TO PLATEAUS OF DEPRAVITY THAT PREVIOUSLY WERE GARGUNZA'S ALONE.

"I'M POSITIVE IT WASN'T ALL FOR FUN. HE TABULATED EACH RESPONSE, HOPING TO CONTROL OUR DESIRE...

Editor's Note: When I was working on the book *Kimota!*, John Totleben wanted me to include Alan's description of a panel that still haunted the artist after thirteen years. Space limitations prevented it, but here it is, showing the incredible detail Alan puts into all his scriptwork.

John Totleben's rendition of Johnny Bates, the protagonist from Moore's first "Marvelman" run.

2.

NOW A SIMILAR SHOT BUT SHOWING YOUNG NASTYMAN'S HEAD INSIDE HIS DREAM BUBBLE. POINTING RIGHT THIS TIME. BEHIND HIM ON THE SCREEN WE SEE YOUNG NASTYMAN'S COMPUTER-INDUCED FANTASY. WE ARE IN A GRAVEYARD. FROM A STONE CRYPT, YOUNG NASTYMAN IS DRAGGING THE BODY OF A WOMAN WEARING A FUNERAL VEIL OF BLACK, GARTER BELT AND HOSE, A BLACK LACE BRA AND NOTHING ELSE. HER SKIN IS BLUE-WHITE, AND HER EYES ARE SLACK AND STUPID. HER HEAD LOLLS, AND SHE'S OBVIOUSLY STONE COLD DEAD. YOUNG NASTYMAN LAUGHS WILDLY AS HE PULLS HER OUT, PERHAPS WITH LIGHTNING FORKING THROUGH THE SKY BEHIND HIM. THE SEXUAL FANTASY IS MAD AND FRIGHTENING AND REPULSIVE, YET ALMOST FASCINATING IN ITS STRANGENESS AND INTENSITY.

CAP. : Terry I think he took a LIKING to, allowing him the greater listence that a villain's role provides, and step by step leading him on to plateaus of depravity that previously were Gargunza's alone.

CAP. : "I'm positive it wasn't ALL for fun. He tabulated each RESPONSE, hoping to control our DESIRE...

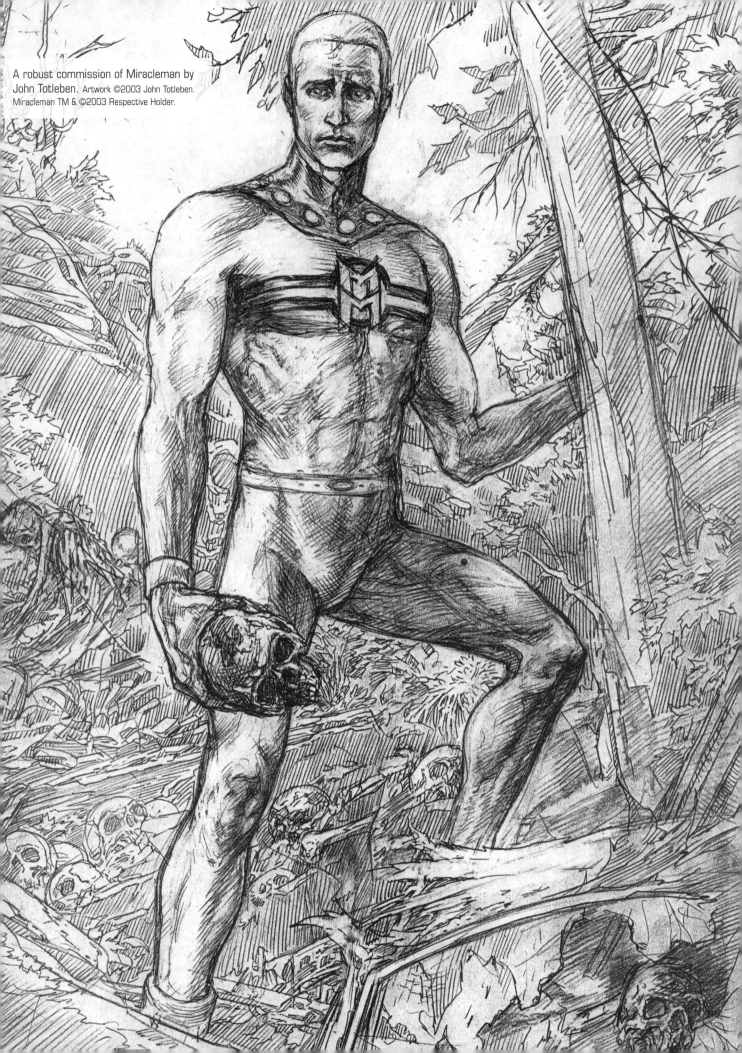

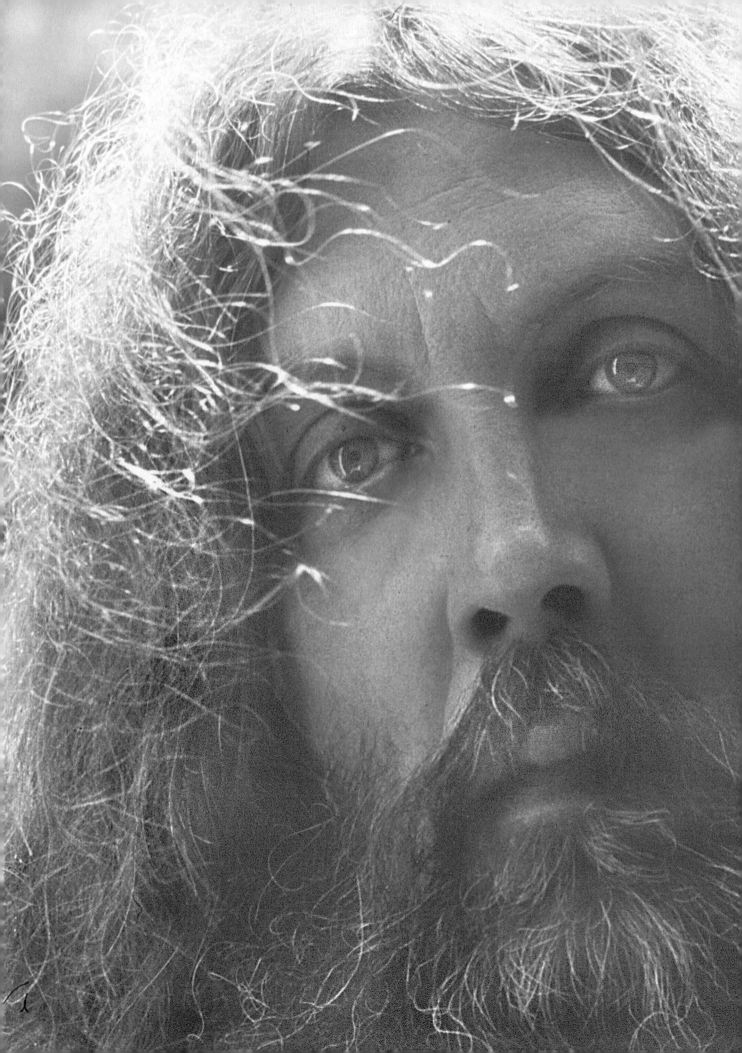

What was one of the first things you did when you left DC? How did you decide where you were going to go?

It was more a matter of deciding what I wasn't going to do. One of the first things I decided was that I wasn't going to do super-heroes and I wasn't going to do stuff for mainstream publishers.

So, if you're not going to do super-heroes, what are you going to do? I thought, I'd like to write a novel; I started doing that. I thought I'd like to—I mean, this is when we'd just done *AARGH!*, which I'd been very pleased with. We'd managed to raise a lot of money for the Organization of Lesbian and Gay Action; yes, we hadn't prevented this bill from becoming law, but we had joined in the general uproar against it, which prevented it from ever becoming as viciously effective as its designers might have hoped. And it had all gone very smoothly. Yes, it had been a bit of extra work, but this comic publishing business didn't look as difficult as we'd thought.

So, since we had an imprint up and running in order to publish *AARGH!*, then it seemed logical that perhaps the next thing I should do would make use of this imprint. That we could do a commercial comic book, my follow-up to *Watchmen*. The thing that I'd moved on from *Watchmen* towards, and that's where we got the idea for *Big Numbers*. That I wanted to take comics as far beyond *Watchmen* as *Watchmen* had taken them beyond what can be thought.

So, we tried in *Big Numbers* to actually design a comic from the ground up with no preconceptions. We wanted it in a different size and shape, different numbers of panels per page; we wanted to have constantly experimental and progressive storytelling techniques that hadn't been used before, that were completely different to those used in *Watchmen*; I wanted it to be about the most mundane thing possible: The town where I live, a shopping center. I wanted to actually write at the top of my range. I wanted

to show people what I could do if I wasn't hampered by the traditions and the luggage of the super-hero genre. This is *not* to say anything against the super-hero genre, but it is a lot of baggage to carry around. It is not the pinnacle of everything that I aspire to. Even when you're doing good super-heroes, at the end of the day it's a bit morally simplistic, it has to be said.

I wanted a world where there wasn't that simplicity of vision. I wanted to explore a world that was much more complex to the point of becoming chaotic, which is exactly where I got the central idea for *Big Numbers* which was the then relatively new concept of fractal mathematics and what was chaos maths. And I wanted to see if in this relatively new mathematical idea, there were possibilities for new ways to see the world. For perhaps a more human and accurate view of the world that we seem to live amidst chaos, this was certainly the case in the late '80s when I was starting work on *Big Numbers*. The world was growing increasingly chaotic. Of course then we didn't know how much further it had to slip into chaos. But really the signs were certainly very evident. It struck me that it might actually be helpful to people if we kind of explain that the chaos that

The first release from Moore's own imprint, Mad Love, was *AARGH!* (Artists Against Rampant Government Homophobia). The anthology book features Moore's "Mirror of Love" as the lead story.
AARGH! cover art ©2003 Dave McKean. "Mirror of Love" ©2003 Alan Moore, Steve Bissette and Rich Veitch.

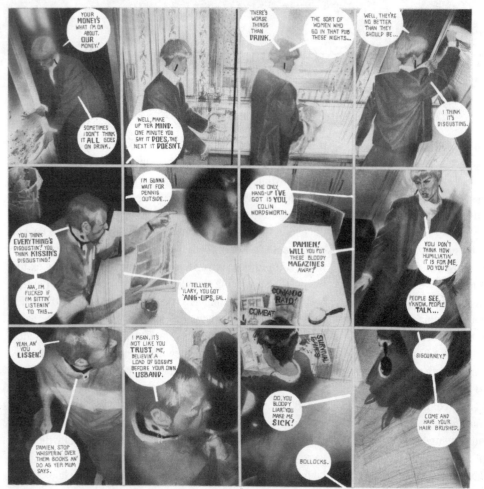

Big Numbers remains one of Moore's most interesting works, but an uncut diamond. A bold experiment with some of Bill Sienkiewicz's best artwork. ©2003 Alan Moore and Bill Sienkiewicz.

they could see around them—in their communities, in their lives, in their world—that chaos was purely a matter of perception. That if you could stand back far enough from this seemingly boiling tumult of events—that does appear chaotic if you're in the middle of them. If you can get a little bit of intellectual distance you might be able to see that what appears like chaos close-up was actually an expression of a very, very complex form of order. That chaos maps offer us new ways in which to understand the world and that those ways were perhaps more useful, more optimistic, less doomed. So that was the kind of thinking behind *Big Numbers*. At the same time, because I figured that wouldn't take up all my time, I was talking about doing something substantial and lengthy for *Taboo* and this evolved into the idea for doing *From Hell*. And then Eddie was on board and we'd said it was going to be 16 chapters but we didn't know how long the individual chapters would be; we certainly didn't know it was going to take us over ten years to finish it. But we—yes I'd done that at the same time and it was around about the same time that I was launching upon *Lost Girls*, because that was something else that I wanted to do that wasn't super-heroes. I wanted to do something about sex; I wanted to do a piece of pornography.

And so, I thought that that was a pretty decent raft of interesting projects to be involved with—*From Hell*, to be involved with *Big Numbers*, with *Lost Girls*, and with *Voice of the Fire*.

That these were all a long way from—I mean in terms of their content, in terms of their setting, they were a long way away from mainstream comics; they were a long way away from America. The subject matter was very European in those things.

But you kinda knew that your audience would follow to these other trips with you?

No, I don't expect that at all, because—yeah, a certain percentage of my audience, the people who are probably serious about this stuff are going to follow me. But—I don't know, what were the sales figures on *Watchmen*, 68,000, 70,000, something like that?

This is a book that has had over ten printings.

Yeah, but sort of back when the individual issues were coming out.

I don't remember.

It couldn't have been that many. But I mean, say it was a hundred thousand tops for the individual issues, I would have thought. Probably less than that. But when we did—*From Hell* was what—15,000?

Yes.

That's what it was brought up to. So no, I never had any sort of illusions that all of the people who buy my books are Alan Moore fans. A lot of them might be Alan Moore super-hero fans.

But then there are some people that are intrigued—that if you're going to do something they want to see it.

Those people... I love them. Those are the people that I feel I'm having some sort of dialogue with. Even though I never respond to their letters, and there's never any personal contact, I feel in contact with those people. And I hope that they feel in contact with me. There's some sort of dialogue going on there—or monologue, I don't know. Those people who've found something affecting in something that I've written and rather than, I don't know, just thinking how "I want to see more of this character," they thought, "I want to see more of this writer." Where they're interested more in how I'm writing

or what I'm writing rather than what I'm actually writing about—those are the readers that I value the most, God bless them.

You know, I like all of them—those ones I feel that I have a special kind of communication with. The ones that have followed my work to these often-peculiar places. The ones who sort of had the tenacity or endurance to follow me through all the horrific twists and turns and dark corridors of *From Hell*. Or that have waded through that first impenetrable chapter of my novel.

Or even those who followed you through most of your Image work.

You know, it's not like I've been the easiest tour guide. But you know, my feelings back then were that I wasn't really concerned with whether everybody had bought *Watchmen*, bought *Big Numbers*, you know? I mean it did pretty well; it was 65,000 for the first issue?

I saw somewhere that the first one sold about 60,000 copies; the second one did 40,000, which are great in today's market.

Those were very good numbers. Big numbers, you know? [laughs] For a non-super-hero book that was square, and all the rest of it and in black-and-white and—it wasn't even like a non-super-hero book, but it was a crime book, or but it was a western, or but it was science-fiction— it had no genre; it was about shopping and mathematics. Not a real big section down at anybody's local bookshop.

It's reality-driven.

Well, I mean it's the same with *Lost Girls*—nominally it's pornography, but it's not like any pornography that anyone's ever read. It's not trying to fit into a genre; it's trying to break the genre open, if you like. I mean, *Voice of the Fire*—that's quite an unusual little book as well. It's difficult to actually put that one into categories at the bookshops; it's not horror, it's not crime, well it's got elements of both of those. It's not local history, it's not exactly fiction, but it is.

I mean, this is what was exciting me at the time. To kick down all the fences and to just declare this all free open countryside, and that I could rampage wherever I wanted and it didn't matter if there wasn't a category or genre or some neat sales niche waiting to receive one. I was fed up with all that market thinking. Art has always been inextricably linked to commerce. Yeah, I can accept that. Even the great works of the past, they were commissioned; they were commissioned by the churches or by whoever, the noblemen and the noble aristocratic families. There was no limit of money there. It is impossible to completely divorce art from commerce, but I was just fed up of that market-driven attitude. A good comic is a comic that sells, you know? Whatever comic sells best, that was the best comic. But that kind of attitude, the aesthetics of a marketing department where the bottom line in any of their aesthetic decisions is, "Well, how much money did it make?" you know? And I really wanted to get as far away from that as possible.

I suppose—I felt on one level I was perversely doing things that were as non-commercial as you could get. I mean, yeah, a Jack the Ripper story is probably quite commercial, but not if you take ten years to do it and go into all of this ridiculous detail about what every one of the characters had for breakfast every morning, all of the people that they'd spoken to on a given night. It had a different agenda to most recognizable crime or murder stories. So again—there were no sure bets. If you did a Batman graphic novel, then it's a sure bet, you know? I didn't want to work on projects that had been suggested by DC's marketing department. "Oh yeah, Alan Moore working on *this* with this artist—that would ship lots of units, so it would be a really great comic." I didn't want to be part of that

The 20th century comes crashing into Northampton in *Big Numbers* #1.
©2003 Alan Moore and Bill Sienkiewicz.

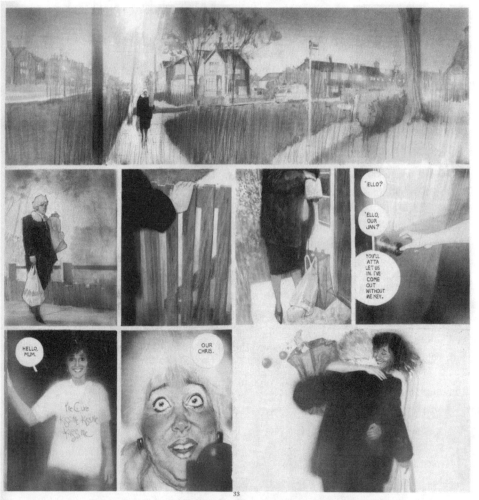

A tender moment before the storm, from *Big Numbers* #1. Lovely art by Bill Sienkiewicz.
©2003 Alan Moore and Bill Sienkiewicz.

for generations. So that was very personal, in fact, like I was talking about something very literally close to home. *Lost Girls*—when you're talking about what you find horny—that's quite personal as well. It's something that's difficult to do without embarrassment or shame for a lot of people. So to actually come out—and I suppose if I'm doing a scene in *Lost Girls* then tacitly I'm saying "Yeah, I find this horny." Now, you've gotta be quite confident about yourself to be able to say that at least in front of thousands of people. So, that was personal.

Big Numbers, yes, that was personal upon a lot of levels because, like *Voice of the Fire*, yes, it was about Northampton, even if we changed the name slightly. It was about people, a wide variety of people, but all of them people that I know or I know types of people that are like that. So there was—there were a lot of elements in it that made it a very personal book to me, and again, I was trying to give—as I'd given in *Watchmen*—my view of how reality hangs together, a worldview. With *Watchmen*, there is this worldview made up of telling sentences of dialogue or imagery where you suggest a lot of kind of subtle, hidden connections that even the characters can't see. With the work in *Big Numbers* it was a different sort of worldview. I was trying to

kind of thinking. So I tried to remove my work as far as I could from that kind of thinking, even if that meant, for a huge amount of the American comic-buying public and probably the British comic-buying public, I ceased to exist. I wasn't writing any comics that they were reading. You'd get articles like "Whatever happened to Alan Moore?" Well actually he's doing lots of books that are available in comic shops right now, but you can't see them [laughs], because they're not super-hero titles and so you screen them out because super-hero titles are all you're interested in. That's it really, you know; it's sort of—a lot of the fans are not Alan Moore fans, they're probably super-hero fans that happen to like the way I do super-hero comics, but would probably rather read a bad super-hero comic than a really good non-super-hero comic. That is probably still the majority of the comic readership. I might be doing them a disservice—I hope so.

Yeah, I don't think they'll read this book. [laughs] **When you were doing *Big Numbers*, that was a personal project, wasn't it? Of the three—**

Well, they were all personal in a way. I mean *Voice of the Fire* was very personal because I was talking about the town in which I was born and which me and my family have lived in

Voice of the Fire was Moore's first novel. It's described as "a dark, human history from the vantage point of a single place." Reading the book, it's obvious Moore's talking about Northampton. Cover by Robert Mason.
©2003 Alan Moore.

come at it from a mathematical point of view, with a poetic eye upon the mathematics, but then I happen to find fractal mathematics very poetic.

Things like, for example, half of the numbers that go to make up what is the fractal phenomenon known as the Mandelbrot Set. Half of them are what used to be called "imaginary numbers." Now since I was looking at the Mandelbrot Set as a new model for the human life and society, I thought, how true is it that half of human life and society is imaginary? And it struck me that, yes, most of it is, that at least half of reality is what's going on in our heads—our little fantasies, our role-playing games, our hallucinations, our dreams. Our reveries. And that's why in the couple of issues of *Big Numbers* that ever saw light of day there was such a lot of attention paid to people's internal worlds. The things that are happening inside their heads which are as important a part of the story as the real events because the things that happen inside our heads, even if they are delusions and fantasies they influence our actions and our actions influence and change the physical world. So the imaginary component of our lives is just as important as the things that we actually do. And this was something that I was trying to get over. So, yeah, there were a lot of thoughts that I had about communities in the 1980s. About the way that life was going.

One thing that's interesting regarding that particular project was that I know the guy who runs the local newspaper—who actually will probably be coming around to visit me in a few moments—but anyway he was telling me that there'd been a story in the local newspaper just a few months ago talking about how Northampton was going to triple in size over the next ten years or something which would probably change the character of the town; that would give bigger opportunities to business interests. And the title of the article in the newspaper was "Big Numbers." [laughs] Probably coincidental, but it was the sort of stuff that I was talking about.

Is that what the mall was going to be like in your story? The completion of it?

Completion of the mall would completely wreck things and disfigure the community that had previously been there—completely alter it forever. As an example, the chaos that we were talking about—that things change, economics change, history changes—the shopping mall that's built—the community that had been there for hundreds of years suddenly starts to fall apart under new and unfamiliar strains. New alliances are formed; some people are ground under by the experience, some people emerge renewed, you know? There was an interesting payoff to that in that nearly 20 years later you find it turning as a story in your local paper with the same title for a headline.

Do you still want to finish it?

There's no way that I can finish it as a comic strip.

The only released *Big Numbers* artwork by Al Columbia, a print given to retailers at the 1992 Capital City Sales Conference. For more on the Al Columbia/*Big Numbers* story, read Eddie Campbell's *Alec: How to Be an Artist.* ©2003 Alan Moore and Al Columbia.

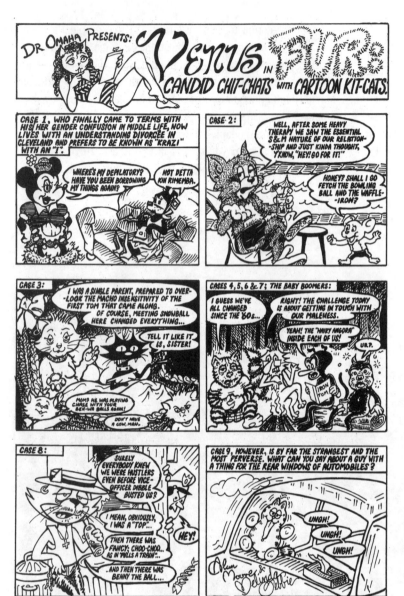

Moore's cat fixation continued in his contribution to *Images of Omaha*. Illustrated by Melinda Gebbie. ©2003 Alan Moore and Melinda Gebbie. All characters ©Respective holder.

Is it because you're not in the same place you were ten years ago?

The thing is that I tried twice, and each time it failed it really hurt. Trying to launch it again the second time around was—it felt wrong, it felt like it was probably cursed, and that I hadn't got—I mean like when I was launching it the first time I'd got nothing but enthusiasm for it. Writing it the second time I came to think, well, how could I ever trust this project to actually come to completion? Even if someone suggested it, which a lot of people have over the years. I mean, what am I going to say to the readers? "Yeah, look, I'm going to try and do *Big Numbers* again and hopefully I'll get past the second issue, but just bear with me?"

No, I wouldn't sit still for that if I was a reader. And also, could I actually work up the enthusiasm to start it again with the thought that, well, maybe this issue that I'm writing will see print one day and maybe it won't. Maybe this sort of attempt at revival is going to go the same as the others. I don't know if

I can get up the energy; I really don't think so. I think it's dead, Jim. [laughs]

There is a treatment worked out for *Big Numbers* as a twelve-part television show. That might never get made, or at some point in the future, it might. I think that is the only way that *Big Numbers* is ever going to reach any kind of conclusion.

How far did you get in terms of the script? You reached the fifth issue, I think, right?

Something like that, yeah.

But you had it all plotted out—

It was at five when it all went down, but I'd gotten the whole thing plotted on that big piece of paper. That huge sheet of graph paper with 480 squares on it. So I knew exactly what was going to happen; that was why it wasn't impossibly difficult to make this adaptation for television. Because, I've got the whole plot there. I knew what was happening to each of the characters in each of the twelve episodes, so it was just a matter of time just composing all that into a workable treatment. That is the only way that realistically *Big Numbers* will ever get resolved, because I simply do not have the energy or strength to write it with any conviction if I haven't got the certain secure knowledge that this time it's going to get finished, and I don't see any way in which I could ever have the certain secure knowledge; it's just too difficult. It's perhaps too difficult for any artist.

How did *Lost Girls* start? Did it start when you met Melinda?

Well, it started before I met Melinda when, for a long time, I'd been chewing over the idea of erotic, pornographic comics. A lot of them didn't really do a lot for me. There were some people who could sort of pull it off, as it were, like Crumb. He's got a very distinctive way of handling the erotic in comics. But with Crumb, it was always sort of a veneer of humor. Nothing wrong with that at all, but, I noticed that if comics ever did approach erotica, then it was only either with a veneer of humor or with a veneer of horror. It was all right to use sexual elements in a horror story to make the horror more visceral. It was all right to use sexual elements in a humorous story because then it was making a joke of sex. And while both of these are valid, my usual reaction to sex is neither to laugh nor to scream. To most people it's just sex; it's enjoyable for what it is. So I wanted to do something that was just purely about sex that was a work of pornography.

I'd originally got vague ideas; I thought that it might be interesting to sexually de-code the Peter Pan story. Because it struck me that, I don't know, I was thinking about Freud's insistence that to fly in dreams is a sexual symbol and I started thinking about Peter Pan and Wendy, and how Wendy is at that

kind of age where she probably would be starting to experience sexual feelings. I could see that, in a sense, you could do a decoding of the Peter Pan story that would take some interesting issues about people's sexual awakenings. It was something where I had a lot of different ideas as to how it might be possible to do an up-front sexual comic strip and to do it in a way that would remove a lot of what I saw were the problems with pornography in general. That it's mostly ugly, it's mostly boring, it's not inventive—it has no standards. Anyway, I thought about doing it originally with a male artist. Just because I'd never worked with a woman artist before and that there weren't that many women artists around, it was natural to think of doing it with a guy.

But at the same time, that seemed to feel wrong, because it would inevitably be a kind of locker-room atmosphere. It would be two guys' sexual fantasies, which—somehow that's not very interesting. When I met Melinda, especially when I saw the color work in her portfolio and the rest of it—that was when I started to see how if it was a man and a woman working together that that would remove all of that kind of clammy locker-room ambiance from things. Also Melinda happened to say, quite by chance that she, in the past, had written a couple of stories that had three women as the main characters. She said that she quite liked the idea of having three women as protagonists. So consequently that was when it all crystallized; Melinda's three women idea collided with my Peter Pan idea and I suddenly thought, well, what if you have three women? What if Wendy was just one of them? Who would the other two be?

And obviously they'd be Alice in Wonderland and Dorothy from *Wizard of Oz*. And once I'd got *that* idea—all right, these three women—I said, let's look at the dates of their stories and see whether there's any period where they could have overlapped interestingly. I think that what, *Wizard of Oz* is around 1910, or thereabouts, and so, it would seem that Dorothy, a young girl in 1910, 1909, then if we assume she's about 15 when that story takes place, then she could be 18 by two years later. At that point Wendy would be middle-aged, but sort of in her 30s, and Alice would have to be around about 60. But that was interesting because we haven't got three young bimbos; we've got three women of different ages with interesting differences between them. And also interesting class differences between them. Alice is kind of upper class, Wendy is distinctly middle-class, and Dorothy is rural. She's blue-collar, she's working class. There were all sorts of little aspects that

suddenly came up, and 1913, that was when the war was picking up and this was a very interesting time in Europe, so all of those factors came together.

I'd got half the idea already, Melinda supplied the other half of the idea and once the two elements were mixed together, *Lost Girls* kind of grew out of that pretty much full blown. We had the entire story worked out within two or three days of having the initial idea. We knew pretty well what was going to be on every page of the 240-page book within a few days.

When you started writing these short stories for *Taboo*, did you envision them as lengthier books?

I think our original reasoning on *Lost Girls* was that we wanted to do a 240-page graphic novel. We wanted to do something that was three books of 80 pages each. I figured that given the nature of the content and given the nature of

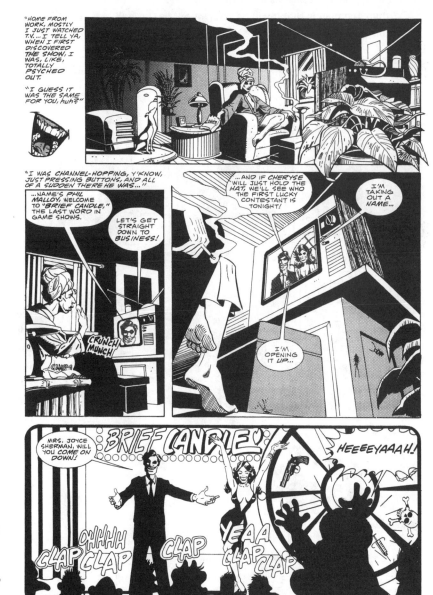

A page from "Come On Down" in *Taboo* #1, 1988. Art by Bill Wray.
©2003 Alan Moore and Bill Wray.

the comic market at the time, that it would probably make more commercial sense to do it in eight-page chapters. Because there were some European magazines that had sexual content and which would run serials. So I think that was the original thinking behind having the eight-page sections. Also, it tends to keep it tight. I remember that some of the things that I've enjoyed the most or where I think that my writing has been at it's tightest have been things like—oh, like "Halo Jones" for *2000 A.D.*, where each little chapter was five, six pages long and where each chapter had to be a complete little entity in itself, at the same time as providing a part of the bigger structure. That means that you can't really waste a page, you can't really waste a panel; you have to keep it very, very tight and precise. So that was another reason for coming up with the idea of eight-page chapters.

Is that how you were doing the book? The same way?

I think the plan is that it will be brought out as three 80-page books in a slipcase.

Johnny Depp and Heather Graham star in the big screen adaptation of *From Hell*, directed by the Hughes brothers. Photo by Jurgen Vollmer. ©2003 Twentieth Century Fox.

How will you write the chapters? Is it the same way you wrote the previous ones?

Yeah—Melinda's now on the last chapter which is an eight-page chapter which has exactly the same elements in it that we've been talking about for nearly twelve or 13 years now. We just are getting to these scenes that we've had in our minds for 13 years now.

Is it different working with someone that you're close with? Like Melinda?

Well, yeah, obviously it's a different dynamic. I find that also, because I am close to Melinda geographically as much as anything else, that that means that we actually see each other more days than we don't, so it's like you can constantly keep studying the project, revising it, working on it. And the way that I actually work with Melinda is pretty much different than the way I work with everyone else, in that with Melinda I started out writing the full scripts that I'm known for. Melinda really had a lot of trouble being able to visualize what I was writing. So what seemed to work better for Melinda was if I did pretty detailed thumbnails of every page, with some scribbled notes. She's ahead of me at the moment. She's working on the last episode; I've still got about the last five episodes to do the dialogue on. I've found that that works better as well. Once Melinda's done the actual pages from my thumbnails, then I can do the final adjustment of the dialogue to Melinda's pictures, so that the two are very close. That there are no redundancies. That's fairly unique in terms of me working in collaboration with an artist; I don't really do that with anybody else. But that is largely because there's nobody else that I could do that with because there's nobody who I live physically close enough to to be able to work like that with. But yeah, books have got their own different characteristics and ways of getting accomplished. *Lost Girls*—I'm pleased with the way it's working out. It's a different working process; it's different in a lot of ways to my other work. But it's got its own benefits and advantages; it's looking pretty good.

What was the genesis of *From Hell*? I remember reading that you weren't that attracted to it at first....

Paranoid! Gull goes mad. *From Hell*, Chapter 10, page 20.
©2003 Alan Moore and Eddie Campbell.

Nice guy, that William Gull. Panel from *From Hell*.
©2003 Alan Moore and Eddie Campbell.

When I was thinking, "All right, what am I going to do after *Watchmen*?"—which was largely a matter of what *don't* I want to do. So, I'd decided that I really did not want to do anything that had super-heroes or that was necessarily set in America. It kind of occurred to me that a murder would be an interesting human event to write about, because they're very intense; they're quite complex if you actually consider the threads that lead into them. Also, it occurred to me that our fiction kinds of turns the thing into a middle-class parlor game. That it's this Agatha Christie, sort of *Clue*-type world, you know—Professor Mustard in the conservatory with the lead pipe. And that the conventions of murder fiction or detective fiction, or crime fiction have evolved so that once you've answered all the forensic questions about the case—who did it, what did they do it with, how did they do it, why did they do it—then as far as the forensics issues are concerned, you've answered all the questions. But an actual murder in the human landscape has effects that are far more profound and subtle than can be described by just the requirements that a jury has when they decide whether to convict.

Sure, to the police involved in the case who did it, how they did it, and why they did it are the only questions that they have to answer. But it struck me that that was selling murder rather short. Murders have profound effects upon the communities that they happen in; they have complex effects and similarly, those murders themselves have grown out of complex effects from the surrounding society.

So, the original idea was just to study a murder. I thought it might be interesting to take a fresh look at murder, so that you didn't make it a "whodunit." When I was looking for a specific murder, I ignored the Jack the Ripper crimes simply because they were so well covered, played out. I considered lots of other crimes much less famous or celebrated. There was an old case, an Indian doctor in England called Dr. Buck Ruxton during the 1920s or '30s—no, perhaps even earlier than that—but he killed his wife and his housekeeper and the body parts were found in a quarry. There was one body part that I'd happened to find newspaper reference to that was said to be a "Cyclops eye"—which could be attributed to neither of the two women's bodies.

These were interesting. Interesting little stories, but more

freakish than generally profound. I felt that I wanted a story that would enable me to really look into society and the various myths that go to make up society. And then, in the centenary year of the murders in 1988, there was an awful lot of written material floating around, and I came across Stephen Knight's book and started to see that there was a way that you could tell the story of the murders in a more inclusive or thorough form, where you could make it a fiction—and you label it plainly as a fiction—where you could, having said that, having given yourself that get-out clause, you can then attempt to be as stringently authentic in all of the details as you possibly can. Once I saw the possibilities of this, and once Eddie [Campbell] got on board as the artist and we actually started to work on it, then that became very exciting. I mean, I started to realize the possibilities. With each new episode, I was starting to realize new possibilities in Eddie's artwork. There were interesting ways in which we could develop the story. But the initial impulse behind *From Hell* was simply that I thought that comics would be an interesting medium to investigate a murder. And the Jack the Ripper stuff was an afterthought; that came later, but on balance, I'm pretty glad that it did.

Did you think that it was the most challenging book you'd done so far? From looking at the bibliography for that book, the amount of

Concert poster art by Moore. ©2003 Alan Moore.

research was massive.

Well, it was—it was challenging in its way. The amount of time that it took—the sheer amount of time—that was the most challenging aspect. But of course, we didn't know, entering into the strip, that it was going to take that amount of time. And also, the other strips that I'd been doing around that period, there were things like, say, *Brought to Light,* where I had to get the entire history of the CIA's doings since the end of the Second World War in about what, 30 pages? And that was challenging, you know, and very satisfying when we managed to pull it off. The "Mirror of Love" strip in *AARGH!* where I had to get a fairly comprehensive history of gay culture into just eight pages—that was challenging. With *From Hell* we'd an almost infinite amount of room, so it was more a matter of endurance, it was more a matter of "If we can go the distance, if we can actually work upon this for as long as it takes then, yeah, we've got enough room to indulge ourselves. We can go into these strange, obscure little corners of the story and poke around and go off on tangents and it doesn't matter because this thing can take as long as it's going to take."

It was a lot tighter with things like *Brought to Light* or "Mirror of Love" where I had an awful lot of historical material to get into, like I say, in some cases very limited amounts of space—you know, 30 pages, 8 pages. So I wouldn't say that *From Hell* was one of the most challenging things that I've attempted; I would say that it's probably one of the most accomplished things that I've completed. That, yes, we have got an unlimited amount of space to do it in, but that said, what we accomplished in that space was pretty satisfying. We managed to take the narrative into some very unusual areas and deal with subjects that are by no means frequently dealt with, you know? And able to make some complex material fairly accessible and lucid, I think, to a lot of the readers.

So yeah, *From Hell*, not necessarily a great challenge, but how it turned out, it's an accomplishment that I'm very, very proud of.

When you look back and you see that it took three publishers to do it, do you get the feeling it was hard finding someone to publish it?

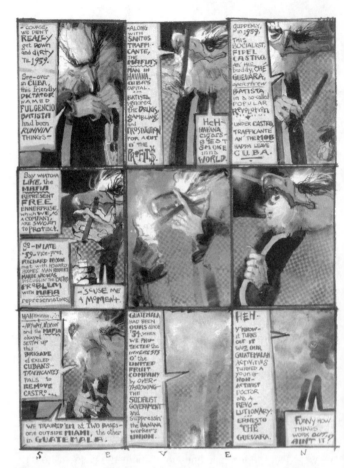

Wake up America! The sins of the United States are revealed in *Brought to Light*. The first collaboration of Moore and Sienkiewicz. ©2003 Alan Moore and Bill Sienkiewicz.

Well, this is exactly the same stuff that happened on *Lost Girls*, for example. *Lost Girls* has had as many different publishers as *From Hell*—exactly as many publishers. We went from place to place and went through all of the same permutations, with Tundra, with Kitchen Sink and everything. My kind of attitude to this is just to keep on working. It's not really as frustrating to me as it may be for readers and Melinda in that, I'm kind of confident that if I just keep on working and get the thing finished, then it's going to get published sooner or later. I mean, they're publishing some of the things that you found from when I was—16 or whatever, for inclusion in this volume. If they're going to get published after all these years then I'm sure that a major work of mine is going to be published sooner or later.

So I've been able to maintain my *sangfroid* concerning the various ups and downs in the publishing status of the books. I'm convinced that the work is the main thing to concentrate on, and when it's ready to be published there'll be a publisher there to do it.

When did your label *Mad Love* cease to exist?

Well, I mean *Mad Love* still exists as a name; it's still a company even though it doesn't actually do anything. I mean, yeah, that was a serious blow.

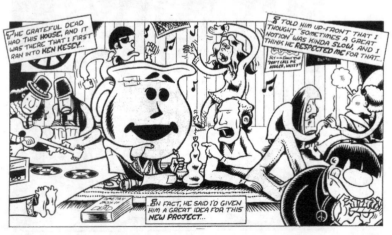

Moore and Peter Bagge get together for *Hate!* #30. ©2003 Peter Bagge & Alan Moore.

When I was unable to finish *Big Numbers*—which coincided with my relationship with Phyllis and Debbie breaking up, you know—it was probably not the best time I've had in my short but eventful life. It was a difficult period, but throughout all of it I tried to carry on getting my work done the best I could. Getting my work done was the thing that got me though a lot of it. Because work is—at least the kind of work I do—if you work in a creative field, it really can be your best friend. When there's nothing else in your life that makes very much sense at all, then you can totally immerse yourself in the story that you happen to be writing and that story makes sense. It's one of the big differences between life and fiction, you know? That fiction makes sense more often. Yeah, it was a tricky period for a lot of reasons. And the fact that *Big Numbers* went under, as part of that—and not only went under, but went under twice—after it had gone under I was prepared to see if it could be rescued, but like I said, by the time the project had collapsed twice; I simply didn't have the heart to continue with it.

Did you write the *Fashion Beat* screenplay right after *Watchmen*?

I can't remember to tell you the truth. I remember that, yeah, it would have been sort of sometime after *Watchmen*. It wasn't a particularly long period of my life—a couple of months—when Malcolm McLaren contacted me and told me that he had these film properties and he'd been thinking that he wanted someone to write and who had a grasp of visual storytelling that perhaps wasn't conditioned in the preconceptions of screenwriting. So he'd gone into this comic shop in St. Mark's Comics and asked one of the customers in there who was their favorite comic writer, and they said my name and so that was good enough for Malcolm. So he got in touch. I went down to meet him mainly because I thought it would be cool to meet Malcolm McLaren. I'd always admired his troublemaking attitude. So, I went down there, got on fine with him. He had three different film properties, one of which was a combination of Oscar Wilde's tour of the North American mining towns in the 1880s—he was going to combine that, but he was going to make Oscar Wilde a woman, and more like Madonna. Actually I couldn't really see that one, so I passed on that. Then there was another one that was called *Surf Nazis* and this was about surfing and

From the back of the *Moon and Serpent* CD, a photo of Moore alongside his performance art collaborators, Tim Perkins and David Jay.

A heartbreaking moment in Moore's life captured by Eddie Campbell in *The Birth Caul*. ©2003 Alan Moore and Eddie Campbell.

Nazis, as far as I could make out, and that didn't really appeal. But he had this other one which was equally odd but had got more to it, at least in my estimation and this was an idea that combined "The Beauty and the Beast"—probably the Jean Cocteau version of "Beauty and the Beast"—with the details of the life story of Christian Dior.

And, after Malcolm explained a bit about Dior's life, I began to see how you could perhaps come up with parallels between that and this old fairy story. So, I started to work upon it; I did a treatment, something like that, perhaps made a few suggestions, and then I went on to write the script. I think he liked the script; in his biography it says that it was what he was looking for, but unfortunately the timing was off. I think by the time he asked me, that the clock was already ticking upon the project and it ran out of time and money. I mean, I got paid everything that I'd been promised on the projects and I got to at least have a try at writing a screenplay without the embarrassment of ever seeing it made.

I found out that, no, I didn't really enjoy writing screenplays. I really enjoyed working with Malcolm McLaren and his

The lightning struck, out of a clear sky.

I was so far away...

I was so far away, I couldn't do anything, couldn't call out...

The lightning, and one of them fell, one of them was dead.

I didn't know it was going to happen, I'd just noticed them, wondered who they were, farmer and stable-lad, child molester and victim, father and son...

They didn't even know anyone was watching them, and that was horrible.

One of them fell, one of them was dead, and I couldn't see if it was the man, if it was the boy...

A sample page from *A Small Killing*, by Alan and Oscar Zarate. This powerful story is currently back in print thanks to Avatar Books. ©2003 Alan Moore and Oscar Zarate.

lovely, charming, then-partner Lauren Hutton, who is one of the nicest women I've ever met, one of the least vain. Which considering that she's extraordinarily beautiful is a rare commodity. Yeah, I had a great time. I mean, I don't know whether the screenplay I wrote would work as a film. One of the main problems that Malcolm had to keep pointing out was that I should leave something for the director and actors because I was writing it pretty much as I would a comic, in that every angle was in there. I was doing panel descriptions for a film! Because, when I'm writing a comic I'm in complete control of all that. But of course in a movie, you don't really expect the screenwriter to be actually talking about which camera angles you should set up and how you should compose the shot.

So, you know, it was an interesting experience. Not one that I would ever want to repeat. I don't really want to do screenplays or anything like that. I gave it a try, but it's nothing

that I'd want to repeat.

When you did *A Small Killing*, was that an experiment for you? I think I remember you saying that it was Oscar Zarate that came up with that story.

I met with Oscar; he told me that he enjoyed my writing and that he'd like to work with me on something. And then he threw me an idea which was somebody being followed by a little boy. That was the only idea he'd got—somebody, a man, being followed by a little boy.

I kind of chewed that over and it reminded me vaguely of a dream that I'd had when I was a teenager or in my early 20s of meeting myself as a child and realizing that the ten-year old was horrified by what I'd turned into, what I'd ended up as. I kind of thought that that would be an interesting thing, if this child that is following this man in Oscar's image was him or some ghost or phantasm of him as a child, and that you could make this story say something about the gap that exists between our childhood dreams or ambitions or ideals and some of the people we end up being. And it did kind of grow

OH, SORRY MARTIN, BUT YOU CAN'T GO OUT TONIGHT!

WHY?

BECAUSE YOU'RE GROUNDED! GO TO YOUR ROOM NOW. BEFORE I SLAP YOU UP SIDE THE HEAD!

A scene from 1995's "Outbreak of Violets." Art by Jamie Hewlett. ©2003 MTV Europe.

from there. The characters started to get filled in, bits of the details of his life. Oscar is much more critical than anybody else that I'd worked with. Oscar would point out if he didn't think something rang true or he thought that I was being emotionally manipulative and you know, I gotta hand it to Oscar, he's one of the artists I've worked with who taught me something. He's got very vigorous sensibilities regarding that sort of stuff and he made me realize that at a couple of points that, yes, I am being emotionally manipulative in this thing; it would be much better if I did it this other way. Oscar's got a very astute sensibility when it comes to art. Working on *A Small Killing* with him, I still think *A Small Killing* was one of the best things I've ever done. And one of the most beautiful books that I've ever been part of. I mean, me and Oscar are kicking over ideas for possibly doing another book—the working title is *The Battle*. Whether this will be any time soon, I really don't know. But he's one of my best friends. He's an incredible man, Oscar.

It seems to be one of the more underrated books; it's like the one book nobody seems to mention.

I think it's a well kept secret. [laughs] I think that people who've read it know how good it is yet there are not a lot of people who've read it.

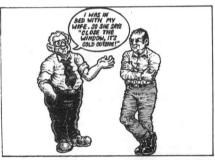
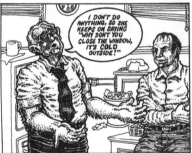
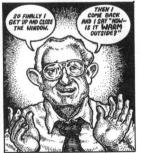

A meeting of the minds: Harvey Pekar wrote, and Alan Moore drew, this 1990 strip for *American Splendor*. ©2003 Harvey Pekar.

In "I Keep Coming Back," a 1996 short story from *It's Dark in London*, Moore and Oscar Zarate are reunited. ©2003 Alan Moore and Oscar Zarate.

But it has a very, I think, European flavor to it.

Yeah, well I know that at the moment I think Avatar is going to be bringing it out, a new edition of it in America, hopefully. It might make better reading now; I think that people might understand now a little bit more of what we were saying. Maybe at the time it was too much of a departure, you know? That perhaps people who had otherwise expected me to be writing *Watchmen* or *From Hell* or something that was at least dramatic and epic with dying in it, found it a bit of a departure to talk about this fairly mundane yuppie-advertising guy and his personal problems, you know? But, well, we'll see what the responses are when the Avatar version's out, but I'm hoping that this time around maybe it'll make a bit more sense to people given the intervening... whatever it is, ten, twelve years, something like that.

Cover to *Angel Passage*, a recent Moore performance CD. ©2003 Alan Moore.

BELLY OF CLOUD

This story comes to us via a recommendation by the ever-friendly Neil Gaiman who has never forgotten the alluring sting he got from reading it many moons ago. "Belly" was intended for Gerhard to illustrate and Dave Sim to publish. It's another interesting project that never came to fruition, but serves us an excellent example of the workmanship that Alan puts into his craft.

©2003 Alan Moore.

PAGE 1.

PANEL 1.

A SINGLE FULL PAGE PICTURE OPENS THE STORY. WE ARE LOOKING OUT ACROSS THE CITY OF NOX AETERNA, AND IT IS NIGHT TIME. SO NO SURPRISES THERE. THE CITY, THOUGH SEEN AS EVER THROUGH A VEIL OF DARKNESS, MUST BE IMMEDIATELY STRIKING IN ITS ARCHI-TECTURE. I SEE IT LOOKING AT LEAST SUPERFICIALLY LIKE A HIGH-TECH CONTEMPORARY CITY, BUT WITH CERTAIN KEY DIFFERENCES: IMAGINE A CITY THAT MAY HAVE EXISTED IN SOME FORM OR OTHER FOR AS LONG AS CITIES HAVE BEEN AROUND. OVER THE CENTURIES BETWEEN ITS INCEPTION AND THE PRESENT DAY, MANY CHANGES HAVE BEEN MADE. OLD CULTURES HAVE BEEN SUPPLANTED BY NEWER ONES; OLD MYTHOLOGIES AND FORMS OF WORSHIP SUPERCEDED BY LATER ORTHODOXIES. OBVIOUSLY, STYLES OF BUILD-ING AND MATERIALS USED HAVE CHANGED AS WELL, BUT ALTHOUGH BUILT WITH THE SAME PRE-STRESSED CONCRETES, GIRDERS AND ASPHALT AS OTHER CITIES, NOX AETERNA AND ITS SISTER CITY, LUX BREVIS, RETAIN A DISTINCT FLAVOUR OF THEIR OWN. FOR ONE THING, THE CITY DOES NOT SEEM TO BE A CHRISTIAN CITY. ALTHOUGH THERE ARE CHRISTIAN CHURCHES AND ICONS IN EVI-DENCE HERE AND THERE, CLOSER INSPECTION WILL ALSO FIND IMAGES AND MODERN TEMPLES DEDICATED TO THE ANCIENT GODS AND ENTITIES OF ALL CULTURES, ANCIENT AND MODERN. THE BUILD-INGS, THOUGH GLEAMING WITH FLUORESCENT LIGHTS AND ADORNED WITH SATELLITE DISHES, HAVE A DARK AND DRAGON-LIKE GOTHIC FEEL TO THEM, WITH MANY INTRICATE AND BAROQUE ARCHITECTURAL FLOURISHES, AGAIN DRAWN FROM A NUMBER OF PERIODS AND STYLES. THE BUILDINGS THAT WE SHOW IN LUX BREVIS AND NOX AETERNA NEEDN'T EVEN BE CONSISTENT FROM STORY TO STORY (WITH A FEW EXCEPTIONS) AS LONG AS THE FEEL OF THEM IS CON-SISTENT. THIS IS THE CITY OF ETERNAL NIGHT, AND I WANT IT TO HAVE THE IMMEDIATE ARCHETYPAL QUALITY THAT THOSE WORDS CONVEY. IT'S A CITY SO ARCHITECTURALLY STRANGE THAT ONE'S FIRST GLIMPSE OF IT SHOULD BE DISORIENTATING, YET AT THE SAME TIME I WANT SOMETHING STRANGELY FAMILIAR ABOUT IT; A PLACE SEEN BEFORE, IN FORGOTTEN DREAMS. IN THIS FIRST PANEL WE ARE LOOKING OUT ACROSS THE CITY FROM THE LEVEL OF THE THIRD OR FOURTH STOREY, AND IN THE RIGHT OF THE FOREGROUND, EXTENDING FROM THE TOP OF THE PAGE TO THE BOTTOM, WE CAN SEE A LITTLE OF THE SIDE OF A TALL HOTEL BUILDING, WITH ONE OF THE LARGE THIRD-OR-FOURTH FLOOR WINDOWS CLEARLY VISIBLE, THE SOFT INTERIOR LIGHT FLOODING OUT THROUGH IT INTO THE NIGHT. IN NEAR-SILHOUETTE AGAINST THIS LIGHT WE SEE THE FIG-URE OF A MAN STANDING GAZING OUT INTO THE DARKNESS.

ALTHOUGH WE MAYBE CAN'T MAKE HIM OUT THAT DISTINCTLY HERE HE IS AROUND TWENTY SEVEN OR TWENTY EIGHT YEARS OLD AND DRESSED IN DARK SUIT TROUSERS AND A WHITE SHIRT OPEN AT THE CUFFS AND ALL DOWN THE FRONT. HE IS HALF-DRESSED IN THE WAKE OF A TOO-BRIEF AND ABORTED SEXUAL ENCOUNTER, AND HE LOOKS SORT OF RESTLESS AND UNSATISFIED AS HE STARES INTO THE BLACKNESS BEYOND THE HOTEL WINDOW. LOOKING PAST THE HOTEL THAT IS PARTLY VISIBLE ON THE RIGHT, WE CAN SEE ACROSS THE SLEEPING CITY WITH ITS ARRAY OF FANTASTIC BUILDINGS LOOM-ING INDISTINCTLY IN THE DARK. ON THE FAR SOUTHERN HORIZON, DIRECTLY IN FRONT OF US, THERE IS A SLIGHT ROSEATE PALLOR, AS IF THE SUN HAD EITHER JUST GONE DOWN OR WERE JUST ABOUT TO COME UP. THE MAN STANDS MOTIONLESS AND GAZES OUT INTO THE NIGHT, TALKING TO SOMEONE IN THE ROOM BEHIND HIM THAT WE CANNOT SEE AS YET. THE TITLE AND CREDITS GO DOWN TOWARDS THE BOTTOM OF THE PAGE.

MAN (FROM WINDOW): I'm sorry.
MAN (FROM WINDOW): That's never happened to me before.
TITLE: BELLY OF CLOUD
CREDITS: (As usual)

PAGE 2.

PANEL 1.

NOW A SIX PANEL PAGE WHICH I SUGGEST IS ARRANGED WITH TWO TIERS OF THREE PANELS EACH. IN THIS FIRST PANEL WE ARE INSIDE THE HOTEL ROOM, LOOKING AT THE MAN FROM SLIGHTLY BEHIND HIM AND TO HIS RIGHT AS HE GAZES OUT OF THE WINDOW INTO THE TWINKLING DARK OF NOX AETERNA. THOUGH STANDING SO AS TO FACE THE WINDOW HE IS TURNING HIS HEAD SLIGHTLY TO THE RIGHT TO LOOK AROUND AT US AND AT WHOEVER IS SPEAKING FROM OFF PANEL BEHIND HIM. HIS EXPRESSION IS SUFFUSED WITH A MILD DEPRESSION, VAGUE REGRET IN HIS EYES. HIS FACE IS DOUBLE LIT BY THE SOFT LIGHT IN THE ROOM AND THE GLOW OF THE STREET-LIGHTS AND NEON FILTERING IN FROM WITHOUT. PERHAPS A FILM OF PERSPIRATION IS DRYING HIS BROW, SUGGESTING A SUMMER HEAT. THERE ARE DAMP CRESCENTS BENEATH THE ARMS OF HIS SHIRT. WE SEE HIM HERE SOMEWHERE BETWEEN HALF FIGURE AND HEAD AND SHOULDERS CLOSE UP AS HE TURNS TO GLANCE IN OUR DIRECTION. THE SPEECH BALLOON OF THE OFF-PANEL GIRL ISSUES FROM SOMEWHERE BELOW AND TO THE RIGHT OF THE PANEL, IN THE DIRECTION THAT THE MAN IS GLANCING.

GIRL (OFF): That's okay. It's the same with most guys. A whole lot of 'em can't do it at all.
GIRL: (OFF): Are you married?

PANEL 2.

WE START TO PULL BACK NOW FROM OUR LAST SHOT, SO THAT NOW WE SEE THE MAN BETWEEN HALF AND THREE QUARTER FIGURE AS HE STANDS, UNMOVED, BY THE WINDOW, PERHAPS WITH ONE HAND RESTING AGAINST THE COOL, CONDENSATION-DEWED GLASS. HE TURNS HIS HEAD BACK AWAY FROM US AND CONTINUES TO GAZE OUT OF THE WINDOW, SO THAT WE SEE HIM MORE OR LESS IN PROFILE HERE. A TROUBLED AND UNCOMFORTABLE LOOK OF GUILT SHADOWING HIS FACE AS HE REPLIES WITHOUT LOOKING AT US. THE FURNISHINGS AND FITTINGS OF THE HOTEL ROOM, AS WE SEE MORE OF THEM, HAVE ODDLY CONTEMPORARY-YET-DATED FEEL THAT DAVID LYNCH GIVES TO SOME OF HIS HOTEL INTERIORS, WITH AN ATMOSPHERE OF NOSTALGIC FAMILIARITY AND ORDINARINESS THAT BECOMES ALMOST SURREAL IN THE CONTEXT OF THE STORY.

MAN: Well...Yeah. Yeah, I am.
MAN: I'm uh, y'know, just supposed to be stopping off in Nox overnight after this convention.
MAN: Back home tomorrow.

PANEL 3.

WE CONTINUE TO PULL BACK SO THAT NOW WE SEE THE MAN FULL FIGURE AS HE STANDS BY THE PICTURE WINDOW, FACING OUT. HE TURNS HIS HEAD ONCE MORE TO GLANCE AT US AS THE OFF PANEL GIRL WHOSE BALLOONS ISSUE FROM THE LOWER RIGHT SPEAKS AGAIN. IN THE LOWER RIGHT NOW WE CAN SEE THE CORNER OF A BEDSIDE TABLE JUST JUTTING INTO THE PICTURE, WITH THE BED PRESUMABLY OFF PANEL TO THE RIGHT OF THE FOREGROUND. IT IS IN THIS DIRECTION THAT THE MAN TURNS HIS HEAD TO GAZE, THE SAME VAGUELY MELANCHOLY AND GUILTY LOOK IN HIS DARK EYES.

GIRL (OFF): Uh-huh. So you didn't get time to visit the Cathedral or All Souls Plaza or stuff like that? That's too bad.
GIRL (OFF): Do you have any cigarettes?

PANEL 4.

THE THREE ON THIS BOTTOM TIER ARE ALL ONE BIG PICTURE WITH A CONTINUOUS BACKGROUND THAT IS DIVIDED INTO THREE EQUAL PANELS. THIS FIRST PANEL HAS THE SAME SET UP AS PANEL THREE, WITH THE MAN AND THE WINDOW IN THE NEAR LEFT BACKGROUND AND THE CORNER OF THE BEDSIDE TABLE JUTTING OUT INTO THE BOTTOM RIGHT FOREGROUND. HE IS STARTING TO WALK AWAY FROM THE WINDOW SLOWLY, AMBLING TOWARDS THE RIGHT OF THIS PANEL AND COMING MORE TOWARDS US. AS HE DOES SO HE GESTURES CASUALLY TOWARDS THE BEDSIDE TABLE, HIS EYES STILL LOOKING AT THE OFF PANEL GIRL, JUST OUT OF SIGHT IN THE RIGHT OF THE FOREGROUND.

MAN: Uh, yeah, there's some by the bed, on the night table there.
MAN: I, uh, I WANTED to see All Souls and the Academie Du Soleil, but, well, y'know.
MAN: Next time.

PANEL 5.

WE PAN ACROSS TOWARDS OUR RIGHT NOW. IN THE FOREGROUND, MORE OF THE BEDSIDE TABLE BECOMES VISIBLE, SO THAT HERE WE CAN SEE THE FRONT END OF THE PACK OF CIGARETTES THAT IS LYING THERE UPON THE TABLE, WITH THE BACK OF THE BACK OVER THE RIGHT PANEL BORDER AND THUS VISIBLE IN OUR NEXT CONTINUOUS PANEL. RESTING BESIDE THE PACK OF CIGARETTES WE CAN SEE THE TOP END OF AN ORDINARY DISPOSABLE CIGARETTE LIGHTER.

LOOKING BEYOND THE BEDSIDE TABLE WE SEE THE MAN AS HE CONTINUES TO STROLL SLOWLY ACROSS THE ROOM TO THE RIGHT, COMING SLIGHTLY MORE TOWARDS US AS HE DOES SO. JUTTING INTO THE RIGHT OF THE PANEL IN THE MIDDLEGROUND WE SEE THE BACK OF ONE OF THE HOTEL ROOM'S CHAIRS JUST ENTERING FROM OFF PANEL RIGHT, THE REST OF IT VISIBLE ACROSS THE GULLEY IN OUR NEXT PANEL. THE MAN IS ABOUT TO WALK BEHIND THE CHAIR, ON THE FAR SIDE OF IT TO US, AND ROUND TO ITS OTHER SIDE IN THE NEXT PANEL. HE IS STILL GAZING TOWARDS THE OFF PANEL GIRL ON THE RIGHT, HIS FACE NOW MORE OR LESS EXPRESSIONLESS AS HE LISTENS TO HER SPEAK.

GIRL (OFF): Sure.
GIRL (OFF): Look, I don't mean to be pushy or anything, but do you have any weed? Any pills or stuff like that?

PANEL 6.

WE CONTINUE TO PAN ACROSS THE BOTTOM TIER TOWARDS THE RIGHT. IN THIS LAST PANEL, IN THE FOREGROUND, WE CAN SEE THE REAR END OF THE CIGARETTES AND THE LIGHTER BESIDE THEM AS THEY REST ON THE BEDSIDE TABLE. FROM OFF PANEL RIGHT WE SEE THE HAND AND WRIST OF A YOUNG WOMAN AS SHE REACHES INTO THE PANEL AND STARTS TO PICK UP THE CIGARETTES, HER BALLOON STILL ISSUING FROM OFF RIGHT AS SHE DOES. LOOKING PAST THIS INTO THE SOFTLY-LIT ROOM WE CAN SEE THE OTHER PART OF THE CHAIR THAT WE SAW LAST PANEL. THE MAN HAS CONTINUED TO WALK AROUND BEHIND IT HERE, FINALLY COMING TO REST ON OUR RIGHT OF IT AND JUST BEHIND IT, ONE HAND RESTING ON ITS BACK AS HE GAZES TOWARDS THE GIRL WHO IS OFF PANEL RIGHT, WEARING A FAINT DISCOMFITED FROWN OF APOLOGY AS HE SPEAKS.

MAN: Uh, no. No, I don't. I'm sorry.
GIRL (OFF): Ah, it doesn't matter. I just thought, y'know, if you had some.
GIRL (OFF): You want one of these?

PAGE 3.

PANEL 1.

ANOTHER SIX PANEL PAGE HERE, WITH THE SAME THREE-UP/THREE-DOWN LAYOUT AS OUR LAST PAGE. ALL SIX PANELS HAVE THE SAME SHOT, WHICH IS THE SAME SHOT AS THE LAST PANEL ON OUR PREVIOUS PAGE, MORE OR LESS. WE CAN SEE THE BEDSIDE TABLE IN THE FOREGROUND, WITH THE GIRL AND THE BED JUST OFF PANEL TO THE RIGHT. IN THE MIDDLE BACKGROUND WE CAN SEE THE CHAIR BY WHICH THE MAN IS STANDING, LOOKING TOWARDS THE OFF PANEL GIRL. THIS BASIC SET-UP DOESN'T VARY THROUGHOUT THE SIX PANELS ON THIS PAGE. IN THIS FIRST PANEL, THE MAN LIFTS ONE HAND IN A SORT OF INDECISIVE GESTURE AS HE GAZES TOWARDS THE GIRL, HIS FACE STILL FAIRLY EXPRESSIONLESS. IN THE FOREGROUND WE SEE THE GIRL'S HANDS AS SHE HOLDS UP THE CIGARETTE PACKET IN ONE HAND AND TAKES A CIGARETTE FROM IT WITH THE OTHER. HER HANDS ARE VERY PALE AND YOUNG AND SLIM. THE CIGARETTES ARE SOME RECOGNIZABLE REAL-WORLD BRAND LIKE CAMELS OR SOMETHING, THE DISTINCTIVE PACK DESIGN VISIBLE HERE. (A BIT OF PRODUCT PLACEMENT NEVER HURTS, IN MY EXPERIENCE.)

MAN: No, I...
MAN: Yeah. Yeah, I will. Thanks. I could use one.
GIRL: (OFF): No problem.

PANEL 2.

SAME SHOT. THE MAN HAS COME CLOSER TOWARDS US FROM THE BACKGROUND AND IS REACHING OUT TO ACCEPT THE CIGARETTE THAT THE GIRL HANDS TO HIM, HER SLIM WHITE FOREARM ENTER-

ING THE PANEL FROM OFF ON THE RIGHT HAND SIDE ALONG WITH HER SOLITARY SPEECH BALLOON. HE LOOKS SORT OF NERVOUS AND HALF-EMBARRASSED AS HE SPEAKS, AS IF HE'S REFERRING TO SOME DISABILITY THAT SHE HAS AND DOESN'T WANT TO OFFEND HER.

MAN: Thanks. Look, it's none of my business, but...
MAN: Well, I dunno, I mean, somebody like you, in this kind of work, it seems...
GIRL (OFF): Funny?

PANEL 3.

SAME SHOT. THE MAN NOW STANDS TOWARDS THE FOREGROUND, LOOKING TOWARDS THE OFF PANEL GIRL AS HE LIFTS THE CIGA-RETTE SHE HAS GIVEN HIM TOWARDS HIS MOUTH. IN THIS FORE-GROUND WE SEE HER HAND ENTERING THE PANEL FROM OFF RIGHT ALONG WITH HER SPEECH BALLOONS AS SHE PICKS UP THE DISPOS-ABLE LIGHTER FROM ITS PLACE ON THE TABLE.

MAN: Well...yeah. I mean, I'm not saying it's something bad. I just never thought about it.
GIRL (OFF): There's not much to think about.
GIRL (OFF): Here lemme light that.

PANEL 4.

THE MAN LEANS FORWARD TOWARDS US NOW, BOWING HIS HEAD TO LIGHT HIS CIGARETTE FROM THE NOW-IGNITED LIGHTER THAT THE GIRL'S HAND IS HOLDING OUT TO HIM AS IT REACHES INTO THE PANEL FROM OFF-FRAME RIGHT. THE MAN'S FACE IS BRIEFLY UNDER-LIT BY THE LIGHTER FLAME AS HE LIGHTS THE CIGARETTE, HIS EYE-LIDS LOWERED HERE AND LOOKING DOWN AT THE TIP OF HIS CIGA-RETTE.

GIRL (OFF): There. Y'got it?
MAN: Um.

PANEL 5.

SAME SHOT. THE MAN STRAIGHTENS UP AGAIN. HE TAKES THE CIGA-RETTE FROM HIS MOUTH AND EXHALES BLUE SMOKE AS HE SPEAKS, STILL LOOKING TOWARDS THE OFF PANEL GIRL. HE MAYBE TAKES HALF A STEP BACK TOWARDS THE CHAIR THAT WE CAN STILL SEE BEHIND HIM AS HE DOES SO. IN THE FOREGROUND WE SEE THE GIRL'S HANDS AS SHE TAKES A CIGARETTE FOR HERSELF FROM THE OPEN PACKET.

MAN: Thanks. What I mean is, I didn't know you people had jobs. Y'know ANY kind of jobs.
GIRL (OFF): Usually we don't. It's just sometimes you need money for stuff.

PANEL 6.

SAME SHOT. IN THE MIDDLE BACKGROUND THE MAN HAS REACHED THE SEAT AND IS LOWERING HIMSELF INTO IT SO THAT HE SITS FAC-ING THE BED, HIS CIGARETTE STILL IN HIS HAND. IN THE RIGHT OF THE FOREGROUND WE CAN SEE THE TIP OF THE GIRL'S CIGARETTE, WHICH IS NOW IN HER OFF PANEL MOUTH, JUST JUTTING INTO VIEW ON THE RIGHT. BENEATH IT WE SEE HER HAND AS SHE RAISES THE AS-YET-UNLIT LIGHTER TOWARDS HER CIGARETTE TO LIGHT IT. THE MAN'S FACE IN THE NEAR BACKGROUND HAS A SUDDEN LOOK OF REAL INTEREST AND CURIOSITY AS HE QUESTIONS THE GIRL.

MAN: What stuff? You said earlier how you don't have to eat or need anywhere to live or whatever.
MAN: What is it you need?

PAGE 4.

PANEL 1.

THIS IS A FOUR PANEL PAGE. THE TOP HALF TO TWO-THIRDS OF THE PAGE IS TAKEN UP BY A SINGLE BIG PICTURE, WITH A BANK OF THREE SMALLER PANELS AT THE BOTTOM BENEATH THAT. IN THIS FIRST BIG PICTURE WE GET OUR FIRST REAL SHOT OF THE ROOM SO THAT WE CAN SEE THE BED AND THE GIRL. WE HAVE CHANGED ANGLE SO THAT WE ARE LOOKING TOWARDS THE BED. WE CAN SEE THE FRONT OF THE CHAIR AND MAYBE A LITTLE OF THE MAN AS HE SITS LOOKING AWAY FROM US IN THE RIGHT FOREGROUND, FACING TOWARDS THE BED IN THE IMMEDIATE BACKGROUND. MAYBE WE CAN JUST SEE HIS KNEES OR ONE OF HIS HANDS HOLDING THE CIGA-RETTE OR SOMETHING, THE SMOKE TWISTING SILENTLY UP INTO THE ROOM. THE DOUBLE BED FILLS MOST OF THE SOFTLY-LIT, COSILY-SHADOWED BACKGROUND OF THE HOTEL ROOM. SITTING UP IN BED WITH THE COVERS UP AROUND HER WAIST IS A BEAUTIFUL WOMAN OF ABOUT TWENTY FIVE WITH A TANGLED MOP OF BLONDE HAIR, STRANDS OF WHICH FALL DOWN INTO HER EYES HERE. SHE IS SLIM WITH SMALL BUT NICELY-SHAPED BREASTS AND A FLAT BELLY. THE ONLY THINGS THAT REALLY MAKE HER OUT FROM THE CROWD, HOW-EVER, ARE THE BALL-LIKE HALO OF GOLDEN LIGHT THAT SUR-ROUNDS HER HEAD AND THE MASSIVE SNOW-WHITE WINGS THAT GROW OUT FROM HER SHOULDER BLADES, FANNED OUT ACROSS THE FULL WIDTH OF THE BED HERE. SHE DIPS HER HEAD TO LIGHT HER DANGLING CIGARETTE FROM THE NOW-ILLUMINATED CIGARETTE LIGHTER AS SHE REPLIES. SHE IS THE MOST BEAUTIFUL AND INNO-CENT CREATURE THAT YOU HAVE EVER SEEN OR IMAGINED.

ANGEL: Heroin.

PANEL 2.

IN THIS FIRST SMALL PANEL ON THE BOTTOM TIER WE CHANGE ANGLES SO THAT WE HAVE PART OF THE HEAD AND SHOULDERS OF THE ANGEL IN THE BOTTOM RIGHT FOREGROUND, FACING SLIGHTLY AWAY FROM US TOWARDS THE NEAR LEFT BACKGROUND AS SHE TAKES THE CIGARETTE FROM HER MOUTH AND EXHALES BLUE SMOKE. WE CAN PERHAPS SEE A LITTLE OF THE BEAUTIFUL WINGS SPROUTING FROM HER SHOULDERS HERE...JUST THE ROOTS OF THEM WHERE THEY JOIN HER SHOULDER BLADES OR SOMETHING. SHE LOWERS HER EYES AND DOESN'T LOOK AT THE MAN AS SHE CONTINUES TO SPEAK TO HIM, CIGARETTE IN HAND AS SHE LOUNGES THERE IN THE BED. LOOKING BEYOND HER WE CAN SEE THE YOUNG MAN AS HE SITS THERE IN HIS POST-COITALLY OPEN SHIRT, SMOKING HIS OWN CIGARETTE AND JUST GAZING AT HER WITH A LOOK OF STRICKEN PITY DAWNING IN HIS EYES.

ANGEL: I mean, don't get me wrong, I don't do a lot. Not like a junkie or anything.
ANGEL: It's more sorta casual. Casual use.

PANEL 3.

WE ZOOM PAST THE ANGEL IN THE FOREGROUND SO THAT WE CAN NO LONGER SEE HER HERE. INSTEAD, WE ARE LOOKING AT THE YOUNG MAN, HALF TO THREE QUARTER FIGURE AS HE SITS THERE IN HIS CHAIR, FACING US. HE STARES DOWN AT THE FLOOR IN DISBELIEF, HIS CIGARETTE DANGLING FORGOTTEN IN HIS HAND. HE LOOKS REALLY INCREDULOUS AND UPSET.

MAN: God, that's...
MAN: That makes me feel terrible.

PANEL 4.

IN THIS LAST PANEL WE CHANGE ANGLE FOR A SHOT THROUGH THE YOUNG MAN'S EYES, SO THAT HE HIMSELF IS NOT VISIBLE. WE ARE

LOOKING AT THE ANGEL AS SHE LIES BACK ON THE PILLOWS AND THE ADDITIONAL DOWNY CUSHION OF HER WINGS, FANNED BENEATH HER. HOLDING HER SMOULDERING CIGARETTE IN ONE HAND SHE FROWNS SLIGHTLY IN GENUINE PUZZLEMENT AS SHE LOOKS QUESTIONINGLY AT US AND THE OFF PANEL YOUNG MAN. SHE SEEMS GENUINELY UNABLE TO UNDERSTAND THE YOUNG MAN'S REACTION. HER EXISTENCE AND HER LIFESTYLE AREN'T SUCH A BIG DEAL TO HER AS THEY ARE TO HIM.

ANGEL: Why? What's terrible?
ANGEL: A lot of the girls are using dope. You know that.

PAGE 5.

PANEL 1.

NOW ANOTHER SIX PANEL PAGE, AGAIN WITH THREE PANELS ON THE TOP TIER AND THREE ON THE BOTTOM, WHICH IS PRETTY MUCH THE LAYOUT THAT I WANT TO STICK TO FOR THESE REMAINING FOUR PAGES. IN THIS FIRST PANEL WE CAN SEE BOTH THE BED WITH THE ANGEL PROPPED UP IN IT AND THE MAN SITTING FACING THE BED FROM HIS CHAIR. HE STILL LOOKS UPSET AND UNABLE TO EXPRESS IT ARTICULATELY, GESTURING WITH HIS HANDS AS HE TRIES TO EXPLAIN HOW THE THOUGHT OF A HEROIN-ADDICTED ANGEL MAKES HIM FEEL. THE ANGEL WATCHES HIM FROM THE BED, STILL WITH A MILD FROWN OF PUZZLEMENT AS SHE TAKES A COUPLE FINAL PULLS ON HER CIGARETTE AND REACHES FOR AN ASHTRAY, WHICH IS PROBABLY SITUATED ON THE BEDSIDE TABLE, TO THE RIGHT OF THE PANEL HERE AS WE LOOK TOWARDS THE BED.

MAN: Well, sure, but...somebody like you, y'know? It seems, I dunno. It seems worse.
MAN: I mean, ordinary people getting fuh...getting messed up, that's one thing, but you, it oughtta be different.

PANEL 2.

NOW A HEAD AND SHOULDERS CLOSE-UP OF THE ANGEL, SHE LOOKS DIRECTLY AT US WITH HER BEAUTIFUL EYES AS SHE STUBS HER ONE-THIRD-SMOKED CIGARETTE IN THE ASHTRAY. HER FACE IS CALM AND SERIOUS.

ANGEL: No. It's exactly the same. We're just YOU unfolded in time, David. Why is it you people NEVER understand that?
ANGEL: Oh, and it's okay to say f*ck.

PANEL 3.

CHANGE ANGLE. WE ARE NOW BY THE LEFT HAND SIDE OF THE BED, WHERE THE NIGHT TABLE IS, LOOKING AT THE BED SIDE ON FROM QUITE CLOSE TO IT WITH THE BEDSIDE TABLE NOW VISIBLE ON THE EXTREME RIGHT OF THE PANEL. THE ANGEL KICKS BACK THE COVERS AND SWINGS HER SLIM LEGS OVER THE BED'S NEAREST EDGE TO SIT UP NAKED ON THE SIDE OF THE BED FACING US. HER EYES AND HEAD ARE LOWERED SLIGHTLY, AND SHE MAYBE RUNS ONE HAND WEARILY THROUGH HER HALO-LIT MOP OF BLONDE HAIR AS SHE DOES SO PERHAPS WITH THE OTHER HAND SHE IS REACHING FOR HER PANTIES, LYING CRUMPLED AND DISCARDED ON THE FLOOR SOMEWHERE IN THE FOREGROUND, IF THAT LOOKS GOOD. LOOKING BEYOND HER WE CAN SEE A LITTLE OF THE MAN AS HE STARTS TO RISE FROM HIS CHAIR, STILL GAZING IN MELANCHOLY BEMUSEMENT AT THE ANGEL'S TURNED BACK. MAYBE HE IS STUBBING OUT HIS OWN CIGARETTE IN THE ASHTRAY AS WE SEE HIM HERE.

ANGEL: I dunno...I guess some stuff is just harder to see when you haven't got wings.
ANGEL: Hey, did you notice where I put my top?

PANEL 4.

NOW A FLOOR LEVEL SHOT. IN THE RIGHT OF THE FOREGROUND WE CAN SEE THE LOWER LEGS OF THE ANGEL AS SHE STEPS INTO THE FIGURE-EIGHT OF HER PANTIES ONE LEG AT A TIME. WE CAN MAYBE ALSO SEE THE BLADE-FEATHERS OF HER WINGS AS THEY TRAIL DOWN INTO THE FOREGROUND BEHIND HER. LOOKING PAST HER LEGS AND FEET WE ARE LOOKING UP AT A FULL FIGURE SHOT OF THE MAN AS HE STANDS THERE STARING AT HER, HIS FACE NOW SUDDENLY BLANK WITH SUBDUED AWE AND ASTONISHMENT AS HE GAZES AT HER. IN HIS HAND HE HOLDS HER SKIMPY TOP OUT TOWARDS HER IN ONE HAND. HAVING JUST PICKED IT UP FROM THE BACK OF HIS CHAIR OR SOMEWHERE. THE TOP IS SOMETHING BRIEF AND SLEEVELESS, LIKE A HALTER TOP EXCEPT WITH MAYBE A ROW OF CORSET-LIKE FASTENINGS DOWN THE BACK. HE LOOKS STUNNED AND AMAZED AS HE HOLDS IT OUT TOWARDS HER.

MAN: Here.
MAN: How did you know my name was David?

PANEL 5.

CHANGE ANGLE SO THAT WE ARE NOW JUST BEHIND DAVID'S RIGHT SHOULDER AS HE STANDS FACING MOSTLY AWAY FROM US. HALF FIGURE IN THE LEFT OF THE FOREGROUND, HOLDING OUT THE TOP TO THE ANGEL WHO WE SEE TURNING TO FACE HIM FROM THE NEAR RIGHT BACKGROUND, ONE HAND HELD OUT AS SHE TAKES THE TOP FROM HIM. SHE SMILES AT HIM, IN A WAY THAT IS AMUSED BUT NOT UNKIND. SHE CHIDES HIM GENTLY FOR HIS NAIVETE.

ANGEL: Oh, come ON. How'd you think? I know your name the same way that you know mine.
ANGEL: Thanks. Can you fasten me up?

PANEL 6.

CHANGE ANGLE AGAIN FOR A HALF FIGURE REACTION SHOT OF THE MAN AS HE STANDS FACING THE ANGEL, WHO IS PERHAPS JUST OUT OF THE PICTURE IN THE RIGHT OF THE FOREGROUND WITH JUST A BIT OF HER ARM AND SHOULDER SHOWING OR SOMETHING AS SHE PULLS ON THE SKIMPY, CHEAP-FABRIC TOP. THE LOOK OF DUMBFOUNDED AWE IN THE MAN'S EYES GREW SUDDENLY MORE PRONOUNCED. HE IS BEING TOUCHED BY SOMETHING BEYOND HIS UNDERSTANDING. HIS FACE IS BATHED BY THE SOFT GLOW CAST BY THE ANGEL'S OFF PANEL HALO. (IN FACT, IT STRIKES ME THAT IT MIGHT BE A GOOD IDEA TO MAKE THE ANGEL'S HALO THE ONLY LIGHT SOURCE IN THE ROOM THROUGHOUT THIS ENTIRE STORY. ALL THE OTHER ROOM LIGHTS ARE SWITCHED OFF. SEE HOW IT LOOKS TO YOU AND THEN DO ACCORDINGLY IF YOU THINK IT WORKS VISUALLY.)

MAN: But I DON'T know what your name i...
MAN: Illesuriah
MAN: You're the Angel Illesuriah.

PAGE 6.

PANEL 1.

ANOTHER TWO-TIER, SIX PANEL PAGE. IN THIS FIRST PANEL WE SEE A LITTLE OF THE MAN, HALF FIGURE, AS HE FACES AWAY FROM US AT AN ANGLE INTO THE PANEL FROM THE LEFT FOREGROUND. ALTHOUGH WE CAN SEE A LITTLE OF HIS PROFILE WE CAN ONLY SEE HIM FROM THE NOSE DOWN, AS I WANT THE ONLY EYES IN THIS PANEL TO BELONG TO THE ANGEL. WE SEE HER ROUGHLY HALF FIGURE IN THE IMMEDIATE BACKGROUND AS SHE TURNS HER BACK TO THE MAN, LOOKING BACK AT HIM OVER HER SHOULDER AND SMILING WARMLY AT HIM, DELIGHTED TO HAVE SHOWN HIM SOMETHING THAT HE HASN'T EXPERIENCED BEFORE. SHE HAS PULLED HER ARMS

THROUGH THE TOP, SO THAT HER BREASTS ARE NOW COVERED, BUT OWING TO THE OBSTRUCTION OF HER MASSIVE AND HEAVENLY WINGS SHE NEEDS HIS HELP FASTENING THE ROW OF HOOKS AND EYES THAT RUN DOWN THE BACK OF THE TOP. SHE REACHES BEHIND HERSELF TO HOLD THE EDGES TOGETHER AS BEST SHE CAN, ASKING HIM TO TAKE OVER.

ANGEL: There. That wasn't so hard, was it?
ANGEL: Here, if you can just get the hook at the top into the right eye, I can do the rest.

PANEL 2.

NOW WE SEE BOTH OF THEM FULL FIGURE AS THEY STAND THERE TOGETHER, MORE OR LESS FACING US, THE GIRL STANDING WITH HER BACK TO THE MAN, WHO IS IMMEDIATELY BEHIND HER. HE FASTENS HER TOP FROM THE BACK AS SHE FUSSILY STRAIGHTENS THE WAY IT FITS AT THE FRONT, LOOKING DOWN AT HER BUST AS SHE DOES SO. BEHIND HER, THE MAN STARES AT HER HALO-ENSHROUDED GOLDEN HAIR AND LOOKS ALMOST DAZED AND STUPID WITH THE BEGINNINGS OF LOVE AS HE SPEAKS TO HER.

MAN: Huh? Oh, Sure. Sure, I'll do all of them.
MAN: Listen, do you have to go? I mean, right away? I could fix us a drink or something...

PANEL 3.

ANOTHER FLOOR LEVEL SHOT. IN THE LEFT OF THE FOREGROUND, STANDING FACING DIAGONALLY AWAY FROM US, WE SEE THE FEET AND LOWER LEGS OF THE MAN AS HE STANDS LOOKING TOWARDS THE WOMAN, WHO WE SEE MORE OR LESS FULL FIGURE IN THE NEAR BACKGROUND. SHE IS BENDING OVER, HER TOP NOW FASTENED, AND PICKING UP A PAIR OF GARISH HOT-PANTS FROM THE FLOOR OF THE HOTEL ROOM/AS SHE DOES SO, SHE TILTS HER HEAD BACK AND SMILES AT US IN POLITE REFUSAL AND APOLOGY TOWARDS WHERE THE MAN'S OFF-PANEL FACE MUST BE, OFF ABOVE THE TOP LEFT OF THE PANEL. AS HE STOOPS NEAR THE FLOOR HER HALO CASTS A WARM GLOW OVER THE FAINTLY DEPRESSING VINE-PATTERNED CARPET.

ANGEL: Oh, that's really sweet of you, but it's like I said. We don't eat, we don't drink. No digestive tract, see?
ANGEL: Besides, I got, y'know, other people to see and everything.

PANEL 4.

HERE, TOWARDS THE RIGHT OF THE FOREGROUND WE SEE THE ANGEL AS SHE SITS DOWN ON THE END OF THE BED, WHICH JUST INTO THE PANEL FROM THE RIGHT, AND STARTS TO PULL HER HOT-PANTS UP OVER HER LEGS. STANDING FULL FIGURE IN THE LEFT OF THE NEAR BACKGROUND WE SEE THE MAN. HE HAS PRODUCED A WALLET FROM HIS TROUSER POCKET AND IS LOOKING DOWN AT SOME TEN DOLLAR BILLS AS HE COUNTS THEM OUT. HE DOESN'T LOOK AT HIM AS SHE REPLIES, CONCENTRATING ON GETTING HER CLOTHES ON.

MAN: Right. Yes, of course. Look, um, how much do I owe you?
ANGEL: It's just the straight fifty. I feel mean asking for it. It seems like I haven't been here long.

PANEL 5.

CHANGE ANGLE SO THAT NOW WE CAN SEE A LITTLE OF THE MAN'S MID SECTION AS HE STANDS FACING INTO THE PANEL FROM OFF LEFT. WE SEE HIS HANDS AS HE CONTINUES TO COUNT TEN DOLLAR BILLS OUT OF HIS WALLET. LOOKING BEYOND HIM AND MORE TO THE RIGHT OF THE IMMEDIATE BACKGROUND WE CAN SEE THE ANGEL AS SHE SITS ON THE EDGE OF THE BED, HER HOT-PANTS NOW COMPLETELY

IN PLACE AND FASTENED. AS SHE REPLIES TO THE MAN'S COMMENT (WHICH ISSUES FROM OFF PANEL LEFT) SHE IS NOT LOOKING AT HIM BUT IS INSTEAD REACHING DOWN WITH A LOOK OF CONSTERNATION TO PICK UP SOMETHING SMALL AND WHITE AND FLUFFY FROM THE CARPET OF THE ROOM. IT IS A FEATHER. WITH HINDSIGHT PERHAPS WE REALIZE THAT THERE HAVE BEEN FEATHERS SCATTERED HERE AND THERE UNOBTRUSIVELY AROUND THE ROOM THROUGHOUT THE WHOLE OF THE PREVIOUS SIX PAGES. THE ANGEL LOOKS VERY DISMAYED AS SHE PICKS IT UP BETWEEN THUMB AND FOREFINGER TO GAZE AT IT.

MAN (OFF): No, no fifty's fine. You're...
MAN (OFF): You're worth a lot more.
ANGEL: Oh, you're sweet. Anytime you're in NOX again, look me up and...
ANGEL: Oh, sh*t. What's this?

PANEL 6.

IN THIS LAST PANEL WE REVERSE ANGLE AGAIN SO THAT NOW WE HAVE THE GIRL SITTING ON THE END OF THE BED IN THE RIGHT OF THE FOREGROUND, FACING LEFT. SHE IS HOLDING UP THE FEATHER IN ONE HAND STILL BUT IS NOW LOOKING AROUND HER AND NOTICING THE OTHER FEATHERS STREWN NEAR THE BED IN THE FOREGROUND. SHE LOOKS HORRIFIED AND DEEPLY EMBARRASSED. FROM THE LEFT OF THE NEAR BACKGROUND THE MAN TURNS TO LOOK AT HER QUESTIONINGLY, HIS WALLET AND BILLS STILL IN HIS HANDS.

MAN: What's what?
ANGEL: Feathers. Sh*t, I'm sorry about this. I'm not due to molt for another month, but it's the dope. It makes me irregular.
ANGEL (SEPARATE BALLOON): Oh LOOK, they're EVERYWHERE...

PAGE 7.

PANEL 1.

NOW A FULL FIGURE SHOT OF BOTH OF THEM FROM ACROSS THE ROOM. SHE IS STILL SITTING ON THE END OF THE BED, ON THE RIGHT OF THE PICTURE AND FACING TOWARDS THE LEFT HERE. THE MAN IS NOW STANDING IN FRONT OF HER. HE GIVES HER THE BILLS THAT HE HAS COUNTED OUT. AS SHE REACHES TO TAKE THEM, SHE LOOKS UP AT HIM, WONDERINGLY. WITHOUT TAKING HER EYES OFF HIM SHE GESTURES TOWARD THE FOREGROUND, WHERE WE CAN SEE FEATHERS BY THE BED.

MAN: It doesn't matter. Here, take this. There's an extra ten...
ANGEL: Y-you're sure? I just...I feel so embarrassed, all this mess...

PANEL 2.

THE ANGEL IS NOW STANDING, JUST OFF PANEL IN THE RIGHT OF THE FOREGROUND. WE CAN SEE A LITTLE OF HER LEGS, ONE KNEE CROOKED INTO THE PANEL AS SHE LIFTS HER HEEL IN ORDER TO SLIP ONE OF HER HIGH-HEELED SHOES ON. THE OTHER IS VISIBLE LYING THERE ON THE CARPET NEARBY. IN THE NEAR BACKGROUND, FULL FIGURE, WE SEE THE MAN AS HE STANDS GAZING TOWARDS HER AND LOOKING PAINED AND UNHAPPY. HE SPREADS HIS HANDS TOWARDS HER IN A SORT OF HOPELESS, UNCOMPREHENDING GESTURE.

MAN: I feel embarrassed too. I feel all sorts of things.
MAN: I feel bad about you doing this stuff. Night after night, in bed with guys you don't love...

PANEL 3.

NOW JUST A THREE QUARTER FIGURE OF THE ANGEL AS SHE STANDS

FACING US. SHE IS NOW COMPLETELY DRESSED AND IS JUST PICKING
UP HER SHOULDER BAG FROM SOME CONVENIENT SURFACE AS SHE
GAZES AT US, HER WINGS SPREAD LIKE A FANFARE BEHIND HER,
ALMOST TOO BIG FOR THE HOTEL ROOM'S LOW CEILING. HER EXPRES-
SION IS ONE OF HEART-BREAKING PITY TINGED WITH A FAINT,
PUZZLED BEWILDERMENT.

ANGEL: Don't love?

PANEL 4.

NOW WE SEE THE MAN HEAD AND SHOULDERS IN THE LEFT OF THE
FOREGROUND, FACING SLIGHTLY AWAY FROM US TOWARDS THE
ANGEL AS SHE APPROACHES HIM GENTLY FROM THE RIGHT OF THE
NEAR BACKGROUND. SHE SMILES AT HIM WITH A DIVINE AND RADI-
ANT SYMPATHY, KINDLY AND FORGIVING. SHE REACHES UP AND GEN-
TLY BRUSHES HIS CHEEK WITH HER PALE FINGERTIPS. HE STARES AT
HER, UNABLE TO SAY ANYTHING IN RESPONSE. THE LIGHT OF HER
HALO CASTS ITS WARMTH INTO THE FAR AND SHADOWY CORNERS OF
THE ROOM; THE FAR AND SHADOWY CORNERS OF HIS HEART. THE
HOTEL ROOM DOOR IS JUST VISIBLE BEHIND HER HERE.

ANGEL: David, I'm an ANGEL, I love them when they slap me around. I
love them when they piss on me. I love them when they tell me the ter-
rible things they've done.
ANGEL: I love everyone.

PANEL 5.

SAME SHOT, WITH HIM STANDING MUTE IN THE FOREGROUND AND
FACING AWAY FROM US TOWARDS THE ANGEL IN THE NEAR RIGHT
FOREGROUND AS SHE WALKS SLOWLY AWAY FROM HIM TO THE DOOR
AND OPENS IT, ABOUT TO STEP OUT THROUGH IT HERE. PAUSED IN
THE PORTAL SHE LOOKS BACK AT HIM WITH THAT SAME TERRIBLE,
LOVING SYMPATHY FOR A POOR CREATURE THAT JUST DOESN'T
UNDERSTAND. HE GAZES AT HER BLANKLY, MUTELY, UNABLE TO
SPEAK AS SHE WALKS OUT OF HIS LIFE.

ANGEL: Why do you think I need Heroin?

PANEL 6.

SAME SHOT EXACTLY, WITH THE MAN GAZING AWAY FROM US, HEAD
AND SHOULDERS IN THE LEFT OF THE FOREGROUND. IN THE NEAR
BACKGROUND NOW WE CAN ONLY SEE THE CLOSED DOOR OF THE
HOTEL ROOM. THE ANGEL HAS GONE, AND CLOSED THE DOOR BEHIND
HER. THE ROOM WITHOUT HER IS SUDDENLY DARK.

No Dialogue

PAGE 8.

PANEL 1.

ANOTHER SIX PANEL PAGE WITH TWO TIERS OF THREE PANELS EACH.
IN THIS FIRST PANEL, IN THE BOTTOM OF THE FOREGROUND WE SEE
A LITTLE OF THE BED, RUMPLED AND UNMADE. THERE ARE A FEW
FEATHERS LYING UPON THE WRINKLED SHEET. LOOKING BEYOND
THIS WE SEE THE MAN, FULL FIGURE, AS HE CROSSES THE DARK-
ENED HOTEL ROOM, NOW LIT ONLY BY THE CITY LIGHTS FROM OUT-
SIDE, AND GOES TO THE WINDOW WHICH WE SEE IN THE BACK-
GROUND.

No Dialogue

PANEL 2.

NOW WE ARE JUST BEHIND HIM AS HE STANDS BY THE WINDOW

LOOKING OUT AND DOWN THE STREET BELOW. WE SEE A LITTLE OF
HIM ENTERING THE PANEL FROM THE RIGHT OF THE FOREGROUND,
LOOKING DOWN THROUGH THE WINDOW AT THE STREET A COUPLE
FLOORS BELOW. DOWN ON THE STREET BELOW WE CAN SEE THE
SMALL FIGURE OF THE ANGEL AS SHE WALKS OUT INTO THE STREET
FROM THE FRONT OF THE HOTEL, HER HUGE WINGS TRAILING
BEHIND HER, AND HAILS A CAB. WE SEE A CAB ALREADY STARTING
TO MOVE TOWARDS HER AS SHE WAVES IT.

No Dialogue

PANEL 3.

SAME SHOT AS LAST PANEL, ONLY HERE AS WE LOOK DOWN INTO THE
STREET WE CAN JUST SEE THE BACK OF THE ANGEL'S WINGS TRAIL-
ING OUT THROUGH THE NOW OPEN DOOR OF THE CAB AS SHE CLIMBS
INTO IT, HAULING THE CUMBERSOME WINGS AFTER HER. THE MAN
LOOKS DOWN ON THIS IMPASSIVELY FROM THE RIGHT OF THE FORE-
GROUND.

CAPTION: He watched her hail a cab and understood she could not fly.
CAPTION: He considered calling his wife, but his head brimmed with
unusual words. Familiar words. Were they something he'd read? As a
child?

PANEL 4.

SAME SHOT AS LAST PANEL. HERE, DOWN IN THE STREET, THE CAB,
WITH ITS DOOR NOW CLOSED AND THE ANGEL INVISIBLE INSIDE IT,
PULLS AWAY FROM THE CURB WITH A PUTTERING TRAIL OF EXHAUST
FUMES. FROM THE RIGHT OF THE FOREGROUND, THE MAN LOOKS
DOWN ON ALL OF THIS EXPRESSIONLESSLY.

CAPTION: "There were three substances that the Angel Illesuriah
would never get used to:
CAPTION: "Polyester;

PANEL 5.

CHANGE ANGLE. NOW, IN THE FOREGROUND WE HAVE THE ROOM'S
TELEPHONE, VERY PROMINENT AT THE BOTTOM OF THE PANEL. LOOK-
ING BEYOND THIS WE CAN SEE THE MAN MORE OR LESS FULL
FIGURE AS HE STANDS ACROSS THE OTHER SIDE OF THE ROOM, WITH
THE WINDOW BEYOND HIM. HE LOOKS TOWARDS THE PHONE WITH A
GUILTY EXPRESSION, PERHAPS THINKING OF HIS WIFE.

CAPTION: "That selective blindness which is in men;

PANEL 6.

LAST PANEL. THE MAN IS SITTING BY THE WINDOW. OUT THROUGH
THE WINDOW WE CAN SEE THE NIGHT CITY, MASSIVE AND SHADOWY
BENEATH THE QUILT OF DARK CUMULUS THAT DRIFTS BETWEEN THE
SKYSCRAPER SPIRES AND THE MOON. THE MAN SITS STARING DOWN
AT THE MOULT FEATHER THAT HE HOLDS IN HIS HAND. HE LOOKS
SAD. HE LOOKS AS IF HE IS TRYING TO UNDERSTAND SOMETHING
VERY IMPORTANT.

CAPTION: "The belly of cloud."

END

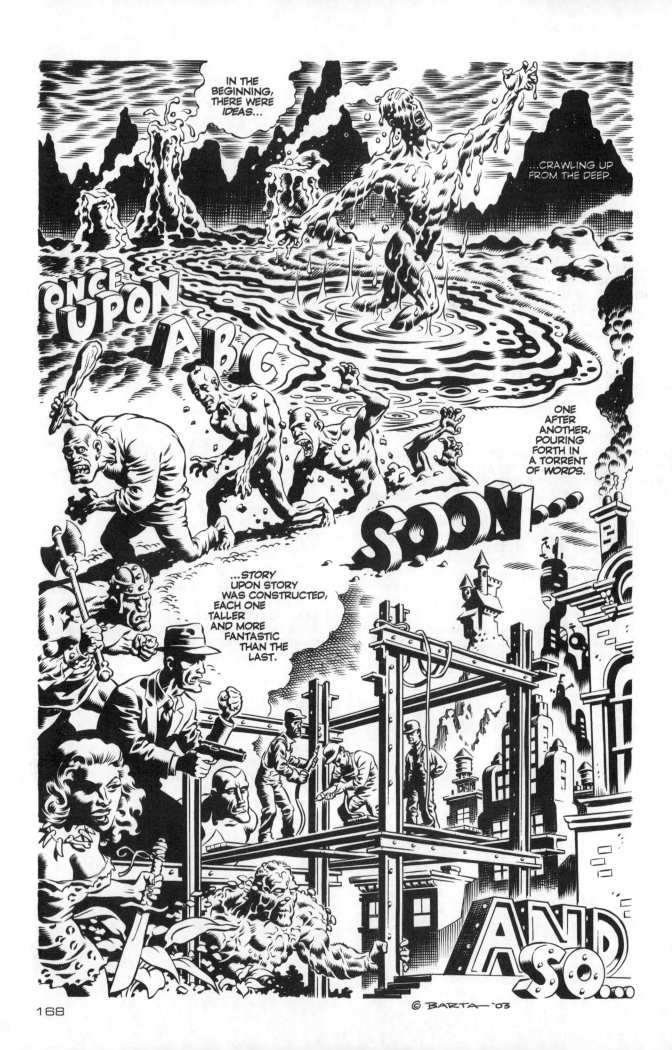

168

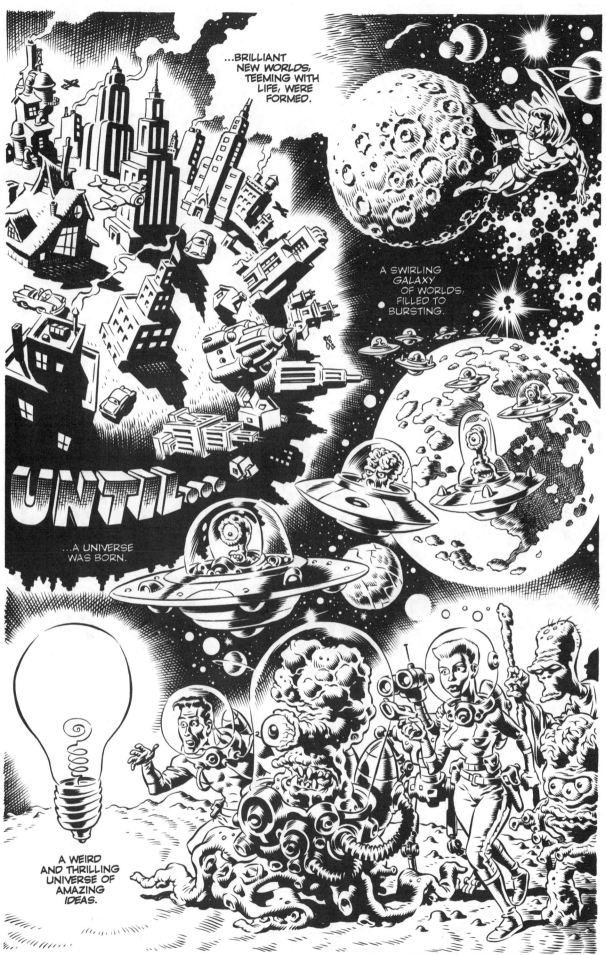

-END-

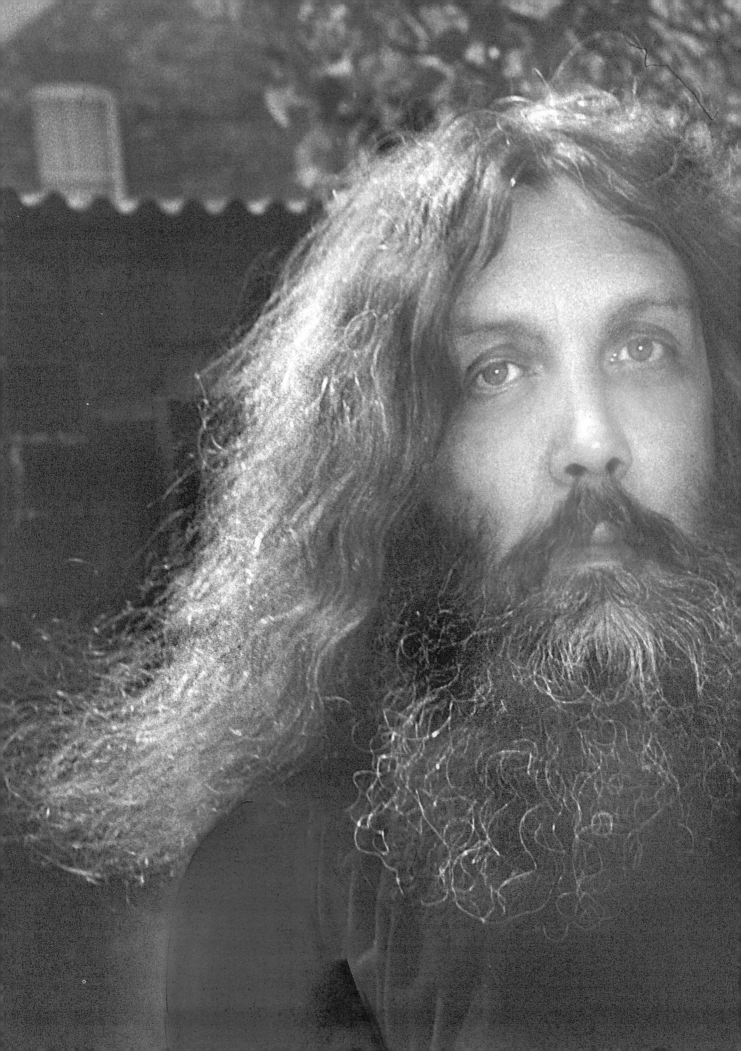

What led you to Image? How did you get there? Was it financially motivated or was it something—you were interested in their cause?

Well, originally it was because I was asked. As I remember, I did the *1963* stuff before I did anything else, right?

Yes. I think it might have been that first issue of *Spawn*—*Spawn #8* came out one month before *1963*.

Ah, well probably—I should say that I'd probably been—it was probably the *1963* thing that was the first thing that I'd agreed to do. I might be wrong, but I can't remember exactly—

I'm sure you're right.

Either Steve or Rick got in touch with me. I mean, I'd heard of Image but I hadn't really—because I was a long way away from the mainstream at that time, with all these other projects—I hadn't got a really clear idea of what it was all about, you know?

But, Steve and Rick approached me and said that they'd been told that they—the way that I understood the deal was that they could get work for Image if I was part of the set-up. That they were asking me if I want to do something for Image because Image was anxious to work with me and Steve and Rick. It'd be work for all of us and so I said, "Well, I've got all this work, I've got this—" you know, I don't remember whether *Big Numbers* was still an ongoing thing at that time, whether we did imagine that it was going to be coming out, but anyway there was *From Hell*, there was *Voice of the Fire*, there was *Lost Girls*. That was more important work to me. So I think, if I remember right, I told Rick or Steve, whoever it was, that if I could think of some way to do something that I enjoyed doing and that wouldn't necessarily take me as long as regular comics stuff did, and I thought about it for a little while, and then I think I got back to—you'd have to ask them, but I think I got back to whoever it was fairly quickly—and said, "Look, I've just worked it out. If we do six issues of Marvel Comics pastiches from the early '60s, we can probably make some sort of point about how different the values in comics are now compared to then." If we do it kind of '60s Marvel style—well actually we never did it that sloppy—even though we were doing it in what was a very streamlined way for me. I was just phoning through the breakdowns for the pages to Rick and Steve and then I'd do the dialogue, after they'd sent it back. And, it seemed to work. We were able to do them, at least at first, relatively quickly. It started to flag towards the end for various reasons, but it seemed that we could do this stuff quickly, and we were able to have a lot fun with it.

Sometime—obviously before *1963* came out, after I'd been approached on it—Todd McFarlane, who I didn't know, phoned up and asked if I wanted to do an issue of *Spawn*. At the time, knowing very little about this, my thinking was that all I really knew about Image was that they're the opposite of DC and Marvel and that sounded pretty good to me, you know? That was really all I needed to know. I figured that if they're making mischief, then I'm generally in favor of them even without having necessarily seen the books. Todd McFarlane called up and asked if I'd want to write an issue of *Spawn*, which I really didn't know what *Spawn* was. But I said, "Yeah, I can write one," and I said that before he'd offered me any money for it, you know? When he started to tell me how much money he'd give for doing it I kind of demurred and said, "Look, I'll do this for whatever the going rate is," just to be generally supportive of something which at the time I saw as fighting back [laughs] against the big companies.

So, yeah, I did a couple of other stories for Todd McFarlane, for Rob Liefeld, because it was—I mean, after I'd done the *1963* stuff I'd become aware of how much the comic audience had changed while I'd been away. That all of a sudden it seemed the bulk of the audience really wanted things that had almost no story, just lots of big, full-page pin-up sort of pieces of artwork.

The *Thor*-inspired *1963* #5.
©2003 Alan Moore, Steve Bissette and Rick Veitch.

And I was genuinely interested to see if I could write a decent story for that market that kind of followed those general directives. And I think that probably for that market the stories that I did were okay—probably better than most of the other ones that were around. But *1963* aside—because that was a special project where we were deliberately not trying to look like

Image. But most of the work I did, whether that's on *Spawn* or *WildCATs* or on whatever—I think that the mistake I was making was that I was trying to second-guess what this largely unknown new audience might want.

You weren't writing these for yourself.

Well, if I'm not writing for myself on one level I won't be able to write it. So there's always going to be some elements in the story that I can find some interest in. And sometimes there are greater interests than others. But, it was kind of, like I say, I was trying to work out what the audience wanted, which is a terrible mistake and I don't know what I was thinking. After a couple of years, I realized that—I came to my senses and realized that it's not my job to guess what my audience wants. It's my job to actually tell the audience what they want.

Sure.

And this coincided with around about the time when I started to do work on *Supreme* and I just decided that I'd do *Supreme* exactly as I wanted. I think the character was pretty much doomed—nobody's had any idea what to do with it—so we weren't given any restrictions and I was able to have Rick doing these back-up stories and we were able to have some fun.

At that time, *WildCATs* was only your second monthly comic series, your first since *Swamp Thing*. Were monthly comics something you wanted to come back to?

I did *WildCATs* because I've always liked Jim Lee; he's a nice guy. I think him and Scott Dunbier had asked if I wanted to do *WildCATs*—originally it was with Travis Charest. I wanted to see if I was given a bit more of a free hand to create the characters, whether I could do something that was any good and, like I said, I'm pleased with the stuff

Chris Sprouse pencils for *Supreme* #53. ©2003 Awesome Entertainment.

Supreme's loyal dog, Radar. Lovely sketches by Alex Ross. Art ©2003 Alex Ross. Radar ©2003 Awesome Entertainment.

we did on *WildCATs*, but I'm not *that* pleased. I think I did as good a job as I could do with the characters, but again, I was probably still trying to—I was imagining that there was a whole bunch of *WildCATs* fans out there who really wanted to see these characters treated a specific way. And once I got over that idea, I realized that with *Supreme* we could pretty much do what we want and have a lot of fun doing it, you know? Then, yeah, I mean, I started to enjoy myself more with the stuff even though I never really—the whole Awesome Comics experience wasn't a lot of fun; there was a lot of messing about and stuff like that dealing with Rob Liefeld, but I enjoyed the work that I did there. I thought that I'd done a good job on *Youngblood*; I thought I'd done a good job on *Supreme*, on *Glory*, you know? Some of the other things—I mean, *Judgment Day*—I did the best job I could.

With *Supreme*, you sort of seemed re-energized; I remember when that came out, it was kind of exciting; you weren't the same guy who wrote *WildCATs* and that other stuff.

Well, *Judgement Day* would have worked, but for some reason Rob Liefeld wanted to do the bulk of the art himself,

and that kind of—I mean, there were some great artists working on that, but I don't really think that Rob Liefeld was one of them.

He killed his own book?

Yeah, yeah.... I was pleased with the script, and it kind of made sense and if there were other decent artists handling the linking sections, it would have worked.

But, you know, Rob Liefeld never seemed to put any enthusiasm into any of these drawings; he wouldn't put enough backgrounds or anything like that. It was pointless writing scripts for him because he'd just ignore most of them because he wanted to do the easiest, simplest thing. So, there were limitations, but yeah, it was fun to be on *Supreme*, on *Youngblood*, like I say. But by the time that Awesome fell apart, I was starting to get a bit frustrated because I was starting to see how you could actually put together a really, really good mainstream comics company.

I kept suggesting this to Rob Liefeld and he didn't seem too interested, he didn't seem to really understand what I was saying. I don't even know if he read the proposal. Oh yeah, I think Eric Stephenson said that Rob Liefeld phoned him up one day about a year ago or something saying that he'd just found this brilliant proposal that Eric had written talking about how to do a really great line of comics. And Eric said, "Well, I didn't write that, Alan wrote that." And Rob Liefeld said, "Oh, I don't remember reading this—when did he write this?" And Eric said, "Well, a couple of years ago," and he said, "Oh, so, all this stuff about how we would do beautiful covers and pay attention to little details and things like that—I bet that this is the stuff that he's going to do with ABC comics, right?" And I think what Eric said was, "Well Rob, you snooze, you lose."

I'd some great fun doing the various bits that we got to on *Supreme*, you know. Working with Jim Mooney, and working with Rick, with Melinda and Jim Baikie and—a lot of my favorite people. It was an interesting experience. I don't think that the ABC books would have turned out the way they did if we hadn't had that sort of springboard or that kind of rehearsal that we were able to get for ourselves with the Awesome comics. I think that I finally got over my desire to please the audience and was starting to get more interested in purely pleasing myself.

After Awesome Comics?

Well, it was just so—I just got fed up with the unreliability of information that I get from him, that I didn't trust him. I didn't think that he was respecting the work and I found it difficult to respect him. And also by then I was probably feeling that with the exception of Jim Lee, Jim Valentino— people like that—that a couple of the Image partners were seeming, to my eyes, to be less than gentlemen. They were seeming to be not necessarily the people that I wanted to deal with. I was quite happy to carry on doing *Supreme* as long as it was there, as long as it was providing work for people that I wanted to work their way and work with, and we were getting to the stories that we wanted; I was quite happy to go along with that.

But, on the other hand, when we got the phone call saying that Awesome had gone belly-up, it was a sort of an incentive to put something else together and put it together from scratch—

Chris Sprouse art from *Supreme: The Return* #1. ©2003 Awesome Entertainment.

a whole line—so that it was sort of designed from the ground floor up to be the kind of comic books that I wanted.

But with *Supreme*, what did you see in that character? Did you see it as an example of what a super-hero could be?

Well, when I was originally given *Supreme*, it's so obvious that it is a Superman knock-off that has been based upon a kind of half-baked understanding of the comics of the mid-1980s. It's somebody who thought, "Right, gritty realistic super-heroes, that's the thing to do. How do you do that? Well you take someone like Superman and make them a psychopath." And so, he'd done that, and it wasn't very interesting, the character wasn't interesting, none of the writers who worked on it seemed to be able to do anything with it because—actually, the idea of Superman as a psychopath is not a very interesting idea, and it's one that other people had probably done better in other places years before. So, when he initially suggested that I might want to write the character, I suddenly thought, "Well, how could I rescue this lame, appalling Superman knock-off?" And I thought, well, perhaps if I were to make it like a really, really good Superman knock-off, if I were to actually try— because at the time, I remember thinking that the regular *Superman* book actually was at least as much of a lame Superman knock-off as *Supreme* was. [laughs]

This wasn't the character that I'd grown up with, or that I was familiar with. It seemed like most of the more enduring parts of the Superman mythology had all been carted away, or changed into something more synthetic and less appealing. So I decided that I'd rather liked the old Superman, that I'd rather enjoyed that rich mythology and continuity, all those kind of stupid but enduring elements, you know? Krypto the Super-dog, all of the old fashioned stuff that had so much more charm than the modern incarnation of the character. And so, having come up with what I thought was the core intriguing and whimsical idea of the Supremacy, the idea that there was some place where whenever a comic got revised, all of the stuff that had been revised out of the book ends up in some sort of limbo dimension. And that every conceivable misguided version of the character exists there somewhere, out of continuity. And once I'd come up with that fairly simple idea, I realized just how rich and funny I could make my treatment of it. The idea of a planet with hundreds of Supremes, every conceivable variation and where of course I could parody the various ills of the comic industry and where I could play with wonderful ideas, you know? Which was always the thing that Superman represented to me as a child. It didn't represent to me power or security or anything like that; it represented wonderful ideas, ideas that to me at that age were certainly magical. Where, to me, they provided a key to the world of my own imagination. And so what I wanted to do with *Supreme* was to try and give some of that sense of wonder, some of that pure imaginative jolt that I'd experienced when I was first reading comics. I

wanted to try and give that to the contemporary readership so they could get an idea of what it had felt like. The kind of buzz that those wonderfully inventive old stories and comics had provided.

What led to the creation of ABC?

Well, again, a more complicated answer is required. The main thing that led to the creation of ABC was the collapse of Awesome Comics in that we suddenly got a phone call saying that Awesome had gone tits-up and there wasn't anyone to publish any more *Supreme* or *Youngblood* or *Glory*. I'd managed to build up quite an interesting little line at Awesome, where I was working with some interesting artists like Brandon Peterson, who was very good on *Glory*, and Steve Skroce, who was terrific on *Youngblood*. And also there were people who were close friends of mine, like Rick Veitch, Jim Baikie, of course Melinda, who I'd been able to work with and who I wanted to carry on working with. So I had to think of some sort of project that would enable me to carry on working with these people.

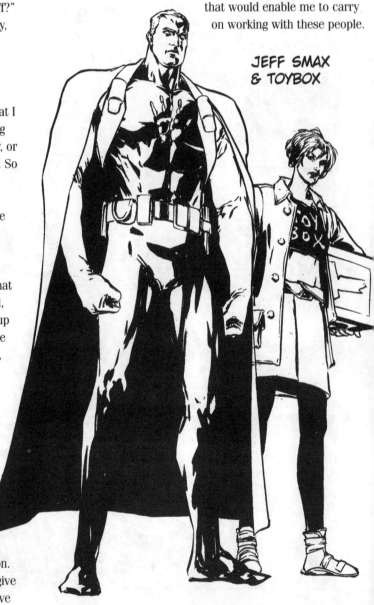

JEFF SMAX & TOYBOX

Gene Ha character designs for *Top Ten*. ©2003 America's Best Comics, LLC.

Originally, they included Brandon and Steve. The *Promethea* book in some ways originally was meant as a sort of a thing that might be a way in which Brandon could carry on doing the fantasy stuff that he liked after *Glory* was finished. Similarly, *Top Ten*. The original idea was that that might be the sort of a team book that Steve might enjoy after *Youngblood* was no longer around. As it turned out, very quickly, Brandon and Steve said that they couldn't commit themselves to ongoing series, so we started looking for artists and very quickly found Jim Williams and Gene Ha, who were perfect for the job. So that was one of the factors: the collapse of Awesome and the fact that I wanted to find a home for the creative energy that we'd managed to get going at Awesome.

The other thing was a bit more mysterious. At some time, probably during the couple years that I was working on *Supreme*, I must have at some point—probably late on a Friday evening or a Saturday evening when I'd finished work and was still actually feeling a creative buzz that I had to drain before I went to bed. So I just spent probably about 20 minutes doodling in a notebook. I can't even remember doing it, but I'd written down a list of names of characters. And the names were all that existed. There was Top Ten, Tom Strong, Promethea, Cobweb, Greyshirt, the Future American (which was the first name that the First American was going under, until we found out that Jaunty Jim Steranko had done a character of that name, so we changed it to the First American), and Jack B. Quick. All the names were there. I had no idea who the characters were when I'd written the names down. I'd just been, perhaps as an exercise, trying to come up with what I thought sounded like interesting names for books or characters. And that was the list. So after Awesome collapsed, when I was looking through a notebook looking for something, I suddenly came across this list of names. And I think that within about 48 hours of Awesome's collapse, I'd got the rough concept for this whole raft of strips. The idea was that if we could find a publisher, someone we can be happy with, then we can take this whole comics line to that publisher. Literally, within about a half an hour of getting the phone call from Awesome, for the rest of that day, it was like there was the beating of black vulture's wings around my telephone. There was just loads of people phoning up. Some of them sounding as if they hadn't heard that Awesome had collapsed and were just phoning to check in with me. A lot of them just came out and said quite honestly, "Is there any chance of you doing any work for us?" So there was a lot of options, but the best offer seemed to come from Jim Lee. And Jim was somebody that I'd enjoyed working with and who I'd always found very gentlemanly; a very considerate man. So we started talking seriously. I proposed all the initial titles. I think that Scott Dunbier found.... Well, we still had Chris Sprouse working on *Tom Strong*, so that was fine. Most of the people like Rick and Jim and Melinda would find homes in *Tomorrow Stories*. Like I said, Brandon and Steve had sort of dropped out by that point, but Scott Dunbier was able to

The *Bloomsbury Quintet* — *Simplicissimus* — 1898.

Frontis piece to *The League of Extraordinary Gentlemen* collection. Art by Kevin O'Neill. ©2003 Alan Moore and Kevin O'Neill.

find—perhaps with some help from Alex Ross, I'm not sure. You'd have to ask the gentlemen concerned about that. But, one way or another, we were pointed in the direction of Gene Ha and Jim Williams, who I think were both artists that even if Alex hadn't suggested them, that they were artists that he very much approved of. Consequently, all of the work began on the thing, the contracts were all signed. That was when I heard that Wildstorm had been bought by DC.

Before Wildstorm was bought by DC, the first issue of *League* was ready, right?

Well, the first issue of *League*, that wasn't so much of a problem. I can't remember whether it was actually ready or not, but *League* was the one that we owned out of the whole bunch of them. With things like *Tom Strong* and the ones that I was putting together mainly to keep.... The thing is that I could have just concentrated on *League*.

Sure.

The original idea was to keep the artists that I was working with employed. So that's why I came up with all the other ones. And the way that the deal was set up was that the creator-owned books, you'd get less money up front. And I figured that, since we were dealing with a very reasonable publisher in the shape of Jim Lee, and that since the main thing was to get work for the other artists, I figured that all the strips other than *League*, which was already in the planning stages before Awesome fell apart, that it would be best to go for a non-creator-owned-by, more-money-up-front sort of deal. So that was the way it was all set up, and some of the artists had begun work. I'd begun work on the strips, some of the artists had begun work on some of the strips, the contracts were all signed, and it was then that we heard about the DC takeover. Obviously, I wasn't very happy about it, although I wouldn't say that I went into a screaming rampage or tantrum or anything like that. I think if you asked Jim and Scott about how I was when they delivered the news, that they'd say that I received it with some equanimity.

But it caught you a little off-guard, because I think they were wanting to tell you before you had heard the news, right?

That's right. Apparently, while I was down in Wales, the internet was buzzing with, "What will Alan Moore do when he finds out?" So when I went down to the station to meet Jim, it was the first time I'd met him. He'd flown over with Scott specially to bring the news to me. I remember getting out of the cab with my customary snake-headed walking cane, and apparently Jim thought that I'd already heard the news and brought the stick to inflict some kind of physical damage upon him. I don't know where people get these ideas about me being a terrifying and violent person from; it's just the look. I've got a choice, basically. I could either stand on principle and say, "Well, now, I said I would never work for DC again and I mean it, so we have to abandon the whole project"—

which I hadn't got the heart to do. And so anybody out there, and I know there were quite a lot of people at the time who were quite eager to point out that this was, "Ahhh, he said he would never work for DC Comics again and he has, ahhh!" Which is always refreshing to hear, especially from people who probably never stood upon a point of principle in their lives. For better or worse, I decided that it was better to forego my own principles upon it rather than to put a lot of people who'd been promised work suddenly out of work. Rather than crash and burn the entire deal, I figured that it was best to keep a stiff upper lip and lie back and think of England.

But Jim Lee was also doing his part by trying to keep you away from DC proper.

Yeah, yeah. Jim was sort of trying to keep it so there was a safe distance, a "firewall," as I believe the company was called. I mean I'm doing a large amount of work, by and large. But even from the relatively early days it was pretty clear that... I remembered why I said that I'd never work for DC ever again in the first place, because they didn't seem to have changed at all in the intervening 15 years. I certainly wouldn't say that they've evolved any. And then you've got all of these occasional little niggles, ones that I can laugh off like when they pulped *The League of Extraordinary Gentlemen* and that ridiculous advert for the Marvel Douche Company. I mean, I could laugh about that. It is kind of funny. Ridiculous, but funny. But when it came to the point of the actual interference in some of the stories, which to me—I might have been misreading the situation, but it seemed personal. It seemed like some sort of big dick contest. It seemed like there were people at DC who wanted to prove they're the leader of the pack. Wanted to prove that they were the biggest monkey. And I guess that's fair enough; they're the biggest monkey. So at this stage, today, it's the fact that... we don't actually have direct interference now, or we haven't had for quite a while. What we have now is the fact that nobody wants to upset Paul [Levitz] at DC. "It would be better if we didn't do anything that was liable to upset Paul at DC." So we kind of modified some things. Like that double-page spread in the recent *Promethea* that was chopped up from the original image, which was a straightforward shot of the god Pan having sex with the goddess Selene, which is a classical scene, but even if classical scenes are okay in the major art galleries of

Detail from "Allan and the Sundered Veil," a story within the *League of Extraordinary Gentlemen* comic. Art by Kevin O'Neill. ©2003 Alan Moore and Kevin O'Neill.

The Vagina Monologues this ain't. This little vintage ad caused DC to pulp the entire first printing of *The League of Extraordinary Gentlemen* #5. Believe it or not!

the world, apparently they're not okay for current American comics. So it's these little things that have gradually convinced me that I was right all along and there probably isn't a place for me in mainstream American comics.

It doesn't discourage you when you work, or do you find it sometimes affecting you when you're writing?

Well, no, I'm a professional. Everything I do... I certainly would never, ever leave out a scene because Paul Levitz might object to it or somebody at Wildstorm might think that Paul

PROMETHEA

Levitz might object to it. I'm just going to do exactly what I've always done, which is whatever I want. I trust my own moral standards. I think they're certainly as good as anybody running an American publishing company can claim to. Perhaps, I daresay, it might even be a little bit better, a little bit less tarnished, a little bit less guilty, a little bit less involved in screwing people decade after decade since this industry's inception. I think that my moral values and standards are ones that I'm quite happy to go along with. So, yeah, this leaves us where... I'm very, very proud of everything that we've done at ABC. It could have been better. If people hadn't screwed around, it could have been better. It's not good enough for me is basically what I'm saying. It's very, very good. I'm very, very pleased with what was done at ABC. I think we've produced a wonderful little comics line there that actually will be remembered for a while. But it's not good enough for me. I mean I'm nearly 50. I really think that I should by this age be allowed to go to bed whenever I want. I should be allowed to leave my dinner if I want. I think I should be allowed to write what I want without getting some parent figure coming and scolding me about it. If that's the best that the American comics industry can offer, then, like I say, it's not good enough for me. So I'm wrapping the show up in another year. When I've finished all the things that I'm committed to, that's it.

If you leave ABC, will it keep going?

I don't think so. I don't know whether it will be able to after I've left ABC. I'm going to conclude it. I'm not just going to leave you hanging in the middle of a storyline. In fact, nobody's ever really had the chance to finish off a comic line deliberately before. Usually, comic companies run out of money halfway through a three-part story, or books get cancelled at the drop of a hat, just like that. All of the comics companies have flirted with the idea of the end of the world, the event so terrible that we wouldn't be able to publish half of these guys anymore. All of them have flirted with it, whether you're talking about *Dark Knight* or *Kingdom Come* or some of the Marvel books that have been set in grim futures; it's a way that you can have your cake and eat it. If you show the incredible drama of what would happen if an entire line of superheroes suddenly faced the apocalypse or whatever and you can carry on publishing them as if nothing happened. Well, what I'd like to do with ABC is to actually do it for real. What if some big, apocalyptic event

Early in the inception of ABC, Alex Ross provided designs for some of the groundwork, like the ABC logo—which he designed and Todd Klein modified. He also provided this composition for Promethea which was intended to be her modern day incarnation, but was used for the Golden Age version instead.

"TOM STRONG"

AN AMERICA'S BEST SERIAL IN 12 CHAPTERS

Chapter **8** **DANGER IN ATTABAR TERU!**

affected the entire line? And it was all real, it wasn't an imaginary story, it wasn't an Elseworlds, it wasn't a *What If?*, this is what happens, this is the end of a comics line planned months in advance, orchestrated and brought hopefully to a fitting conclusion. I mean, I don't want it to be a complete wet fire-cracker, but I'd like to see what it was like to actually really finish a line of comics with a wonderful little apocalypse. So it ends? I've not got much idea of how that'll be yet, but I think it will be fun. And I don't think it will have been seen before. So whether anybody could actually revive the characters after I've finished with them, I don't know. I suppose they could, legally, if they wanted to look really silly. And I guess that if any writer wanted to take over one of these books from me, that might be a way of furthering their career, so good luck to them if they think so. So, yeah, I'm not that bothered, George. Once I've wrapped it up, it will stay wrapped up. And even if it doesn't, I can't say it bothers me anymore. These are children that I've sold to the gypsies, and I'll do my best to preserve them from any future desecration, but ultimately, that's out of my hands.

You can always continue doing your *League* stories at the same time?

The League is something that I can continue indefinitely. And that would be nice, as well, to be able to do *The League*.... Me and Kevin haven't reined ourselves in much, but we could go further, and that might be quite interesting, because *The League*.... It wouldn't take more than a couple of twists of the screwdriver to make that into practically an underground strip. It's on the borderline. I don't mean underground in the sense of sex, drugs, and rock 'n' roll, I mean

something where it's not really a mainstream strip anymore. Where its concerns have become a bit more intense. Well, we could be more frank about the sexuality. Although we are being quite frank about the sexuality in the second book. But I'm just not bothered about restraints anymore. I can trust myself. I know that whatever I do, it'll be something that comes up to *my* standards. And I really don't want any unnec-essary hurdles; I don't want any unnecessary bits of chicken wire getting in my way. The stuff that I do after next November, if everything goes well, it will all be *exactly* what I want to do, without *any* censorship, without *any* limitations whatsoever. That's the way that I want it.

There's something that I keep telling people, I think it's one of the things I've learned from reading your stuff. You always go forward in your plot, the way you write your story. You don't restrain your-self. That's one of the things that's killing comics, every month Superman's got to be the same way, but there are so many possi-bilities if you just keep going forward.

Yeah, if something is unthinkable, then do it.

Do it and there's more possibilities, more stories.

The possibilities will spring up. Always do the most unthinkable thing. Not every experiment will work, but enough will succeed to make a big difference for the industry and to your work in particular. If you're prepared to take those chances, if you're prepared to look at stuff and think, "How could I do this better? How could I do this differently? What would the opposite of this be? Is there any way that I could change some of the parameters, twist things around?" Then you'll come up with something new. Another reason why I

want to get out of comics is because I look at the comics land-scape at the moment, and I've had far too great an influence upon it, and I don't like the way that that influence has panned out. Like, the Vertigo line, as Karen has often pointed out, was mainly set up inspired by my writing. Neil as well, but it was mainly because of the success of *Swamp Thing* and because I recommended Neil, that she got Neil in the first place. And I think that there probably was a conscious attempt—perhaps editorially derived—but there probably was a conscious attempt with those early Vertigo comics to come up with something that was Alan Moore-like or Neil Gaiman-like. And I think that the same is true of a lot of the recent Marvel comics. I mean, Joe Quesada has told me personally that me and, I think, Frank Miller, were the two people he was trying to base his Marvel revolution upon. I'm sure this is meant flatteringly, but that's not how I'm inclined to take it. I never wanted to see things that were just stylistic quirks of mine Xeroxed and made a standard of the industry. I think that when I did an article on how to write for comics, I made a big point of stressing that this was not how to write comics the Alan Moore way, because the industry no more needed 50 writers who write like Alan Moore than it needed 50 artists who draw like John Buscema, which is what you got from *How to Draw Comics the Marvel Way*. Yeah, John Buscema was a great artist, and people will inevitably be influenced by other people, but it doesn't do the industry any favors, and it certainly does the individual creators no favors if they are recycling a mood, a feeling, techniques that were perhaps fresh and new 25 years ago. That is not good for comics. So conse-quently I'd rather exert most of my efforts... I mean, yes, I shall still be doing comics, some comics, but I'd rather make most of my efforts in other fields for a little while, away from comics. Because I'd like to see comics be able to evolve on its own. I'd like to give people a chance, should we say. Because I know there were a lot of—or at least there were some—say, the previous generation of American artists and writers who I think felt a bit... unprivileged? Disadvantaged? When I turned up in the '80s. And I know there are a couple that feel that me arriving in the '80s is what led to the demise of comics in general, or perhaps their popularity in particular, I can't really say. On the other hand, there were some members of the younger generation of writers who came up after me who felt that I over-

shadowed them. So if I get out of the way, then everybody can be happy.

But they weren't that good in the first place. [laughs]

Well, nobody will be overshadowed by me. My curse will be lifted from the field so that they can do all these I'm sure wonderful stories that they were going to do before I over-shadowed them. So, like I say, this would be best for everybody. I'm sure that the comics field will be enriched by the work that these people do once they haven't got me holding them back. So it's a win-win situation, George, that's the way I see it.

You get the same satisfaction when you do a performance or when you're writing a novel or short story?

I get much more satisfaction from a performance; that's like hard drugs. A good performance is such a rush. I wouldn't

Alex Ross' cover pencils for the *America's Best Comics 64 Page Giant*.

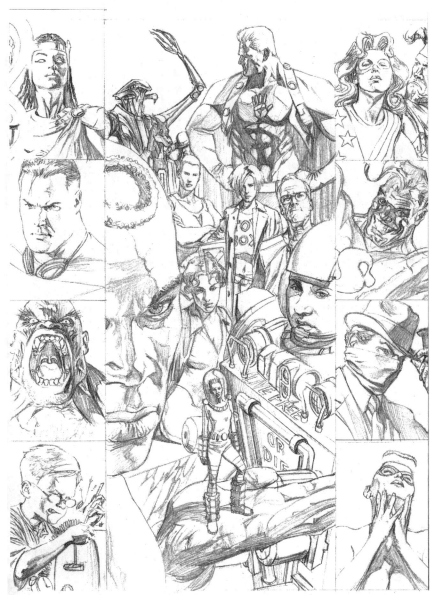

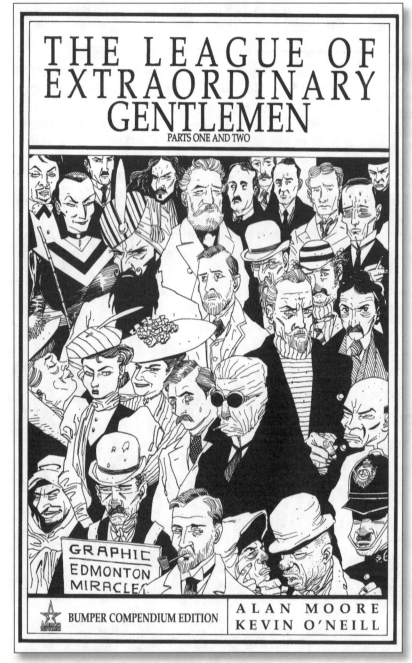

Cover to *The League of Extraordinary Gentlemen Bumper Compendium #1*.
©2003 Alan Moore and Kevin O'Neill.

quite into doing magical drawings about ten years ago. I did a few of them. I was very pleased with them, but I just haven't had time to get back to it. Maybe I could. Or anything. I'm hoping to engineer a situation where literally anything I want to do will have a market for it. It may not be a huge market, but it will be a market, and where I'll be able to explore to my heart's content. And hopefully, should I need the money, then there's still the *Extraordinary Gentlemen* there—well, even if I don't need the money, that would be something that I'm sure would be a lot of fun to carry on doing. And we've certainly got stories that could take *The League of Extraordinary Gentlemen* up to the 30th century and beyond, because the thing about literature and the world of literature is that it extends into the future as well as the past. There's plenty of old science-fiction stories that were set in the future that are now so far in the past that they're out of copyright. They're fair game for our literary connect-the-dots puzzle. So there's plenty of mileage left in that.

Was that something that you always wanted to do? Because I remember your introduction to the *Swamp Thing* said something about Doctor Frankenstein kidnapping all of the Little Women. Is that something that you've always wanted to do, to cross these classical characters over?

Um... what was that in the introduction of?

***Swamp Thing*, the first *Swamp Thing* collection.**

Did I say that?

Yes. You wrote that in the introduction. [laughs] **I thought, "Whoa, that's weird."**

Well, isn't it? Because I've said that more recently about *League of Extraordinary Gentlemen*. I really didn't remember.... Well, actually, now that you say it.... Was I talking about not having super-heroes in a horror book?

Uh-huh! Let me see if I can find it....

I think, yeah, I can remember it now, George; it's all coming back to me. Yeah, so I was talking about the same thing, coming at it from a different angle. That might have been the first time that I actually had the beginnings of the idea for treating mainstream fiction as if it was a super-hero continuity. That might have been the first place. Probably the original idea, there must have been some kernel of it back around then, but it didn't really develop until a few years ago, when it started to.... Certainly well after I'd done *Lost Girls*, when I'd started to think how much fun it had been using these fictional characters together in the same context, and started to have musings about whether you can put together a Victorian literary super-hero thing. But that's interesting about

want to do it every night. I wouldn't want to do repeat performances of anything. They've all got to be one-off. Because I can't bear repeating anything. I've never really rewritten any of my comics, because going back to something again is just so boring. But doing these one-off performances is fantastic. The sense of achievement when I was doing my novel...when I finished that, I was really, really proud of it. I'd said something that I wanted to say in the way that I wanted to say it. I'd like to do some drawing again. Having watched Melinda work all those years, I've picked up an awful lot about the use of pencil crayons, how you can get these wonderful effects by layering different colors. And while I'm nowhere near as adept as Melinda is, I'm a lot better than I used to be. And, yeah, I got

the *Swamp Thing*, George. I had forgotten that.

You mentioned it a couple of times after that.... It looked like it was something that was always on your mind, but you never had a way to channel it until you did *League*. But you were going to do this book originally with Simon Bisley?

Originally, I'd put the idea forward without an artist attached to it, to Kevin Eastman, I think. And at that point, I think Kevin Eastman had advanced me some money on the understanding that I would do a 64-page graphic novel for him at some point. And he wanted me to work with Simon Bisley. So that was the original idea, that we'd perhaps put together this *League of Extraordinary Gentlemen* thing. But then I think I got a phone call from Kevin saying that he didn't want me to do the graphic novel with Simon Bisley, he'd rather that I'd work off his advance by doing the Spirit stories for the *Spirit* comic that he was going to be bringing out. So I did those for that first issue of *The Spirit* with Dave Gibbons, which was great fun. So the other stuff never happened with Simon Bisley, and the idea was still around. Then when I started thinking about it seriously, Kevin O'Neill was the artist that was right at the forefront of my mind. It just seemed, once I thought of Kevin, he seemed to be the perfect artist. He would allow the strip to evolve in a completely different way. Kevin's work is meticulous, but there is an exaggerated and cartoony quality, which is part of its genius. And that kind of almost cartoony flexibility allows you a much greater emotional range in the strip. With *The League of Extraordinary Gentlemen*, partly because of Kevin's art, we can span comedy, horror, and pathos in a couple of pages. Often in one page, sometimes in one *panel*. The emotional range that Kevin's artwork lends to the story is fantastic. It's one of the main assets of *The League*. There's some scenes in there which are going to be horrible, silly, and all sorts of other things. Quite erudite, intelligent. It's an interesting mix that we can get away with, regarding *The League*.

Were you surprised how successful this book was when it came out?

I don't know. I don't know that I'd really thought about it. I mean, it was a killer idea, I knew that from the moment I first had it, you can just tell. When you just think, "That is a brilliant idea," and you can take that so many places. So I suppose on that level I wasn't surprised. On the other level, I suppose that I *was* favorably surprised to find that I could be as obscure as I wanted, that me and Kevin could do exactly the strip we wanted to do, which made references to things that only me and Kevin have ever heard of or whatever, and that a predominantly American audience would respond to it so enthusiastically. *That* was very encouraging. It was very reassuring. Certain sections of America's public image, shall we say, can seem to be afflicted by a kind of terrible insularity, where it's almost as if a large section of America's populace don't seem to really understand that there are countries in the world other than America, and that there was ever a historical event that

During the Summer of 2003, *The League of Extraordinary Gentlemen* is released as a major motion picture starring Sean Connery as Allan Quatermain. ©2003 Twentieth Century Fox.

Americans didn't play—I mean, Hollywood has to largely carry a lot of blame for this, but sometimes you can sense a disinterest, an obliviousness to other cultures. But the response to *The League*, which is all set in Britain, and where there's hardly an American influence to be seen—the response to that, like I say, is really reassuring, really encouraging. And the incredibly intelligent letters that we got from readers, and what was best of all, letters where people wrote in saying that, "Yes, I'm a 13-year-old kid and I've just gone out and read *King Solomon's Mines* and *Dracula*." Or, from what Jess Nevins tells me, there's even been some people who've gone out and gotten copies of Flann O'Brien's excellent *The Third Policeman* after reading a cryptic reference to it in the almanac notes to the first issue of the second volume. So that's good, the idea that you can use a comic to make people interested in books again, which, considering the incredible wealth of wonderful material that exists in books, and considering how little wonderful material exists in comics, it's probably doing the readers a service if it can get them interested in these incredible worlds of wonder again. So I'm very pleased with the response to it. It was very gratifying to think that I could do something that was so personal in some ways, so perversely English, and to have it go down so well in America is tremendous. That's really, really good. That warms my heart, genuinely.

Top Ten was inspired by NYPD Blue and Hill Street Blues?

Well, the thinking behind *Top Ten* was that—

Are those shows that you like?

I could criticize either of them. There are some things about them that I don't like, but there are some things about them that I really do. In the context of *Top Ten*, I was thinking about super-hero teams. It might well have been that I was trying to think of something I could do with Steve Skroce after *Youngblood*. We might do a super-hero team, we might do something that's modern, something that hasn't been done before. Let's do some thinking about modern super-hero teams. And the first thing that I thought is, well, they don't very often work. For some reason, super-hero teams work a lot better on paper than they do in actuality. In fact, the best thing about—well, I was talking to Steve Moore about even a classic super-hero team. You think of the *Justice League of America*. The best thing about them was Murphy Anderson's covers. The actual stories were never as wonderful as the covers. This is not to knock Gardner Fox or Mike Sekowsky or anybody, 'cause they did a great job. But the essence of what the Justice League was about was in Murphy Anderson's covers. That was it. Putting the heroes all together, that was the money shot. You didn't really need a story. Because when you try to have these characters all interacting, the story became too crowded. None of the characters acted like they did in their regular books, because they'll all kind of been reduced to a lowest common denominator so they'd all fit together. You couldn't have Harry Peter's Wonder Woman next to Curt Swan's Superman or Dick Sprang's Batman, because they all inhabited different worlds to a degree. So they all had to be kind of made homogenous. The Mike Sekowsky version didn't look like Carmine Infantino's Flash, it didn't look like Gil Kane's Green Lantern. It didn't look like any of them as they ordinarily were, but somehow that worked. It made them all a homogenous whole. So there was something lacking there that you didn't seem to be able to get around. If you had a lot of characters in it, then there was never enough time to actually develop them as characters. None of them got enough room. So I was thinking about that, and then I thought, well, what about the American cop shows? They seem to be able to have a large cast of characters, and by jumping back and forth

ALAN MOORE
GENE HA
ZANDER CANNON
ALEX SINCLAIR
TODD KLEIN

TOP 10

HIS FIRST DAY ON THE NEW JOB...

11 MAY 2001

©2003 America's Best Comics, LLC.

between the characters, they manage to keep a lot of plot threads going simultaneously. They allow for quite interesting character development. Is there a way that you could use those same techniques for a super-hero book? Although then I realized that a precinct of super-cops, it wouldn't be the same as *NYPD Blue*, because a team of super-cops would still have to have super-menaces to justify all of them going out and dealing with them. And it would end up exactly like an ordinary super-hero book, but with sort of a vague cop conceit grafted on. Then it struck me that if you went all the way, and make everybody in this environment into some sort of super-hero, super-villain, partner or pet, then you could. If everyone was a super-villain, a super-hero, a super-character of some sort, then it would become completely normal and mundane and boring. Then you'd be able to do the same gritty realism stories as they did in *NYPD* or *The Shield* or whatever, but everybody would be wearing some sort of long underwear costume. Everybody would have some half-baked, second-rate super-power. And nobody would be special, because everybody was a super-hero. And if you treated it

completely straight-faced, you thought it all through, didn't treat it as a big joke but treated it completely straight-faced, I thought, "I bet that would work." And lo and behold, it did. I think that *Top Ten* is an incredible series. Like I say, all the ABC books, I've been pleased with all of them. But some of the stuff in *Top Ten*, while it wasn't originally planned as such, it almost became a big parable about the comics industry. Somebody pointed that out in a letters page. They were saying, "I really like the way that you used this massive surfeit of super-heroes all crowded together as an analogy for today's overcrowded super-hero market." And I thought, "Hmm, yeah! That *would* have been good if I'd actually thought of that! Yeah, I guess it is!" There's a satirical level to it. Although it's very straight-faced, there is a satirical level to it. And one of the thing's that's interesting is that, with everybody having super-powers, it tends in some ways that I don't quite understand to concentrate the stories more on the humanity. It reverses the impetus of a lot of super-hero stories. I mean, take the Legion of Super-heroes. Who they are as people is not at all important. They are a collection of powers and insignia and costumes. They are regarded in terms of, "Oh, yeah, this is the one who wears a pink costume and uses magnetism,

this is the one who wears a blue costume and uses lightning bolts." The characters in most super-hero teams are never more than their powers and their costumes. But something about *Top Ten*, where they are lost in a swamp of super-heroes, where everyone is a super-hero, so it doesn't matter if you've got this goofy power of that stupid costume, everybody else has as well. So this tends to focus the stories more upon the characters of these people. And I think that with *Top Ten*, people tended to think of the characters before they thought of their powers. We always tried to keep it mostly focused on the interaction of the characters rather than the interaction of their powers. And I think that that worked. I think that people, say, thinking of Smax, before they thought, "Oh, yes, he's the invulnerable one with some sort of telekinetic force field punch power," they'd probably think, "He's the really gloomy, angry, impossible-to-get-on-with, pain-in-the-ass one." Which is the way I prefer it. They're more interested in character than in somebody who can fire force bolts and is invulnerable, which is not that interesting, really. Especially not in a city where everyone can do that. It's what the characters are as people that becomes more important.

So, yeah, *Top Ten* was fascinating. It was something where I just took a stupid idea and ran with it, and saw what happened if you took that idea to its illogical limits and let the idea carry itself through. I was very pleased with what we ended up with, the cultural texture that started to emerge. Like, when I was thinking there didn't seem to be any racial tensions in the city. Black, Asian, white people seemed to be completely integrated. So then I started thinking about, "Well, that's not very realistic, when most of our inner cities *do* have racial tension." So I started thinking about super-hero or fantasy type groups that could correspond. And I started thinking about robots. There would probably be prejudice against robots. I started thinking, "Okay, the way people regard robots in Neopolis is something like the way certain sections of the community regard black people." So there's a kind of analogy there. So I thought, instead of rap music and hip hop, then it's gotta be "scrap music." Instead of rappers, you'd have scrappers. And I started making up little machine rap song its own kind of obvious slang. Instead of "bitch," it's "glitch." Instead of "Holmes," it's "ohms." So it was

funny. And I started thinking, all right, so if the robots and the blacks had some kind of equivalents, what about the other ethnic groups. If there's no Italian mobsters, say, is there another group? And I thought, "What about vampires? That would be funny." That's when I came up with the Deadfellas thing that Zander did in the 64-page special. These are, yeah, Deadfellas, and an awful lot of them... like the thing about how there's plenty of Italian-Americans who want nothing to do with organized crime. The vast majority of them—millions of them, ordinary people—are a credit to their community. It's

A Moore vampire moment from "The New European," featured in *Vampirella/Dracula: The Centennial*. Art by Gary Frank and Cam Smith. Vampirella ©2003 Harris Comics.

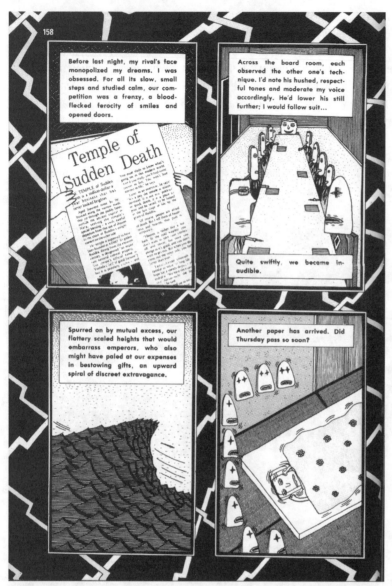

A sample of "The Bowing Machine," from *Raw* vol. 2, #3 (1991), a remarkable anthology. Art by Mark Beyer. ©2003 Alan Moore and Mark Beyer.

current comic market. And no offense, but this to me indicates that the current comic market is kind of stupid. What on Earth is wrong with anthology books? Do any of these people who say, "Oh, we don't like anthology books," do they realize where the comic industry came from? Do they know of anything further back than, what, 1985, 1990? Everything in comics, all of the high points of comics, all of the beloved characters, y'know? I mean, Spider-Man...didn't he start out in an anthology book, or am I missing something? Most of the Marvel characters—okay, you've get the odd few like the Fantastic Four that turned up in their own book right from the start—but the majority of them started out in anthology titles. And even when *Journey into Mystery* was an all-Thor experience, they still had things like "Tales of Asgard," in the back of it, which I used to buy the book for. I thought "Tales of Asgard" was fantastic. Yeah, the lead story was great, but "Tales of Asgard" was what excited me. I mean, Superman, Batman, all of the DC characters, they started out in anthology books, right? The great highs of the comics industry. EC comics, unless I'm mistaken, were a bunch of anthology books. Things like *Raw* or *Comic Arcade*. When you're thinking of a great comic, you're probably thinking of an anthology title. Any of the ones that are gigantic landmarks in the industry, they're probably anthology titles. The best comic ever was *Mad*. I don't care if I sound opinionated, it's true. And it's an anthology title. I used to read anthology titles when I was a kid. When I'd go out and buy my Marvel comics, say, I would arrange them in the order that I wanted to read them in, saving the best until last. And it would be probably would be something like *Strange Tales* that was saved until last, because it felt like I was getting better value. The Superman books that I read—they'd all have three stories in them. They were eight pages or whatever, but there were three complete stories that you'd read when you'd read an issue of Superman. I remember how rare it was that they would occasionally have, complete in this issue, a great three-part novel, which was where they had linked together three anthology stories to make a long, uninterrupted story. How rare that was, and how special that was. But when it came time to do America's Best Comics, I thought, "Well, if this is going to be my dream comics line, it's got to have at least one anthology in it." Because I like the way that in anthologies, you can do these wide mixtures of things. You can do things that have completely different genres. It doesn't have to be an anthology of humor stories or an anthology of horror stories. It can be a mix. That's the benefit of an anthology, that there's something in there for everybody. And, quite frankly, those "Jack B. Quick" stories, say. Does anybody really think that I'd have been able to do full-length "Jack B. Quick"

perfectly true. So I'd have dialogue explaining that terms like "cosa nosferatu" are an insult to the millions of Hungarian-Americans who don't rise from their graves to feast upon the living. You can have a lot of fun playing around with these ideas, the stereotypes. We've got a lot of cultural texture in Neopolis. We hear songs on the radio, we know what sort of TV they watch, we even know that they have comic books called things like *Businessman*, that are about people who remarkably don't have any unusual powers. These are little things you can drop into the background. We know they've got street gangs, we know that they've got politicians, all these things. It's been an awful lot of fun doing *Top Ten*.

Was *Tomorrow Stories* an experiment for you? Doing these four strong stories that could have well stood on their own?

Well, the thing is, I really like anthology books. Now, I understand that anthology books are really unpopular with the

stories that were better than those? They're so intense, and doing "Jack B. Quick," to follow that example, was really difficult, because you have to write "Jack B. Quick," you have to sort of get your mind into this completely irrational state. You have to take scientific ideas to absurd lengths. You have to be able to think in a certain way to do those stories. I couldn't do them all the time, and I certainly can't see myself being able to do

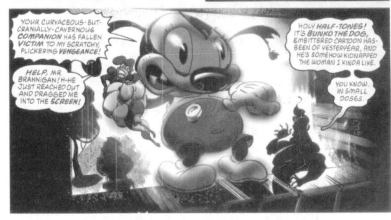

Kyle Baker illustrated an Alan Moore-penned "Splash Brannigan" short in the *America's Best Comics 64 Page Giant*. ©2003 America's Best Comics, LLC.

ones that were more than six to eight pages long. Some stories are better short. Like with Rick's "Greyshirt." Why do comic fans pay respect and reverence to Eisner's *Spirit* if they're so all-fired set against anthology stories? Will Eisner created these perfect little six- and eight-page gems. He showed other

people how to do it. One of the greatest writers in the history of comics. And until he started working on these graphic novels, until he invented the current graphic novel, it was short stories that were the art form that Will Eisner perfected. So it was great to have, with Greyshirt, a character that could explore some of those Will Eisner alleyways and cul-de-sacs. "Cobweb," I wanted something that was... I always used to like the glamour strips. There's something really archetypal about, say, the Phantom Lady. These prurient glamour strips are kind of charming at the end of the day. It's perhaps more of a sign of how culture changes, but whereas probably 20 years ago I could have got quite offended at the sexism inherent in glamour strips, but now you look back at it, it's harmless, it's charming. It's kind of stupid, but it's harmless and charming and it's got a romantic quaintness to it. So what I wanted to do with "Cobweb," was to come up with a more fully-sexualized glamour character, but also be more experimental in what could be done with that character, to give it a different experimental edge, so that we could do things like the "Li'l Cobweb" episode, this sort of "Li'l Archie"-type version that we did, where we've got it alternating with a kind of Johnny Craig Cobweb, that provides more of a *noir* take on the same material. Or the "Annie Fanny" parody that we did. Or the collage episode, the surrealist Max Ernst version of Cobweb. I love the elasticity of these characters that as long as the name and something about the aura of the character was the same, I could do whatever I wanted. That the characters were flexible to the point where they allowed me to do almost anything. "First American," that sort of came about because one of my all-time favorite comics is *The Fighting American*. I thought that what Jack Kirby and Joe Simon did with that was fantastic. They started out doing a kind of serious, straightforward, gung-ho, patriotic Commie-baiter. And then, I think to their credit, they realized early on that this Joe McCarthy guy was bullsh*t, that America's obsession with Communism and the Communist witch hunts would probably look kind of embarrassing given another ten years, and so they made the Fighting American into one of comics' most brilliant parody characters. Some of the lines of dialogue in there were tremendous. Also, some of those great Kirby grotesque villains, Hotsky Trotsky and Poison Ivan. So I thought it'd be nice to try to imagine if you took a bit of the *Fighting American*, and also take a bit of Harvey Kurtzman and his satirical bite, which was probably stronger than that of Simon and Kirby, and mix it together and applied it all to the modern day and to

things that are happening in modern culture. A more satirical *Fighting American* for the 21st Century. And we had a lot of fun with that. Yeah, we got a lot of reviews telling us we thought we were funny, but we weren't, but we don't care. There was plenty of stuff in there that I thought was *really* funny. And Hilary on "Splash Brannigan," I've always loved Plastic Man and I've also always loved the *Mad* super-hero parodies, and in "Splash Brannigan" we found a way of combining the two. And I think with some of those issues of *Tomorrow Stories*, it was like a cocktail. There were so many different ingredients in it, and all of them were good in their own right. There were some little classics in there. That second "Greyshirt" story, "How Things Work Out," that's one of the cleverest stories I've ever done. I couldn't have done that in a 24-page comic. That's something that you could only ever do once, in a little, contained, six-page, eight-page structure. Then it works. You couldn't do that over 24 pages. Also, if you don't have anthology comics, then you're not going to have any entry-level books for new talent. What comics used to have, Marvel had various anthology titles, DC had all their mystery books, and when they found new artists and new writers, they could try them out. They needn't throw them into deep water by giving them a hot series as their first project, they could try them out. Okay, do a little eight-page story for *House of Mystery*. Write a little story for House of Secrets. Do some sort of back-up "Iron Man" story for *Tales of Suspense*, whatever. If you've got these kinds of anthology books, then it was a great way of introducing new talent to the field. I'm very glad that I learned my craft working at *2000 A.D.*, when it had a decent editor, with Alan Grant handling most things. That was a brilliant way of learning how to write. Writing short stories is the best way of learning how to write. Don't plow straight in with a multi-part series or some giant graphic novel. See if you can handle a four-page story or a six-page story. Or go berserk, make it an eight-page story. Because it's by far the best way of learning how to write. The thing is that these days it would be very difficult to find a place to sell a six-page or four-page or eight-page story, because "comic fans don't like anthologies." They won't have anthologies, so they'll have to put up, I should imagine, with the results of that. It'll be more difficult for interesting talent to enter the field, more difficult for it to develop satisfyingly. They haven't had to work upon tight little short stories for anthologies, they've been

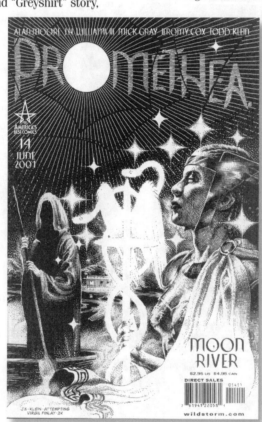

Promethea #14. ©2003 America's Best Comics, LLC.

allowed to indulge themselves and be lavish and sloppy right from the start, whereas there is no substitute for the kind of discipline that writing a short story teaches you. So, yeah, I think that anthologies are great, I think that anthologies are practically vital to the health and continued well-being of the field. But what do I know? I guess the current reading public will get the comic medium that it wants and that it deserves.

Is *Promethea* the most intimate of the ABC books? Is that the one you're going to miss most?

Promethea is about magic. So, on some levels, yes, it's something that I have a very, very deep, personal interest in. Magic is so much a part of my everyday life—it's the way that I think, it's the way that I do things, it's the way that I see the world. So *Promethea* was designed to be a book that could talk about those areas. It was such a lovely vehicle for being able to talk about magic, especially with Jim and Mick's artwork and Jeremy's coloring, that we were able to do something that was beautiful enough to live up to magic as I see it, which is a very beautiful thing. I wanted to be able to do an occult comic that didn't portray the occult as a dark, scary place, because that's not my experience of it. I don't think it's the experience of many occultists. Why would we want to be occultists if that meant that we had to spend our lives in a dark, scary place? Utilizing my occult experiences, I could see a way that it would be possible to do a new kind of occult comic, that was more psychedelic, that was more sophisticated, more experimental, more ecstatic and exuberant. In Jim and Mick and Jeremy, I've obviously found people who were exactly right for the book, that have shared my vision on it, or have come to share my vision on it, and have added their own bits to that vision. So *Promethea* is about as perfect an expression of the occult as I could imagine doing in a mainstream super-hero comic book. It's also got a bit of a Trojan horse element in that yes, it does look like a Wonder Woman-type super heroine. If you squint your eyes up a bit and you're looking at it in a dim light, then you might mistake it for something a bit like Wonder Woman. So if that keeps the super-hero fans happily involved, great. But the sort of stuff that we've done in *Promethea* has obviously got a very different agenda to almost any conceivable super-heroine book.

From reading *Promethea*, I kind of get the idea that you relate magic to self-discovery; is that what it is? Or exploring...?

Well, that's what magic is about. I was talking with Scott Allie at Dark Horse the other night, and he was saying that some while ago he'd got this brilliant idea for a comic he was going to write about a magician whose big magic act was to make himself a better person. And then he started looking into magic and suddenly realized that actually, yeah, that is kind of what it's about. That he wasn't being as post-modern and clever as he thought he was, that this is a lot of what magic's about. It's the thing of, over the archway of Apollo's Oracle at Delphi, it said "*Gnothi see, auton,*" I believe. It means "know thyself." And that is the goal of magic: know thyself, become thyself. By self, it means highest self. Now, does that mean that magic is not therefore involved with demons, angels, gods and all the rest of it? No, not at all. The demons, gods, angels, and other supernatural beings are completely real. That is what magic is about. But the demons and gods and all the rest of it, yes, they are completely real, but they are also, in some ways, a part of you. In coming to know yourself, you will have to come to know all of these entities that represent parts of you in the world of your mind. It's exactly what magic has always been portrayed as being. But it's just that you have to understand that the emphasis is not upon what you might think it would be on. Yes, there are angels, devils, ghosts, goblins and all the rest of it, but they're all part of you. So dealing with demons, say, binding demons to your will, this is a real thing. You will probably experience the demons as real, three-dimensional beings that are separate from you and have separate personalities, but you will also understand on one level that these demons are your own drives that have been allowed to run out of hand through neglect and have fallen into misuse. For example, there are demons that govern wrath or anger. Now, if you feel a sense of anger at some injustice, you could maybe use that energy as the fuel that will make you write a brilliant, impassioned book, or perhaps run a political campaign against this injustice. Or you could just get angry and furious and completely misuse that energy in pointless, incoherent rage rather than directing the energy toward something useful and positive that will benefit you and the people around you. Demons basically would much prefer being put to a different use. But we are lazy, and we're scared of doing this. We don't want to look too closely at these nasty things, because they might look quite like us if we looked too closely. We might recognize them. We might realize that these vile, loathsome creatures are in fact part of our personality. By objectifying them as separate entities, you are suddenly able to deal with them a lot easier. To talk about dealing with one's anger. It's still abstract, isn't it? You're dealing with part of your own mind. It's difficult. Even thinking about it could make you angry, if you were predisposed to that sort of thing. Well, if you can say, "Yes, I characterize my anger as this demon, and I'm going to try to establish a dialogue with this demon, and if that is on some level establishing a dialogue with my own anger, fair enough." It doesn't really matter whether there is a real demon there or not. It will probably appear that there is a real demon there. But that can also be understood as part of us. So in a way, yes, the world of magic is every bit as exotic, bizarre, and full of peculiar non-human beings as you might expect from *Doctor Strange* or reading whatever else that you care to read. But the world of magic is also about things that are very, very real, very, very human, and very, very much a part of everyone's daily life. I certainly know that if I hadn't been able to organize myself around magical principles, I really very much doubt that I would have been able to do the entire ABC line in the way that I have. In terms of output—and you're probably better placed to judge this than I am, because you've probably got a better archive than I do. But I've got to be putting out more work now than I've ever done before.

Exactly. You didn't do a regular series until the mid-'90s. Before you did *WildCATs*, I think you'd only done *Swamp Thing* as a regular series.

Well, that's it. *Swamp Thing*, and at the same time as I was doing *Swamp Thing*, that was when I was very young and at my peak, in some ways. Or at least traditionally speaking, I should have been at my peak. And I remember there was a point where I was doing *Swamp Thing*, *Watchmen*, probably "Captain Britain," "Marvelman"—it might have been "Marvelman"—"V for Vendetta," "Halo Jones," I was doing all this stuff at once. I think I was even still doing "Maxwell the Magic Cat." And I thought, "God, this is a pretty fantastic amount of stuff." I think that with the ABC stuff, I've been doing more. And that is very pleasing to me, that I can channel this energy, and I can do stuff where I can do more work and the quality does not suffer. There are no ABC books that I'm embarrassed about, where I think, "Aw, if I'd taken a bit longer on that, then I could have done a better story." Well, we've done some fantastic things. Yeah, it's very gratifying to me to prove to myself that I can still generate that much energy even at this tired and exhausted last stretch of my mainstream career. And I think that a lot of that is to do with magic, which is mainly to do with organizing energy. It's all about a kind of ecology of personal energy. Well, that's not all it's about, but that's one of the things. And the fact that I can organize my mind and my energies much more effectively now than I ever could before, then I'd have to say that magic has played a big part in that. I don't think that I could have done what I've done with the ABC books if it hadn't been for magic.

Wizard #81 art by Sprouse & Gordon.
©2003 America's Best Comics, LLC.

COLLABORATING WITH ALAN

by Todd Klein

I first met Alan Moore in September of 1983 when I was given the script for *Swamp Thing* #22 to letter. After lettering many comics for the previous five years, I had begun trying to write some of my own, thinking I could do at least as well as most of the scripts I was handed, but this tome from Alan was a revelation. Comics scripts can be written in a bare bones way... brief description of the action, dialogue... but most writers put more of themselves into it than that. Alan's scripts have been notorious for their great length and detail, but what makes up that detail? Plenty of description, sure, but beyond that, Alan brings everyone reading his scripts into his personal world and vision of the story, not only describing every detail he can think of, but reaching out to you, asking you to join him in collaboration, in the great and glorious adventure of storytelling. Let me give you an example, from the script for Page 5, Panel 1 of *Tom Strong* #11, describing the appearance of Tom Strange, an alternate-world version of Tom Strong. Note that Alan always types his panel descriptions in all capitals.

"ANOTHER THING THAT SHOULD BE IMMEDIATELY APPARENT FROM THIS SCENE IS THAT THIS CHARACTER, IN TERMS OF SHEER POWER, IS SEVERAL FACTORS ABOVE TOM STRONG. I KNOW THAT, INEVITABLY, SOME PEOPLE HAVE MISSED THE POINT OF TOM STRONG AND HAVE ASSUMED THAT IT IS OUR ATTEMPT TO PRESENT "SUPERMAN DONE RIGHT." LET'S TRY AND MAKE IT CLEAR FROM THESE OPENING SCENES THAT IN FACT DR. TOM STRANGE IS OUR ATTEMPT TO SEE SUPERMAN "DONE RIGHT"...NOT THE WAY WE DID IN "SUPREME" WITH A SORT OF MUTATED PASTICHE OF A SPECIFIC MODE OR ERA OF THE SUPERMAN STRIP, BUT INSTEAD WITH AN ATTEMPT TO GET BACK TO THAT INITIAL IDEA OF ABSOLUTE GOD-LIKE COMPETENCE AND ABILITY THAT IS AT THE ROOT OF THE IDEA. AS I SEE IT, DOC

STRANGE IS MORE POWERFUL THAN SUPERMAN. THE WAY I WANT TO HANDLE THE CHARACTER, HE COMES NOT FROM THE SIEGEL/SHUSTER SUPERMAN TRADITION, BUT FROM THE PAUL BUNYAN TALL-TALE TRADITION: 'So old Doc Strange, what do you know if he don't just up and run across the whole Milky Way Galaxy? Took him nigh on thirty years, but he weren't even out of breath!' I KNOW THAT THIS PROBABLY SOUNDS LIKE A LOT OF POINTLESS RAMBLING, BUT I JUST WANTED TO SHARE WITH YOU AS BEST I COULD THE SORT OF AURA THAT I SEE THIS CHARACTER AS HAVING."

Alan's scripts are full of that sort of inclusive, yet humble, exhortation, as well as a good deal of humor. I can't find the exact script to quote, but one recent panel description read something like:

CLOSER ON THE WINDOW. (THIS IS PROBABLY THE SHORTEST PANEL DESCRIPTION I'VE EVER WRITTEN....OH, BLOODY HELL, I'VE RUINED IT NOW, HAVEN'T I?)

And always, Alan encourages the artists, letterers and colorists to follow or ignore what he's described, to do whatever seems best to them to make the story work. Here's another example from the Cobweb story in *Tomorrow Stories* #11, written for Joyce Chin and Art Adams.

"HI. BEFORE WE KICK OFF, CAN I JUST SAY HOW PLEASED MELINDA AND I WERE TO HAVE YOU TWO DOING THIS EPISODE... PLEASE HAVE AS MUCH FUN ON IT AS YOU ARE ABLE, AND IF THE PANEL DESCRIPTIONS GET TEDIOUS OR IF YOU HAVE BETTER VISUAL IDEAS (WHICH YOU ALMOST CERTAINLY WILL HAVE), THEN PLEASE DIVERGE FROM MY INSTRUCTIONS (MORE SUGGESTIONS, REALLY) WHEREVER YOU FEEL LIKE IT."

What a breath of fresh air in a business where everyone is usually battling for control. And the thing is, Alan's ideas are usually so wonderful that we want to realize them as closely as we possibly can, given the restrictions of space available!

I met Alan in person only once, not too long after that *Swamp Thing* issue, perhaps in 1984, on the rare occasion of a visit to the DC Comics offices in New York City. Alan was wearing a suit, as I recall, with that celebrated mane and beard exploding from the top of his tall frame, giving the impression of some wild creature barely tamed, and on display. He seemed uncomfortable and nervous, but I was able to sit down with him for a few minutes to tell him how much I was

enjoying his work on *Swamp Thing*, especially the masterful verse he had been putting into the mouth of The Demon, a Jack Kirby character that had never been written in such a profound yet truly menacing way. He was surprised that I'd noticed, and seemed to appreciate the comments. Not long after, he agreed to write some backup stories for *The Omega Men*, a book I was scripting with considerable effort, especially after seeing what comics scripts could really be like in the hands of someone as gifted as Alan. Note that: Alan was writing back-ups for me. Talk about the tail wagging the dog! A few years later, I started lettering Neil Gaiman's *Black Orchid* and *Sandman*, and soon threw over all scripting attempts... I knew I'd never be able to come close what those two were doing.

I was privileged to letter a few later Moore scripts for DC before Alan stopped writing them, and then became only another avid Moore reader whenever possible. Skip ahead to early 1996 when I got a phone call from Eric Stephenson: Alan was going to be writing a revamp of the above mentioned Rob Liefeld character Supreme. Was I interested in lettering it? I jumped at the chance, and when the first batch of script arrived, it was like reuniting with an old friend. And what a great time we had doing it! That first long story arc had me gasping and laughing with delight at every unexpected twist and turn.

After *Supreme* ended rather suddenly, Rick Veitch and I were talking about future plans, and I learned that he and Alan were putting together a pitch for a new line of comics, and presenting it to several publishers. I was, of course, very interested in participating. Some time in 1998 I learned from Rick that Wildstorm had bought the concept, and I felt it was time to talk to Alan and find out what he was planning. We spoke for the first time since that long-ago meeting in what became a regular series of phone calls, as the concepts for the ABC line of comics were developing. At one point, Alan was describing what he had in mind for the covers of the books, how each issue should be something strikingly different, a unique gem. He mentioned *ACME Novelty Library* as an inspiration for this, and perhaps *The Spirit*. It sounded good, but I wasn't sure it could work. "There you had one person doing the whole concept: design, type, logo, and art," I said. "The bigger comics companies don't work that way. They have art directors doing a lot of it." There was a pause, as Alan considered this. "Well, you could do that, couldn't you?" I thought about it for a minute, remembering all the logo designs and cover lettering I'd done,

as well as the production background I had at DC. "Well... yeah, I guess I could!" And that's how I got involved in not only lettering most of the ABC comics line, but designing the covers as well. Fortunately, editor Scott Dunbier was willing to let me give it a try, and it's been the most satisfying experience imaginable, working with Alan and the artists, trying to come up with something new and different every time.

Best of all, I get to talk to Alan a lot. Our conversations usually begin, "Hi Alan, it's Todd." And the quick response is always a hearty, "Oh, 'ello, Todd, how are you, everything all right, mate?" As we discuss the business at hand, I'm always filled with the warm glow of comraderie... I'm Alan Moore's "mate." We're working on this together. How cool is that?

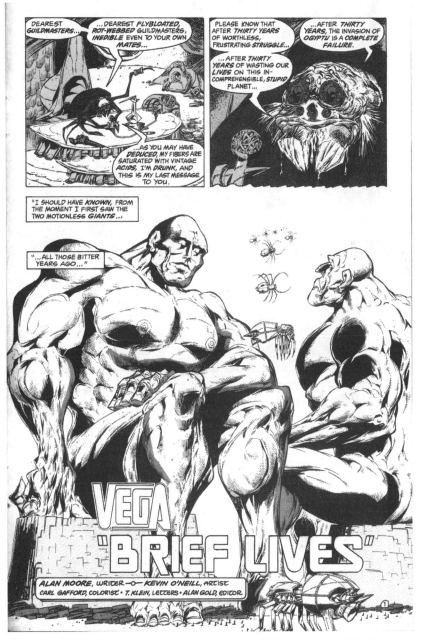

Page from "Vega: Brief Lives," printed in *Omega Men* #26. Art by Kevin O'Neill.

192

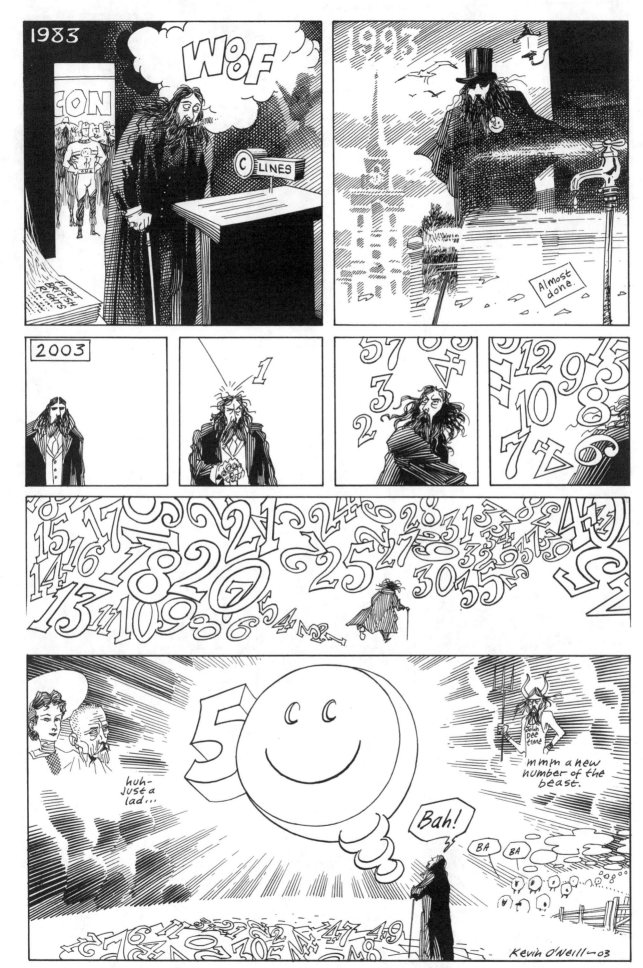

What motivates you to write nowadays? Do you feel at times that you want to do other things, like you don't have enough personal time, that you don't want to write all day and talk on the phone?

I've removed myself, to a certain degree, from the world of celebrity and the world of being famous. I don't do many interviews, I don't go to conventions, and I don't do any of that stuff, because that, to me, is all irrelevant. I don't think people need to meet me. I don't think that people even really need to hear interviews with me. (No offense, George.) If my stories are good enough, then that's the primary buzz. People know me through reading my stories. I think people have been reading my stories for 20 years or whatever, they probably know me as well as a lot of my friends do. A lot of my friends don't read my stories, because they don't happen to be interested in them. They're not comic readers or whatever. That is where I interact in a genuine way with my readers in the stories. That is my mind meeting theirs. That's all that's really needed in the relationship, and other parts can kind of get in the way of that and can cloud it. I am primarily a writer. That is what I'm best at. I love to manipulate words, and to manipulate consciousness by manipulating language. That's what I've always been interested in. And I should imagine that a lot of what I do in the future will be writing. Some of it will be comics, but probably not the majority. There's a lot of other things that I like doing. I like writing songs. I've just finished a brilliant article for my friend Joel Biroco's magic magazine, *Kaos*. I've written this article called "Fossil Angels," which should be coming out in *Kaos* #15, and which is a critique of the modern magical scene. It's saying what a lot of rubbish modern magic is and how pointless it is. It's a kind of call to arms. It rattles on for about 20 pages. It's very thorough. And I'm very pleased with it. And Kevin O'Neill's probably going to do some illustrations to it just so that we can show that we're serious about beautifying magic, making magic as beautiful as it deserves to be. That's a field where I feel that I can make an impact. I feel that I've made my primary impact on comics 20 years ago. Near enough. Obviously, there are still things that I can add to that and develop and all the rest with regard to comics, but I think that in the field of magic I've got a lot more to offer, because it's fresher. I

can see a lot of things that I could do. And the field of magic is in pretty much the same kind of state that the field of comics was in back in 1980. It's ripe for plunder. There's not much there that could stand up to a sufficiently motivated campaign by somebody with a sufficiently strong agenda, which is pretty much what comics was like back in the early '80s. There wasn't anybody offering any opposition to what I was doing. I'd an open field. I could have fun with magic in the same way, I think. So that's one way that I should like to develop things. Whether that be art, or... I've just got the first copy of the new CD through today, *Snakes and Ladders*, which is.... I've not played it yet, but it looks beautiful. And there's other things I could do there. Who knows, I might even make a film or something. It wouldn't matter if nobody ever saw it. I might get into doing sculpture or weaving baskets, I don't know. But there's a lot of things that I can do and that I could perhaps do better if I spent a little bit of time working on them, and which I'd be interested in doing. So that's my plan. Not to give up comics entirely, because comics is still a medium that I have got a great deal of respect for and one I think there's an awful lot that can be done. Probably not in mainstream comics. I'm not sure. Mainstream comics are always going to be dominated by the industry, and the industry is always going to suck. That's perhaps a grim summary of the situation, but I think it's probably a true one. So if I do comics in the future, it will be outside the mainstream. And as for the other work, like I say, I'm kind of working upon trying to engineer a situation where in a few years time there will be some interesting little venues and platforms for my work that won't have anything to do with the mainstream comic industry (or with any mainstream industry, for that matter). I should be gloriously free.

Do you plan on doing a lot of traveling?

Oh, no, no. No, I don't do a lot of traveling. I very seldom leave one end of the living room. The other end of the living room is a bit of a foreign country where they do things differently and have different stamps and passports and currency. I'm not interested in traveling. I'm all over the world. In my head, I'm everywhere. I'm not very often where I actually am, so I don't really have to move. Everybody

Moore as seen through the eyes of *Hate's* Peter Bagge. Artwork ©2003 Peter Bagge

The best of the *9-11* stories is "This Is Information," by Moore and Melinda Gebbie. Simply beautiful. ©2003 Alan Moore and Melinda Gebbie.

comes to see me, anyway.

And you do get phone calls from everybody.

Well, you know, I'm connected to everybody. I don't have to go and have some packaged experience of another person's country or whatever. I like Northampton. I understand Northampton. And I don't find that I have any problem understanding other parts of the world, because all parts are pretty much the same when you get down to a certain depth. All

cultures in the world, there's still a basic human bedrock that we all rest upon. And by understanding Northampton very deeply, I find that I've got a way of understanding any culture very deeply. Whereas if you were to take somebody who'd visited a country, and you were to take me and give me a week to do the research, and then asked us both to write an account of the time we'd spent in that country, I bet I'd write a more convincing one. I bet I would. When I first started doing *Swamp Thing*, all I did was do a little bit of basic research about Louisiana. About its history, about the music that comes from Louisiana, about its culture. And by dropping this into *Swamp Thing*, we suddenly start getting all the letters asking how long I've lived in America. Because the American writers who'd worked on *Swamp Thing* had not bothered to put in bits of American culture.

They hadn't bothered to put a swamp in there, either. [laughs]

Well, not really. They'd got the "thing" at least, but not the swamp. It was because the culture around them was so familiar and commonplace that they couldn't be bothered mentioning it. So when I started talking about, "Yeah, and in the swamp you're going to get your water hyacinths that can sometimes look like solid ground but they're growing over water, and you'll get your Spanish moss, and you'll get these sorts of birds and these sorts of animals." I mean, it was a tiny little bit of research, but it gave me a load of things that I could drop in that give texture and make the place come alive. So most of the audience reaction seemed convinced that I had firsthand knowledge of the Louisiana bayous. I've never been near the place. But that's the beauty of writing. It's all just words. If you can find the right words for a place, you can conjure it out of the air. So it's not going to involve a lot of traveling. I might go to the odd place, but I haven't even got a passport. I believe that there was a rumor that I wasn't allowed into America—

I was going to ask you about that! [laughs]

—because of *Brought to Light* or something.

Maybe you don't even want to come back here.

Well, that's true. You're right, I don't. I've just got no interest in going anywhere. That probably sounds a bit weird,

but... I met some lovely people when I was in America, but I found the entire experience kind of grueling. There was a lot about America that I didn't like. Well, there's lots about England that I don't like, so America needn't take it personally. But there was just something about... You know, I didn't particularly like France. I've never enjoyed going to any of these places. I'm always really glad to get home. And that's why I've stopped going places. Because I've not got a passport, I've allowed it to lapse. And I've got no real intention of getting another one. I am everywhere that I want to be in my head. It doesn't really matter where I actually am. That's just my body. And while it is a very fine, handsome, and beautiful body, it is not the most important part of me. The most important part of me goes wherever it wants.

I don't mean to sidetrack, but when do you usually write? Do you write at night or—

There's not a "usually" about it. I write whenever I get the chance. If the mood is upon me to write, then I write. And because I know that there's probably going to be interruptions of one sort or another that are going to stop me from writing, so if I have to write at night, then I will do.

Or if you have to disconnect the phone, you'll do that also?

Well, I don't very often, because there's so many people that need to get in touch with me, so I don't disconnect the phone. And I don't have an answer phone, because I think answer phones seem somehow rude. I don't know why, I've just never liked them. Also, I'd never get back to any of them, just like I don't answer letters. I don't have the time. So with the phone calls, I have to leave the phone on the hook, because there are so many people who need to get in touch with me. There are an awful lot of people who don't need to get in touch with me but just want to, but I can't screen those from the other ones. So, yeah, a lot of my life is spent on the phone. Far too much of it. I mean I spend more time talking on the phone about these things than I actually do writing them. That's another reason why I'm pulling out. I'm pulling back from any kind of celebrity status, because I've never been interested in it. I don't care whether I'm famous; I don't care whether anybody likes my work. I don't care about any of that, that's not important. All I care about is whether I am pleasing myself. I am very selfish. I'm selfish to the point where genuinely the only person's opinion I'm interested in is mine. I know that's arrogant, but it's just the way I am. It's always nice if people like a thing, but it doesn't make me like it any more just because other people like it. If I've decided that I didn't like a certain thing, it doesn't matter how many people tell me that they thought it was great, it's not going to change my opinion. If I do like a thing and everybody else in the world thinks its rubbish, that's not going to change my opinion either, because actually I'm right. So I don't need acclaim. That only gets in the way, and it means that I spend a lot of time on the phone, a lot of time handling a career, when I didn't ever want a career. I just wanted to write stories and mess around and generally be a bit arty. So that's what I shall hopefully eventually be achieving in about a year's time. It might mean that any readers who are particularly interested in my work and want to follow it, they might have to look a little bit harder. But, hey, this is the Internet Age. Everybody's surely able to find out these things at the drop of a hat. So I can't see anybody being that upset. I certainly won't be. I shall be skipping through the fields, metaphorically speaking.

Are you proud of your daughter Leah's writing ambition, which might follow your path?

She's sort of checking out and seeing how that goes. I think she should be talking to Scott Dunbier tonight about a series that she's come up with a proposal for, that Scott was interested in. But, on the other hand, she's not committed to a career as a writer. She might find that she doesn't enjoy it better than other things she might want to do. Certainly I would never want to force her into any career as a writer. I'll give her whatever help I can in terms of advice or stuff like that. But no, I don't want to force my daughters to be anything other than what they want to be.

Back cover to *Angel Passage*, a CD of Moore's performance work with Tim Perkins. ©2003 Alan Moore.

So you're very proud of them?

I'm incredibly proud of them. Despite what I say about them, despite the unflattering and the horrific terms I describe them in. I love them. I think that they are some of the brightest things in my life. I've some very bright things in my life, but my daughters are amongst the very brightest. They're fantastic people. I've really got no idea how they've managed to turn out like that, but they're both sunny, kind, very intelligent, and very good people, who've got a grip upon their own lives. I couldn't have asked for better kids. They're fantastic. And as for what the future holds for them, who knows? Yeah, Leah seems to be moving into kind of a writing career, but again, that might not always be in comics. She's talked to me about possibly writing plays. Amber does some writing. Both of them play musical instruments, and I know that Amber was writing songs at one point, very good little song lyrics that she was writing. I know she's got an interest in writing. And she's done some beautiful little pieces of writing that she's shown me. It's just that at the moment, her time seems to be mainly split between the security/bouncer job and this all-important computer degree that she's currently finishing off. A well-rounded individual. On one hand, she's taking a degree in Computer Studies; on the other hand she's sort of a violent thug who can control the worst that Hull can throw at her. That's balanced. She might very well go into computer design, design computer games. Or she might decide, once she's actually proven to herself that she can get the degree that she doesn't want to do that. She might decide that she wants to be a writer as well, or an artist or something. I've tried to let both of them understand that their options are open. I mean, I've never thought of myself as a comics writer, because all the time I've been writing comics, I've also been writing songs and I've been doing bits of artwork and all sorts of things. There's no need to rigidly define yourself as, "All right, that's it. I am this one thing and that is what I am forever." Human beings are very multi-faceted if they allow themselves to be. If we can enjoy it, we can do nearly anything. So I've always tried to let the kids be aware that their options are open, that there's no reason why they should limit themselves by one definition. That life is their playground, and they should enjoy as many aspects of it as they can.

Do you feel more content with your life right now?

Yeah. And I'm certainly looking forward to it in a year's time. I mean, my life at the moment is a bit of a grind, because I've got a lot of work to get done in this next year. When I say "grind," that makes it sound a lot more joyless than it actually is. I'm enjoying all the work I'm doing. There's just rather a lot of it. I shall be glad when I've got it all done. But I'm enjoying my life now more than I've enjoyed my life previously. It gets better and better. I sometimes suspect that the forces of destiny must be saving me for some particularly horrid finale, because it's just going too well. Everything that I want to do, I do it. There is nothing that I have to restrain myself upon. Nothing to think about restraining, and it's moving more towards that

situation all the time. My personal ecology is greatly increased and is still increasing. My personal power, which is power over myself, which is the only sort of power that's worth having. Power over other people is going to lead you into all sorts of trouble. Power over yourself, that's worth having. My personal sense of balance and understanding of the universe around me, it's on a steep upward curve, but I'm very much enjoying the ride. Life gets more wonderful and mysterious and radiant the older I get. I would not trade what's in my head now for all of the glory days of my youth. I have achieved something in my own terms that I'm very proud of. And I'm very impressed by it, and I'm not easy to impress. I've done something, particularly over this last ten years, I've done something in my head that has moved me to levels that I didn't previously know existed, and I'm very proud that I did. I just can't imagine not having discovered this territory. I don't know what my life would be like. But certainly this was the right way. Even if it all ends in tears tomorrow, this was the right way. And I'm very glad to be here.

ALAN MOORE'S FIVE TIPS FOR WOULD-BE COMICS WRITERS

1. **Don't.**
2. **No, really don't.**
3. **DEFINITELY don't—I mean it.**
4. **Whatever you might be imagining about a life of writing, it's not like that.**
5. OK, if you're going to anyway, if you're going to be a writer of any quality, **you will have to commit yourself to writing—** which is something that, when you're young and idealistic, sounds incredibly easy to do, but you should commit yourself to writing almost as if you were some ancient Greek or Egyptian committing yourself to a god.

If you do right by the god, then the god may, at some point in the future, reward you. But if you slack off and **don't** do right by your talent or your god, then you are heading for a world of immense and unimaginable pain. If you have a gift that you choose to pursue, then you have to pursue it seriously. Don't be half-assed about it, but realize what that commitment means.

Committing yourself to writing will mean, to a certain extent, your writing will become the most important part of your life—and that's a big thing to say. It can have a distancing effect upon other relationships. It can be sometimes quite a solitary life. If you're committed to your writing, you're going to spend most of your life indoors in a silent, empty room, concentrating on a pen and a piece of paper or their equivalent. Be prepared to take it seriously and be prepared to follow where it takes you, even if that takes you to some very strange places.

This is by no means the most glamorous profession. Don't say that I didn't warn you.

My pal, Walt Parrish, has a fetish for drawings with cliffs featured in them. J.H. Williams III did this little gem just for him – George

Promethea ©2003 America's Best Comics, LLC. Art ©2003 J.H. Williams III

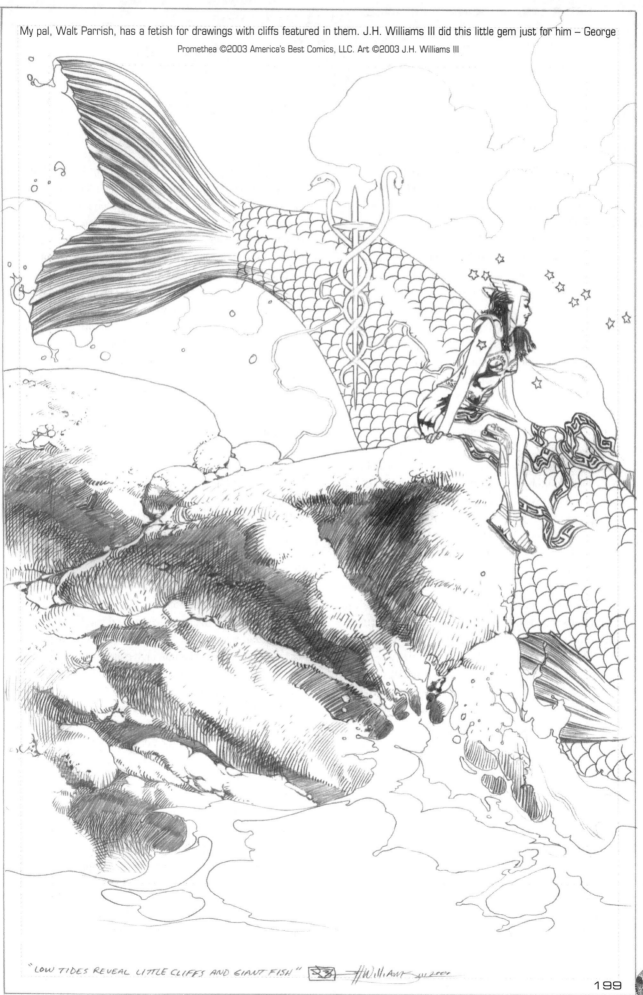

"LOW TIDES REVEAL LITTLE CLIFFS AND GIANT FISH."

It appears I get to have the last word. I don't know why, but this fact seems to be making the all-powerful Alan nervous. When it was decided that I was writing the afterword for this book he just said, "Well at least we'll be ending the book on a bitter note." I can't say the idea doesn't appeal to me, it seems only fair. The media in general have been up his arse and singing his praises for decades, and this afterword could be an ideal opportunity to give the general public a chance to glimpse the light of day, the light at the end of the tunnel (so to speak).

Somehow though, I don't think I can bring myself to tarnish my fathers near godlike reputation, after all, in his own special way he has helped to raise and nurture me throughout my life. Indeed, I'll never forget the first father-to-daughter words of wisdom he imparted to me. I was five and it was my first day of school. Instead of disappearing into his study first thing as usual, he stopped me on the way out of the door, knelt down on one knee and told me he had some very important advice that would help me through this terrifying day. He looked down on me, my big blue eyes staring back at him through the platinum ringlets that framed my little round face. He said, "Now remember this: don't say 'Yes Miss'... say 'Jam-it Bitch!'" and then stood up and went to the kitchen to make a cup of tea, chuckling to himself as he went. My mother only raised a single and perfectly arched eyebrow and ushered me across the road to school. Luckily and perhaps indicatively of the regularity of such incidents, I already had a well formed and healthy mistrust of adults in general and when Miss Hardwick called "Amber Moore?" I answered "Yes Miss."

Don't get me wrong: Having the All Scrying, All Writing phenomena that is Alan Moore for a father is way cool. Over the years it's meant having lunch with Neil Gaiman in Pizza Hut, it's meant meeting Kevin Eastman when all my friends were still actually using the phrase "Radical Dude!", but it does have its drawbacks. Everyone's got those memories of their dad dancing at parties because he's 'still got the moves'. Well, while I can safely say I've never seen my dad actually dance (possibly due to a crippling platform-shoe related incident in the Seventies) he can regularly be found discussing John Dee's sexual habits on late night re-runs on Channel Four. Usually around the time of night my friends and me are watching TV with a beer. Or sometimes in a magazine explaining exactly why the film *Hannibal* was a 'Bag of wank'. It was also a little distressing when at fifteen, I was sitting in my first love's room, making-out in the way only fifteen-year-olds can,

when "She Loves Me Not" by Pop Will Eat Itself began to play without my notice on a mix tape on the stereo. The first time I become aware of what is playing is when my father's deep Northamptonian voice is suddenly resonating around the room. While these random interjections into mass media culture are harmless in themselves, there is to this day, a metaphorical social Sword of Damocles hanging over my head. I was sitting in my dad's living room a couple of years ago and, not unusually, he was being interviewed over the telephone. Within minutes of the conversation commencing my train of thought was rudely broken by him saying, "Of course, that was around the time I first decided to kiss the smouldering foreskin of Beelzebub...". I was a tad disturbed by the imagery but presumed it was an interview for *Satanic Pole-Smokers Digest* and carried on with whatever I was reading. When the conversation ended an hour or so later I asked him if that was strictly necessary and he assured me it was. I was about to leave it when he dropped the bombshell; the interview was for *Metal Hammer*. Now in case you missed his description of me in *Voice of the Fire* as a fifty-foot Goth, it suffices to say I am rather attached to the alternative music scene. After already having had to explain my horror at the 'John Dee was a swinger' programme, most of my friends, their friends, and by this time, their friends, know that I am Alan Moore's Daughter and that he writes comics. Now, can you imagine your father discussing the kissing of Beelzebub's foreskin in one of the only two magazines that ALL of your friends read monthly? No? Well let me give you a clue: your dad doing the twist when he arrives to pick you up from a school disco? Not even close. As luck would have it some of my father's favour with (not 'favours' for) the gods appears to have rubbed off on me, and as far as I'm aware (and I'm pretty sure I'd have been told) the article has yet to actually be printed. However, one of these days there may be a slow news month in metal and when that day comes? I'm emigrating.

Now it only seems fair to give a perhaps broader and more rounded picture of the man who has re-shaped comics as we know them. He is, in brief, a sweetheart. He's a lovely bloke. He's the kind of man who can take on an industry he's only just entered while still in his twenties. He can remain patient, kind and calm when the assistant in WHSmiths tells him he could make a really good living playing 'Hagred' at kids' parties.

He's the bloke who when he's been up for days fighting deadlines and is so stressed that he is having dizzy spells and blackouts, will answer the phone and listen to whoever is on

the other end, without mentioning that he has but three days to save mankind (or at least the staggering number of people he has committed to supply with regular work). When he has to cover the receiver and violently throw up the only food he's eaten for days, he still finds time to say "I'm terribly sorry but I have to go... something's come up" before running upstairs to deposit the rest of his lunch.

He is not, as you can gather, a man of half measures. I am fairly sure the look he described as 'gecko-eyed evasion' in *Voice of the Fire*, comes from many years of seeing only the big picture, a picture perhaps a little too big for the rest of us to see. He can re-orientate the target demographic of a whole industry because he wants to. He can write *Watchmen*, a comic, a kid's story with pictures no less, that is now on the syllabus of English degrees. He can write porn and almost have us believe it's an artistic quest to produce acceptable erotica for the thinking man *and* woman. He has even been known to get girls to read comics. But if you ask the man to replace the fuse in a plug? You could be waiting a while. He moved into his house well over a decade ago, for at least a decade he has been getting it fixed up. The room that was my sister's and mine is now a huge and luxuriant bathroom; the tub is so big my vertically challenged sister cannot lie down because her feet do not reach dry land. There is a UV light above the huge mirror (the one that faces the raised toilet) so that, should he feel the need, Alan Moore can drop the kids off at the pool in the dark and still locate the bog-roll by the phosphorescent glow. It's a masterpiece in blue and gold rag-rolled splendour. It does not however, have carpet; beneath

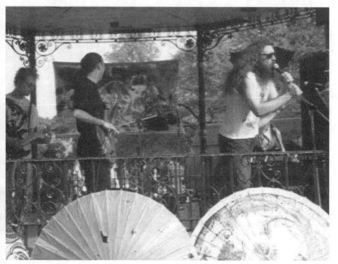

the heated towel rail are bare floorboards (and not the trendy Scandiwegian pine sort either). The cellar of the house has been dug out, mined into the hard orange rock beneath the area. This was to make way for a 'black lodge' style party room á lá *Twin Peaks*. Circumstances have put these plans on hold for several years. This is the kind of man who decides to mine out his own 'Bat Cave' before he thinks to replace the frankly hideous living room carpet that was unbearable when he moved in in the very early Nineties and has not improved

with age. I am forced to admit that my father is both psychologically far-sighted and, more importantly, a big kid.

Above this sputum patterned, matted monstrosity (the carpet, not my father) hangs a wall of enochian tables, beautiful plaques strangely reminiscent of a divine homage to Ma-Jhong. Around other walls intricately painted wands are carefully hung. The room is divided by a stained glass representation of the Kabbalah, and on a startlingly empty shelf above the comically overburdened bookshelves sits an exquisite human skull, apparently that of a young monk. It has, hundreds of years ago, been decorated with intricate silver work and had the top cut into a drinking bowl. These sacred and wonderful adornments are the earthly manifestations of his self-imposed reinvention as 'Magic Al'.

Having done as he pleased with the comics industry he has now set his sights upon the magical realm. He has planned the big move from comics to magic to occur on his fast-approaching fiftieth birthday. Those who know and love him well can only pray he is going to stick with the *Moon and Serpent* theme and not announce at his birthday party that he plans to single-handedly reinvent the world of topless fortune telling. While we wait with bated breath to see what effect a mid-life crisis could have on a man who only seems capable of affecting the universe on a multi-dimensional and universal scale, I can give only two hints at the gist of his thoughts on the magical world: Me and Leah badly singing "'Cause I've been scryyiying ov-er yooooooou..." at the poor man whenever he mentions how effective and interesting he's found the combination of enochian invocation and reading a scrying ball is apparently still funny for now. Calling his four hundred year old monk's skull 'Yorrick' and putting a party hat on him is not.

Finally, while I may one day tire of his not-so-subtle hints that I should write a book, I do still know that he probably told his hetero-life-mate and local corner shopkeeper, Germitt, about my new job as a bouncer in as proud a tone as if I actually had written my first novel at 13.

This is where I get to return the favour. Despite many promises to myself and my sister to end this on a comically dark note I feel the urge to re-iterate that, at base level, before you get to the guy who gets talked about in chat rooms, Alan Moore is not nearly as big and scary as he likes to think he is, and minor cottaging of the dark side apart, he is, and you can quote me, a fluffy bunny.

So here's to you Alan Moore: Father, Writer, Magician, Singer, Songwriter, Artist, and Kisser of Smouldering Foreskins. May the next fifty years (and well beyond if I know the sort of deals you'll be striking with the industry moguls of your new chosen field) be as productive and successful as you want and more relaxing than the last twenty-five.

Oh yeah, and here's a little friendly advice; should you ever happen to invoke Lillith (child slayer/night monster) remember this: Don't say "yes Miss".... Say "Jam-it Bitch!".

Within your dictionary, next to word "prolific" you'll find a photo of Alan Moore – who since his professional writing debut in the late Seventies has written hundreds of stories for a wide range of publications, both in the United States and the UK, from child fare like *Star Wars* to more adult publications such as *Knave*. We've organized the entries by publishers and listed every relevant work (comics, prose, articles, artwork, reviews, etc...) written by the author accordingly. You'll also see that I've made an emphasis on mentioning the title of all his penned stories because it is a pet peeve of mine when folks only remember the issue number of a story and not its title. (Special thanks to Greg Strokecker and David Hume for their assistance)

AARDVARK VANAHEIM INC.
CEREBUS #124 – **FROM HELL: "Prologue: The Old Men On The Shore"** – Art: Eddie Campbell – 1989 (Note: Preview of the first eight pages of *From Hell* story)

CEREBUS #126 – 1989 (Note: Introduction by Moore to Rick Veitch's *The One*)

CEREBUS #217-220 – **"Dialogue: From Hell"** – 1997 (Note: Moore and Dave Sim exchange over 30 pages worth of letters)

ACE BOOKS
LIAVEK: WIZARD'S ROW – **"The Hypothetical Lizard"** – 1987 (Note: Novelette; co-published with Arcane)

ACME PRESS
MAXWELL THE MAGIC CAT #1-4 – Art: Jill de Ray (Alan Moore) – 1986/1987 (Note: Reprints Moore's newspaper strip which were written and drawn under pseudonym of Jill de Ray; Afterword in #1 by Moore)

SPEAKEASY #43 – **"Nutter's Ruin"** – Art: Curt Vile (Alan Moore) – 1984 (Note: A tryout strip from 1979 is printed for the first time)

ACME TOUR PRODUCTS
BAUHAUS: BURNING THE INSIDE TOUR – 1983 (Note: Contents of this tour program written by Moore)

AMERICA'S BEST COMICS (ABC)
THE ABC SKETCHBOOK – Art: Various – 2002 (Note: Insight to the designs of the characters Moore created with their respective co-creators/artists)

AMERICA'S BEST COMICS 64 PAGE GIANT – **Tom Strong "Skull & Bones"** – Art: H. Ramos & John Totleben / **"Jack B. Quick's Amazing World of Science Part 1"** – Art: Kevin Nowlan / **Top Ten: "Deadfellas"** – Art: Zander Cannon / **"The FIRST First American"** – Art: Sergio Aragonés / **"The League Of Extraordinary Gentlemen Game"** – Art: Kevin O'Neill / **Splash Brannigan: "Specters from Projectors"** – Art: Kyle Baker / **Cobweb: "He Tied Me To a Buzzsaw (And It Felt Like a Kiss)"** – Art: Dame Darcy / **"Jack B. Quick's Amazing World of Science Part 2"** – Art: Kevin Nowlan – 2001 (Note: Book also contains a reprint of *ABC Wizard Preview*)

GREYSHIRT: INDIGO SUNSET #1-6 – Art: Rick Veitch – 2001/2002 (Note: Series written by Rick Veitch; Moore acted as editorial consultant)

GREYSHIRT: INDIGO SUNSET Trade Paperback – Art: Rick Veitch – 2003 (Note: Reprinting of limited series with an introduction by Moore)

THE LEAGUE OF EXTRAORDINARY GENTLEMEN (Volume One) #1 – **"1: Empire"** & **"Chapter 1: Allan and the Sundered Veil's The Dead Man"** – Art: Kevin O'Neill – 1999 (Note: "The Allan and The Sundered Veil" are prose stories; the vintage ads appearing through both volumes of the series are said to be original 19th century ads; there is a variant Dynamic Forces version of this issue that features a different cover by O'Neill)

THE LEAGUE OF EXTRAORDINARY GENTLEMEN (Volume One) #2 – **"2: Ghosts and Miracles"** & **"Chapter 2: Allan and the Sundered Veil's In The Ruins of Time"** – Art: Kevin O'Neill – 1999

THE LEAGUE OF EXTRAORDINARY GENTLEMEN (Volume One) #3 – **"3: Mysteries of the East"** & **"Chapter 3: Allan and the Sundered Veil's In The Shadow of the Sphinx"** – Art: Kevin O'Neill – 1999

THE LEAGUE OF EXTRAORDINARY GENTLEMEN (Volume One) #4 – **"4: Gods Of Annihilation"** & **"Chapter 4: Allan and the Sundered Veil's The Abyss Of The Lights"** - Art: Kevin O'Neill – 1999

THE LEAGUE OF EXTRAORDINARY GENTLEMEN (Volume One) #5 – **"5: Some Deep, Organizing Power..."** & **"Chapter 5: The Glint In Fortune's Eye"** – Art: Kevin O'Neill – 1999 (Note: The initial printing of this issue was pulped by DC hierarchy because of a Marvel Co. feminine hygiene product ad. A few copies were saved from the company's shredder and are now costly collectibles)

THE LEAGUE OF EXTRAORDINARY GENTLEMEN (Volume One) #6 – **"6: The Day of Be With Us"** & **"Chapter 6: Allan and the Sundered Veil's The Awakening"** – Art: Kevin O'Neill – 1999

THE LEAGUE OF EXTRAORDINARY GENTLEMEN VOLUME 1 – Art: Kevin O'Neill – 2000 (Note: Hardcover and softcover feature compilation of the entire six-issue mini-series along with plenty of bonus material)

THE LEAGUE OF EXTRAORDINARY GENTLEMEN VOLUME 1: THE ABSOLUTE EDITION – Art: Kevin O'Neill – 2003 (Note: Two oversized hardcovers in a slipcase featuring the entire mini-series and Moore's scripts)

THE LEAGUE OF EXTRAORDINARY GENTLEMEN (Volume One) Bumper Compendium #1 – 1999 (Note: Reprinting of the first two issues of series sans vintage ads and text stories)

THE LEAGUE OF EXTRAORDINARY GENTLEMEN (Volume One) Bumper Compendium #2 – 1999 (Note: Reprinting of issues #3 & 4 without vintage ads and text stories)

THE LEAGUE OF EXTRAORDINARY GENTLEMEN (Volume Two) #1 – **"1: Phases Of Deimos"** – Art: Kevin O'Neill / **"The New Traveller's Almanac"** – Art: Kevin O'Neill – 2002

THE LEAGUE OF EXTRAORDINARY GENTLEMEN (Volume Two) #2 – **"2: People Of Other Lands"** – Art: Kevin O'Neill / **"The New Traveller's Almanac: Chapter Two"** – Art: Kevin O'Neill – 2002

THE LEAGUE OF EXTRAORDINARY GENTLEMEN (Volume Two) #3 – **"3: "And the Dawn Comes Up Like Thunder"** – Art: Kevin O'Neill / **"The New Traveller's Alamanac: Chapter Three** – Art: Kevin O'Neill – 2002

THE LEAGUE OF EXTRAORDINARY GENTLEMEN (Volume Two) #4 – **"4: All Creatures Great and Small"** – Art: Kevin O'Neill / **"Chapter Four: Africa and The Middle East: Lights of a Dark Continent"** – Art: Kevin O'Neill – 2003

"I Can Hear the Grass Grow" is the last fully illustrated story that Moore completed. This "somewhat" autobiographical strip was originally published in *Heartbreak Hotel* #3. ©2003 Alan Moore.

THE LEAGUE OF EXTRAORDINARY GENTLEMEN (Volume Two) #5 – Art: Kevin O'Neill – 2003

THE LEAGUE OF EXTRAORDINARY GENTLEMEN (Volume Two) #6 – Art: Kevin O'Neill – 2003

THE LEAGUE OF EXTRAORDINARY GENTLEMEN (Volume Two) Bumper Compendium Edition Parts 1 & 2 – Art: Kevin O'Neill – 2002 (Note: Reprinting issue #1 and #2 sans text stories and vintage ads)

THE LEAGUE OF EXTRAORDINARY GENTLEMEN (Volume Two) Bumper Compendium Edition Parts 3 & 4 – Art: Kevin O'Neill – 2003 (Note: Reprinting issue #3 and #4 sans text stories and vintage ads)

THE MANY WORLDS OF TESLA STRONG – Co-Plot: Alan Moore – Co-Plot & Script: Peter Hogan – Art: Chris Sprouse, Adam Hughes, Michael Golden, Jason Pearson, Jose Luis Garcia-Lopez, Frank Cho, Claudio Castellini, Phil Noto, J. Scott Campbell, Arthur Adams and Karl Story – 2003

PROMETHEA #1 – "The Radiant, Heavenly City" – Art: J.H. Williams III & Mick Gray- 1999 (Note: There are two versions of cover)

PROMETHEA #2 – "The Judgment of Solomon" – Art: J.H. Williams III & Mick Gray – 1999

PROMETHEA #3 – "Misty Magic Land" – Art: J.H. Williams III & Mick Gray – 1999

PROMETHEA #4 – "A Faerie Romance" – Art: J.H. Williams III, Mick Gray & Charles Vess – 1999

PROMETHEA #5 – "No Man's Land" – Art: J.H. Williams III & Mick Gray – 2000

PROMETHEA #6 – "The 5 Swell Guys: Firefight On The Avenue" – Art: J.H. Williams III & Mick Gray – 2000

PROMETHEA #7 – "Rocks and Hard Places" – Art: J.H. Williams III, Mick Gray and Jose Villarrubia – 2000 (Note: Villarrubia's art was all done digitally)

PROMETHEA #8 – "Guys and Dolls" – Art: J.H. Williams III & Mick Gray – 2000

PROMETHEA #9 – "Bringing Down The Temple!" – Art: J.H. Williams III & Mick Gray – 2000

PROMETHEA #10 – "Sex, Stars & Serpents" – Art: J.H. Williams III & Mick Gray – 2000

PROMETHEA #11 – "Pseunami" – Art: J.H. Williams III & Mick Gray – 2001

PROMETHEA #12 – "The Magic Theatre" – Art: J.H. Williams III, Mick Gray & Jose Villarrubia – 2001

PROMETHEA #13 – "The Fields We Know" – Art: J.H. Williams III & Mick Gray – 2001

PROMETHEA #14 – "Moon River" – Art: J.H. Williams III & Mick Gray – 2001

PROMETHEA #15 – "Mercury Rising" – Art: J.H. Williams III & Mick Gray – 2001

PROMETHEA #16 – "Love And The Law" – Art: J.H. Williams III & Mick Gray – 2001

PROMETHEA #17 – "Gold" – Art: J.H. Williams III & Mick Gray – 2001

PROMETHEA #18 – "Life On Mars" – Art: J.H. Williams III & Mick Gray – 2002

PROMETHEA #19 – "Fatherland" – Art: J.H. Williams III & Mick Gray – 2002

PROMETHEA #20 – "The Stars Are But Thistles…" – Art: J.H. Williams III & Mick Gray – 2002

PROMETHEA #21 – "The Wine Of Her Fornications" – Art: J.H. Williams III & Mick Gray – 2002

PROMETHEA #22 – "Et In Arcadia" – Art: J.H. Williams III & Mick Gray – 2002

PROMETHEA #23 – "The Serpent And The Dove" – Art: J.H. Williams III & Mick Gray – 2002

PROMETHEA #24 – "Cross, Star, Moon, Shapes In The Sand (Everything Goes Wrong)" – Art: J.H. Williams III & Mick Gray – 2003

PROMETHEA #25 – "A Higher Court" – Art: J.H. Williams III & Mick Gray – 2003

PROMETHEA #26 – Art: J.H. Williams III & Mick Gray – 2003

PROMETHEA BOOK ONE – 2000 (Note: Collects *Promethea* #1-6)

PROMETHEA BOOK TWO – 2001 (Note: Collects issues #7 – 12 of *Promethea*)

PROMETHEA BOOK THREE – 2002 (Note: Collection of issues from #13-18)

SMAX #1-5 – Art: Zander Cannon – 2000

TERRA OBSCURA #1-6 – Co-Plot: Alan Moore – Script & Co-Plot: Peter Hogan – Art: Yanick Paquette and Karl Story – 2003 (Note: Tom Strong spin-off series)

TOMORROW STORIES #1 – Jack B. Quick: "Smalltown Stardom" – Art: Kevin Nowlan / **Greyshirt: "Amnesia"** – Art: Rick Veitch / The **Fighting American: "Dumbsday"** – Art: Jim Baikie / **"The Cobweb"** – Art: Melinda Gebbie – 1999 (Note: There are two different covers)

TOMORROW STORIES #2 – Greyshirt: "How Things Work Out" – Art: Rick Veitch / **Jack B. Quick: "The Unbearableness Of Being Light"** – Art: Kevin Nowlan / **The Cobweb: "Waltztime"** – Art: Melinda Gebbie / **The First American: "The Curse Of The Reverse"** – Art: Jim Baikie – 1999

TOMORROW STORIES #3 – Jack B. Quick: "Pet Theory" – Art: Kevin Nowlan / **The Cobweb: "Eurydice: A Retrospective"** – Art: Melinda Gebbie / **The First American: "The Peril Of The Pediatric Perpetrators"** – Art: Jim Baikie / **"The Making of Greyshirt"** – Art: Rick Veitch – 1999

TOMORROW STORIES #4 – The First American: "The Bitter Crumbs of Defeat!?!" – Art: Jim Baikie / **"Li'l Cobweb"** – Art: Melinda Gebbie / **Greyshirt: "Tempus Fugitive"** – Art: Rick Veitch / **Jack B. Quick: "A Brief Geography of Time"** – Art: Kevin Nowlan – 2000

TOMORROW STORIES #5 – Greyshirt: "Dr. Crescendo!" – Art: Rick Veitch / **The Cobweb: "La Toile Dans Le Chateau Des Larmet"** – Art: Melinda Gebbie / **The First American: "A Christmas Cop-Out"** – Art: Jim Baikie – 2000

TOMORROW STORIES #6 – Greyshirt: "Day Release" – Art: Rick Veitch / **The First American: "Lo! There Shall Come A Closeness And Commitment!"** – Art: Jim Baikie / **The Cobweb: "Shackled in Silk!"** – Art: Melinda Gebbie / **Splash Brannigan: "The Return Of The Remarkable Rivulet!"** – Art: Hilary Barta – 2000

TOMORROW STORIES #7 – Splash Brannigan: "A Bigger Splash!" – Art: Hilary Barta / **Cobweb: "Grooveweb"** – Art: Melinda Gebbie / **The First American: "The 20th Century: My Struggle"** – Art: Jim Baikie / **Greyshirt: "Hit And Run"** – Art: Rick Veitch / 2000

TOMORROW STORIES #8 – First American: "Justice In Tights!" – Art: Jim Baikie / **"Splash Brannigan: "Testostor The Terrible!"** – Art: Hilary Barta / **Cobweb:** *Newspaper Strips* – Art: Melinda Gebbie / **Greyshirt: "Thinx"** – Art: Rick Veitch – 2001

TOMORROW STORIES #9 – "Cobweb: Farewell, My Lullabye" – Art: Dame Darcy / **"The Origin Of The First American"** – Art: Jim Baikie / **Greyshirt: "The Musical"** – Art Rick Veitch / **Splash Brannigan: "Splash Of Two Worlds"** – Art: Hilary Barta – 2001

TOMORROW STORIES #10 – Jack B. Quick: "Why The Long Face?" – Art: Kevin Nowlan / **Greyshirt: "…For A Blue Lady"** – Art: Rick Veitch / **First American: "What We Probably Inhaled At The Toilet's Last Cleaning!"** – Art: Jim Baikie / **"Cobweb Of The Future"** – Art: Dame Darcy

TOMORROW STORIES #11 – Splash Brannigan: "Splash City Rocker" – Art: Hilary B. Barta / **Greyshirt: "Vermin"** – Art: Rick Veitch / **"Being The First American"** – Art: Jim Baikie / **Cobweb: "Bedsheets & Brimstone!"** – Art: Joyce Chen – 2001

TOMORROW STORIES #12 – Greyshirt & Cobweb: "Strands of Desire" – Art: Rick Veitch & Hilary Barta / **Jack B. Quick: "The Facts Of Life!"** – Art: Kevin Nowlan / **"The Death/Marriage/Son Of The First American Of The Future"** – Art: Jim Baikie

TOMORROW STORIES BOOK ONE – Art: Various – 2001 (Note: Hardcover collects the first six issues of the series)

TOM STRONG #1 – "How Tom Strong Got Started, Part One: The Fabulous Island", "Part Two: The Earthquake", and "Part Three: His Early Years" – Art: Chris /Sprouse & Al Gordon – 1999 (Note: There's also a variant cover by Sprouse & Gordon)

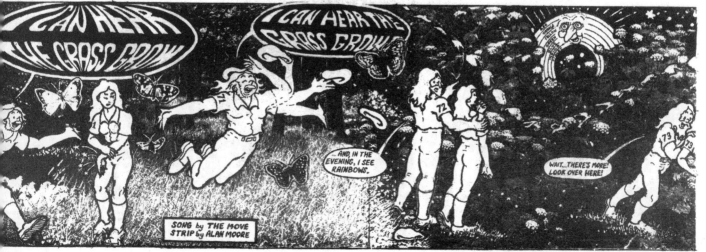

SONG by THE MOVE
STRIP by ALAN MOORE

TOM STRONG #2 – "Return Of The Modular Man" – Art: Chris Sprouse & Al Gordon – 1999

TOM STRONG #3 – "Aztech Nights" – Art: Chris Sprouse & Al Gordon – 1999 (Note: Art assist by Cully Hammer)

TOM STRONG #4 – "Swastika Girls!" – Art: Chris Sprouse, Arthur Adams & Al Gordon – 1999

TOM STRONG #5 – "Memories Of Pangaean" – Art: Chris Sprouse & Al Gordon / "Escape From Eden" – Art: Jerry Ordway & Gordon – 1999

TOM STRONG #6 – "Dead Man's Hand" – Art: Chris Sprouse & Al Gordon / "The Big Heat?" – Art: Dave Gibbons – 2000

TOM STRONG #7 – "Son's And Heirs" – Art: Chris Sprouse & Al Gordon / "Tom Strong 2050 A.D.: Showdown In The Shimmering City!" – Art: Gary Frank & Cam Smith – 2000

TOM STRONG #8 – "Riders Of The Lost Mesa!" – Art: Alan Weiss / "Tom Strong and the Strongmen of America: The Old Skool!" & "Tesla Strong: Sparks" – Art: Chris Sprouse & Al Gordon – 2000

TOM STRONG #9 – "Terror Temple of Tayasal!" – Art: Paul Chadwick / "The Perils Of Dhalua: Volcano Dreams" & "Tesla Strong: Flip Attitude" – Art: Chris Sprouse & Al Gordon – 2000

TOM STRONG #10 – "Tom Strong And His Phantom Autogyro" – Art: Gary Gianni / "Funnyland" & "Too Many Teslas?"- Art: Chris Sprouse & Al Gordon – 2000

TOM STRONG #11 – "Strange Reunion" – Art: Chris Sprouse & Al Gordon – 2001

TOM STRONG #12 – "Terror On Terra Obscura" – Art: Chris Sprouse & Al Gordon – 2001

TOM STRONG #13 – "The Family Strong: And The Tower At Time's End!" – Art: Chris Sprouse, Al Gordon, Pete Poplaski, Kyle Baker & Russ Heath – 2001

TOM STRONG #14 – "Space Family Strong!" – Art: Hilary Barta / "The Land Of Heart's Desire!" & "Tom Strong & Johnny Future: Baubles Of The Brain Bazaar" – Art: Chris Sprouse & Al Gordon – 2001

TOM STRONG #15 – "Ring Of Fire" – Art: Chris Sprouse & Karl Story – 2002

TOM STRONG #16 – "Some Call Him The Space Cowboy" & "The Weird Rider: Gone To Croatoan"- Art: Chris Sprouse & Karl Story – 2002

TOM STRONG #17 – "Ant Fugue" – Art: Chris Sprouse & Karl Story – 2002

TOM STRONG #18 – "The Last Roundup" – Art: Chris Sprouse & Karl Story – 2002

TOM STRONG #19 – "Tom Strong: Electric Ladyland" – Art: Howard Chaykin / "The Hero-Hoard of Horatio Hogg!" – Art: Chris Sprouse & Karl Story – 2003

TOM STRONG #20 – "How Tom Strong Got Started – Chapter One" – Art: Jerry Ordway & Karl Story – 2003

TOM STRONG #21 – Art: Jerry Ordway & Karl Story – 2003

TOM STRONG BOOK I – 2001 (Note: Reprints first seven issues of the series; hardcover and softcover edition exist)

TOM STRONG BOOK II – 2002 – (Note: Reprinting of issues eight to fourteen)

TOM STRONG'S TERRIFIC TALES #1 – "Tom Strong: In The Dark Inside" – Art: Paul Rivoche / "Tesla Time" – Art: Jaime Hernandez – 2002

TOM STRONG'S TERRIFIC TALES #2 – "Tom Strong: Live Culture" – Art: Paul Rivoche – 2002

TOM STRONG'S TERRIFIC TALES #3 – "Tom Strong: The Rule Of Robo-Saveen!" – Art: Jerry Ordway – 2002

TOM STRONG'S TERRIFIC TALES #4 – "Tom Strong: Leap Of Faith" – Art: Paul Rivoche – 2002

TOM STRONG'S TERRIFIC TALES #5 – Tom Strong Family "Collect The Set!" – Art: Jason Pearson –2002 (Note: Professional writing debut of Moore's daughter Leah with "King Solomon: Pines" short)

TOM STRONG'S TERRIFIC TALES #6 – Tom Strong "Goloka: The Heroic Dose" – Art: Jerry Ordway – 2003

TOM STRONG'S TERRIFIC TALES #7 – 2003

TOP TEN #1 – Art: Gene Ha & Zander Cannon – 1999 (Note: There are two versions of the cover: one by Alex Ross, the other by Gene Ha)

TOP TEN #2 – "Blind Justice" – Art: Gene Ha & Zander Cannon – 1999

TOP TEN #3 – "Internal Affairs" – Art: Gene Ha & Zander Cannon – 1999

TOP TEN #4 – "Eight Miles High" – Art: Gene Ha & Zander Cannon – 1999

TOP TEN #5 – "Great Infestations" – Art: Gene Ha & Zander Cannon – 2000

TOP TEN #6 – "You Better Watch Out, You Better Not Cry..." – Art: Gene Ha & Zander Cannon – 1999

TOP TEN #7 – "Myth Demeanors" – Art: Gene Ha & Zander Cannon – 2000

TOP TEN #8 – "The Overview" – Art: Gene Ha & Zander Cannon – 2000

TOP TEN #9 – "Rules Of Engagement" – Art: Gene Ha & Zander Cannon – 2001

TOP TEN #10 – "Music For The Dead" – Art: Gene Ha & Zander Cannon – 2001

TOP TEN #11 – "His First Day On The Job" – Art: Gene Ha & Zander Cannon – 2001

TOP TEN #12 – "Court On The Street" – Art: Gene Ha & Zander Cannon – 2002

TOP TEN: BOOK ONE – Art: Gene Ha & Zander Cannon – 2000 (Note: Reprinting of Top Ten #1-7 with an intro by author)

TOP TEN: BOOK TWO – Art: Gene Ha & Zander Cannon – 2002 (Note: Hardcover & softcover collect Top Ten #8-12)

ARCADE

INFINITY #7 & #8 – "Too Avant Garde For The Mafia?" – 1984/1985 (Note: Article by Moore)

ARCADE COMICS

ALAN MOORE'S JUDGMENT DAY COMPLETE COLLECTION HARDCOVER – Art: Various – 2003 (Note: Hardcover reprinting the Awesome Comics mini-series with extra material; also available in a deluxe version)

ARK

THE SUTTONS: THREE YEARS IN MAIDSTONE – 1999 (Note: Moore intro for Phil Elliott's book)

ATOMEKA PRESS

A1 #1 – Warpsmith: "Ghostdance" – Art: Garry Leach/ Bojeffries: "Festus: Dawn Of The Dead" – Art: Steve Parkhouse – 1989

A1 #2 – Bojeffries: "Sex With Ginda Bojeffries" – Art: Steve Parkhouse – 1989

A1 #3 – Bojeffries: "A Quiet Christmas With The Family" – Art: Steve Parkhouse – 1990

A1 #4 – Bojeffries: "Song Of The Terraces" – Art: Steve Parkhouse – 1990

A1 TRUE LIFE BIKINI CONFIDENTIAL – Bojeffries: "Our Factory Fortnight" – Art: Steve Parkhouse – 1991

AVATAR PRESS, INC.

ALAN MOORE'S ANOTHER SUBURBAN ROMANCE – Art: Juan Jose Ryp – 2003 (Note: Adaptation of Moore's play; hardcover edition also available)

ALAN MOORE'S THE COURTYARD #1 & #2 – Script: Antony Johnson – Art: Jacen Burrows – 2003 (Note: Comic book adaptation of "The Courtyard" prose originally featured in Starry Wisdom)

ALAN MOORE'S MAGIC WORDS – "The Hair of the Snake That Bit Me" – Art: Sergio Bleda / "Leopard Man at C & A" – Art: Martin Caceres / "Fires I Wish I'd Seen" – Art: Vicente Cifuentes / "14.2.99" – Art: Juan Jose Ryp – 2002 (Note: Book also includes an article and discography of Moore's music and performances; hardcover edition also exist)

ALAN MOORE'S WRITING FOR COMICS –Art: Jacen Burrows – 2003 (Note: Reprints Moore's How-To-Writing essay along with an update piece; this had been previously reprinted in Fantasy Advertiser and The Comics Journal)

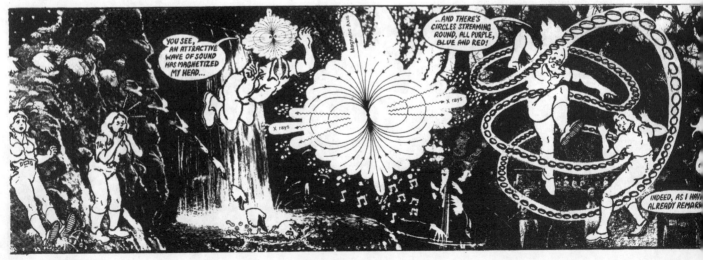

AVATAR GRAPHIC NOVEL SAMPLER (FCBD EDITION) – 2003 – (Note: Free Comic Book Day giveaway features samples of Moore's Avatar work)

GLORY PREVIEW – Art: Marat Mychaels & Robert Jones – 2001 (Note: Five-page preview of *Glory* #1; there's also two variant editions of book)

GLORY #0 – Art: Brandon Peterson & Edwin Rosell – 2001 (Note: Reprints story from Awesome Comics' *Glory* #0; there are ten different editions of this issue)

GLORY #1 – "The Gates Of Tears" – Art: Melinda Gebbie, Marat Mychaels & Robert Jones – 2001 (Note: There are fifteen different versions of this comic)

GLORY #2 – "The End Of Delight" – Art: Marat Mychaels / Robert Jones – 2002 (Note: Only six different versions of this edition)

AVON BOOKS
FORBIDDEN ACTS – "Light Of Thy Countenance"- 1995 (Note: Original prose fiction for this paperback novel)

AWESOME COMICS
ALAN MOORE'S AWESOME UNIVERSE HANDBOOK #1 – 1999 (Note: Contains the original series synopsis for *Youngblood* and *Glory*; there's also a preview of *Awesome Adventures* #1)

AWESOME ADVENTURES #1 – "Dandy In The Underworld" – Art: Steve Skroce / Lary Stucker – 1999 (Note: Continued from *Youngblood* #2; there's two Dynamic Forces variant covers)

AWESOME HOLIDAY SPECIAL #1 – "Youngblood Prologue Featuring Shaft" – Art: Steve Skroce / Lary Stucker – 1997 – (Note: There are five variants of this comic)

GLORY #0 – "Glory And The Gates Of Tears" – Art: Brandon Peterson & Edwin Rosell – 1999 (Note: Issue contains preview of *Supreme: The Return* #1)

GLORY / RE: GEX ORLANDO FLIPBOOK – Art: Brandon Peterson & Edwin Rosell – 1998 (Note: Preview of *Glory* #0 story)

JUDGMENT DAY: AFTERMATH – Art: Gil Kane & Marlo Alquiza – 1998

JUDGMENT DAY: ALPHA – "Heroes, Heroines & Homicide"- Art: Gil Kane, Stephen Platt, Joe Weems V, Keith Giffen, Bill Wray, Adam Pollina, Dan Jurgens, Al Gordon, Rob Liefeld, and Jon Sibal – 1997 (Note: Variant cover by Dave Gibbons)

JUDGMENT DAY: FINAL JUDGMENT – "Brought To Book" – Art: Jeff Johnson, Dan Panosian, Rick Veitch, Ian Churchill, Norm Rapmund, Rob Liefeld, Marat Mychaels, Cedric Nocon, Jon Sibal, Lary Stucker and Norm Rapmund – 1997 (Note: Variant cover by Dave Gibbons)

JUDGMENT DAY: OMEGA – "The Trail" – Art: Chris Sprouse, Al Gordon, Steve Skroce, Stephen Platt, Lary Stucker, Jim Starlin, Alan Weiss, Terry & Rachel Dodson, Rob Liefeld and Jon Sibal – 1997 (Note: Variant cover by Dave Gibbons)

JUDGMENT DAY SOURCEBOOK – Art: Chris Sprouse & Al Gordon – 1997 (Note: Originally available as a premium from the defunct American Entertainment comic store; book also features twelve character descriptions of Moore created characters for the Awesome line)

SUPREME #49 – "The Supreme Story Of The Year: There Is A Light That Never Goes Out..." – Art: Mark Pajarillo, Norm Rapmund, and Rick Veitch – 1997

SUPREME #50 – "The Supreme Story Of The Year: A Love Supreme" – Art: Chris Sprouse, Al Gordon & Rick Veitch – 1997

SUPREME #51 – "The Supreme Story Of The Year: A Roster Of Rogues" – Art: J. Morrigan, Norm Rapmund, Al Gordon and Rick Veitch – 1997

SUPREME #52A – "The Supreme Story Of The Year: The Return of Darius Dax" – Art: J. Morrigan, Mark Pajarillo and Norm Rapmund / **"Tales Of Supremacy Featuring Squeak The Supremouse"** – Art: Kevin O'Neill / **"Secrets Of The Citadel Supreme"** – Art: Rick Veitch / **"Suprema, Sister Of Supreme"** – Art: Jim Mooney / **"Supreme's Rogues Roster"**- Art: Rick Veitch – 1997

SUPREME #52B – "The Supreme Story Of The Year: The Return Of Darius Dax" – Art: J. Morrigan and Al Gordon / **"Supreme With Professor Night"** – Art: Rick Veitch / **"Public Service Announcement"** – Art: Rick Veitch / **"Cover Gallery Supreme"** – Art: Rick Veitch / **"Supreme And The Funnybook Felonies"** – Art: Rick Veitch – 1997

SUPREME #53 – "19th Dimensional Nervous Breakdown" – Art: Chris Sprouse & Al Gordon – 1997

SUPREME #54 – "The Ballad Of Judy Jordan" – Art: Rick Veitch, Melinda Gebbie, Chris Sprouse and Al Gordon – 1997

SUPREME #55 – "Silence At Gettysburg" – Art: Chris Sprouse, Al Gordon, and Gil Kane – 1997

SUPREME #56 – "The Mirror Crack'd From Side To Side..." – Art: Chris Sprouse, Al Gordon, and Rick Veitch – 1998 (Note: Series continues in *Supreme: The Return* #1; there's a variant cover by Ed McGuiness)

SUPREME: THE RETURN #1 – "Through A Glass Darkly..." – Art: Chris Sprouse and Al Gordon – 1999 (Continued from *Supreme* #56; two-page preview of *Supreme: The Return* #2; there's several variant covers)

SUPREME: THE RETURN #2 – "A World Of His Own!" – Art: Jim Starlin – 1999

SUPREME: THE RETURN #3 – "The Three Worlds Of Diane Dane!" – Art: Matt Smith, Rick Veitch, Jim Baikie, Rob Liefeld, Al Gordon – 1999

SUPREME: THE RETURN #4 – "And Every Dog Has Its Day!" – Art: Matt Smith & Rick Veitch – 2000

SUPREME: THE RETURN #5 – "Suddenly... The Supremium Man!" – Art: Ian Churchill, Rick Veitch and Norm Rapmund – 2000

SUPREME: THE RETURN #6 – "New Jack City" – Art: Rick Veitch & Rob Liefeld – 2000 (Note: Jack Kirby tribute and seemingly last Moore issue of *Supreme*)

YOUNGBLOOD #1+ – "A Brief History of Twilight" – Art: Steve Skroce / Lary Stucker – **"Youngblood Prologue Featuring Shaft"** – Art: Steve Skroce / Lary Stucker – 1997 – (Note: There are five variants of this comic)

YOUNGBLOOD #1 – "Occupations" – Art: Steve Skroce / Lary Stucker – 1998 (Note: There are twelve different covers)

YOUNGBLOOD #2 – "Bad Blood" – Art: Steve Skroce / Lary Stucker – 1998 (Note: Continues into *Awesome Adventures* #1)

BEGGARS BANQUET SITUATION 2
THE SINISTER DUCKS *vinyl single* – Side A: **"March of the Sinister Ducks"** – Side B: **"Old Gangsters Never Die"** – comic: **"Old Gangsters Never Die"** – Art: Lloyd Thatcher – 1983

BLUE NOTES
PUMA BLUES #20 – "Act of Faith" – Art: Stephen Bissette & Michael Zulli – 1988

BLUE SILVER ENTERTAINMENT
TALES OF MIDNIGHT – "The Serpent And The Sword" – 1999 (Note: Short prose)

BORDERLANDS PRESS
FROM HELL: THE COMPLEAT SCRIPTS (BOOK ONE) – Art: Eddie Campbell – 1994 (Note: This book reprints the scripts for the first three chapters of *From Hell* and was the first – and only – of a planned series of four books)

FROM HELL: THE COMPLEAT SCRIPTS S/N EDITION (BOOK ONE) – Art: Eddie Campbell – 1994 (A numbered, slipcased edition, limited to 1000 copies and signed by Moore, Campbell & Bissette)

CALIBER PRESS
ALAN MOORE'S SONG BOOK – Art: Various – 1998 (Note: Compilation of illustrated lyrics which originally appeared in issues of *Negative Burn*)

THE BEST OF NEGATIVE BURN: YEAR ONE – 1995 (Note: Features "Positively Bridge Street" from *Negative Burn* #11)

NEGATIVE BURN#9 – "Another Suburban Romance" – Art: Ken Meyer Jr. – 1994

NEGATIVE BURN #10 – "London" – Art: Richard Case – 1994

NEGATIVE BURN #11 – "Positively Bridge Street" – Art: Phillip Hester & Ande Parks – 1994

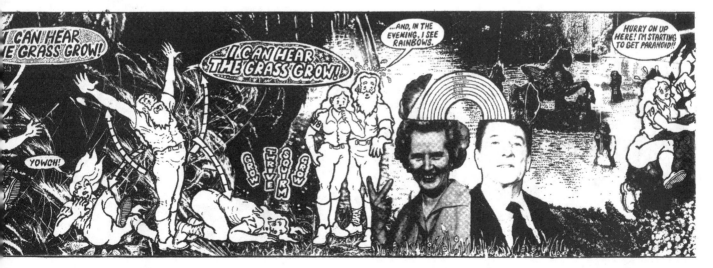

NEGATIVE BURN #12 – "14.2.99" – Art: Dave Johnson – 1994

NEGATIVE BURN #13 – "The Murders On The Rue Morgue" – Art: Neil Gaiman – 1994

NEGATIVE BURN #14 – "Fires I Wish I'd Seen" – Art: Colleen Doran – 1994

NEGATIVE BURN #16 – "Madame October" – Art: Terry Moore – 1994

NEGATIVE BURN #17 – "The Hair Of The Snake That Bit Me" – Art: Bill Koeb – 1994

NEGATIVE BURN #18 – "Trampling Tokyo" – Art: Arthur Adams – 1994

NEGATIVE BURN #19 – "Litvinov's Book" – Art: Richard Pace – 1995

NEGATIVE BURN #25 – "Chiaroscuro" – Art: Dave Gibbons – 1995

NEGATIVE BURN #26 – "Me and Dorothy Parker" – Art: Michael Gaydos – 1995

NEGATIVE BURN #28 – "Rose Madder" – Art: James A. Owen – 1995

NEGATIVE BURN #35 – "Leopard-Man at C & A's" – Art: Jordan Raskin – 1996

NEGATIVE BURN #37 – "Town Of Lights" – Art: Mark Ricketts – 1996 (Note: This song not included in *Alan Moore's Songbook* tpb)

CONTACT II PUBLISHING

A DAY IN THE LIFE: TALES FROM THE LOWER EAST: AN ANTHOLOGY OF WRITINGS FROM THE LOWER EAST SIDE, 1940-1990 – 1990 (Note: Moore wrote introduction)

CHAOS! COMICS

NIGHTMARE THEATER #4 – "Itchy Peterson: Born Lucky I Guess" – Art: Val Semeiks & Kevin Conrad – 1997

CHECKER BOOK PUBLISHING

SUPREME: THE RETURN – Art: Various – 2003 (Note: Paperback reprints the last half of the *Supreme* run)

SUPREME: THE RETURN PREVIEWS EXCLUSIVE LEATHER BOUND EDITION – Art: Various – 2003 (Note: Hardcover with extra background material)

SUPREME: THE STORY OF THE YEAR – Art: Various – 2003 (Note: Paperback reprints first half of the *Supreme* run)

SUPREME: THE STORY OF THE YEAR PREVIEWS EXCLUSIVE LEATHER BOUND EDITION – Art: Various – 2003 (Note: Hardcover with extra background material)

COMICO

GRENDEL: DEVIL BY THE DEED – 1986 (Note: Moore provided introduction; softcover & hardcover edition exists)

CREATION BOOKS

DUST: A CREATION BOOKS READER – "Recognition" – "Zaman's Hill" – 1995 (Note: Both prose selections are from the lost collection entitled Yuggoth Cultures)

HEXENTEXTS: A CREATION BOOKS SAMPLER – 1991 (Note: This is a CD featuring "Hair of a Snake" song and cover art by Moore; also listed in discography)

RAPID EYE #3 – "Mirror of Love" – 1995 (Note: Reprints the text to "Mirror of Love", and has a lengthy interview with Moore)

THE STARRY WISDOM – "The Courtyard" – 1994 (Moore contributed prose tale to this H P Lovecraft tribute book)

DARK HORSE COMICS

THE ADVENTURES OF LUTHER ARKWRIGHT #1 – 1990 (Note: Introduction by Moore)

ART ADAMS' CREATURE FEATURES – 1996 (Note: Reprints "Trampling Tokyo")

BASIL WOLVERTON'S PLANET OF TERROR #1 – Cover art: Alan Moore – 1987 (Note: Moore only remembers doing the cover for just this issue and not *Basil Wolverton's Gateway To Terror* #1 which I don't even think exists)

CLASSIC STAR WARS: DEVILWORLDS #1 & #2 – Art: Various – 1996 (Note: Reprint of five Moore stories originally published by Marvel UK)

GODZILLA Graphic Novel – 1995 (Note: Reprints Moore pin-up from *King of Monsters*)

GODZILLA: KING OF MONSTERS #1 – Pin-up art: Alan Moore – 1987

GODZILLA PORTFOLIO – Art: Alan Moore – 1988 (Note: Features print of Moore's pin-up)

HELLBOY: WAKE THE DEVIL TPB – 1996 (Note: Introduction by Moore)

MR. MONSTER (Vol. 2) #5 – Pin-up: Alan Moore – 1989

9-11: ARTISTS RESPOND (Vol. 1) – "This Is Information" – Art: Melinda Gebbie – 2002 (Note: Although published by Dark Horse, the material of this charity book was compiled along with Image Comics and Chaos! Comics)

DC COMICS

ACROSS THE UNIVERSE STORIES: THE DC UNIVERSE STORIES OF ALAN MOORE – Art: Various – 2003 (Note: Trade paperback reprints most of Moore's non-*Swamp Thing* stories)

ACTION COMICS #583 – "Whatever Happened To The Man Of Tomorrow – Part Two" –Art: Curt Swan & Kurt Schaffenberger – 1985

BATMAN ANNUAL #11 – "Mortal City" – Art: George Freeman – 1987

BATMAN: THE KILLING JOKE – Art: Brian Bolland – 1988

THE BEST OF DC #61 – 1985 (Note: Digest features reprint of *Swamp Thing* #21)

THE BEST OF DC #71 – 1986 (Note: Reprints "Mogo Doesn't Socialize" – "Brief Lives" – "Rites Of Spring")

DARK KNIGHT RETURNS – 1986 (Note: Moore wrote introduction entitled "The Mark of Batman")

DC COMICS PRESENTS #85 – "The Jungle Line" – Art: Rick Veitch & Al Williamson – 1985

DC SAMPLER #2 – "This Is The Place" – Art: Stephen Bissette & John Totleben – 1984

DC SAMPLER #3 – "The Saga of Swamp Thing" – Art: Stephen Bissette & John Totleben – 1984 (Note: This is an original three-page teaser for series.)

DETECTIVE COMICS #549 & #550 – "Green Arrow: Night Olympics" – Art: Klaus Janson – 1985

ESSENTIAL VERTIGO: SWAMP THING #1-24 – Art: Bissette, Totleben & Others – 1996/1998 (Note: Reprints of Moore's *Swamp Thing* issues, from #21-43, in glorious black and white)

THE GREATEST SUPERMAN STORIES EVER TOLD – Art: Dave Gibbons – 1987 (Note: Reprints *Superman Annual* #11)

GREEN LANTERN #188 – "Mogo Doesn't Socialize" – Art: Dave Gibbons – 1988

THE HOUSE ON THE BORDERLAND –2000 (Note: Moore provides intro)

MILLENNIUM EDITION: WATCHMEN #1 – Art: Dave Gibbons – 2000 (Note: Reprint of *Watchmen* #1)

OMEGA MEN #26 – "Vega: Brief Lives" – Art: Kevin O'Neill – 1985

OMEGA MEN #27 – "Vega: A Man's World" – Art: Paris Cullins – 1985

ROOTS OF SWAMP THING #3 – 1986 (Note: Two-page article about Wein & Wrightson's *Swamp Thing*)

SAGA OF SWAMP THING #20 – "Loose Ends" – Art: Dan Day & John Totleben – 1984

SAGA OF SWAMP THING #21 – "The Anatomy Lesson" – Art: Stephen Bissette & John Totleben – 1984

SAGA OF SWAMP THING #22 – "Swamped" – Art: Bissette & Totleben – 1984

SAGA OF SWAMP THING #23 – "Another Green World" – Art: Bissette & Totleben – 1984

SAGA OF SWAMP THING #24 – "Roots" – Art: Bissette & Totleben – 1984

SAGA OF SWAMP THING #25 – "The Sleep Of Reason" – Art: Bissette & Totleben – 1984

SAGA OF SWAMP THING #26 – "A Time For Running" – Art: Bissette & Totleben – 1984

SAGA OF SWAMP THING #27 – "...By Demons

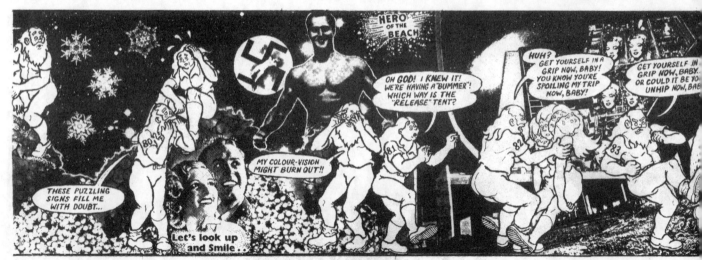

THESE PUZZLING SIGNS FILL ME WITH DOUBT...

Let's look up and Smile.

MY COLOUR-VISION MIGHT BURN OUT!!

OH GOD! I KNEW IT! WE'RE HAVING A 'BUMMER'! WHICH WAY IS THE "RELEASE" TENT?

HERO OF THE BEACH

HUH? GET YOURSELF IN A GRIP NOW, BABY! YOU KNOW YOU'RE SPOILING MY TRIP NOW, BABY!

GET YOURSELF IN A GRIP NOW, BABY, OR COULD IT BE YOU UNHIP NOW, BAB...

Driven" – Art: Bissette / Totleben – 1984

SAGA OF SWAMP THING #28 – "The Burial" –Art: Shawn McManus – 1984

SAGA OF SWAMP THING #29 – "Love And Death" – Art: Bissette / Totleben – 1984

SAGA OF SWAMP THING #30 – "A Halo Of Flies" – Art: Bissette / Alfredo Alcala – 1984

SAGA OF SWAMP THING #31 – "The Brimstone Ballet" Art: Rick Veitch / Totleben – 1984 (Note: This story continues into *Swamp Thing Annual #2*)

SAGA OF SWAMP THING #32 – "POG" – Art: Shawn McManus – 1985

SAGA OF SWAMP THING #33 – "Abandoned Houses" – Art: Ron Randall – 1985 (Note: Moore & Randall only provide framing story around the reprint of *House of Secrets #92*.)

SAGA OF SWAMP THING #34 – "Rites of Spring" – Art: Bissette & Totleben – 1985

SAGA OF SWAMP THING #35 – "The Nukeface Papers, Part I" – Art: Bissette & Totleben – 1985

SAGA OF SWAMP THING #36 – "The Nukeface Papers, Part II" – Art: Bissette & Totleben – 1985

SAGA OF SWAMP THING #37 – "Growth Patterns" – Art: Veitch & Totleben – 1985 (Note: First appearance of John Constantine.)

SAGA OF SWAMP THING #38 – "Still Waters" – Art: Stan Woch & Totleben – 1985

SAGA OF SWAMP THING #39 – "Fish Story" – Art: Bissette & Totleben – 1985

SAGA OF SWAMP THING #40 – "The Curse" – Art: Bissette & Totleben – 1985

SAGA OF SWAMP THING #41 – "Southern Change" – Art: Bissette & Alcala – 1985

SAGA OF SWAMP THING #42 – "Strange Fruit" – Art: Bissette & Totleben & Randall – 1985

SAGA OF SWAMP THING #43 – "Windfall" – Art: Woch & Randall – 1985

SAGA OF SWAMP THING TPB – Art: Bissette & Totleben – 1987. (Note: Trade paperback collection of *Saga of Swamp Thing #21-27*; there's also a different cover for the Warner Brothers edition; introduction by author.)

SECRET ORIGINS #10 – "Phantom Stranger: Footsteps" – Art: Joe Orlando – 1987

THE SPIRIT ARCHIVES Volume I – 2000 (Note: Foreword by Alan Moore)

SUPERMAN #423 – "Whatever Happened To The Man Of Tomorrow? – Part One" –Art: Curt Swan & George Perez – 1985

SUPERMAN: WHATEVER HAPPENED TO THE MAN OF TOMORROW? – Art: Swan/ Perez / Schaffenberger – 1997 (Note: Reprint of *Action Comics #583 & Superman #423*)

SUPERMAN ANNUAL #11 – "For The Man Who Has Everything" – Art: Dave Gibbons – 1985

SWAMP THING #44 – "Bogeymen" – Art: Bissette & Totleben – 1986 (Note: Same title that was previously *Saga Of Swamp Thing*)

SWAMP THING #45 – "Ghost Dance" – Art: Woch & Alcala – 1986

SWAMP THING #46 – "Revelations" – Art: Bissette & Totleben – 1986

SWAMP THING #47 – "The Parliament Of Trees" – Art: Woch & Randall – 1986

SWAMP THING #48 – "A Murder Of Crows" – Art: Totleben – 1986

SWAMP THING #49 – "The Summoning" – Art: Woch & Alcala – 1986

SWAMP THING #50 – "The End" – Art: Bissette, Totleben & Veitch – 1986

SWAMP THING #51 – "Home Free" – Art: Veitch & Alcala – 1986

SWAMP THING #52 – "Natural Consequences" – Art: Veitch & Alcala – 1986

SWAMP THING #53 – "The Garden Of Earthly Delights" – Art: Totleben – 1986

SWAMP THING #54 – "The Flowers Of Romance" – Art: Veitch & Alcala – 1986

SWAMP THING #55 – "Earth To Earth" – Art: Veitch, Alcala & Totleben – 1986

SWAMP THING #56 – "My Blue Heaven" – Art: Veitch & Alcala – 1987

SWAMP THING #57 – "Mysteries In Space" – Art: Veitch & Alcala – 1987

SWAMP THING #58 – "Exiles" – Art: Veitch & Alcala – 1987

SWAMP THING #59 – "Reunions" – Art: Veitch & Alcala (Note: Issue written by Bissette from a plot by Bissette, Totleben, Moore, & Veitch) – 1987

SWAMP THING #60 – "Loving The Alien" – Art: Totleben – 1987

SWAMP THING #61 – "All Flesh Is Grass" – Art: Veitch & Alcala – 1987

SWAMP THING #63 – "Loose Ends (Reprise)" – Art: Veitch & Alcala – 1987

SWAMP THING #64 – "Return Of The Good Gumbo" – Art: Bissette, Veitch, Alcala & Tom Yeates – 1987

SWAMP THING ANNUAL #2 – "Down Amongst The Dead Men" – Art: Bissette & Totleben – 1985

SWAMP THING: THE CURSE – Art: Bissette, Totleben, Veitch, Alcala, Randall & Woch – 2000 (Note: Reprinting of *Saga of the Swamp Thing #35-42*)

SWAMP THING: EARTH TO EARTH – Art: Veitch, Alcala & Totleben – 2002 (Note: Compilation of *Swamp Thing #51-56*)

SWAMP THING: LOVE AND DEATH – Art: Bissette, Totleben & Alcala – 1990 (Note: Reprinting of *Saga Of The Swamp Thing #28-34*)

SWAMP THING: A MURDER OF CROWS – Art: Bissette, Totleben, Veitch, Woch, Randall, and Alcala –2001 (Note: Reprints *Swamp Thing #43-50*)

TALES OF THE GREEN LANTERN CORPS ANNUAL #2 – "Tygers" – Art: Kevin O'Neill – 1986

TALES OF THE GREEN LANTERN CORPS ANNUAL #3 – "In Blackest Night" – Art: Bill Willingham & Terry Austin – 1987

V FOR VENDETTA #1-12 – Art: David Lloyd – 1988/1989 (Note: Colorized reprints from the *Warrior* series with new material appearing in issue #7)

V FOR VENDETTA – Art: David Lloyd – (Note: Compilation of the entire *V For Vendetta* series in trade paperback and hardcover format)

VIGILANTE #17 & #18 – "Father's Day" – Art: Jim Baike – 1985

WATCHMEN #1-12 – Art: Dave Gibbons – 1986-1987

WATCHMEN – Art: Dave Gibbons – 1987 (Note: Compilation of the entire *Watchmen* series in trade paperback and hardcover format)

WATCHMEN *DELUXE EDITION* – Art: Dave Gibbons – 1988 (Note: Produced in association with Graphitti Designs; the hardcover contains forty pages of background material)

DREAMHAVEN BOOKS
NOW WE ARE SICK: AN ANTHOLOGY OF NASTY – **"The Children's Hour"** – 1991 (Note: Moore contributed this poem to this book which was co-edited by Neil Gaiman; hardcover exists as well)

EAGLE COMICS
2000AD MONTHLY #1-5 – 1985 (Note: Reprints *D.R. & Quinch* material)

ECLIPSE COMICS
AXEL PRESSBUTTON #2 – "COLD WAR, COLD WARRIOR" – Art: Garry Leach – 1984 (Note: Features a reprint of a two-part Warpsmith story that originally appeared in *Warrior #9* and #10.)

BROUGHT TO LIGHT – "Shadow Play: The Secret Team" – Art: Bill Sienkiewicz – 1989

MIRACLEMAN #1 – "Rebirth" – Art: Garry Leach & Mick Anglo – 1985 (Note: Reprints Marvelman material from *Warrior #1, 2, 3* and the *Marvelman Special*; the Marvelman character was renamed to Miracleman.)

MIRACLEMAN #2 – "When Gods Cry War...." – Art: Garry Leach & Alan Davis – 1985 (Note: Reprints Marvelman material from *Warrior #5, 6, 7* and 8; this issue also features a Miracleman essay by Alan Moore.)

MIRACLEMAN #3 – "Out of the Dark" "Inside Story" & "Zarathustra" – Art: Alan Davis & Garry Leach – 1985 (Note: Reprints Marvelman material from *Warrior* #9, 10 and 11)

MIRACLEMAN #4 – "Catgames" "One of Those Quiet Moments" "Nightmares" Art: Alan Davis / "Miracleman Family: The Red King Syndrome, Part I" Art: John Ridgway. 1985. (Note: Reprints Marvelman material from *Warrior* #13, 14, 15 & 17)

MIRACLEMAN #5 – "The Approaching Light" "I Heard Woodrow Wilson's Guns..." "A Little Piece Of Heaven" – Art: Alan Davis / "Miracleman Family: The Red King Syndrome, Part II" – John Ridgway – 1986 (Note: Reprints Marvelman material from *Warrior* #16, 17, 18 and 20)

MIRACLEMAN #6 – "And Every Dog Its Day!" – Art: Alan Davis / "All Heads Turn as the Hunt Goes By" – Art: Chuck Beckum / "Young Miracleman: 1957" – Art: John Ridgway – 1986 (Note: Reprints Marvelman material from *Warrior* #21, the last of *Warrior*'s Marvelman stories. The Chuck Beckum material begins the Eclipse era of Miracleman with brand new material. The Ridgway illustrated story is a solo Young Miracleman story that originally appeared in *Warrior* #12.)

MIRACLEMAN #7 – "Bodies" – Art: Chuck Beckum – 1986.

MIRACLEMAN #9 – "Scenes From Nativity" – Art: Rick Veitch & Rick Bryant – 1986

MIRACLEMAN #10 – "Mindgames" – Art: Rick Veitch and John Ridgeway – 1986.

MIRACLEMAN #11 – "Cronos" – Art: John Totleben – 1987

MIRACLEMAN #12 – "Aphrodite"- Art: John Totleben – 1987

MIRACLEMAN #13 – "Hermes" – Art: John Totleben – 1987

MIRACLEMAN #14 – "Pantheon" – Art: John Totleben – 1988

MIRACLEMAN #15 – "Nemesis" – Art: John Totleben – 1988 (Note: Alludes to events that occurred in *Warrior* #4.)

MIRACLEMAN #16 – "Olympus" – Art: John Totleben – 1989 (Note: Tom Yeates gave art assistance)

MIRACLEMAN, BOOK ONE: A DREAM OF FLYING Art: Garry Leach & Alan Davis – 1988 (Note: Reprints the first three issues of the series; hardcover and softcover editions exist)

MIRACLEMAN, BOOK TWO: THE RED KING SYNDROME – Art: Alan Davis, Chuck Beckum, John Ridgeway, Rick Veitch & Rick Bryant – 1992 (Note: Reprints *Miracleman* #4, 5, 6, 7, 9 and 10; printed in hardcover and softcover editions.)

MIRACLEMAN, BOOK THREE: OLYMPUS – Art: John Totleben – 1992 (Note: Reprints *Miracleman*

#11-16; Printed in hardcover and softcover editions)

MIRACLEMAN 3-D #1 – "Saturday Morning Pictures" – Art: Alan Davis – 1985 (Note: This issue features a framing sequence written by Moore and illustrated by Alan Davis; most of this book was reprinted from the *Marvelman Special* published by Quality Communications.)

MR. MONSTER #3 – "The Riddle Of The Recalcitrant Refuse!" – Art: Michael T. Gilbert – 1985

REAL WAR STORIES #1 – "Tapestries" – Art: Stephen Bissette, Stan Woch & John Totleben – 1987

WORDS WITHOUT PICTURES – "The Hypothetical Lizard" – 1990 (Note: Reprinting of "The Hypothetical Lizard" story from *Liavek: Wizard's Row*; co-published with Arcane)

EDDIE CAMPBELL COMICS

BACCHUS #18 – "Legless" – 1996 (Note: Moore drew Maxwell the Magic Cat for two panels on one page)

THE BIRTH CAUL – Art: Eddie Campbell – 1999 (Note: Adaptation of Moore's original performance reading)

FROM HELL (TPB) – Art: Eddie Campbell – 1999 (Note: Trade paperback compilation of the entire epic)

FROM HELL *S/N EDITION* – Art: Eddie Campbell – 2000 (Note: The hardcover was held to a signed and limited edition of one thousand; Co-produced by Graphitti Designs)

FROM HELL *PAINFULLY LIMITED* – Art: Eddie Campbell – 2002 (Note: Only 19 copies of this edition exist, each one created personally by Campbell. The book comes in a clothbound clamshell case with a black kangaroo leather cover and an original color painting by Campbell inside the front cover.)

SNAKES & LADDERS – Art: Eddie Campbell – 2001 (Note: Adaptation of Moore's original performance reading)

ESCAPE PUBLISHING

ALEC MCGARRY – 1984 (Note: Moore wrote intro for this book)

DOC CHAOS – 1985 (Note: Moore wrote introduction)

ESCAPE #6 – "COMICS USA: An Impossible Rich Celebrity's Guide" – 1985 (Note: Three-page account of Moore's first (of three) trips to the United States)

ESCAPE #8 – 1986 (Note: Moore writes a small review about "At Home With Rick Geary")

ESCAPE #10 – 1987 (Note: Moore reviews *Lady Chatterley's Lover* by Hunt Emerson & *Maus: A Survivor's Tale*)

ESCAPE #14 – "Revelations" – (Note: Op page)

ESCAPE #15 – "No More Sex" – (Note: Op page)

VIOLENT CASES – 1987 (Note: Moore wrote intro for Gaiman's first graphic novel; intro featured only in first printing)

FANTAGRAPHICS BOOKS

ANYTHING GOES! #2 – "Pictopia" – Art: Don Simpson – 1986

THE BEST COMICS OF THE DECADE – Art: Don Simpson with Pete Poplaski & Mike Kazeleh – 1990 (Reprints: "Pictopia" story; hardcover & softcover editions)

BILL SIENKIEWICZ SKETCHBOOK – Art: Bill Sienkiewicz – 1990 (Note: Four-page introduction by Alan Moore)

COMICS JOURNAL #119-121 – "On Writing For Comics" – 1988 (Reprinted: Moore articles from *Fantasy Advertiser*; highlighted by two illustrations from Bill Sienkiewicz of the author and his typewriter)

COMICS JOURNAL #167 – 1994 (Note: Half-page commentary by Moore on Jack Kirby's passing)

CRITTERS #23 – "Rock 'n Roll Animals" – Art: Doug Erb – 1988 (Note: Besides article, book also contains Flexi-disc of Moore penned single "March of the Sinister Ducks" performed by his band)

DALGODA #8 – "Batfishing In Suburbia" – Art: Steve Parkhouse – 1986 (Note: Preface to the American edition of *The Bojeffries Saga*)

FLESH & BONES #1-4 – Art: Steve Parkhouse – 1986 (Note: Colorized reprints of the *Bojeffries Saga* which originally appeared in *Warrior*)

HATE #30 – "The Hasty Smear Of My Smile" – Art: Peter Bagge & Eric Reynolds – 1998

HONK #2 – "Brasso With Rosie" – Art: Peter Bagge – 1987 (Note: Prose story that was printed in *Knockabout Special* with new art by Mr. Bagge)

HONK #4 – "Globetrotting For Agoraphobics" – Art: Eddie Campbell – 1987 (Note: Prose story)

MEAT CAKE #9 – "Hungry Is The Heart" – Art: Dame Darcy – 1999

THE MECHANICS #1 – 1985 (Note: Introduction by Moore)

FANTACO ENTERPRISES, INC.

FANTACO HORROR YEARBOOK – 1989 (Note: Moore wrote a two-page essay on *From Hell*)

FIRST COMICS

AMERICAN FLAGG! #21 – "Mark Thrust: The Hot Slot" – Art: Larry Stroman & Don Lomax – 1985 (Note: Moore wrote this series of short stories for Howard Chaykin entitled "The Kansas Saga")

AMERICAN FLAGG! #22 – "Luther Ironheart: Machineries of Joy" – Art: Larry Stroman & Don Lomax – 1985

AMERICAN FLAGG! #23 – "Raul: There Is A Happy Land, Fur, Fur Away..." – Art: Larry Stroman

& Don Lomax – 1985

AMERICAN FLAG! #24 – "Jules 'Deathwish' Folquet: Zen And The Art Of Motormater Maintenance" – Art: Don Lomax – 1985

AMERICAN FLAG! #25 – "Medea Blitz: Welcome to the Pleasure Dome" – Art: Don Lomax – 1985

AMERICAN FLAG! #26 – "Q-USA: The People's Choice" – Art: Don Lomax – 1985

AMERICAN FLAG! #27 – "The Erogenous Zone" – Art: Don Lomax – 1985 (Note: Only full length issue and the conclusion of "The Kansas Saga")

AMERICAN SPLENDOR #15 – "Bob Wachsman Tummler" – Art: Alan Moore – 1990 (Note: This one-page strip is written by Harvey Pekar)

FLEETWAY EDITIONS
ROBIN SPECIAL – 1992 (Note: Reprints Moore's Green Arrow story from *Detective Comics*)

FLEETWAY PUBLICATIONS
COMIC RELIEF: THE TOTALLY STONKING, SUR-PRISINGLY EDUCATIONAL AND UTTERLY MIND-BOGGLING...- "Spotlight On Red Nose Events" – Art: Melinda Gebbie – 1991 (Note: Moore wrote Gebbie's two-page sequence uncredited)

D.R. & QUINCH: DEFINITIVE EDITION – Art: Alan Davis – 1991 (Note: Colorized reprints of this *2000AD* strip)

2000AD Annual 1982 – Ro-Busters "Bax the Burner" – Art: Steve Dillon – 1981

2000AD Annual 1983 – Ro-Busters "Old Red Eyes is Back" – Art: Bryan Talbot / Rogue Trooper "Pray For War" – Art: Brett Ewins – 1982

2000AD Annual 1984 – Ro Busters "Storm Eagles Are Go" – Art: Joe Eckers / Rogue Trooper – Art: Jesus Redondo / "How I Write Skizz" – Art: Jim Baikie – 1983

2000AD Annual 1985 – ABC Warriors "Red Planet Blues" – Art: Steve Dillon & John Higgins – 1984

2000AD Annual 1990 – 1989 (Note: Reprinting of a Time Twister story from *2000AD* #309)

FLEETWAY QUALITY
JUDGE DREDD #40 – 1990 (Reprints "The Startling Success of Sideways Scuttleton")

JUDGE DREDD CLASSICS #74 – 1992 (Note: Reprinting of "Killer In The Cab")

666: MARK OF THE BEAST #12 – (Note: Reprinting of *2000AD* material)

666: MARK OF THE BEAST #13 – 1993 (Note: Reprinting of IPC's *Monsters* #1 story & *2000AD* material)

SKIZZ: FIRST ENCOUNTER #1-3 – 1988 (Note: Reprinting of Skizz stories)

SPELLBINDERS #7 – 1987 (Note: Reprint of "The Dating Game")

FLYING PIG
FOOD FOR THOUGHT – "Cold Snap" – Art: Bryan Talbot – 1985

FUNNY VALENTINE PRESS
UNKNOWN QUANTITIES – "Sidewalk Jockeys" – Art: Guy Davis – 1999 (Note: Prose story)

FOUR WALLS EIGHT WINDOWS
THE NEW AMERICAN SPLENDOR ANTHOLOGY – 1991 (Note: Reprints one-page strip from *American Splendor* #15)

GALAXY PRODUCTIONS
KNAVE December 1984 – "Sawdust Memories" – 1984 (Note: An original prose story written for this adult magazine)

GRANDDREAMS
BATMAN ANNUAL U.K. 1985 – "The Gun" – Art: Garry Leach – 1985 (Note: Prose story for this British publication)

B.J. AND THE BEAR ANNUAL U.K. 1983 – "Bear's Monkey Business" & "C.B.? – That's A Big Ten Four" – Art: Alan Moore – 1983

SCOOBY DOO ANNUAL U.K. 1982 – 1982 (Note: Illustrations and an article by Moore)

SUPER-HEROES ANNUAL U.K. 1984 – "Superman: Protected Species" – Art: Bryan Talbot – 1984 (Note: Prose story)

SUPERMAN ANNUAL U.K. 1985 – "I Was Superman's Double" – Art: Bob Wakelin – 1985 (Note: Text Fiction)

HARRIER COMICS
BRICKMAN #1 – 1986 (Note: Moore wrote intro)

SWIFTSURE – "The Twenty Year Party" – 1985 (Note: one-page article)

HARRIS COMICS
VAMPIRELLA / DRACULA: THE CENTENNIAL – "The New European" – Art: Gary Frank & Cam Smith – 1997 (Note: There's also a five-page interview with Moore)

VAMPIRELLA / DRACULA SHOWCASE #1 – Art: Gary Frank / Cam Smith – 1997 (Note: Two-page preview of Moore's Dracula story from *Vampirella / Dracula: The Centennial*; there's also a two-page Moore interview)

IMAGE COMICS
FIRE FROM HEAVEN #1 – "Chapter One: Gamorra Rising" – Art: Ryan Benjamin, Chuck Gibson, Richard Friend and Mark Irwin – 1996

FIRE FROM HEAVEN #2 – "Finale 2: Moonlight and Ashes" – Art: Jim Lee and others – 1996 (Note: Although credited to Moore, this issue was ghostwrit-

ten by an unknown writer)

HORUS: LORD OF LIGHT ASHCAN – 1993 (Note: Black and white ashcan)

HORUS: LORD OF LIGHT PREVIEW – 1993 (Note: Ashcan giveaway given with copies of *Hero Illustrated*)

MAXX #21 – Story & Art: Sam Kieth – 1996 (Note: Moore is only credited for writing dialogue)

MR. MONSTER'S GAL FRIDAY: KELLY #3 – "It's Kelly's Boyfriend..." – Art: Alan Smith & Pete Williamson – 2000

1963 BOOK ONE: MYSTERY INCORPORATED – "Mayhem on Mystery Mile!" –Art: Rick Veitch & Dave Gibbons – 1993 (Note: Moore, Veitch & Bissette wrote copy for ads, letters pages and editorial throughout the *1963* series; variant covers also exist)

1963 BOOK TWO: NO ONE ESCAPES...THE FURY! – "When Wakes The War-Beast!" – Art: Stephen Bissette & Dave Gibbons – 1993

1963 BOOK THREE: TALES OF THE UNCANNY – U.S.A. (Ultimate Special Agent!): "Double-Deal In Dallas" – Art: Rick Veitch & Don Simpson / **"THE HYPERNAUT! It Came From... Higher Space!"** – Art: Steve Bissette & Chester Brown – 1993

1963 BOOK FOUR: TALES FROM BEYOND – N-MAN: "Showdown In The Shimmering Zone!" – Art: Steve Bissette & John Totleben / **JOHNNY BEYOND: "Flipsville!"** – Art: Jimmy Valentino / Steve Bissette – 1993

1963 BOOK FIVE: HORUS *LORD OF LIGHT* – HORUS: "Twelve Hours To Dawn" – Art: Rick Veitch & John Totleben – 1993

1963 BOOK SIX: TOMORROW SYNDICATE – TOMORROW SYNDICATE: "From Here To Alternity" – Art: Rick Veitch & Dave Gibbons – 1993 (Note: "The Double Image Eighty Page Giant" mentioned at the end of the issue was never released although Moore had plotted most of that book)

SHADOWHAWKS OF LEGEND – "Shadows in the Sand" – Art: Steve Leialoha – 1995

SPAWN #8 – "In Heaven (Everything Is Fine)" – Art: Todd McFarlane – 1993

SPAWN #32 – "Blood Feud: Preludes & Nocturnes" – Art: Tony Daniel & Kevin Conrad – 1995 (Note: Five-page prelude to *Spawn: Blood Feud* Mini-Series)

SPAWN #37 – "The Freak" – Plot: Todd McFarlane / Art: Greg Capullo & McFarlane (Note: Moore jazzed up this plot and provided script) – 1995

SPAWN: BLOOD FEUD #1 – "Part One" – Art: Tony Daniel & Kevin Conrad – 1995

SPAWN: BLOOD FEUD #2 – "Part Two" – Art: Tony Daniel & Kevin Conrad – 1995

SPAWN: BLOOD FEUD #3 –"Part Three" – Art:

Tony Daniel & Kevin Conrad – 1995

SPAWN: BLOOD FEUD #4 – "Part Four" – Art: Tony Daniel & Kevin Conrad – 1995

SPAWN: BOOK TWO – Art: Todd McFarlane – 1997 (Note: Reprinting of *Spawn* #8)

SPAWN / WILDC.A.T.S #1 – "Number One" – Art: Scott Clark & Sal Regla – 1995

SPAWN / WILDC.A.T.S #2 – "Number Two" – Art: Scott Clark & Sal Regla – 1996

SPAWN / WILDC.A.T.S #3 – "Number Three" – Art: Scott Clark & Sal Regla – 1996

SPAWN / WILDC.A.T.S #4 – "Number Four" – Art: Scott Clark & Sal Regla – 1996

SUPREME #41 – "The Supreme Story Of The Year" – Art: Joe Bennett, Norm Rapmund, Keith Giffen and Al Gordon – 1996 (Note: There are three different editions of this book)

SUPREME #42 – "The Supreme Story Of The Year: Part Two" – Art: Joe Bennett, Norm Rapmund, and Rick Veitch – 1996 (Note: Continues with *Supreme* #43 now published under Maximum Press banner)

VIOLATOR #1 – "The World" – Art: Bart Sears & Mark Pennington – 1994 (Note: Features samples of Moore's thumbnails & script)

VIOLATOR #2 – "The World: Part Two" – Art: Bart Sears & Mark Pennington – 1994

VIOLATOR #3 – "The World: Part Three" – Art: Greg Capullo & Mark Pennington – 1994

VIOLATOR VS BADROCK #1 – "Rock and Hard Places: Part 1" – Art: Brian Denham & Jonathan Sibal – 1995 (Note: There are two different covers for this comic)

VIOLATOR VS BADROCK #2 – "Where Angels Fear To Tread…" – Art: Brian Denham & Jonathan Sibal – 1995

VIOLATOR VS BADROCK #3 – "Mondo Inferno!" – Art: Brian Denham & Jonathan Sibal – 1995

VIOLATOR VS BADROCK #4 – "Badrock's Bogus Journey" – Art: Brian Denham, Jonathan Sibal & Danny Miki – 1995

VIOLATOR VS BADROCK TPB – Art: Denham, Sibal & Miki – 1996

VOODOO #1 – "Legba" – Art: Mike Lopez & Edwin Rosell – 1997 (Note: There's also a variant cover by Jason Pearson)

VOODOO #2 – "Erzulie" – Art: Al Rio, Michael Lopez, Trevor Scott, Mark Irwin, Luke Rizzo & Randy Elliott – 1997 (Note: Letter's page has corrected panel from previous issue)

VOODOO #3 – "Samedi" – Art: Al Rio & Trevor Scott – 1998

VOODOO #4 – "Damballa" – Art: Al Rio & Trevor Scott – 1998

WILDC.A.T.S #21 – "Untitled" – Art: Travis Charest & Troy Hubbs – 1995 (Note: Title of story wasn't printed)

WILDC.A.T.S #22 – "Cat's Cradle" – Art: Kevin Maguire & Troy Hubbs – 1995

WILDC.A.T.S #23 – "Cat's Eye!"- Art: Ryan Benjamin & Art Thibert (*Spaceside*) / Jason Johnson & Terry Austin (*Earthside*) – 1995

WILDC.A.T.S #24 – "Catacombs" – Art: Ryan Benjamin (*Spaceside*), Jason Johnson (*Earthside*), and Tom McWeeney – 1995

WILDC.A.T.S #25 – "Catfight!" – Art: Dave Johnson, Kevin Nowlan and John Nyberg (*On Earth…*) / Travis Charest and Troy Hubbs (*…As It Is On Heaven*) – 1995

WILDC.A.T.S #26 – "Catspaws" – Art: Travis Charest, JD, and Scott Williams (*Khera*) / Art: Dave Johnson (*Earth*) – 1996

WILDC.A.T.S #27 – "Catastrophe" – Art: Scott Clark & Bob Wiacek (*Khera*) / Art: Dave Johnson &

Dexter Vines – 1996

WILDC.A.T.S #28 – "Cataclysm!" – Art: Travis Charest, Dave Johnson, Aron Wiesenfeld and JD – 1996

WILDC.A.T.S #29 – "Catcall!" – Art: Travis Charest, Ryan Benjamin, JD and Richard Friend – 1996

WILDC.A.T.S #30 – "Fire From Heaven: Chapter 13" – Art: Travis Charest, Ryan Benjamin, Richard Friend, Sal Regla, Sandra Hope and John Tighe – 1996

WILDC.A.T.S #31 – "Cats & Dogs" – Art: Jim Lee, Josh Wiesenfeld, Richard Bennett and Travis Charest – 1996

WILDC.A.T.S #32 – "Catharsis" – Art: Jim Lee, Mat Broome, Pat Lee, Trevor Scott, Richard Bennett and Jason Gorder – 1997

WILDC.A.T.S #33 – "Belling the Cat!" – Art: Mat Broome, Troy Hubbs & Trevor Scott – 1997

WILDC.A.T.S #34 – "Catechism!" – Art: Mat Broome, Rob Stotz, Troy Hubbs, Scott Taylor, JD, Sandra Hope & Trevor Scott – 1997

WILDC.A.T.S #50 – "Reincarnation" – Art: Travis Charest – 1998 (Note: There is a regular and foil version of cover)

WILDSTORM SPOTLIGHT #1 – "Majestic: The Big Chill"- Art: Carlos D'Anda & Richard Friend – 1997

INDIGO FICTION

VOICE OF THE FIRE – 1997 (Note: New edition of novel originally published by Victor Gollancz)

IPC / REBELLION MAGAZINES

EAGLE #3 – The Collector: "Trash" – Photography: Sven Arnstein – 1982 (Note: This is a fumetti strip, meaning the story is told using sequential photography)

EAGLE #12 – The Collector: "Profits Of Doom" – Photography: Gabor Scott / Artwork: Rex Archer – 1982 (Note: Another fumetti strip)

SCREAM! #1 – "Monster" – Art: Heinzl – 1984 (Note: This comic came with free vampire fangs; many British comics come with giveaways tailored to children)

2000AD #170 – Ro-Jaws Robo Tales "The Killer in the Cab" – Art: John Richardson – 1980

2000AD #176 – Ro-Jaws Robo Tales "The Dating Game" – Art: Dave Gibbons

2000AD #189 – Abelard Snazz "Final Solution" – Art: Steve Dillon – 1980

2000AD #190 – Abelard Snazz "Final Solution" Part 2 – Art: Steve Dillon – 1980

2000AD #203 – Future Shocks "Grawks Bearing Gifts" – Art: Ian Gibson – 1981

2000AD #209 – Abelard Snazz "The Return of the Two-Storey Brain" – Art: Mike White – 1981

2000AD #214 – Future Shocks "The English Phlondrutian Phrasebook" – Art: Brendan McCarthy – 1981

2000AD #217 – Future Shocks "The Last Rumble of the Platinum Horde" – Art: John Higgins – 1981

2000AD #219 – Future Shocks "They Sweep the Spaceways" – Art: Garry Leach – 1981

2000AD #234 – Future Shocks "The Regrettable Ruse of Rocket Redglove" – Art: Mike White – 1981

2000AD #237 – Abelard Snazz "The Double Decker-Dome Strikes Back" – Art: Mike White – 1981

2000AD #238 – Abelard Snazz "The Double Decker Dome Strikes Back" Part Two – Art: Mike White – 1981

2000AD #240 – Future Shocks "A Cautionary Fable" – Art: Paul Neary – 1981

2000AD #242 – Future Shocks "Mister, Could

You Use A Squonge?" – Art: Ron Tiner – 1981

2000AD #245 – Abelard Snazz "Halfway to Paradise" – Art: John Cooper / **Future Shocks** "A Second Chance" – Art: Casanovas – 1982

2000AD #246 – Future Shocks "Twist Ending" – Art: Paul Neary – 1982

2000AD #247 – Future Shocks "Salad Days!" – Art: John Higgins – 1982

2000AD #249 – Future Shocks "The Beastly Beliefs of Benjamin Blint" – Art: Eric Bradbury – 1982

2000AD #251 – Future Shocks "All of Them Were Empty" – Art: Paul Neary – 1982

2000AD #252 – Future Shocks "An American Werewolf in Space" – Art: Paul Neary – 1982

2000AD #253 – Future Shocks "The Bounty Hunters" – Art: John Higgins – 1982

2000AD #254 – Abelard Snazz "The Multi-Storey Mind Mellows Out!" – Art: Paul Neary – 1982

2000AD #257 – Future Shocks "The Wages of Sin" – Art: Bryan Talbot – 1982

2000AD #265 – Future Shocks "The Return Of The Thing" – Art: Dave Gibbons – 1982

2000AD #267 – Future Shocks "Skirmish" – Art: Dave Gibbons – 1982

2000AD #268 – Future Shocks "The Writing on the Wall" – Art: Jesus Redondo – 1982

2000AD #269 – Future Shocks "The Wild Frontier" – Art: Dave Gibbons / **Future Shocks** "Wages of Sin" – Art: Bryan Talbot – 1982

2000AD #270 – Future Shocks "The Big Day" – Art: Robin Smith – 1982

2000AD #271 – Future Shocks "One Christmas During Eternity" – Art: Jesus Redondo – 1982

2000AD #272 – Future Shocks "No Picnic" – Art: John Higgins – 1982

2000AD #273 – Future Shocks "The Disturbed Digestions of Doctor Dibworthy" – Art: Dave Gibbons – 1982

2000AD #278 – "Hot Item" – Art: John Higgins – 1982

2000AD #282 – Future Shocks "Sunburn" – Art: Jesus Redondo – 1982

2000AD #291 – Future Shocks "Bad Timing" – Art: Mike White – 1982

2000AD #299 – Abelard Snazz "Genius Is Pain"- Art: Mike White – 1983

2000AD #302 – "The Pioneer" – Art: Jesus Redondo – 1983

2000AD #308 – Time Twisters "The Reversible Man" – Art: Mike White / "Skizz" – Art: Jim Baikie – 1983

2000AD #309 – Time Twisters "Einstein" – Art: John Higgins / "Skizz" "Neon Nightmare-Dark Demons!" – 1983

2000AD #310 – Time Twisters "The Chrono-Cops" – Art: Dave Gibbons / "Skizz" "First Contact" – 1983

2000AD #311 – Skizz "Skizz Revealed" – Art: Jim Baikie – 1983

2000AD #312 – Skizz "Comes the Hunter" – Art: Jim Baikie – 1983

2000AD #313 – Skizz "On The Right Track" – Art: Jim Baikie – 1983

2000AD #314 – Skizz" Brave Words – Harsh Facts" – Art: Jim Baikie – 1983

2000AD #315 – Time Twisters " The Big Clock!" – Art: Eric Bradbury / Skizz "Unwelcome Visitors" – Art: Jim Baikie – 1983

2000AD #316 – Time Twisters "Dr. Dibworthy's Disappointing Day" – Art: Alan Langford / Skizz "Trouble..Torment..Terror!"- Art: Jim Baikie – 1983

2000AD #317 – Time Twisters "D.R. and Quinch Have Fun on Earth" – Art: Alan Davis / **Skizz** "Just A Terrible Dream?" – Art: Jim Baikie – 1983

2000AD #318 – Time Twisters "Going Native" – Art: Mike White / **Skizz** "Alien-Speak" – Art: Jim Baikie – 1983

2000AD #319 – Skizz "The Monster and The Madness!" – Art: Jim Baikie – 1983

2000AD #320 – Time Twisters "Ring Road" – Art: Jesus Redondo / **Skizz** "Cornelius Understands" – 1983

2000AD #321 – Time Twisters "I Could Do That" – Art: Mike White / **Skizz** "We Have Weapons!" – Art: Jim Baikie – 1983

2000AD #322 – Time Twisters "The Hyper Historical Headbang" – Art: Alan Davis / **Skizz** "Protest!"– Art: Jim Baikie – 1983

2000AD #323 – Time Twisters "The Lethal Laziness of Lobelia Loam" – Art: Arturo Boluda / **Skizz** "Clean Break!" – Art: Jim Baikie– 1983 (Note: This particular Time Twisters was an uncredited writing assignment for Moore)

2000AD #324 – Time Twisters "The Time Machine" – Art: Jesus Redondo / **Skizz** "Hello, Roxy" – Art: Jim Baikie – 1983

2000AD #325 – Time Twisters "Eureka" – Art: Mike White / **Skizz** "Parent Problems"– Art: Jim Baikie – 1983

2000AD #326 – Skizz "New Horizons" – Art: Jim Baikie – 1983

2000AD #327 – Time Twisters "The Startling Success of Sideways Scuttleton" – Art: John Higgins / **Skizz** "Saturday Night!" – Art: Jim Baikie – 1983

2000AD #328 – Skizz "Flashpoint!" – Art: Jim Baikie – 1983

2000AD #329 – Future Shocks "Dad" – Art: Alan Langford / **Skizz** "Casualty" – Art: Jim Baikie – 1983

2000AD #330 – Skizz "Coming For To Carry Me Home" – Art: Jim Baikie – 1983

2000AD #331 – "Buzz Off" – Art: Jim Eldridge – 1983

2000AD #332 – "Look Before You Leap" – Art: Mike White – 1983

2000AD #350 – D.R. and Quinch "Go Straight!" Part 1 – Art: Alan Davis – 1984

2000AD #351 – D.R. and Quinch "Go Straight!" Part 2 – Art: Alan Davis – 1984

2000AD #352 – D.R. and Quinch "Go Girl Crazy!" Part 1 – Art: Alan Davis – 1984

2000AD #353 – D.R. and Quinch "Go Girl Crazy!" Part 2 – Art: Alan Davis – 1984

2000AD #354 – D.R. and Quinch "Go Girl Crazy!" Part 3 – Art: Alan Davis – 1984

2000AD #355 – D.R. and Quinch "Get Drafted!" – Art: Alan Davis – 1984

2000AD #356 – D.R. and Quinch "Get Drafted!" Part 2 – Art: Alan Davis – 1984

2000AD #357 – D.R and Quinch "Get Drafted!" Part 3 – Art: Alan Davis – 1984

2000AD #358 – D.R. and Quinch "Get Drafted!" Part 4 – Art: Alan Davis – 1984

2000AD #359 – D.R. and Quinch "Get Drafted!" Part 5 – Art: Alan Davis – 1984

2000AD #363 – D.R. and Quinch "Go To Hollywood" Prologue – Art: Alan Davis – 1984

2000AD #364 – D.R. and Quinch "Go To Hollywood" Part 1 – Art: Alan Davis – 1984

2000AD #365 – D.R. and Quinch "Go To Hollywood" Part 2 – Art: Alan Davis – 1984

2000AD #366 – D.R. and Quinch "Go To Hollywood" Part 3 – Art: Alan Davis – 1984

2000AD #367 – D.R. and Quinch "Go To

Hollywood" Part 4 – Art: Alan Davis – 1984

2000AD #377 – The Ballad of Halo Jones – Art: Ian Gibson – 1984

2000AD #378 – The Ballad of Halo Jones "A Little Night Music" – Art: Ian Gibson – 1984

2000AD #379 – The Ballad of Halo Jones "Consumer Protection" – Art: Ian Gibson – 1984

2000AD #380 – The Ballad of Halo Jones "Vicious Circles" – Art: Ian Gibson – 1984

2000AD #381 – The Ballad of Halo Jones "The Wild Brown Yonder" – Art: Ian Gibson – 1984

2000AD #382 – The Ballad of Halo Jones "Fleurs du Mal" – Art: Ian Gibson – 1984

2000AD #383 – The Ballad of Halo Jones "Home Again, Home Again, Jiggety Jig" – Art: Ian Gibson – 1984

2000AD #384 – The Ballad of Halo Jones "When the Music's Over" – Art: Ian Gibson – 1984

2000AD #385 – The Ballad of Halo Jones "I'll Take Manhattan" – Art: Ian Gibson – 1984

2000AD #396 – The Ballad of Halo Jones "Going Out" – Art: Ian Gibson – 1984

2000AD #405 – The Ballad of Halo Jones "Prologue" – Art: Ian Gibson – 1985

2000AD #406 – The Ballad of Halo Jones "A Postcard From Pluto" – Art: Ian Gibson – 1985

2000AD #407 – The Ballad of Halo Jones "Exercising the Dog" – Art: Ian Gibson – 1985

2000AD #408 – The Ballad of Halo Jones "I'll Never Forget Whatsizname" – Art: Ian Gibson – 1985

2000AD #409 – The Ballad of Halo Jones "By Royal Appointment" – Art: Ian Gibson – 1985

2000AD #410 – The Ballad of Halo Jones "Cat and Mouse" – Art: Ian Gibson – 1985

2000AD #411 – The Ballad of Halo Jones "Memories Are Made of This..." – Art: Ian Gibson – 1985

2000AD #412 – The Ballad of Halo Jones "Puppy Love" – Art: Ian Gibson – 1985

2000AD #413 – The Ballad of Halo Jones "Hounded" – Art: Ian Gibson – 1985

2000AD #414 – The Ballad of Halo Jones "The Last Dance" – Art: Ian Gibson – 1985

2000AD #415 – The Ballad of Halo Jones "Ice Cold on Charlemagne" – Art: Ian Gibson – 1985

2000AD #451 – The Ballad of Halo Jones "Prologue" – Art: Ian Gibson – 1986

2000AD #452 – The Ballad of Halo Jones "Tarantula Rising" – Art: Ian Gibson – 1986

2000AD #453 – The Ballad of Halo Jones "With Your Musket, Fife and Drum" – Art: Ian Gibson – 1986

2000AD #454 – The Ballad of Halo Jones "Occupations" – Art: Ian Gibson – 1986

2000AD #455 – The Ballad of Halo Jones "Petrified Forest" – Art: Ian Gibson – 1986

2000AD #456 – The Ballad of Halo Jones "Armies of the Night" – Art: Ian Gibson – 1986

2000AD #457 – The Ballad of Halo Jones "A Soldier's Things" – Art: Ian Gibson – 1986

2000AD #458 – The Ballad of Halo Jones "Leavetaking" – Art: Ian Gibson – 1986

2000AD #459 – The Ballad of Halo Jones "Heavy Duty" – Art: Ian Gibson – 1986

2000AD #460 – The Ballad of Halo Jones "The Gravity of the Situation" – Art: Ian Gibson – 1986

2000AD #461 – The Ballad of Halo Jones "The Crush" – Art: Ian Gibson – 1986

2000AD #462 – The Ballad of Halo Jones "Slow Death" – Art: Ian Gibson – 1986

2000AD #463 – The Ballad of Halo Jones "The Fast Forward War" – Art: Ian Gibson – 1986

2000AD #464 – The Ballad of Halo Jones "When They Sound The Last All Clear..." – Art: Ian Gibson – 1986

2000AD #465 – The Ballad of Halo Jones "Breakfast In The Ruins" – Art: Ian Gibson – 1986

2000AD #466 – The Ballad of Halo Jones "Tarantula Descending" – Art: Ian Gibson – 1986

2000AD #500 – "Tharg's Head Revisited" – Art: Ian Gibson – 1986 (Note: One-page statement with Halo Jones about 2000AD)

2000AD #725 – 1991 (Note: Reprinting of first Halo Jones' chapter)

2000AD SUMMER SPECIAL 1980 – Future Shocks "Holiday in Hell" – Art: Dave Harwood – 1980

2000AD SUMMER SPECIAL 1985 – D.R. and Quinch "Go Back To Nature" – Art: Alan Davis – 1985

2000AD WINTER SPECIAL 1988 – Art: Jesus Redondo – 1988 (Note: Reprints "First of the Few")

JUNO BOOKS
BREAD & WINE: AN EROTIC TALE OF NEW YORK – 1999 (Note: Moore wrote introduction for this Samuel R. Delany book)

KIMOTA MAGAZINE
KIMOTA #3 – "The Nativity On Ice" – Art: Bryan Talbot – 1995 (Note: Strip written under "Kurt Vile" pen name; fanzine also has a reprint of one personalized Maxwell The Cat strip)

KING HELL
THE ONE – 1989 (Note: Provided introduction for this Rick Veitch classic)

KITCHEN SINK PRESS
BLAB #3 – "Comments On Crumb" – 1988 (Essay about R. Crumb)

FROM HELL #3 – 1993 (Note: Reprints *From Hell* stories from *TABOO* #6 & 7 and appendix)

FROM HELL #4 – "Chapter 7: A Torn Envelope" – Art: Eddie Campbell – 1994 (Note: Also contains an appendix)

FROM HELL #5 – "Chapter 8: Love is Enough" – Art: Eddie Campbell – 1994. (Note: Includes an appendix)

FROM HELL #6 – "Chapter 9: "From Hell" – Art: Eddie Campbell – 1994 (Note: Includes an appendix)

FROM HELL #7 – "Chapter 10: "The Best of All Tailors" – Art: Eddie Campbell – 1995 (Note: Contains an appendix)

FROM HELL #8 – "Chapter 11: "The Unfortunate Mr. Druitt" – Art: Eddie Campbell – 1995 (Note: Includes appendix)

FROM HELL #9 – "Chapter 12: "The Apprehensions of Mr. Lees" & "Chapter 13: A Return to Cleveland Street" – Art: Eddie Campbell – 1996 (Note: Includes appendix to Chapter 12 & 13)

FROM HELL #10 – "Chapter 14: Gull, Ascending" & "Epilogue: The Old Men on the Shore" – Art: Eddie Campbell – 1996 (Note: Also contains an appendix)

FROM HELL: EPILOGUE – "Dance Of The Gull-Catchers" – 1998 (Note: Epilogue to series)

IMAGES OF #2 – "Dr. Omaha Presents Venus In Fur: Candid Chit-Chats With Cartoon Kit-Cat – Art: Melinda Gebbie – 1992

KITCHEN SINK PRESS: THE FIRST 25 YEARS – 1994 (Note: Moore contributed a paragraph to this tome)

THE LIFE AND TIMES OF R. CRUMB – 1998 (Note: Essay on Crumb by Moore)

THE LOST GIRLS #1 & #2 – Art: Melinda Gebbie – 1995 / 1996 (Note: Reprints the *Lost Girls* stories

from *Taboo* with new material as well)

THE SPIRIT: THE NEW ADVENTURES #1 – "The Most Important Meal" "Force of Arms" "Gossip and Gertrude Granch" – Art: Dave Gibbons – 1997 (Note: These three stories were planned as supplement material for the defunct Overstreet Fan magazine)

THE SPIRIT: THE NEW ADVENTURES #3 – "Last Night I Dreamed Of Dr. Cobra" – Art: Daniel Torres – 1998

KNOCKABOUT COMICS
THE BIG BOOK OF EVERYTHING – Introduction: Alan Moore – 1983

EX-DIRECTORY: THE SECRET FILES OF BRYAN TALBOT – Art: Bryan Talbot – 1997 (Note: Reprinting of "Cold Snap")

KNOCKABOUT #9 – "Globetrotting for Agoraphobics" – 1985 (Note: Three-page essay which was latter reprinted in *Honk!* #4)

KNOCKABOUT TRIAL SPECIAL – "Brasso With Rosie"- Art: Savage Pencil – 1984 (Note: Hardcover)

OUTRAGEOUS TALES FROM THE OLD TESTAMENT – "Leviticus" – Art: Hunt Emerson – 1987

SEVEN DEADLY SINS – "Lust" – Art: Mike Matthews – 1989

LAST GASP ECO-FUNNIES
SLOW DEATH – Art: Bryan Talbot – 1992 (Note: Reprint of "Cold Snap")

LOCUS + ART ORGANIZATION
LOCUS+ 1993- 1996 – "The Birth Caul"- 1996 (Note: *The Birth Caul* text is printed along with photos and coverage of the event)

LONGMEADOW PRESS
THE COMPLETE FRANK MILLER BATMAN – 1989 (Note: Reprinting of "The Mark Of Batman", Moore's original intro to *The Dark Knight*)

MAD DOG GRAPHICS
SPLAT! #2 – 1987 (Note: Three pages of Maxwell The Magic Cat strips)

MAD LOVE
A.A.R.G.H. (Artists Against Rampant Government Homophobia) – "The Mirror Of Love" – Art: Rick Veitch & Stephen Bissette – 1988 (Note: First book of Moore's imprint which he also edited)

BIG NUMBERS #1 – Art: Bill Sienkiewicz – 1990

BIG NUMBERS #2 – Art: Bill Sienkiewicz – 1990

MALIBU COMICS
PROTOTYPE #10 – Cover: Alan Moore – 1994

MARLOWE & COMPANY
MR. MONSTER: HIS BOOK OF FORBIDDEN KNOWLEDGE – Art: Alan Moore – 1996 (Note: Moore provides a pin-up and foreword for this book, which comes in a hardcover, softcover & a signed and number edition)

MARTIN LOCK
FANTASY ADVERTISER #77 – "Moonstone's Tomorrow's Truth: Part 3" – Art: Mike Collins & Mark Farmer – 1983 (Note: Moore is listed solely for scripting)

FANTASY ADVERTISER #92-95 – "On Writing For Comics" – 1985/1986 (Note: "How-To" column)

MARVEL COMICS
CAPTAIN BRITIAN COLLECTION– Art: Alan Davis – 2002 (Note: Reprint of Marvel UK material which was also previously printed as *X-Men Archives* #2-6; a hardcover signed edition was solicited as well)

DOCTOR WHO MAGAZINE #14 – Art: David Lloyd – 1985 (Note: Reprints "Black Legacy" storyline from Marvel U.K. - Reprinted without Moore's permission)

DOCTOR WHO MAGAZINE #15 – Art: David Lloyd – 1985 (Note: Reprints "Business As Usual" storyline from Marvel U.K. - Reprinted without Moore's

permission)

EPIC ILLUSTRATED #34 – "Love Doesn't Last Forever"- Art: Rick Veitch – 1986 (Note: Published by Marvel under their Epic Comics banner)

HEROES – "Now We Are All in Guernica" – Art: Dave Gibbons – 2001 (Note: Poem contributed to this 9-11 benefit book)

HEROES FOR HOPE #1 – Art: Richard Corben (Note: Moore wrote the three-page Magneto sequence in this benefit comic for famine relief in Africa)

X-MEN CLASSICS: FEATURING CAPTAIN BRITAIN #2-7 – Art: Alan Davis – 1995 / 1996 (Note: Reprints all of Moore's *Captain Britain* strips in colour)

MARVEL COMICS UK
DAREDEVILS #1 – Captain Britain: "A Rag Of Bone, A Hank Of Hair" – Art: Alan Davis / "The Importance of Being Frank" – 1983 (Note: Moore was a Jack Of All Trades for this title writing also articles and reviews)

DAREDEVILS #2 – Captain Britain: "An Englishman's Home" – Art: Alan Davis / "Fanzine Reviews" – 1983

DAREDEVILS #3 – Captain Britain: "Thicker Than Water" – Art: Alan Davis / "Stan Lee: Blinded by the Hype" Part One – "Fanzine Reviews"- 1983

DAREDEVILS #4 – Captain Britain: "Killing Ground" – Art: Alan Davis / "Stan Lee: Blinded by the Hype" Part Two – "Sexism in Comics: Invisible Girls & Phantom Ladies" Part One – "Fanzine Reviews" – 1983

DAREDEVILS #5 – Captain Britain: "Executive Action" – Art: Alan Davis / "Sexism in Comics: Invisible Girls & Phantom Ladies" Part Two – "Fanzine Reviews" – "O Superman: Music and Comics" – "About the Special Executive" – 1983 (Note: Also includes reprinting of Star Death from Dr. Who Weekly.)

DAREDEVILS #6 – Captain Britain: "Judgement Day" – Art: Alan Davis / Nightraven: "The Anesthetic Wearing Off" – Art: Alan Davis / "Sexism in Comics: Invisible Girls & Phantom Ladies" Part Three – 1983 (Note: Also includes reprinting of "4-D War")

DAREDEVILS #7 – Captain Britain: "Rough Justice" – Art: Alan Davis / Nightraven: "The Snow Queen" Part One – Art: Alan Davis – "Fanzine Reviews" – 1983 (Note: Also includes reprinting of "Black Sun Rising"

DAREDEVILS #8 – Captain Britain: "Arrivals" – Art: Alan Davis / Nightraven: "The Snow Queen" Part Two – Art: Alan Davis / "Grit" – Art: Mike Collins & Mark Farmer / "Fanzine Reviews" – 1983

DAREDEVILS #9 – Captain Britain: "Waiting For The End Of The World" – Art: Alan Davis / Nightraven: "The Snow Queen" Part Three – Art: Alan Davis – "Fanzine Reviews" – 1983

DAREDEVILS #10 – Captain Britain: "The Sound And The Fury" – Art: Alan Davis / Nightraven: The Snow Queen" Part Four – Art: Alan Davis – "Fanzine Reviews" – 1983

DAREDEVILS #11 – Captain Britain: "But They Never Really Die" – Art: Alan Davis – "Fanzine Reviews" – 1983

DOCTOR WHO SUMMER SPECIAL 1981 – Art: David Lloyd – 1981 (Note: Reprints the entire "Business As Usual" storyline)

DOCTOR WHO WEEKLY #35 – "Black Legacy" Part One – Art: David Lloyd – 1980

DOCTOR WHO WEEKLY #36 – "Black Legacy" Part Two – Art: David Lloyd – 1980

DOCTOR WHO WEEKLY #37 – "Black Legacy" Part Three – Art: David Lloyd – 1980

DOCTOR WHO WEEKLY #38 – "Black Legacy" Part Four – Art: David Lloyd – 1980

DOCTOR WHO WEEKLY #40 – "Business As Usual" Part One – Art: David Lloyd – 1980

DOCTOR WHO WEEKLY #41 – "Business As Usual" Part Two – Art: David Lloyd – 1980

DOCTOR WHO WEEKLY #42 – "Business As Usual" Part Three – Art: David Lloyd – 1980

DOCTOR WHO WEEKLY #43 – "Business As Usual" Part Four – Art: David Lloyd – 1980

DOCTOR WHO MONTHLY #47 – "Star Death" – Art: John Stokes – 1980

DOCTOR WHO MONTHLY #51 – "The 4-D War" – Art: David Lloyd – 1981

DOCTOR WHO MONTHLY #57 – "Black Sun Rising" – Art: David Lloyd – 1981

DOCTOR WHO MONTHLY #83 – "Slipstream: The Superior Solution" – Art: Steve Dillon / John Higgins – 1983 (Note: One-page parody ad that was featured in other Marvel UK publications as well)

EMPIRE STRIKES BACK #151 – "The Pandora Effect" – Art: Adolfo Buylla – 1981

FRANTIC WINTER SPECIAL – "Scant Applause" – Art: Alan Moore – 1979

MARVEL SUPER-HEROES #386 – Captain Britain: "If The Push Should Fail" – Art: Alan Davis – 1982 (Note: Moore wrote, uncredited, only the last page of this story)

MARVEL SUPER-HEROES #387 – Captain Britain: "A Crooked World" – Art: Alan Davis – 1982

MARVEL SUPER-HEROES #388 – Captain Britain: "Graveyard Shift" – Art: Alan Davis – 1982

MARVEL SUPER-HEROES #389 – "A Short History of Britain" – 1982

MARVEL SUPER-HEROES #390 – Nightraven: "The Cure" Part I – Art: Mick Austin – 1982

MARVEL SUPER-HEROES #391 – Nightraven: "The Cure" Part II – Art: Paul Neary – 1982

MARVEL SUPER-HEROES #392 – Nightraven: "White Hopes, Red Nightmares" Part I – Art: Paul Neary – 1982

MARVEL SUPER-HEROES #393 – Nightraven "White Hopes, Red Nightmares" Part II – Art: Paul Neary – 1982

MARVEL SUPER-HEROES #394 – Nightraven "Sadie's Story" Part One – Art: Paul Neary – 1983

MARVEL SUPER-HEROES #395 – Nightraven "Sadie's Story" Part Two – Art: Paul Neary – 1983

MIGHTY WORLD OF MARVEL #7 – Captain Britain: "The Candlelight Dialogues" – Art: Alan Davis – 1983

MIGHTY WORLD OF MARVEL #8 – Captain Britain: "The Twisted World (Reprise)" – Art: Alan Davis – 1984

MIGHTY WORLD OF MARVEL #9 – Captain Britain: "Among Those Dark Satanic Mills" – Art: Alan Davis – 1984

MIGHTY WORLD OF MARVEL #10 – Captain Britain: "Anarchy In The U.K." – Art: Alan Davis – 1984

MIGHTY WORLD OF MARVEL #11 – Captain Britain: "Foolsmate" – Art: Alan Davis – 1984

MIGHTY WORLD OF MARVEL #12 – Captain Britain: "Endgame" – Art: Alan Davis – 1984

MIGHTY WORLD OF MARVEL #13 – Captain Britain: "A Funeral On Otherworld" – Art: Alan Davis – 1984

NOT! THE WORLD CUP SPECIAL! – "Untitled" – Art: Barrie Mitchell – 1982

STAR WARS #154 – "Tilotny Throws A Shape" – Art: John Stokes – 1982

STAR WARS #155 – "Dark Lord's Conscience" – Art: John Stokes – 1982

STAR WARS #156 – "Rust Never Sleeps" – Art: Alan Davis – 1982

STAR WARS #159 – "Blind Fury" – Art: John

Stokes – 1982 (Note: The final page of this story was not included; reprinting by Dark Horse more than a decade later corrected this oversight)

STAR WARS SUMMER SPECIAL – 1983 (Note: Reprints two Moore *Star Wars* stories)

VERY BEST OF DOCTOR WHO – 1981 (Note: Reprints material)

MAXIMUM PRESS
SUPREME #43 – "The Supreme Story Of The Year: Part Three" – Art: Joe Bennett, Norm Rapmund, Rick Veitch, and Dan Jurgens – 1996

SUPREME #44 – "The Supreme Story Of The Year: Part Four" – Art: Richard Horie, Norm Rapmund, Rick Veitch and Bill Wray – 1996 (Note: Hilary Barta provided an uncredited assist to flashback sequence)

SUPREME #45 – "The Supreme Story Of The Year: Part Five" – Art: J.J. (Joe) Bennett, Norm Rapmund & Rick Veitch – 1997

SUPREME #46 – "The Supreme Story Of The Year: Part Six" – Art: J. Morrigan, Norm Rapmund, Rick Veitch and Jim Mooney – 1997

SUPREME #47 – "The Supreme Story Of The Year: Part Seven" – Art: J. Morrigan, J.J. Bennett, Norm Rapmund and Rick Veitch – 1997

SUPREME #48 – "The Supreme Story Of The Year: Part Eight" – Art: Mark Pajarillo, Norm Rapmund and Rick Veitch – 1997 (Note: Continues in Awesome Comics' *Supreme* #49)

SUPREME #1 COLLECTED EDITION – Art: Joe Bennett & others – 1997 (Note: Bumper Compendium of *Supreme* #41 & 42)

MONKEYBRAIN BOOKS
Heroes & Monsters – Introduction: Alan Moore – 2003

MTV EUROPE
OUTBREAK OF VIOLETS – Art: Various – 1995 (Giveaway card set for MTV Europe Awards show)

MYRA MAGAZINES
MYRA #8 – "A True Story" – Art: Myra Hancock – 1986 (Note: A biographical Moore strip)

NEPTUNE BOOKS
ROBIN HOOD: THE SPIRIT OF THE FOREST – Forward: Alan Moore – 1993

ODDMAGS
MAD DOG #10 – "Captain Airstrip One" – Art: Chris Brasted – 1986

ONEIROS BOOKS
HAUNTER OF THE DARK – "The Great Old Ones" – 1999 (Note: Also includes a ten-page original piece by Moore titled "Evocations". Each individual page is a poetic description of one of Lovecraft's "Great Old Ones". After each single-page prose piece by Moore, there is a single splash page illustration by John Coulthart)

PENGUIN BOOKS
RAW (Vol. 2) #3 – "The Bowing Machine" – Art: Mark Beyer – 1991

Q MAGAZINE
Q MAGAZINE (Vol. 1) #11 – 1990 (Note: Moore wrote music reviews of the Brian Eno and Captain Beefheart & The Magic Band albums)

QUALITY COMICS
CYBER CRUSH #14 – 1987 – (Note: Reprints story from *2000AD Annual* 1982)

HALO JONES #1-12 – 1987/1988 (Note: Reprints *2000AD* material)

ROGUE TROOPER #7 & #47 – 1987 & 1990 (Note: Reprint: *2000AD* material)

SAM SLADE: ROBO-HUNTER #6 & #7 – 1987 (Note: reprinting of *2000AD* strips)

STRONTIUM DOG #1 & #4 – 1987 (Note: Colorized *2000AD* reprints in each)

TIME TWISTERS #1-4, #6-9, #14, #21 – 1987/1989 (Note: Reprinting *2000AD* material)

QUALITY COMMUNICATIONS
MARVELMAN SPECIAL #1 – "Saturday Morning Pictures" – Art: Alan Davis – 1984 (Note: This is only a four-page framing device to accompany vintage Marvelman material)

WARRIOR #1 – Marvelman: "A Dream Of Flying" – Art: Garry Leach / **V For Vendetta:** "The Villain" – Art: David Lloyd – 1982

WARRIOR #2 – Marvelman: "Legend" – Art: Garry Leach / **V For Vendetta:** "The Voice" – Art: David Lloyd – 1982

WARRIOR #3 – Marvelman: "When Johnny Comes Marching Home" – Art: Garry Leach / **V For Vendetta:** "Victims" – Art: David Lloyd – 1982

WARRIOR #4 – Marvelman: "The Yesterday Gambit" – Art: Steve Dillon, Paul Neary & Alan Davis/ **V For Vendetta:** "Vaudeville" – Art: David Lloyd – 1982

WARRIOR #5 – Marvelman: "Dragons" – Art: Garry Leach/ **V For Vendetta:** "Versions" – Art: David Lloyd – 1982

WARRIOR #6 – Marvelman: "Fallen Angels, Forgotten Thunder" – Art: Garry Leach & Alan Davis/ **V For Vendetta:** "The Vision" – Art: David Lloyd – 1982 (Note: Moore writes a opinion piece about censorship)

WARRIOR #7 – Marvelman: "Secret Identity" – Art: Alan Davis & Garry Leach / **V For Vendetta:** "Virtue Victorious" – Art: David Lloyd – 1982

WARRIOR #8 – Marvelman: "Blue Murder" – Art: Alan Davis/ **V For Vendetta:** "The Valley" – Art: David Lloyd – 1982

WARRIOR #9 – Marvelman: "Out Of The Dark" – Art: Alan Davis/ "Warpsmith: Cold War, Cold Warrior" Part One – Art: Garry Leach / **V For Vendetta:** "The Violence" – David Lloyd – 1983

WARRIOR #10 – Marvelman: "Inside Story" – Art: Alan Davis/ Warpsmith: "Cold War, Cold Warrior" Part Two – Art: Garry Leach / **V For Vendetta:** "Venom" – Art: David Lloyd – 1983

WARRIOR #11 – Marvelman: "Zarathustra" – Art: Alan Davis/ **V For Vendetta:** "The Vortex" – Art: David Lloyd – 1983

WARRIOR #12 – Young Marvelman: "1957" – Art: John Ridgway/ **V For Vendetta:** "The Vicious Cabaret" – Art: David Lloyd – Music: David Jay/ **The Bojeffries Saga:** The Rentman Cometh" – Art: Steve Parkhouse – 1983

WARRIOR #13 – Marvelman: "Catgames" – Art: Alan Davis / **V For Vendetta:** "The Vanishing" – Art: Alan Davis/ **The Bojeffries Saga:** "One Of Our Rentmen Is Missing" – Art: Steve Parkhouse – 1983

WARRIOR #14 – Marvelman: "One of Those Quiet Moments" – Art: Alan Davis/ **V For Vendetta:** "The Veil" – Art: David Lloyd – 1983

WARRIOR #15 – Marvelman: "Nightmares" – Art: Alan Davis/ **V For Vendetta:** "Video" – Art: David Lloyd – 1983

WARRIOR #16 – Marvelman: "The Approaching Light" – Art: Alan Davis/ **V For Vendetta:** "A Vocational Viewpoint" – Art: David Lloyd/ "Christmas on Depravity" – Art: Curt Vile (Alan Moore) – Script: Pedro Henry (Steve Moore) – 1983

WARRIOR #17 – The Marvelman Family: "The Red King Syndrome" – Art: John Ridgway / "Behind the Painted Smile" – Art: David Lloyd – 1984 (Note: The second entry is an article about *V For Vendetta*)

WARRIOR #18 – Marvelman: "I Heard Woodrow Wilson's Guns..." – Art: Alan Davis/ **V For Vendetta:** "The Vacation" – Art: David Lloyd & Tony Weare – 1984

WARRIOR #19 – V For Vendetta: "Variety" – Art: David Lloyd/ **The Bojeffries Saga:** "Raoul's Night Out" Part I – Art: Steve Parkhouse – 1984

WARRIOR #20 – Marvelman: "A Little Piece of Heaven" – Art: Alan Davis / **V For Vendetta:** "Vincent" – Script: David Lloyd – Art: Tony Weare/ **The Bojeffries Saga** "Raoul's Night Out" Part II – Art: Steve Parkhouse (Note: Moore only plotted the *Vendetta* story for this issue) – 1984

WARRIOR #21 – Marvelman: "...And Every Dog It's Day!" – Art: Alan Davis/ **V For Vendetta:** "Visitors" – Art: David Lloyd – 1984

WARRIOR #22 – V For Vendetta: "Vengeance" – Art: David Lloyd – 1984

WARRIOR #23 – V For Vendetta: "Vicissitude" – Art: David Lloyd – 1984

WARRIOR #24 – V For Vendetta: "Vermin" – Art: David Lloyd – 1984

WARRIOR #25 – V For Vendetta: "Valerie" – Art: David Lloyd & Tony Weare – 1984

WARRIOR #26 – V For Vendetta: "The Verdict" – Art: David Lloyd – 1985

REBELLION
JUDGE DREDD MEGAZINE #1, #3 & #7 (Vol. 4) – 2001 (Note: Reprinting of *2000AD* material; there might be other issues featuring more Moore reprints)

RENEGADE PRESS
Spiral Cage – 1988
(Note: Moore wrote the introduction for this book)

RIP OFF COMICS
RIP OFF COMICS #8 – "Three-Eyed McGurk" – Art: Curt Vile (Alan Moore) – 1981 (Note: Reprinting all four McGurk strips which were written by Steve Moore)

ST. MARTIN'S GRIFFIN
THE YEAR'S BEST FANTASY: FIRST ANNUAL COLLECTION – 1988 (Note: Reprinting of "A Hypothetical Lizard")

SAVOY BOOKS
A VOYAGE TO ARCTURUS – Introduction: Alan Moore – 2003 (Note: This is a ten-page introduction)

SERPENT'S TAIL
IT'S DARK IN LONDON – "I Keep Coming Back" – Art: Oscar Zarate – 1996

SLAB-O-CONCRETE PUBLICATIONS
THE WORM – "The Longest Comic Strip In The World" – Art: Various – 1999 (Note: Moore devised the storyline for this story which would end-up being scripted by five writers and illustrated by over 125 British cartoonist)

SPIDERBABY GRAPHIX
TABOO #1 – "Come On Down" – Art: Bill Wray – 1988

TABOO #2 – FROM HELL: "Chapter 1: The Affections of Young Mr. S" – Art: Eddie Campbell – 1989

TABOO #3 – FROM HELL: "Chapter 2: A State of Darkness" – Art: Eddie Campbell – 1989

TABOO#4 – FROM HELL: "Chapter 3: Blackmail of Mrs. Barrett" – Art: Eddie Campbell – 1990

TABOO #5 – FROM HELL: "Chapter 4: What Doth the Lord Require of Thee?" – Art: Eddie Campbell / **LOST GIRLS: Chapter 1: The Mirror" & LOST GIRLS: "Chapter 2: Silver Shoes"** – Art: Melinda Gebbie / Back cover art: Alan Moore – 1991

TABOO #6 – FROM HELL: "Chapter 5: The Nemesis of Neglect" – Art: Eddie Campbell / **LOST GIRLS:** "Chapter 3: Missing Shadows" and **LOST GIRLS:** "Chapter 4: Poppies" – Art: Melinda Gebbie – 1992

TABOO#7 – "FROM HELL: "Chapter 6: September" – Art: Eddie Campbell / **LOST GIRLS:** "Chapter 5: Straight On Til Morning" and "LOST GIRLS Chapter 6: The Twister"- Art: Melinda Gebbie – 1992

SYMPATHETIC PRESS
CORPSEMEAT 2 – "Driller Penis" – Art: Savage Pencil – 1989

TITANS BOOKS
ALAN MOORE'S SHOCKING FUTURES – Art: Various – 1986 (Note: Reprints a selection of *2000AD* stories and introduction by Moore)

ALAN MOORE'S TWISTED TIMES – Art: Various – 1986 (Note: Reprints a selection of *2000AD* stories and introduction by Moore)

BALLAD OF HALO JONES Book One – Book Three – Art: Ian Gibson – 1986 (Note: Entire *Halo Jones* saga reprinted in three separate trade paperbacks with Moore intros)

THE COMPLETE BALLAD OF HALO JONES – Art: Ian Gibson – 2001 (Note: Reprints the entire *Halo Jones* saga in one tome)

D.R. & QUINCH'S TOTALLY AWESOME GUIDE TO LIFE – Art: Alan Davis – 1986 (Note: Black & white reprint of these *2000AD* stories)

SKIZZ – Art: Jim Baikie – 1989 (Note: Reprints the entire Skizz storyline which originally appeared in *2000AD*)

SPAWN: THE ABDUCTION TPB – Art: McFarlane & Capullo – 1998 (Note: Reprints *Spawn* #37)

SPAWN: BLOOD FEUD TPB – Art: Tony Daniel & Kevin Conrad – 1999 (Note: Reprinting of the original limited series)

SPAWN: EVOLUTION – Art: Todd McFarlane – 1997 (Note: Reprints *Spawn* #8; there is both a trade paperback and hardcover edition)

SWAMP THING TITAN TRADE PAPERBACK SERIES Volume 1 to Volume 11 – Art: Bissette, Totleben, Veitch and others – 1986/1988 (Note: Reprinting the entire Alan Moore run *Saga of Swamp Thing* #21-64 with introductions from such folks as Clive Barker, Neil Gaiman and Stephen Bissette)

TOP SHELF
LOST GIRLS – Art: Melinda Gebbie – 2003 (Note: The complete 240 pages of this series will see print in fancy three-book slipcase edition)

MIRROR OF LOVE – Art: Jose Villarrubia – 2003 (Note: New edition of this story with new art from Villarrubia)

TOP SHELF ASKS THE BIG QUESTIONS – "La Toile" – Art: Melinda Gebbie – 2003 (Note: Printing of Cobweb story originally banned by DC Comics)

VOICE OF THE FIRE – Art: Jose Villarrubia – 2003 (Note: New edition of the novel with an introduction by Neil Gaiman)

TUNDRA PUBLISHING
THE COMPLETE BOJEFFRIES SAGA – Art: Steve Parkhouse – 1992 (Note: Reprints all the Bojeffries strips and five new strips)

FROM HELL #1 – 1991 (Note: Reprints *From Hell* chapters from *Cerebus* #124 and *Taboo* #2 & 3 with an appendix; there are different printings available as well as a Kitchen Sink edition)

FROM HELL #2 – 1992 (Note: Reprints *From Hell* stories from *Taboo* #4 & 5 with an appendix; there's also a Kitchen Sink edition of this book)

TWOMORROWS PUBLISHING
KIMOTA! THE MIRACLEMAN COMPANION – "Lux Brevis" – Art: John Totleben – 2001 (Note: Book features script of the first episode of Marvelman and the original pitch for the character by the author)

I HAVE TO LIVE WITH THIS GUY! – 2002 – Reprints several of Moore's early strips to accompany a chapter on Melinda Gebbie.

VALKYRIE
THE ADVENTURES OF LUTHER ARKWRIGHT BOOK TWO – 1987 (Note: Moore typed intro for this Bryan Talbot's comic)

VG GRAPHICS (VICTOR GOLLANCZ)
A SMALL KILLING – Art: Oscar Zarate – 1991 (Note: American Edition of this graphic novel was published in conjunction with Dark Horse in 1993; hardcover version exist)

VOICE OF THE FIRE – 1996 (Note: Moore's first novel)

WILDSTORM / DC COMICS
DEATHBLOW: BYBLOWS #1 – "Byblows: Part One" – Art: Jim Baikie – 1999

DEATHBLOW: BYBLOWS #2 – "Byblows: Part Two" – Art: Jim Baikie – 1999

DEATHBLOW: BYBLOWS #3 – "Byblows: Part Three" – Art: Jim Baikie – 2000

MR. MAJESTIC – 2002 (Note: Trade paperback reprints *Wildstorm: Spotlight* #1)

PLANETARY TPB – 2000 (Note: Introduction by Moore)

VOODOO: DANCING IN THE DARK – Art: Michael Lopez & Al Rio – 1999 (Note: Trade paperback of the original four issue limited series)

WILDC.A.T.S: HOMECOMING – 1999 (Note: Trade paperback reprints: *WILDC.A.T.S* #21-27)

WILDC.A.T.S: GANGWAR – 2000 (Note: Trade paperback reprints *WILDC.A.T.S* #28-34)

WILDSTORM COMICS – "A Few Words About America's Best Comics From Alan Moore" – 1999 (Note: Wildstorm Comics date May of 1999 featured this Moore essay)

ZERO GIRL TPB – 2001 (Note: Moore wrote introduction)

WILLYPRODS / SMALL TIME INK
HEARTBREAK HOTEL #1 – "Letter From Northampton" – Art: Alan Moore – 1988 (Note: One-page account of Moore's last trip (of three) to the USA)

HEARTBREAK HOTEL #3 – "I Can Hear The Grass Grow" – Art: Alan Moore – 1988 (Note: Strip was intentionally designed to be cut out and fitted together to form a circular frieze)

STRIPAIDS: A CHARITY PROJECT FOR LONDON LIGHTHOUSE – Art: Alan Moore – 1996 (Note: Moore illustrates Maxwell The Magic Cat for a jam piece with other cartoonist & four Maxwell strips are reprinted also)

WIZARD ENTERTAINMENT
AMERICA'S BEST COMICS PREVIEW & SKETCHBOOK – "America's Best Comics" – Art: Chris Sprouse & Al Gordon – 1999 (Note: This special supplement was issued with *Wizard Magazine* #91 and features sketchbook material from most of the ABC artists)

EDITOR'S NOTE: THE EDITOR OF THIS BOOK STRONGLY RECOMMENDS THAT YOU READ **ALAN MOORE: PORTRAIT OF AN EXTRAORDINARY GENTLEMAN** FROM ABIOGENESIS PRESS, EDITED BY MY GOOD FRIEND SMOKY MAN AND THE TALENTED GARY SPENCER MILLIDGE. THEIR BOOK IS AN EXTRAORDINARY COMPLIMENT AND TRIBUTE TO ALAN'S WORK FROM ARTISTS ACROSS THE WORLD. IT'S NOT TO BE MISSED.

Quack! Art by Doug Erb featured in *Critters* #23. ©2003 Doug Erb.

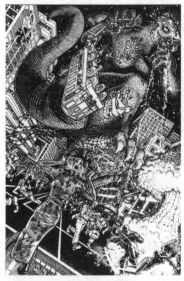

Alan Moore's pin-up of Japan's most famous movie star, from *Godzilla, King of the Monsters Special* #1.
Artwork ©2003 Alan Moore.
Godzilla ©2003 Toho Co., Ltd.

Moore and Richard Corben jam for *Heroes for Hope*.
©2003 Marvel Characters, Inc.

DIGGING UP MOORE'S UNDERGROUND

by Greg Strokecker

Another envelope arrived in my mailbox today from a friend across the pond. It's stuffed full of photocopies of some very hard to find comic strips by Alan Moore. I am, of course, ecstatic. As a collector of "Moore books" (as fans refer to his comics), I relish the chance to read rare early works by Moore. Like many of his fans, I've gone to great lengths to find some of these elusive works by comics' bard, in hopes of catching a glimpse of the brilliant writing with which he would grace his later comics. Though they aren't as sophisticated or intricately conceived as later works like *Watchmen, Big Numbers* or *From Hell*, they do offer a chance to see Moore's development as a creator and a hint of the comics that influenced him. A virtual stratum of comics history are recognizable inspirations for these early strips – Eisner's *Spirit*, classic EC and early Marvel – but what strikes me most is how much they show the influence of underground comix.

Remember underground comix? They started in the 1960s and lasted until the mid-Seventies. They are probably more familiar to younger fans as those old books you find in 25 cent boxes with a pot leaf doodled on the cover and a big wet stain where some stoned hippie spilled the bong, but most comics historians recognize them as being the first comic books to openly address themes of sex, drugs and social commentary since the inception of the comics code effectively censored the industry. The artwork in them was printed mostly in black & white and reflected the popular psychedelic aesthetic of the time, with its exaggerated proportions, surrealist landscapes and hallucinogenic page layouts. They had a limited distribution, mostly through "head shops," and are generally associated with drug culture. Many consider them to be the precursors to today's independent /alternative comics.

A lot of modern comics creators cite underground comix as having influenced them, but Moore's early work is abundant with references and homages to them. The artwork, themes and characters in his early strips could easily have fit into any issue of *Zap, Freak Brothers* or *Arcade* (Moore's first work published in the states appeared in one of the later undergrounds, *Rip-off Comix #8*). Moore himself recognizes and has discussed this influence in interviews and pieces he's written. In his review of the works of R. Crumb, he mentions the deep impression that undergrounds made on him, saying that they both shocked and amused him when he first saw them. The influence is strikingly apparent in much of Moore's early work, where he was usually afforded a greater latitude in the subject matter than in the comics mainstream.

Some of Moore's earliest comics work appeared in "The Back-Street Bugle (Oxford's Other Paper)," which was an alternative newspaper similar to the tabloids like *Yarrowstalks* or the *East Village Other* where underground comix began. Moore's contributions consisted of a few single-panel gag strips, one-offs like "Fat Jap Defamation Funnies" and infrequent guest appearances in fellow cartoonist Dick Foreman's strip, "Moeby Palliative." Moore's main contribution, however, was the serialized "St. Pancras Panda," a funny animal strip which ran for twelve episodes from February 1978 to March 1979. In the strip, Moore has his main character go through a series of absurd adventures, from almost being skinned alive by furriers, being worshipped as a god by a religious sect, abducted by aliens, to finally meeting Dog, the less-than-omnipotent creator, who is Moore himself. This is one of the first instances of an autobiographical appearance by Moore (there would be a few more), a device which, I believe, was either originated by or at least perpetuated by R. Crumb in his underground work. Moore includes many classic underground characters in the backgrounds of these strips – you really get the impression that he was trying to recreate an underground strip.

Also similar to the old undergrounds were Moore's comics in *Sounds*, the weekly British rock music newspaper. His comics here were again, mostly light humor, but often featured depictions of sex, war & racism while investigating social themes with satire and commentary. Moore did a few articles and reviews for *Sounds*, along with a few one-off comics and two serialized strips. "Roscoe Moscow," which he wrote and drew, ran intermittently for 61 episodes from March 1979 to June 1980, and "The Stars My Degradation," running until 1983. "Roscoe," which Moore has said was inspired by underground artist art speigelman's strip "Ace Hole" (and possibly Bryan Talbot's British underground strip "The Omega Report"), was a serial about a private detective along the lines of Sam Spade with an absurdist twist. The theme of the strip, in keeping with Sounds' focus on rock music, is the main character trying to unravel the mystery of "Who Killed Rock and Roll," meeting along the way a host of comical characters including: Mycroft, a six-foot crow who wears a zoot suit and is, in fact, an recurring alcohol-induced hallucination; "Wiggy Pulp," a satire of Iggy Pop, who is an ubermasochist; and Dr. Zoltan von Zygote, the world famous psychologist who resembles a four-foot developing human foetus. Moore's artwork for the early episodes shows a lot of experimentation and owes more than a little to underground artists. It's very reminiscent of Crumb, with Dave Sheridan inspired stippling thrown in for good measure. One episode is even a homage to S. Clay Wilson – a parody of his signature crowded splash panels, with an added dedication from Moore reading "Long may he Felch".

The other serialized strip that Moore did for *Sounds*, "The Stars my Degradation," ran (also intermittently) from July 1980 until March of 1983. The later half of the strips were written by Moore's longtime friend and collaborator Steve Moore, with Alan providing all of the artwork for the series. The title itself is a satire of Alfred Bester's novel, "The Stars my Destination," setting the tone for the entire strip. It's a story set in a futuristic outer space, chronicling the misadventures of its main character, Dempster Dingbanger, and also re-introducing Axel Pressbutton, the psychotic cyborg (a character created by Steve Moore who originally appeared in the Grateful Dead fanzine *Dark Star*), in this incarnation sporting a phallic image on his chest. The strip includes many homages to the undergrounds, including background appearances by Fat Freddy's Cat and another of those S. Clay Wilson inspired splash panels. Moore is again, allowed a wider range as far as subject matter than in mainstream comics, one time permitting him to portray dozens of nude Fay Wray duplicates and in another episode a rather somber scene where Harry the Hooper meets his demise. But there is also one episode (12/18/82) depicting a scene of "titanic copulation," which might or might not have had two panels taken out by the editors. The limits in *Sounds* were broad it seems, but not absolute.

Moore also demonstrated his fondness for the underground in some of his later works. In one autobiographical strip he did for *Heartbreak Hotel*, Moore depicts himself distorting his own head in such a fashion that it had to be directly influenced by Crumb's famous "Stoned Agin" strip. In *Swamp Thing*, the mainstream series that earned Moore his first accolades in the US, Moore created the character "Chester Williams," the aging hippie who was based on Bryan Talbot's character "Chester P. Hackenbush, the psychedelic alchemist," that appeared in the British underground *Brainstorm Comix*. In a story that could have easily run in an issue of *The Freak Brothers*, this character stumbles across one of the hallucinogenic tubers that grew out of the Swamp Thing. In the last panel of the same issue, as a homage to one of the great underground comix, the artist even includes a copy of a *Freak Brothers* comic.

For the most part these early pieces consist of light-hearted humor rather than the intense writing in Moore's later work. Part of their value is in documenting the progression of an artist who is honing his skills and finding his voice – developing into a true craftsman. Unfortunately, most of the pieces I've mentioned still remain inaccessible to fans, having never been reprinted. Finding copies of the original works is a difficult (and often expensive!) task, but it's worth the effort. In every one, you'll find a turn of a phrase, an imaginative idea or a witticism that is uniquely Moore – the type of descriptive expositional writing that is the main reason fans continue to follow all of his work.

ALAN MOORE IN SOUNDS MAGAZINE

by David Hume with Greg Strokecker

ROSCOE MOSCOW IN "WHO KILLED ROCK 'N' ROLL?"

Published in *Sounds* magazine March 31, 1979 – June 28, 1980 in 60 episodes plus special.

Written and drawn by 'Curt Vile'. All strips printed half-page at top or bottom of A3 pages unless stated otherwise. *NB – I've reproduced the titles as originally printed, including the number of exclamation! marks! or not, exactly as they appeared within the strip...*

March 31, 1979, Episode 1, "The Corpse Wore Leather!!" (page 24)

April 7, 1979, Episode 2, "The French Correction!!" p.46
Jean Jacques Burnel (The Stranglers) appears

April 14, 1979, Episode 3, "The Big Sheep!!" p.37

April 21, 1979, Episode 4, "The Paranoid Abroad!!" p.63
"Electrick Hoax" parody; Maxwell the Magic Cat guest appearance in one panel

April 28, 1979, Episode 5, "Enter the Foetal Freudian!" p.18
Dr. Zoltan Von Zygote introduced.

May 5, 1979, Episode 6, "Lushed for Life!!" p.63
'Wiggy Pop' first appearance; (NB – the week of the 1979 General Election...)

May 12, 1979, Episode 7, "Terror of the Tactless 'Tec!!" p.48
'David Boko' (Bowie) introduced

May 19, 1979, Episode 8, "Send in the Clones!!" p.48

May 26, 1979, Episode 9, "...But He Thinks He'd Blow Our Minds!" p.29
Lovecraft parody begins; Brian Eno ('Brain One') introduced

June 2, 1979, Episode 10, "I Was On First Name Terms With A Monster From Outer Space!" p.36
'The Sinister Gloves' introduced.

June 9, 1979, Episode 11, "Holiday in Berlin (Full Blown)" p.45

June 16, 1979, Episode 12, "The Big Bang Theory" p.47

June 23, 1979, Episode 13, "Horror in Hamburg!!" p.47
Will Eisner/Spirit homage

June 30, 1979, Episode [14]*, "Moonlight and Munchkins!!" p.35
(*NB. states episode 15 by mistake)

July 7, 1979, Episode 15, "A Pulp Adventure" p.45

July 14, 1979, Episode 16, "O-Deed On Life Itself!" p.43

July 21, 1979, Episode 17, "Ich Bin Ein Hamburger!" p.46
'Freeway F*ckdogs' Motorcycle Club

July 28, 1979 NOT FEATURED

August 4, 1979, Episode 18, "Fry the Krauts on Passion Bridge!!!" p.55
Whole strip is single splash panel battle scene S.Clay Wilson tribute "Dedicated to S.Clay Wilson. Long May He Felch!!" The Checkered Demon appears, plus 'the Old Witch' from EC horror comics... etc?

August 11, 1979, Episode 19, "Autobahn" p.32

August 18, 1979, Episode 20, "Farewell My Laundry!" p.37

August 25, 1979, Episode 21, "A Dork in the Black Forest!!" p.55
'Roscoe the Barbarian' parody; signed 'Curt Windsor Vile'; Lene Lovich appearance

Sept 1, 1979, Episode 22, "This Train is Bound for Glory..." p.47
'Bauhaus 1919', 'Bela Lugosi's Dead' ref (plug for 12" single) margin note

Sept 8, 1979, Episode 23, "Watching the Detective!" p.50
'Rafiawerk' (ie. Kraftwerk) parody, first appearance

Sept 15, 1979, Episode 24, "Growing Up Twisted" p.39

Sept 22, 1979, Episode 25, "Teenage Kicks!" p.12

Sept 29, 1979, Episode 26, "Ham Fisted Tales!" p.43
Sgt Fury and his Howling Commandos parody

October 6, 1979, Episode 27, "Who's Who in Roscoe Moscow?" p.47
Curt Vile appears in own strip to re-cap story so far... (post-modern!)

October 13, 1979, Episode 28, [Untitled??] p.38
NB. This episode doesn't seem to have a title...

October 20, 1979, Episode 29, "Showroom Dummies" p.31
St.Pancras Panda appears in background(!); "by Curt Vile (England's Best-Loved Acid Casualty!)"

October 27, 1979, Episode 30, "Washing the Detective!!" p.46

November 3, 1979, Episode 31, "Our Senior Supermen..." p.53
Superhero parody; Dick Foreman ref ("Dr Marginally Abnormal appears courtesy of the Foreman studios")

November 10, 1979, Episode 32, "The End of Civilisation As We Know It!!!" p.63
weird single-panel poetic episode (great!)

November 17, 1979, Episode 33, "Roscoe Makes Yet Another Faux-Pas; The Fat Slobbering Sh*t-Head" p.47
inc. a plug for the De-Go-Tees, a band from Birmingham, in the margin; NB. strip is mistakenly credited as "Rock'n'Roll Zoo" by Sounds

November 24, 1979, Episode 34, "Night Classes!" p.12
'A. Brilburn Smorch' character appears; Axel Pressbutton ref?

December 1, 1979, Episode 35, "You Need Gloves!" p.50
Story of 'A.Brilburn Smorch'

December 8, 1979, Episode 36, "Night Fever" p.44
weird dream episode; 'by Curt "No More Rarebits For Me" Vile'

December 15, 1979, Episode 37, "The Great Bambi Swindle" p.38
'Slittervest Enterprises' (ie.Glitterbest) Malcolm McLaren satire; second Will Eisner/Spirit homage

December 22, 1979 "ROSCOE MOSCOW" BOARD GAME, DOUBLE-PAGE SPREAD! (Xmas issue special) PP. 16-17 & 24-25, '(c) by Curt + Phyllis Vile'.

December 29, 1979 NOT FEATURED

January 5, 1980, "Episode 38, "Better Than One" p.26
Two-headed Malcolm McLaren/Richard Branson satire

January 12, 1980 NOT FEATURED

January 19, 1980, Episode 39, "Bondage!" p.42

January 26, 1980, Episode 40, "Mrs Moscow's Diary!" p.39

Feb 2, 1980, Episode 41, "One Step Beyond!!" p.36
Strip titled "Roscoe Montreal" ("A sincere protest by Curt "Carry On Up The Khyber" Vile") (...?) contemporary political reference?

Feb 9, 1980, Episode 42, "Freaks" p.42

innovative 'open book' design; illustrated text panels

Feb 16, 1980, Episode 43, "Rat Race!" p.45
Sex Pistols parody continues; Charles Manson appears

Feb 23, 1980, Episode 44, "Without A Paddle!" p.70

March 1, 1980, Episode 45, "Turdsville!" p.39

March 8, 1980, Episode 46, "Tarzan of the Rats!" p.46
'(c) 1980 by the Curt Vile Estate'

March 15, 1980, Episode 47, "Just When You Thought It Was Safe To Go Back In The Water..." p.42

March 22, 1980 NOT FEATURED

March 29, 1980, [Episode 48]*, "Meanwhiles!" p.30
(*NB. stated as being episode 47 again, but is really 48)

April 5, 1980, [Episode 49]*, "Untitled" p.40
(*NB. credited as "Episode Forty...uh...Eight? Nine?"); episode *is called* "Untitled"

April 12, 1980, Episode 50, "The Short Goodbye" p.54

April 19, 1980 NOT FEATURED

April 26, 1980, Episode 51, "It's My Party..." p.30
Guest appearances (in one splash panel): John F. Kennedy, Leonid Brezhnev, Lee Harvey Oswald, Charles Manson, Jimmy Carter, Ayatollah Khomeini, Hermann Goring, the Kray Twins, Anthony Blunt... (!)

May 3, 1980, Episode 52, "Tupenny Rush!!" p.41

May 10, 1980, Episode 53, "Working For The Clampdown!!" p.44
"The Author" (ie. Alan Moore not Curt Vile) appears; 'by Curt "Haircuts Are For Homos" Vile'

May 17, 1980, Episode 54, "State of the Nation!" p.25

May 24, 1980, Episode 55, "The Selling of Roscoe Moscow" p.20

May 31, 1980, Episode 56, "The Last Great Switcheroo!!" p.51

June 7, 1980, Episode 57, "Triumph of the Will!" p.36
'The Sinister Gloves' revealed to be Adolf Hitler

June 14, 1980, Episode 58, "Comin' For To Carry Me Home!" p.20
Note printed at head of strip, "Dear Alan... Yours, Curt Vile"

June 21, 1980, Episode 59, "Breakdown" p.30
Roscoe in the asylum; silent episode, innovative layout, inc. panels from earlier episodes

June 28, 1980, Episode 60, "Life's Improper Number!" p.15
"The very last episode (sob!) of the world's most loved/hated comic strip..."; Alan Moore appears in photo-booth panels to tell joke; 'An' a big flourish of the fez to Savage Pencil for being a wonderful human organism" – margin note.

BACKGROUND NOTES:

"The Electrick Hoax" strip by Brendan McCarthy and Pete Milligan was the precursor to Roscoe Moscow in Sounds magazine. It first appeared in the September 16, 1978 issue and ended in March 24, 1979 – the week before Roscoe Moscow appeared. Moore included a satirical reference to it in Episode 4, April 21 1979.

Savage Pencil's "Rock 'n' Roll Zoo" strip appeared almost every week in Sounds from, I think, 1977, and was published simultaneously with both of Alan Moore's strips, often being printed on the same page. Savage Pencil (Edwin Pouncey) and Moore swapped strips with each other for one week's episodes in the August 15, 1981 issue, page 54. Moore drawing and writing "R'n'R Zoo," and Sav Pencil doing the same with "The Stars My Degradation".

I couldn't find the reference, but in an interview some-

where – possibly one of the Comics Journal *ones late 80s/90s – Moore says that he got the idea for Roscoe Moscow from an early strip by Art Spiegelman called "Ace Hole – Private Detective". I think he said that he virtually ripped the idea off. In the same interview, IIRC, he also praised Spiegelman's* Arcade *magazine as in his opinion the finest comic ever produced, though I don't think Ace Hole appeared in it (I have a few issues but not all).*

Sounds magazine published a "special" of its regular comic strip in the 'Christmas issue' every year. Usually four whole pages instead. For instance, the year before, 1978, contained a special "The Clash" boardgame... Also published humorous versions of its regular features. In the same issue, 1979, there is also a one-off Curt Vile xmas cartoon (see separate bibliography).

NB. I haven't detailed every single reference included in "Roscoe Moscow" as there are just too many of them! I've tried to list all the most relevant or interesting ones, but there is a plethora of single-panel jokes and walk-ons of various pop-cultural figures, eg. Dick Tracy, Humphrey Bogart, The Perishers, Snoopy, The Lone Groover, Spider-Man, Mickey Mouse, Goofy, Popeye, Tin Tin, The Spirit, Dr Doom, Moriarty, Fu Manchu, etc, etc...

"THE STARS MY DEGRADATION"

Published in *Sounds* magazine July 12, 1980 – March 19, 1983. 100 episodes plus two specials (inc. 37 episodes written by Steve Moore, and one episode written and drawn by Savage Pencil). One unrelated special, "Ten Little Liggers," was also published during its run. The title is of course a parody of Alfred Bester's seminal 1956 sf novel, "The Stars My Destination" (aka "Tiger! Tiger!"). *[Incidentally, in 1979 – the year before Moore's strip appeared – Howard Chaykin and Byron Preiss's comic strip adaptation of Bester was published by the Baronet Publishing Company, one of the very first American "graphic novels". I'm sure this must have been an influence at least on his choice of subject for his follow-up strip to Roscoe Moscow.]*

"Dempster Dingbunger is my name/Sputwang is my nation/The depths of space gob in my face.../The Stars My Degradation"

Mostly written and entirely drawn by Alan Moore as "Curt Vile". From February 6, 1982 to March 12, 1983 it was written by "Pedro Henry" (Steve Moore) with only the artwork being produced by Curt Vile – except for the October 9, 1982 episode, and the "Bride of Pressbutton" Xmas special 4-page strip which were both *all* Alan Moore work. Moore also wrote and drew the very last episode, of March 19, 1983, entirely by himself. All episodes are untitled and un-numbered. All are printed A4 size on A3 magazine pages apart from the specials (four whole pages each, centre-pages).

[The last episode of Roscoe Moscow was published in the June 28, 1980 issue. The following week, July 5, did not feature any Moore material]

July 12, 1980 (page 29)
"Beginning this week, a cataclysmic new Curt Vile comic strip concept..." (first episode) Dempster Dingbunger introduced.

July 19, 1980 (p.20)

July 26, 1980 (p.27)
Judge Dedd (Dredd parody); Mupdook and C. Henry Fooble introduced

August 2, 1980 (p.16)
Lance Laser; Space Marines/"Planet of the Grapes" storyline begins

August 9, 1980 (p.34)
Axel Pressbutton introduced ("...courtesy of the Pedro Henry cartoon odditorium. Thanx Pedro.")

August 16, 1980 (p.49)
Harry Harrison "Deathworld"-type planet (Zutzbaa); sentient vegetables; Fay Wrays

August 23, 1980 (p.28) Fay Wray androids

August 30, 1980 NOT FEATURED

Sept 6, 1980 (p.63)

Sept 13, 1980 (p.61) Priapin 90 aphrodisiac

Sept 20, 1980 (p.35)

Sept 27, 1980 (p.35) Bunslott's World (Mega City One parody?)

Oct 4, 1980 (p.30)
Mega City Judges parody; Harry the Hooper introduced

Oct 11, 1980 (p.31) Agent Orange (The Shadow parody)

Oct 18, 1980 (p.38) 'N-space warp-hoop' introduced

Oct 25, 1980 (p.7)

Nov 1, 1980 NOT FEATURED

Nov 8, 1980 (p.56)

Nov 15, 1980 (p.41)

Nov 22, 1980 (p.30)

Nov 29, 1980 (p.19)
Tonka Man; Roscoe Moscow and Rock'n'Roll Zoo references

Dec 6, 1980 (p.62) Harry the Hooper vs Tonka Man ("Tonka Man's dialogue courtesy of Steve "Shakespeare He Ain't" Moore")

Dec 13, 1980 (p.20)
first appearance of Nekriline, the Dead Lady (NB. later *mostly* spelt "Nekraline," but not consistently... from Feb 6, 1982 is spelt as Nekriline again...)

Dec 20, 1980 (p.27) Curt Vile appears as The Watcher (great episode!)

Dec 27, 1980 NOT FEATURED
Xmas issue. "TEN LITTLE LIGGERS" PP.19-22 "(c) 1980 by Curt Vile"; "Brought to you by three men... Alan Lewis [Sounds editor], Garry Bushell [Features Editor], Curt Vile"... (ie. who contributed what??)

Jan 3, 1981 NOT FEATURED

Jan 10, 1981 (p26)

Jan 17, 1981 (p.23) Pressbutton vs Tonka Man

Jan 24, 1981 (p.33)

Jan 31, 1981 (p.37) "Alien" parody begins; characters board S.S. Nostrillo en route for planet Barfo; Three Eyes McGurk; Ex-Men

Feb 7, 1981 (p.63) Maxwell the Magic Cat appears (!); innovative panel layout, reminiscent of later use of panels to convey passing of time in *Watchmen*

Feb 14, 1981 (p.36) Pressbutton takes a shower

Feb 21 1981 (p.34) "Alien" facesucker attaches to Mupdook

Feb 28, 1981 NOT FEATURED

March 7, 1981 (p.31)

March 14, 1981 NOT FEATURED
("The Stars My Degradation was lost in the post but will be back next week, Curt Vile and Post Office permitting..." – note, p.28, above "Rock'n'Roll Zoo" strip)

March 21, 1981 (p.59)

March 28, 1981 (p.28)

April 4, 1981 (p.28) "Alien" (mutant Clodagh Rodgers clone) bursts out of Mupdook's stomach

April 11, 1981 (p.35) Mupdook's funeral

April 18, 1981 (p.45) sexy! (reminiscent of "Lost Girls"?); pen and pencil/wash used?

April 25 – May 2, 1981 NOT FEATURED

May 9, 1981 (p.27) very faint (looks like reproduced from pencils instead of ink?)

May 16, 1981 NOT FEATURED

May 23, 1981 (p.26) S.S.Nostrillo arrives on Barfo; Foobl's Bar; first appearance of Three Eyes McGurk in person; The Ex-Men

May 30, 1981 (p.53) Curt Vile appears as The Watcher again ("In recent weeks this strip's been a bit erratic..."); re-cap of story so far

June 6, 1981 (p.38)

June 13, 1981 (p.45)

June 20, 1981 (p.71)

June 27, 1981 (p.25) "Thought Balloons" episode; close-up panels of each character (Dingbunger, Nekraline, Axel Pressbutton, Harry the Hooper, the Clodagh Rogers clone)

July 4, 1981 (p.45) Curt Vile/Alan Moore appearance: at the drawing board ("Only a day till my deadline and no story worked out..." etc)

July 11, 1981 (p.45)

July 18, 1981 (p.53) "Very special thanks to the lovely and talented Ms Clodagh Rogers for not suing my ass off. Hope you liked the original artwork, Clo! – A fan forever, Curt xxx" (last clone/Alien episode)

July 25, 1981 (p.45) Nekraline and Dingbunger have sex

Aug 1, 1981 (p.49) Nekraline and Dingbunger have sex; arrival on Barfo

Aug 8, 1981 (p.41) The Ex-Men appear in person; Three Eyes McGurk

Aug 15, 1981 (p.54) THIS EPISODE BY SAVAGE PENCIL (Alan Moore writes and draws this week's "Rock 'n' Roll Zoo" strip instead, also on page 54)

Aug 22, 1981 (p.58) Ex-Men introduced; Claremont's writing satirised

Aug 29, 1981 NOT FEATURED

Sept 5, 1981 (p.50) Single-panel battle with the Ex-Men; cameos by Roscoe Moscow, St Pancras Panda, Maxwell the Magic Cat, Quasimodo/Quasi-Mod cartoon, Abelard Snazz [and sidekick Edwin?], probably a couple of others I don't recognise.

Sept 12, 1981 (p.31) Three Eyes McGurk vs 'The Look' (Cyclops)

Sept 19, 1981 (p.62) Nekraline vs 'Scorn' (Storm) ("The Mutant Mistress of Sarcasm"...)

Sept 26, 1981 (p.40) Harry the Hooper vs 'Curbcrawler' (Nightcrawler)

Oct 3, 1981 (p.46) Axel Pressbutton vs 'Warfarin' (Wolverine)

Oct 10, 1981 (p.19) Dingbunger vs 'Cholestorol' (Colossus)

Oct 17, 1981 (p.42) celebrations in Foobl's Bar; C.Henry Foobl briefly re-appears

Oct 24 – Nov 7, 1981 NOT FEATURED

[Nov 14, 1981 *SOUNDS* MAGAZINE NOT PUBLISHED – printers' strike] Thanks to Clive Whichelow of "Backnumbers," London for the info!

Nov 21, 1981 (p.44) WHOLE PAGE, ie. *two* strips printed on same page, presumably to 'catch up' after missing week. On "Numinous Paddle Steamer" en route to Depravity, "Planet of Perversion!"; Description of Depravity, Unstuck Simpson.

Nov 28, 1981 (p.54) Human/vegetable sex! Lance Laser returns!

Dec 5, 1981 (p.58) "Character Notes...Harry the Hooper" NB. all the copies I've seen so far have very faintly printed text, with a red colour- overlay that has spread and splattered over the whole strip, making it unreadable...

Dec 12-19, 1981 NOT FEATURED

Dec 26, 1981 "CHRISTMAS ON DEPRAVITY" PP.19-22 Xmas special **CO-WRITTEN BY PEDRO HENRY (STEVE MOORE)**; Plug for forthcoming first issue of *Warrior* magazine, and sample of Steve Dillon artwork from the new "Laser Eraser and Pressbutton" strip in one panel. Mysta Mystralis appears. "This strip is dedicated to EC comics genius, Wally Wood, 1927-1981"

Jan 2-30, 1982 NOT FEATURED

Feb 6, 1982 (p.26) **"SCRIPT BY PEDRO HENRY, 'ART' BY CURT VILE, (c) 1982 VILE / HENRY"** *First strip written by Steve Moore!* A.Moore's artwork noticeably 'rushed' and less detailed from now on... ;

Nekriline now spelt w/ an "i" again...

Feb 13, 1982 (p.63) "ART BY CURT VILE, STORY BY PEDRO HENRY"

Feb 20, 1982 (p.51) "STORY BY PEDRO HENRY, ART BY CURT VILE" Hedda Lite ("Miss Mazda Mammaries herself") introduced.

Feb 27, 1982 (p.53) No credits (or at least I couldn't see any)

March 6, 1982 (p.47) "SCRIPT BY PEDRO HENRY, ART BY CURT VILE" Strilo Gomphox, and Adelbert, introduced.

March 13, 1982 (p.55) "SCRIPT: PEDRO HENRY, ART: CURT VILE"

March 20, 1982 (p.55) "SCRIPT: PEDRO HENRY, ART: CURT VILE"

March 27, 1982 (p.59) "ART BY CURT VILE, SCRIPT BY PEDRO HENRY"

April 3, 1982 (p.59) "SCRIPT – PEDRO HENRY, ART – CURT VILE"

April 10, 1982 (p.57) "ART BY CURT VILE, SCRIPT BY PEDRO "SWAMP OF GUTS" HENRY" [?] ("And it's not a dream... not a hoax... not an imaginary story...")

April 17, 1982 (p.51) "SCRIPT – PEDRO HENRY, ART – CURT VILE"

April 24, 1982 (p.59) "SCRIPT BY PEDRO HENRY, ART BY CURT VILE" Pressbutton kills Harry the Hooper

May 1, 1982 NOT FEATURED

May 8, 1982 (p.51) "SCRIPT BY MR. PEDRO HENRY, ART BY MR. CURT VILE"

May 15, 1982 (p.55) "ART BY CURT VILE, SCRIPT BY PEDRO HENRY"

May 22, 1982 (p.51) "ART BY CURT VILE, SCRIPT – PEDRO HENRY" Pressbutton gets new Meganaut body.

May 29, 1982 (p.59) No credits (doesn't read like Alan Moore though...)

June 5, 1982 NOT FEATURED

June 12, 1982 (p.41) "SCRIPT BY PEDRO HENRY, ART BY CURT VILE" Unstuck Simpson; Isaiah Hellboy and the Newtralizers

June 19, 1982 NOT FEATURED

June 26, 1982 (p.49) "ART BY CURT VILE, SCRIPT BY PEDRO HENRY" 'Gomorrah's World' amusement park on Depravity

July 3, 1982 (p.49) "SCRIPT BY PEDRO HENRY, ART BY CURT VILE"

July 10, 1982 (p.13) "ART BY CURT VILE, SCRIPT BY PEDRO HENRY" The Siege of Gomorrah's World: Incident One. [ie."Tomorrow's World"? lame joke...]

July 17, 1982 NOT FEATURED

July 24, 1982 (p.41) "SCRIPT BY PEDRO HENRY, ART BY CURT VILE" The Siege of Gomorrah's World: Incident Two, Incident Three.

July 31, 1982 NOT FEATURED

August 7, 1982 (p.39) "ART BY CURT VILE, SCRIPT BY PEDRO HENRY" Dingbunger and Unstuck Simpson in bar; splash panel of Pressbutton on rampage

August 14, 1982 (p.47) "ART BY CURT VILE, SCRIPT BY PEDRO HENRY" The Siege of Gomorrah's World: Incident Four. "For Dave Sheridan (creator of Dealer McDope, died 1982)"

August 21, 1982 NOT FEATURED

August 28, 1982 (p.33) "SCRIPT BY PEDRO HENRY, ART BY CURT VILE" The Dark Dodo (Dark Phoenix parody) introduced

Sept 4, 1982 NOT FEATURED

Sept 11, 1982 (p.43) "SCRIPT – PEDRO HENRY, ART – CURT VILE" The Siege of Gomorrah's World: Incident Five

Sept 18 – Oct 2, 1982 NOT FEATURED

Oct 9, 1982 (p.57) "ART BY CURT VILE, SCRIPT BY

MMMPF-MNNGH-MMGHMF" ie. **SCRIPT BY ALAN MOORE!** ("Hi! Cuddly Curt Vile here! For all of you who've become utterly confused with the scripts that this deranged dago's been writing recently I thought we'd pause and check out what's been happening to everyone...") re-cap of story

Oct 16, 1982 (p.36) "SCRIPT – PEDRO HENRY, ART – CURT VILE" The Siege of Gomorrah's World: Incident Six ('sluzzgreep' ref... cf Ragnarok video?) Unstuck Simpson begins battle with the Dark Dodo

Oct 23, 1982 (p.30) "SCRIPT: PEDRO HENRY, ART: CURT VILE" The Siege of Gomorrah's World: Incident Seven. Hunt Emerson appears??

Oct 30, 1982 (p.34) "STORY: PEDRO HENRY, ART: CURT VILE" The Siege of Gomorrah's World: Incident Eight.

Nov 6-20, 1982 NOT FEATURED

Nov 27, 1982 (p.31) "SCRIPT BY PEDRO HENRY, ART BY CURT VILE" The Siege of Gomorrah's World: Incident Nine.

Dec 4, 1982 (p.42) "SCRIPT BY PEDRO HENRY, ART BY CURT VILE" The Siege of Gomorrah's World: Incident Ten. (Priapin 90 aphrodisiac takes effect...)

Dec 11, 1982 NOT FEATURED

Dec 18, 1982 (p.26) No credits CENSORED BY *SOUNDS* MAGAZINE!? (two panels whited out/missing – a *printed* note at the bottom of the strip reads: "Astute readers may have noticed the absence of several panels from this week's cartoon. I leave you to draw your own conclusions. – Censorial Ed.") I assume this is not a deliberate device as the 'story' doesn't really make sense without the panels. Must have been rather too explicit for the Editor ... (!)

Dec 25, 1982 "THE BRIDE OF PRESSBUTTON" PP.19-22 Xmas special "ART AND STORY BY CURT VILE" "Not a dream! Not a hoax! Not an "imaginary story"!!" (...he is fond of that phrase isn't he!)

Jan 1-8, 1983 NOT FEATURED

Jan 15, 1983 (p.23) "ART BY CURT VILE, SCRIPT BY PEDRO HENRY" The Siege of Gomorrah's World: Incident Eleven. Priapin 90 orgy continues. Fay Wrays return. 'Guest starring' Warpsmith (!), ET the Extra Terrestrial, a Dalek, H.R.Giger's Alien... others?

Jan 22 – Feb 5, 1983 NOT FEATURED

Feb 12, 1983 (p.40) "SCRIPT: PEDRO HENRY, ART: CURT VILE" Nekriline presses Axel's button...

Feb 19, 1983 (p.48) "SCRIPT BY: "NUTS BOY" HENRY, ART BY: BLIND LEMON VILE, (c)'83, PAT. PENDING" The Siege of Gomorrah's World: Incident Twelve: The Big Bang!! "Hello everyone I haven't written to." – margin note. Encounter between Unstuck Simpson and the Dark Dodo comes to a climax. Maxwell the Magic Cat – yet another guest appearance!

Feb 26, 1983 (p.40) "SCRIPT BY MR.HENRY, ART BY MR.VILE" 'Immolato Tomato' released

March 5, 1983 NOT FEATURED

March 12, 1983 (p.44) "ART CURT VILE, SCRIPT BY PEDRO HENRY – THANKS A BUNCH, PEDRO" Pressbutton gets his old body back.

March 19, 1983 (p.52) "Epilogue: (What happened to everybody)..." **"SCRIPT AND ART – CURT VILE (c)1983"** Features Curt Vile and Pedro Henry standing before huge golden statue of main characters [rather like the statue of Superman on the cover of "Whatever Happened to the Man of Tomorrow" in fact]: Dingbunger, Pressbutton, Harry the Hooper, McGurk, Nekriline, Mupdook. Statue is inscribed with the legend, "Sex, Madness & Meteors." There is a mention of "a Ms.Ginda Bojeffries" (!) Is it possible that The Bojeffries Saga was originally conceived as the follow-up strip for *Sounds* after "Stars..." finished its run?? ie... Printed note at side of strip: "*CURT VILE will return soon with a wild and wacky NEW cartoon series. Watch out for it!*" Well, it never happened of course, but perhaps he'd pitched an idea to them for another strip? "Curt Vile" continued to be listed as *Sounds* Cartoonist (along with Savage Pencil) in the credits box each week for several months after this.

Bryan Talbot's "Scumworld" strip (not his best work) started appearing in *Sounds* a longish while after Stars finished. (Perhaps Moore suggested him as a replacement when it was clear he wouldn't have the time to do more work for them himself? And no doubt he wasn't pleased with the censorship of the Dec 18, 1982 strip...) I can find out exactly when "Scumworld" began (sometime in 1983) if it's of any interest...

ADDITIONAL MATERIAL AND NOTES:

March 31, 1979 – first Roscoe Moscow strip printed

July 7, 1979 – Letters, page 58, includes first response to strip I can find, a reader's own version of Rock 'n' Roll Zoo/Roscoe Moscow (not very good)

November 17, 1979 – Curt Vile cartoon on p.18 ("Quasimodo")

December 15, 1979 – reader's letter printed, headed "The Ripper is No Joke," complaining about Yorkshire Ripper gag in Roscoe Moscow strip. Letter from one Dave Harling, Sheffield. No reply printed.

December 22, 1979 – Curt Vile cartoon on page 21 (Frankincense/stein). NB the same cartoon was also printed in the Back Street Bugle #34, December 1979 issue.

February 16, 1980 – page 29, "Phantoms of the Teenage Opera" half-page article on the group Bauhaus, uncredited but unmistakeably by Moore [NB. later confirmed on the letters page of the November 29, 1980 issue (p.62): in the course of replying to a reader's letter the editor remarks, "Listen, we did the world's very FIRST Bauhaus feature, *by our dishy cartoonist Curt Vile*, a whole year ago". [my italics]

May 3, 1980 – Letters, page 55: "Agent of Misfortune". *Sounds* reader Derek Hitchcock complains about Roscoe Moscow strip ("Is there any intelligent life which reads *Sounds*?... after erading a recent episode of Roscoe Moscow's adventures I wanted to crawl into a corner and vomit!... etc... Yours disgustedly, Derek Hitchcock")

May 17, 1980 – Letters, page 63: "Curt Replies". Alan Moore (as Curt Vile) responds to letter of May 3. Large illustration of Roscoe Moscow printed with reply.

July 12, 1980 – The Stars My Degradation strip begins

October 25, 1980 – Cockney Rejects article pp.32-33, "At Home With The Rejects: a pictorial guide to the thinking punk's SAS" Captions/concept by Garry Bushell; Photographs by Ross Halfin; Cartoon(s) by Curt Vile (a medley of East End icons and memorabilia, the Kray Twins, the Queen Mother, etc, etc...) Article is really a set of photos with 'humorous' captions. Centre-pages.

December 13, 1980 – Saxon (ie. heavy metal group) article pp.28-29, "Rock Dreams" by Garry Bushell. Illustration by Curt Vile. Photos by Jill Furmanowsky. signed "(c) 1980 by Curt "likes drawing leather" Vile"

February 14, 1981 – Bauhaus interview by Curt Vile pp.32-33 (centre- pages): "Terror Couple Kill Telegram Sam In The Flat Field... and other Bauhaus nightmares"

February 21, 1981 – note in margin of "Rock'n'Roll Zoo" strip by Savage Pencil: "This episode dedicated with love to Alan, Phyliss [sic] and Amber"

April 4, 1981 – The Jets interview by Curt Vile, p.21, "Here Come The Jetsons – Curt Vile visits Northampton's legendary Rockabilly band The Jets"

June 27, 1981 – Article on the group Bad Manners pp.26-27, centre-pages: "The Deranged Doings of Desperate Doug ...and his Demented Droogs," features Curt Vile illustrations of band etc in style of old British comics (Beano/Dandy, etc). Photo essay about band's European tour in

same style as earlier Cockney Rejects article, by Garry Bushell. "Graphic by Curt "Cuddles" Vile". Photos by Ross Halfin, *including* small photo of Alan Moore dressed as wrestler Giant Haystacks (!) with caption: "...will he [ie band singer] be able to meet the next challenge to his ring-centre sovereignty, as the grapple gauntlet's hurled down by our own Giant Haystack cuddly curve carnival Curt Vile (right) himself???"

July 11, 1981 – reader's letter printed page 51, "Ranking Rodgers," re. Stars My Degradation strip: "What's all this about putting down Clodagh Rodgers in your Curt Vile strip... etc" with photo of Clodagh... (No reply printed)

July 18, 1981 – reader's letter page 59, "Savage Indictment" – "Savage Pencil, what has become of you?... has he been murdered by Curt Vile?..."

August 8, 1981 – Mystery Guests article by Curt Vile on p.22: "Mystery and Abomination: Curt Vile introduces you to the magical Mystery Guests"

August 22, 1981 – Curt Vile LP review of Half Japanese, "Loud" LP, page 43: "Deformation Row" (w/ band photo). Mention of Superboy comics and Bizarro World.

August 29, 1981 – Article on centre-pages, pp.24-25 (cont'd p.44): "Mutate and Survive: our nuclear heritage documented by John Gill, illustrated by Curt Vile," featuring "detourned" drawings taken from government civil defence leaflet ('Protect and Survive'). Very funny! Also, on page 26, Betty Page reviews 2nd Mystery Guests single, "The Sparrow That Ate New York" ("...Come on Curt, own up, it is him isn't it? Please?")

Sept 26, 1981 – p.55, reader's letter re. Stars strip/Curt Vile, "Optical Illusion"

Oct 17, 1981 – p.43, letter ("Bitchy") praising Curt Vile X-Men parody, from "Dark Phoenix" – p.24, advert for Bauhaus "Mask" LP uses Moore's sleevenotes –

Dec 12, 1981 – p.32, Curt Vile review of Bauhaus "Mask" LP, "Haus trained"

Dec 26, 1981 – pp.19-22, "Christmas on Depravity," (co-written by Pedro Henry)

Feb 20, 1982 – p.28, Bauhaus article by Johnny Waller quotes Alan Moore/Brilburn Logue sleevenotes to "Mask" LP as epigraph.

March 6, 1982 – p.8, article on Warrior magazine by Geoff Barton mentions Curt Vile/ Alan Moore connection, Stars My Degradation/Pressbutton, "totally off the wall" quote, etc.

October 23, 1982 – p.33, ALAN MOORE (ie. not "Curt Vile") review of "The Sky's Gone Out" LP by Bauhaus: "Haus of surprising fun"

Nov 6, 1982 – Hawkwind article by ALAN MOORE (ie *not* as "Curt Vile"), pp.16-17 (cont'd on p.49): "Wind Power – Alan Moore joins the congregation at the church of Hawkwind"

Jan 22, 1983 – p.37, letter headlined "Press Gang": "As no-one else seems to have written in about this yet, I'd just like to say that the four-page Pressbutton cartoon in your Xmas issue was magnificent! Artist/writer Curt Vile is an absolute genius – I would have paid 35p just for the cartoon alone. Is there any chance of Pressbutton becoming editor of Sounds, or at least a staff writer? He would be perfect for your paper's brand of hack journalism (geddit). – Captain Cuthbert"

March 19, 1983 – last episode of The Stars My Degradation printed

Sept 17, 1983 – p.28, *Sinister Ducks* single reviewed by Garry Bushell (!)

Oct 15, 1983 – p.17, article on the group King Kurt (by Tony Mottram) is headlined "Kurt Vile"...

DISCOGRAPHY

by Greg Strokecker and David Hume

THE MYSTERY GUESTS
Boys Own Label, 1980 (BO 1)
Side One – Wurtlizer Junction
Side Two – The Merry Shark You Are
Moore wrote both of the songs on this single. The group did a second single which had no work by Moore on it. Moore wrote an article titled "Mystery and Abomination" on the group that appeared in the August 8, 1981 issue of *Sounds* magazine.

MASK – (by Bauhaus)
Beggars Banquet Music, 1981 (BEGA 29)
Moore wrote a seven line poem on the inside sleeve under the pseudonym "Brilburn Logue"

SATORI IN PARIS EP – (by Bauhaus)
Beggars Banquet Music, 1982
Moore does the spoken introduction on side one.

EMPERORS OF ICE CREAM (First incarnation)
1982, Never released commercially
Band included Alan Moore, David J. and Alex Green, who refers to the band as "The dream band that never got beyond rehearsals". It's unknown if this was just a conceptual band or if they actually performed and/or recorded any music. Much of this material was performed by The Dego Tee's. This first incarnation of the band was probably the precursor to the Sinister Ducks.

THE SINISTER DUCKS
Situation Two/Beggars Banquet Music, 1983 (SIT 25)
Side One – "Suiside (This Side)" – March of the Sinister Ducks
Side Two – "Homiside (Other Side)" – Old Gangsters Never Die
Moore wrote and sings both of the songs on this 45 rpm under the pseudonym "Translucia Baboon". The other members of the trio are "Max Acropolis" (Alex Green) and "Capt. Jose Da Silva" (David J.). The song "March of the Sinister Ducks" was re-released on a flexi-disc in the comic *Critters* #23. The inside sleeve includes an 8-page comic adaptation of the song "Old Gangsters Never Die," art by Lloyd Thatcher. Both of these songs are included as part of the soundtrack to the video "Monsters, Maniacs & Moore" (Moore lip-synchs to both of them).

V FOR VENDETTA
Glass Records/Beggars Banquet Music, 1984 (Glass 12032)
Re-issued on CD by Cleopatra Records, 1998
Side One – This Vicious Cabaret
Side Two "(A V.T.V. Broadcast)" –
 V's Theme (Intro)
 Incidental
 V's Theme (Outro)
Lyrics by Moore and music arranged by David J. The score for this song was printed in *Warrior Magazine* #12. Some of these songs were included on David J.'s record "On Glass" (see below).

THE SATANIC NURSES
Cold Spring Records, 1990. Never released commercially
Words and vocals by Moore. Includes the song "Murders in the Rue Morgue," lyrics to which appeared in *Negative Burn* #13 and in Alan Moore's Songbook. With Curtis E. Johnson on guitar, this is probably the precursor to the second incarnation of the Emperors of Ice Cream.

EMPERORS OF ICE CREAM (Second incarnation)
Northampton Music Collective, 1992-94
This incarnation of the band was Alan Moore, Tim Perkins, Chris Barber, Curtis E. Johnson and Pete Brownjohn, as well as the "Lyons Maids" including Melinda Gebbie, on accompanying vocals. They had one track released on the cassette/zine "Frank". The band's performances were all local to Northampton.

WATERING THE SPIRITS – (Tom Hall)
Sore Head Music, 1994, limited distribution
Tom Hall was the part of the UK folk scene that recorded – with Alan Moore, of all people, reciting the words to the chilling and entirely European "Madame October," possibly the most gory stamp collecting story ever told.

HEXENTEXTS: A CREATION BOOKS SAMPLER
Codex Records, 1995 (CODE1)
One track written and recited by Moore with music by Tim Perkings. Includes the first recorded release of the piece "Hair of the Snake that Bit Me," which would later appear on *The Moon & Serpent Grand Egyptian Theatre of Marvels* CD. Moore also did the cover artwork.

THE BIRTH CAUL: A SHAMANISM OF CHILDHOOD
Charrm/Locus+, 1995 (CHARRMCD22)
All words written and recited by Moore, music by David J. and Tim Perkins. Recorded live at a Victorian magistrates court in Newcastle upon Tyne, England on November 18th, 1995 (Moore's 42nd birthday). The CD includes liner notes by Moore. Adapted into a comic book by Eddie Campbell (1999).

MAURICE AND I – (by The Flash Girls)
Fabulous Records, 1995
Moore wrote the song "Me and Dorothy Parker". Lyrics printed in issue #26 of *Negative Burn* and in *Alan Moore's Songbook* (see bibliography). The Flash Girls are fantasist Emma Bull and The Fabulous Lorraine (their alter egos Pansy Smith and Violet Jones are seen in DC Comics' *Sovereign Seven*).

THE MOON & SERPENT GRAND EGYPTIAN THEATER OF MARVELS
Cleopatra Records, 1996
All words written and recited by Moore; music by David J. and Tim Perkins. Recorded at the Bridewell Theatre on July 16th, 1994, coinciding with the collision of the Shoemaker-Levy 9 comet into Jupiter. The CD also includes a small essay in the CD booklet on the performance written by Moore.

BROUGHT TO LIGHT
Codex records, 1998 (CODE5)
All words Written and recited by Moore, music arranged by Gary Lloyd. It is a spoken word adaptation of the comic by Moore and Bill Sienkiewicz. The CD also includes a 4 page essay in the CD booklet on the original comic and the demise of the Christic Institute.

ON GLASS – (David J)
Cleopatra Records, 1998 (originally released in 1986?)
Lyrics to "This Vicious Cabaret" by Moore. Includes three out of four tracks from the "V for Vendetta" record (see above) – "This Vicious Cabaret"; "Incidental" and "V's Theme (Outro)".

THE HIGHBURY WORKING
RE: , 2000 (RE:PCDNO3)
All words written and recited by Moore, music by Tim Perkins. Includes small text pieces to each track in the booklet to the CD.

ANGEL PASSAGE
RE: 2000 (ASIN: B000068PYJ)
All words written and recited by Moore, music by Tim Perkins.

SNAKES & LADDERS
RE:, 2003 (RE:PCD05)
All words written and recited by Moore, music by Tim Perkins. Includes a small text piece in the CD booklet. This was another one-off performance with Moore reciting the monologue and musical accompaniment by Tim Perkins. This occasion was held at Conway Hall near Red Lion Square for the Oxford and London Golden Dawn Society.

SPECIAL MENTION:
THIS IS THE DAY…THIS IS THE HOUR…THIS IS THIS! – (by Pop Will Eat Itself)
BMG Records/RCA – 1989
No work by Moore, but does include the now-famous chorus "Alan Moore Knows the Score" in the song "Can U Dig It". Also refers to Moore's work in the song "Defcon.one".

VIDEOGRAPHY

compiled by Greg Strokecker and David Hume

A CHAT WITH ALAN MOORE: 1985 – Lynn Vannucci productions.
Documentary in which Lynn Vannucci interviews Moore about his success with *Swamp Thing* and how he came to write American comics. Also includes interviews with Len Wein and Karen Berger.

ANTI-GRAVITY ROOM: 1994-1999 – YTV; Sci-fi Channel
A series which ran on both American and Canadian cable television focusing on comics. Moore appeared in 4 (?) episodes.
Episode #37 – "Pot Luck" – Dave Gibbons on *Watchmen*.
Episode #38 – "Monsters & Evil" – Moore discusses *From Hell*.
Episode #42 – "Great Stories" – Moore discusses *Watchmen*.
Episode #46 – "Pot Luck" – Moore discusses *Miracleman*.
Episode #55 – "Legends"

THE CARDINAL & THE CORPSE (or a Funny Night Out): 1992 – British Channel 4
A show about books and bibliophiles in London. Shown as part of the Channel 4 "offbeat arts and culture series," Without Walls. Moore appears in a series of framing sequences in which he is trying to locate a copy of Francis Barrett's classic occult work "The Magus".

CLIVE BARKER'S A-Z OF HORROR: 1997 – BBC2
Moore appeared in one episode of this six episode series. To tie-in with the series there was also a book version (compiled by Stephen Jones," BBC Books, 1997). Moore is featured in the section, "Y for Year Zero," pp.228-236 talking about From Hell.

COMICS PROFILES: 1988 – Acme Video and C.A. Productions
A series of videos about comics. Moore was to appear in the first four, but not all were actually produced.
#1 – "Ten Years of 2000 AD – A Video Celebration" – Video looks back at the British comic *2000 AD* and interviews creators who have contributed to the comic, including Moore.
#2 – "Will Eisner – A Life in Sequential Art" – Video looks at Will Eisner's career in comics and interviews various professionals including Moore as to their opinions on Eisner's work.
#3 – "Watch the Men – Dave Gibbons and Alan Moore" – This never-released video was to be of interviews with Gibbons and Moore about *Watchmen*.
#4 – "Alan Moore Iconoclasm at the I.C.A." – Video of the talk Moore gave at the ICA (Institute of Contemporary Arts) convention.

COMIC TALES WITH ALAN MOORE: 2001 – Channel 4
Part of Channel 4's "The Other Side" series. By Robert Farmer.
A half-hour show in which Moore goes to various locations in Northampton that are featured in his novel "Voice of the Fire".

GENERATION 90: HEROES: 1991 – Antenne 2 / NBdc Productions; Channel 4.
A series which focused on "a look at the changing face of heroes and leaders around the world." As well as Alan Moore, this featured Anthony Burgess, Bob Geldof, Alvin and Heidi Toffler, Sting, JG Ballard, the Dalai Lama, Jacques Verges, Oleg Gordievsky and others.

HISTORY OF COMICS, VOL. 4: 1990 – Episa / White Star
A series of videos which explores the history of the comics medium. Moore is featured in this volume talking about super-heroes.

HOLY SMOKE!: 1998 – LWT (London Weekend Television)
An 8-part series of "multi-faith programmes for young people/the under-25s" shown on ITV. Presented by Anna Richardson and Jason Bradbury. Moore appeared in the second episode. "Anna Richardson's guests examining different beliefs include comic

writer Alan Moore and poet John Hegley".

MASTERS OF DARKNESS: 2002 – Channel 4
A 4-part documentary series that focused on famous historical persons involved with the occult. The last episode, "Queen Elizabeth's Magician," featured Moore talking about Dr. John Dee, Queen Elizabeth's court magician.

THE MEDIA SHOW: 1989 – Channel 4
Moore appeared in one episode, being interviewed by Muriel Gray. He spoke about his *Brought to Light* project.

MONSTERS, MANIACS & MOORE: 1986 – "England Their England"
Moore was involved in the production of this video. It is about Moore's career in comics up to this time. It features him interviewing himself, showing his "method acting" approach to writing comics and lip-synching to a song he wrote.

PRISONERS OF GRAVITY: 1993 – Canadian cable; YTV
This was a television series which ran on Canadian cable and focused on comics and science fiction.
#11 – "Horror" – Stephen Bissette talks about working on *Swamp Thing* and collaborating with Moore.
#16 – "Chaos" – Bill Sienkiewicz talks about collaborating with Moore on *Big Numbers*.
#17 – "Ecology" – Moore talks about working on *Swamp Thing*.
#19 – "Watchmen" – This entire episode is a tribute to *Watchmen* and features interviews with Moore and Dave Gibbons.
#28 – "Cosmic Cavalcade" – Moore and Oscar Zarate are interviewed about *A Small Killing*.
#49 – "Comic Book Layout" – Dave Gibbons discussed the layouts he used on *Watchmen*.
#67 – "Politics" – Moore and David Lloyd are interviewed about *V for Vendetta*.
#72 – "Awards" – Dave Gibbons discusses winning a Hugo award for *Watchmen*.
#77 – "Sex" – Moore discusses *Lost Girls*.
#79 – Violence" – Moore discusses *Miracleman* vol. 3, especially issue #15.
#100 – "The Ricky Awards" – The host ("Commander Rick") shows clips from his favorite past shows. Some previous interviews with Moore are shown.

RAGNAROK: 1983 – Nutland Video Limited
A "still-animation" sci-fi video. It has three segments, all scripts written by Moore, art by Mike Collins and Mark Farmer. Cover by Bryan Talbot.

SATURDAY REVIEW: 1986 – British Television
Moore was interviewed in an episode titled "The Resurgance of Horror Popularity".

SCI-FI BUZZ: 1994-1997 – Sci-fi Channel / USA Network
This was a series that ran on American cable's Sci-fi channel. Moore was interviewed in one episode (#137). During the interview, the host asks Moore what kind of people read his comics. Moore replies, "I don't know, but I wouldn't want to be caught in an elevator with them!".

SF:UK: 2000 – MMM TV production for Channel 4.
A series which ran on British Channel 4. Moore was interviewed in an episode titled "Ultra-Violence" which focused on violence in science fiction and comics. He spoke about *Watchmen* and *V for Vendetta*.

THE TUBE: 1986 – British Television
A show which ran on British television featuring new pop music. Moore was interviewed in one episode.

WATCHMEN 15TH ANNIVERSARY: 2000 – DC Comics
This was a promotional video that DC Comics was going to distribute for the *Watchmen* 15th anniversary hardcover edition. The video was never distributed after both Moore and Dave Gibbons withdrew their support for the project, due to DC's censoring of a story Moore wrote for the "Cobweb" strip in *Tomorrow Stories*.

WORD BALLOONS AND MODERN FABLES: 1986 – Tyne Tees TV
This show was an episode in a series called "The Works" which ran on British television in a limited

viewing area. It featured interviews with Moore and other comics creators at the Birmingham Comic Art Show.

XXX TRIPPING: 1997 – Edit Box Television Facilities
This was another series which ran on British Channel 4. This series only had three episodes. Moore appeared in all three.
#1 – "Magick" – Moore discusses magick and psycho-geography.
#2 – "Body" – Moore discusses sex and *Lost Girls*.
#3 – "Death" – Moore discusses Death, serial killers and *From Hell*.

MISCELLANEOUS MOORE BIBLIOGRAPHICAL INFORMATION
by David Hume and Greg Strokecker

ANON (Alternative Newspaper of Northampton) –
#1, Dec 1974 Anon E Mouse first strip [p.7]
#2, Jan 1975 Anon E Mouse (p.9)
#3, Feb/March 1975 Anon E Mouse (p.9) *no issue number on cover*
#4, April 1975 Anon E Mouse (p.11)
#5, May 1975 Anon E Mouse (p.11) *no issue number on cover*

BACK-STREET BUGLE 1978-1980
(Published by EOA Books)
#6 (Feb 7 – 19, 1978) – "The Adventures of St. Pancras Panda".
#7 (Feb 21 – Mar 6) – "St. Pancras Panda – The story so far..."
#8 (Mar 7 – 20) – "The Widescreen Adventures of St. Pancras Panda"
#9 (Mar 21 – Apr 3) – [? – Title not available].
#10 (Apr 4 – 17) – "The Trial of St. Pancras Panda"
#11 (Apr 18 – May 3) – "The Prison Writings of St. Pancras Panda"
#12 (May 4 – 15) – "St. Pancras Panda Encounters Mental Illness"
#14 (Jun 6 – 19) – "The Astounding Adventures of St. Pancras Panda"
#15 (Jun 20 – Jul 4) – Moeby Palliative strip, written and drawn by Moore – "Moeby Palliative 'The paraplegic's push-bike' and His Faithless Sidekick Ygron – in 'The Sensuous Beachball' ".
#16 (Jul 4 – 17) – "St. Pancras Panda Gets Right Up the Nose of 'The Nose in the Pyramid' "
#18 (Aug 15 – Sep 11) – "St. Pancras Panda confronts Apathy in the U.K."
#22 (Dec) – "The Electric Kool Ade St. Pancras Panda"
#23 (Jan 1979) – "Fat Jap Defamation Funnies"
#24 (Feb 1979) – No Moore content but there is a note in the editorial column on page 2: "As often happens, there is no Panda this week – Alan Moore was told that the deadline was NEXT week! However, he did send us a drawing of Siouxsie (of The Banshees), which we haven't printed due to lack of space/ideological objections/moral cretinism/plain cowardice (delete as appropriate). This pic was also rejected by the NME, so we're in good company (only joking, Alan!)."
#25 (Mar) – "St. Pancras Panda Gets a Dose O'dat Old Time Religion"
#26 (April 1979) – note on p.5: "Has Alan Moore been eaten by Venusian gleeks? Read the next exciting issue of B.S.B. & you may find out."
p.15: advert for St.Pancras Panda poster! (i.e. blown-up panel from strip in #25, "Because God is Love, you vile little bastard!!"...) printed in six colours, produced by Paupers Press p.14: Moeby Palliative strip by Dick Foreman includes a one- panel Moore reference – poster of him with slogan, "Happiness is a Loony Cartoonist". No strip by Moore in this issue.
#30 (Aug 1979) – Article on p.3: "Roscoe Moscow's St.Pancras Panda" about Moore's work for Sounds (and Dark Star) and what happened to Pandastrip, signed "Forbushman" [Dick Foreman?]
#31 (Sept 1979) – Report on the "Comicon '79" comics convention in Birmingham, signed "Dick" [Foreman], mentions Alan Moore in passing ("I might

get a Panda drawn for Christmas") and uses a panel from Roscoe Moscow episode 5 (April 28, 1979) as one of the illustrations. Moeby Palliative strip on p.15 uses character from Roscoe Moscow in two panels ("Dr.Zoltan Von Zygote courtesy Vile-O-Vision")
#34 (Dec 1979) – Curt Vile cartoon on p.14 (Frankincense/Frankenstein and the Three Wise Men), signed "Metro-Goldwyn-Vile". NB same cartoon is also printed in Sounds, Dec 22, 1979. Moeby Palliative strip on p.15 includes two panels drawn by Alan Moore, and an "appearance" by Curt Vile ("Curt Vile (c) Curt Vile '79") and St. Pancras Panda.
#40 (June 1980) – advert for Oxford Claimants Union ("Problems with the DHSS?") on page 12 has an illustration that looks like the work of Moore, though unsigned...
#42 (August 1980) – full page strip on p.5 by Moore (as Curt Vile) and Dick Foreman: "Just Another Day" (starring "those lovable cartooning jerks, Curt V. & Foreman D." ; Curt Vile cartoon on p.12 (ufo/vegetables)
#43 (Sept 1980) – two Curt Vile cartoons in this issue, on p.2 (Dracula) and p.5 (Siamese twins).

CITY LIMITS
May 19-26 1988. Alan Moore review of "Empire of the Senseless" by Kathy Acker, p.88.

CYCLOPS
Innocence and Experience Publishers, 1970.
"The First English Adult Comic Paper!". Folded over A4 tabloid comic.
Edited by Graham Keen. 4 issues only.
#1, July 1970
#2, Aug 1970
#3, Sept 1970 "Dark They Were..." advert by Alan Moore, p.8
#4, Oct 1970 "Dark They Were..." Moore ad (same as #3) printed p.12

DARK STAR (Published by Dark Star Publishing)
Moore did some single page comic strips in these issues. The first two were written and drawn by him, the last five were written by Steve Moore with Alan providing the artwork.
#19 – The Avenging Hunchback (reprinted in "I Have to Live with This Guy").
#20 – Kultural Krime Comix (reprinted in "I Have to Live With This Guy").
#21 – Talcum Power
#22-25 – Three Eyes McGurk and His Death Planet Commandoes (reprinted in Rip-off Comix #8).

ESOTERRA: The Journal of Extreme Culture
#6 (Spring/Summer 1996) – Moore contributed the cover art and a review of Peter Whitehead's book "The Risen," for which he also did the cover art. This issue also has an interview with Moore titled "The Authentic Fake".

FASHION BEAST
A screenplay by Alan Moore – 1988
A screenplay Moore wrote for Malcolm McLaren. Based on the Beauty and the Beast story as interpreted by Jean Cocteau, as well as the life of Christian Dior.Further information on Moore's only film script and Moore's involvement included in the biography, *"The Wicked Ways of Malcolm McLaren"* by Craig Bromberg (New York: Harper & Row, 1989; London: Omnibus Press, 1991) *passim*.

FORTEAN TIMES MAGAZINE – (Published by John Brown Publishing)
#73 – (Feb-Mar 1994) – Moore reviews Bernard DuClos's "Fair Game" and Ressler, et. al.'s "Sexual Homicide".
#76 – (June-July 1994) – Moore reviews "The Diary of Jack The Ripper" by Shirley Harrison.
#80 – (Apr-May 1995) – Moore reviews "The Complete History of Jack the Ripper" by Phillip Sudgeon.
#82 – (Aug-Sept 1995) – Moore reviews "The R'Lyeh Text" by Robert Turner.
#85 – (Feb-Mar 1996) – Moore reviews "Qabalah: A Primer" by John Bonner.
#86 – (May 1996) – Moore reviews "Fortean Studies".
#90 – (September 1996) – Moore reviews "The Entertainment Bomb" by Colin Bennett.

#95 – (February 1997) – Moore reviews "Blake" by Peter Ackroyd.
#104 – (December 1997) – Moore reviews "I, Crowley – Almost the Last Confession of the Beast" by Snoo Wilson.

FRONTAL LOBE #2 [undated, November 1994]
"Published quarterly by ORGANISM... West Yorkshire" Editor: Robert T. Miller. A5 sf/poetry/alternative fanzine. "The Moon and Serpent Grand Egyptian Theatre of Marvels, Part One" (pp.16-22) Includes 'Overture – Hair of the Snake That Bit Me', 'The Map Drawn on Vapour (Part I)', 'Litvinov's Book', 'The Map Drawn on Vapour (Part II)', 'The Stairs Beyond Substance', and ends "To be continued..." Part Two was supposed to appear in Frontal Lobe #3, but I don't know if it was ever published or not (tried writing to the publisher several times with no reply). Steve Sneyd, sf poet and authority on British fanzines told me he doesn't have a copy either...

JAGO GALLERY EXHIBITION:
"Jago and Out: 8 Pedagogical Excursions" Exhibition curated by Iain Sinclair, 30 Oct to 28 Nov 1997, The Jago Gallery, 73 Redchurch Street, Shoreditch, London E2
Included work by Moore (the John Dee piece that can be seen on the Comicon website) as well as Michael Moorcock, Marina Warner, Dave McKean, Chris Petit, Iain Sinclair himself, Nick Groom, and others. Listed in *Art Monthly*, #211, November 1997.

K FOUNDATION BURN A MILLION QUID
ellipsis, 1997. Edited by Chris Brook. Photographs by Gimpo. Documents reactions to the film of the K Foundation (Bill Drummond and Jimmy Cauty)burning a million pounds in cash on 23 Aug 1994. Includes comments on the film by Alan Moore.

MIDIAN MAILER 2 (Nov 1998)
Free catalogue/magazine published by Midian Books (Jonathan Davies), Tamworth, Staffordshire, UK. "Beyond Our Ken" – Review by Moore of Kenneth Grant's book, "Against the Light: a nightside narrative," which is also an essay on Grant's life and work. Later *REPRINTED* in Joel Biroco's online *Kaos* magazine, 2002, along with the original essay on "The Moon and Serpent..." by Alan and Steve Moore.

MYSTERY GUESTS
Wurlitzer Junction/The Merry Shark You Are (Boys Own records, cata.#BO 1, 1980) has lyrics, etc?, by Moore

The Sparrow That Ate New York/The Nude (Boys Own Records, cata.#BO 3, July 1981)

NME (New Musical Express)
October 21, 1978 page 27 – Alan Moore illus. of Elvis Costello accompanying the Singles reviews (by Tony Parsons). NB. Moore signs himself "Alan Moore" (ie NOT as "Curt Vile"!)

November 11, 1978, page 14 – Moore illustration of Malcolm McLaren holding Johnny Rotten's severed head, in style of Aubrey Beardsley's "The Climax" for *Salome* by Oscar Wilde. Signed "ALAN MOORE. WITH APOLOGIES TO AUB THE DAUB." [ie. NOT signed "Curt Vile"] Accompanies article, "The Great Rock 'n' Roll Celluloid Swindle – Sex Pistols Movie Details" by Frere Jacques and Giovanni Dadomo.

NORTHAMPTON POST
Moore's strip "Maxwell the Magic Cat" ran in this weekly newspaper from August 1979 to October of 1986. The strip was later reprinted in the fanzine Speakeasy.

ONEIROS BOOKS
From a letter to me by Dave Kelso-Mitchell of Oneiros Books, Nov 2001:
"Alan has been incredibly busy over the last few years so our title [*The Moon and Serpent*] hasn't come together as yet but it's still on the cards – and its intended format changes every time I talk to the great Yeti, so your guess as to what it will eventually consist of is as good as ours... I have two very rare pieces by Alan that have never ever been published –

one of them is an amazing essay on Lovecraft and the other is the first chapter of an ongoing book about Crowley illustrated by John [Coulthart], called "*The Four Gated City*". They will appear somewhere in the future, trust me." Oneiros Press website at oneiros.freeyellow.com/BOOKS.html
E-mail: dave@oneirosbooks.freeserve.co.uk
Oneiros Books, 64 Crescent Road, Hadley, Telford TF1 4JX, UK Their publishing schedule appears to have stalled however...

ORPHEUS #1, March 1971
Edited by Steve Moore and Steve Parkhouse
(formerly published as *Aspect*) Fantasy/SF/comics fanzine. This includes a short – very short – letter by Alan Moore: "Aspect was incredible. I am overwhelmed. I have whelms all over me." (page 29) That's the whole letter. There were two issues of *Aspect*, before the name was changed to *Orpheus*. Moore's letter apparently refers to #2 (March 1970), which was entirely edited and published by Steve Moore, and included work by Barry [Windsor] Smith, Jim Baikie, Steve Parkhouse, Paul Neary, etc. Contents of *Orpheus* much the same. Text stories and comic strips. Nothing by Alan Moore. *Aspect* #1 (published 1969). The second and final issue of *Orpheus* was published Spring 1973. Steve Moore told me that there was no other material by Alan printed.

THE RISEN by Peter Whitehead
Moore painting on dust-jacket of this novel. With blurb also. NB. the paperback version has a completely different cover, not by Moore

THE SATANIC NURSES: "...MORGUE" (4m29s) or, "MURDERS IN THE RUE MORGUE"
8-track master-reel. (4mins29s). Recorded 29 March 1990. Cold Spring Records, Northampton.
Group including:
Alan Moore (Vocals)
Kevin Haskins (Drums)
Chris Barber (Bass)
Tim Perkins (Guitar)
Curtis E Johnson (Guitar)
Engineer – Mark Thomas
Currently on loan to me from Justin Mitchell of Cold Spring. For further details see the Cold Spring website (discography). Trying to find somewhere to convert it to CD format cheaply... (lyrics printed in *Negative Burn* and then *Alan Moore's Songbook*, as "Murders in the Rue Morgue". An original song from the 1970s incarnation of Moore and Alex Green's band, The Emperors of Ice Cream. Confirmed to me by Alex Green. All other songs from *Negative Burn* – except for "Another Suburban Romance" – were written or recorded in the 1990s.)

SOCIETY OF STRIP ILLUSTRATORS (SSI)
SSI Newsletter/ Journal – 1982
#45 – Moore wrote an essay, "Why We're All going to Die Poor (Being and essay by Alan 'But I thought I was joining the SAS' Moore)".
#46 – Moore answers a questionnaire on writing for comics (along with four other UK comics writers).
#47 – Moore wrote a piece titled "Comic Strip Artists: Should their still-living brains be dunked in battery acid, or is that too good for them, or what? – being a discourse by Mr. Alan Moore, the prominent aesthete and theorist".
#49 – Essay by Moore describing his and Bryan Talbot's then-developing strip "Nightjar," which was to have appeared in Warrior magazine.

"SPAWN" PLAYSTATION GAME
From the 'Image Info' column of *Spawn* #43 (Feb 1996): "I'm also off to San Diego later this month to visit the Sony boys about the upcoming PlayStation version of the Spawn game. I received the design breakdown last week, and and it's pretty good. It's based on an entirely new story written by the one and only... Alan Moore. More at a later date." – Terry Fitzgerald. It was released but we're not certain if it is based on a Moore story.

VIGILANTE VULTURE
Moore wrote an introduction to this mid-80s UK small-press comic. (cf review/listing in *Escape* magazine...check... This is the one thing I can't find proof of

right now, but it was listed in an early Escape magazine (when it was still A5 format), I've never seen a copy of Vigilante Vulture itself but just for the title alone would be great to find one. Will try to find the mag with the reference in it. Swear it's true...)

VIRTUAL FUTURES 1995
Conference held May 26-28, 1995 at the University of Warwick, Coventry, UK.
Moore and possibly Tim Perkins (but NOT David J – I asked him, he wasn't there) perform a Moon & Serpent piece that sounds a lot like the short story, "Light of Thy Countenance," ie. very much anti-television. See a report here:
http://users.wmin.ac.uk/~fowlerc/vf95jael.html
"Then Alan Moore comes on. In contrast to Evans, Moore and his musician set up their own system, they are fast and professional. They also mount a row of huge candles before the table and put out all of the overhead lights, leaving candlelight and the glow of television screens, tuned to noise. The "music" is a low, modulated electronic drone. The piece is an invocation/evocation of the Nemon, the ancient Egyptian god of television. If you've ever heard the voice of Alan Moore you know how thunderous he is. At four feet from his amplifiers he is even more massive. A powerful rhythmic rant on the God which has commanded more worship than any in history. "We give him our sexual juices...he enters our eyes, uses eyelids as lips... then he takes our children." By the end I am holding one hand in the other and shaking. At the throbbing climax, I shriek and slam my hands together, incredible, utterly amazing.

I congratulate Moore and rush from the room to Rendezvous with Chris and Pat; too late. I've missed Gwyneth Jones. "
and:
"I meet Pat Cadigan and Chris Fowler outside the theatre – yes, we should do lunch... They tell me Gwyneth Jones (noted SF writer, winner of the James Tiptree award) is doing her talk at 5.30 over by the social studies building. I check my programme: that shouldn't be a problem, I'll meet you there. I drift back into the Panorama Room. And there is noted comics artist Alan Moore. I don't know if he's honest or he's doing some smooth Norman Vincent Peale sh*t, but he remembers me. "Hey, you can't have; last time I saw you was at the Watchmen Signing and there must have been about a thousand other people in line." (One way or the other, I'm going to remember this trick; "Sure I remember you, or at least you look familiar to me."). Like so many other guests at VF, Moore is an absolute peach. He tells me about the forthcoming collection of From Hell (real soon now!) and his work using ritual magic techniques to analyze the media. I mention The Temple Ov Psychic Youth's use of television in their ceremonies, but what Moore says about Genesis P'Orrige is unpublishable." (possibly this wasn't an 'official' Moon & Serpent performance, it certainly hasn't been put out on CD subsequently like the others... Makes me wonder how many other Moore performances remain 'unknown'?)

ONLINE MOORE

COMICON.COM
1963 interviews – Moore as "Affable Al" does a satire of Stan Lee.

Maii. 23. hor. 6 post meridiem. Mortlak. – This piece is from the Jago Gallery exhibition, 1997. It is a cut-up writing based on the works of Dr. John Dee. Holy Smoke! – text titled "What is Reality" originally written for a TV program that ran on London Weekend Television.

KAOS #14 – 2002
Moore writes a review of Kenneth Grant's work and does an original article with Steve Moore on "The Moon and Serpent Grand Egyptian Theatre of Marvels".

THE ONION
Moore answer's the questions "Is there a God" and "Who could you beat up".